SHINE

SHINE

The Visual Economy of Light in African Diasporic Aesthetic Practice

★ ★ ★ ★ ★

KRISTA THOMPSON

★ ★ ★ ★ ★

Duke University Press

Durham and London 2015

Designed by Amy Ruth Buchanan
Typeset in Chaparral Pro by Tseng Information Systems, Inc.

Library of Congress Cataloging-in-Publication Data
Thompson, Krista A., 1972–
Shine : the visual economy of light in African diasporic aesthetic practice /
Krista Thompson.
pages cm
Includes bibliographical references and index.
ISBN 978-0-8223-5794-0 (hardcover : alk. paper)
ISBN 978-0-8223-5807-7 (pbk. : alk. paper)
ISBN 978-0-8223-7598-2 (e-book)
1. Mass media and culture—United States. 2. Mass media and culture—Caribbean
Area. 3. Photography—Social aspects—United States. 4. African diaspora. I. Title.
P94.5.M552U685 2015
302.2′22—dc23 2014029965

Cover art: Ebony G. Patterson, *Untitled Lightz I*, 2013, detail. Mixed media
on paper, 81 × 148 in. Courtesy of the artist and Monique Meloche Gallery;
collection of Bill and Christy Gautreaux, Kansas City, MO.

This project was supported by the Creative Capital | Warhol Foundation Arts
Writers Grant Program.

Duke University Press also gratefully acknowledges the support of the
Globalization and the Artist Project of the Duke University Center for
International Studies, and Northwestern University, which provided funds
toward the publication of this book.

★ ★ ★ ★ ★

For Ella, Chaz, Xavier, and Gabriella,

for the next show and tell

★ ★ ★ ★ ★

CONTENTS

ILLUSTRATIONS

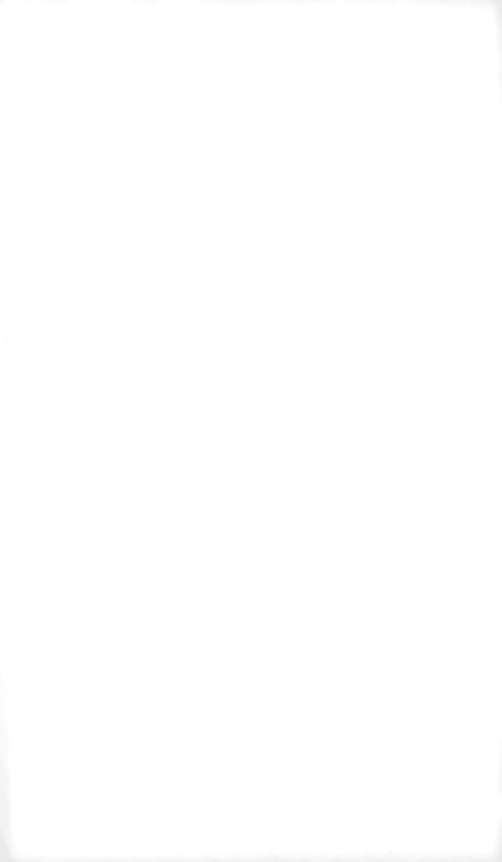

ACKNOWLEDGMENTS

I began to document street photography studios set up on the streets in Atlanta and New Orleans in the late 1990s, as I researched my dissertation on late nineteenth-century and early twentieth-century photographs of Jamaica and the Bahamas. In the course of this work I was always frustrated by the lack of information on local black photographers and the communities they pictured, while the photographs by and histories of British colonials, white local elites, or tourists could more easily be traced in the archives. Indeed some of the latter photographers seemed to preserve their images and papers with a sense of their historical importance, with the archives in mind as their eventual destination. An exhibition I curated in 2008 at the National Art Gallery of the Bahamas, *Developing Blackness: Studio Photographs of "Over the Hill" Nassau in the Independence Era*, was an attempt to provide an alternate or an "other" history of photography (to use Christopher Pinney's and Nicholas Peterson's term) in the Bahamas, one that focused on the studio photographs created in the island's black communities. Over the years when I researched black photographers in Nassau, my efforts were dogged by a sense among many that these popular photographic practices and their material remains were not significant or valuable. Decades-old negative collections were thrown away, were left in insect-infested cabinets, and were never collected by local institutions. I started documenting the contemporary popular photographic practices that I present in this study not for the purpose of making a book but to forestall a future absence. In this respect, I see this book as a type of historical study, one that creates a record that is ever mindful of the conditions of race and class and place that facilitate the disappearance of black subjects from the photographic archive.

I am eternally grateful to the photographers and videographers who took the time to share their images, histories, and knowledge of their trades with me, eventually trusting that I was not a business competitor or tax collector. I especially thank photographers and photo backdrop

artists Darren Clark, John Davis, James Green, Terell Hawkins, Larry Reid, Marlon Reid, Edward Robinson, Richard Sims, Sonny The Photographer, Jack Sowah, and Sthaddeus Terrell, who generously allowed me to follow them and to pester their clients and who spent considerable time helping me to flesh out the histories of popular photographic practices. I feel very fortunate to have been in your company and to start to document your work.

I also thank the photographers and videographers Josh Chamberlain, Davian A. Hodges, John Jones, Leading, Radcliffe Roye, Larry Short, Otis Spears, and V. Thacker, who also added substantially to my understanding of these practices. My appreciation to the many studio artists and directors, namely Marvin Bartley, Luis Gispert, James Green, Ras Kassa, Che Lovelace, the late Charles H. Nelson, Rashaad Newsome, Ebony G. Patterson, Peter Dean Rickards, Hank Willis Thomas, Kehinde Wiley, and Harold "Hype" Williams, who shared invaluable insights into the visual economy of the popular practices and helped me to develop an understanding of a current running across contemporary art in the circum-Caribbean. I thank the artists, galleries, museums, and estates that granted me permission to reproduce artwork.

I thank too the many media specialists and producers who have offered their invaluable perspectives on these popular practices and broader insights into the history of the camera and visual media: Johann Dawes, Delano Forbes, Marcia Forbes, Sonjah Stanley Niahh, Yvette Rowe, Franklyn "Chappie" St. Juste, Carlene Samuels, Ras Tingle, and Jay Will. My appreciation goes too to Sydney Bartley and Nicolette Bethel, two government officials in the ministries of sports, youth, and culture in Jamaica and the Bahamas. I also want to express my gratitude to the many people—dancers, prom-goers, photography studio clients—who considered my questions and who trusted me with their stories and photographs. Thanks to the librarians at the Nassau Public Library in New Providence; the National Library of Jamaica and the National Gallery of Jamaica, both in Kingston; and the library at the University of the West Indies at Mona. During my research I worked with videographers Esther Figueroa, Maria Govan, Jermaine Richards, and Charlie Smith. I want to thank them for helping me not only to document the photographic practices but also to see these expressions in more nuanced ways.

I could not have produced the book without the financial support of postdoctoral fellowships from the J. Paul Getty Foundation, the American Council of Learned Societies, and the Kaplan Institute for

the Humanities at Northwestern University. I am eternally grateful to the David C. Driskell Prize committee and David C. Driskell and Rhonda Matheison and Philip Verre at the High Museum of Art in Atlanta for supporting and encouraging my work at an early stage of this project. Northwestern University's Weinberg College of Arts and Sciences provided significant research support, for which I am thankful. I am indebted to the Andy Warhol Foundation for a Creative Capital Art Writer's Grant, which provided crucial financial support and a publication subvention.

This book benefited from the writing, research, and comments of many scholars. I want to acknowledge the influence of photography historians like Deborah Willis and the late Marilyn Houlberg, who early on started to document popular photographic practices in the African diaspora. I benefited from the crucial feedback and intellectual engagement of many individuals through public lectures at Indiana University, Swarthmore College, Brown University, Southern Methodist University, McGill University, Princeton University, Columbia University, the Kansas City Art Institute, the Telfair Museum, the University of Alabama, the Academy at the University of Trinidad and Tobago for Arts, Letters, Culture and Public Affairs, the College Art Association's annual conference, New York University, and journal review processes. I want to acknowledge especially Tim Barringer, Geoffrey Batchen, Maria Elena Buszek, Tina Campt, Anne Cheng, Christopher Cozier, Rachael Z. DeLue, Hannah Feldman, Tatiana Flores, Hal Foster, Anthony S. Foy, Saidiya Hartman, Barnor Hesse, Cecily Hilsdale, Corrine Kratz, K. Dian Kriz, Nicholas Laughlin, Thomas Lax, Harvey Neptune, Christopher Pinney, Richard Powell, Christine Ross, and Harvey Young.

Thanks to Ken Wissoker, editorial director at Duke University Press, for his encouragement and interest in this project and his broader field-bolstering support of visual and art-historical studies of the African diaspora. My appreciation goes to Jade Brooks and Liz Smith for shepherding the book through the production process.

The years of research, travel, and grant-writing undertaken for the book could not have happened without the support of Badia Ahad, Rocio Aranda-Alvarado, Judith Bettelheim, Magdalene Carey, Hollis Clayson, Petrina Dacres, Khyla Finlayson, Jacqueline Francis, Pamela Franco, Jonathan Greenland, Michael Hanchard, Arlington King, Amy Mooney, Steven Nelson, Annie Paul, Jerry Philogene, Kymberly Pinder, Veerle Poupeye, Lane Relyea, Vaughn Roberts, Rebecca J. Saah, Thomas Saah, David Scott, Michelle Joan Wilkinson, and David Van Zanten. The com-

munity of innovative scholars at Northwestern University who compose the Blacks Arts Initiative, which includes Lisa Corrin, E. Patrick Johnson, Ramón Rivera-Servera, Ivy Wilson, and Harvey Young, are sources of inspiration and support. I thank the chair of the Department of Art History at Northwestern University, Jesús Escobar, for his encouragement and willingness to create conditions for me to further my endeavors. My deepest gratitude goes to my colleague and friend Huey Copeland for his close and critical reading of parts of the manuscript; for his wisdom, humor, and vision.

I want to acknowledge Richard Iton, my former professor and good friend, who passed away suddenly as I was finishing this manuscript. Your generosity, integrity, humility, and wit, and your scholarly legacy of redefining politics through a reading of popular culture, are things I will keep with me always. I also want to acknowledge two of my mentors, the late Richard Long and Ivan Karp, who were so influential on my scholarly career.

Thanks to James Bliss, Emilie Boone, John Farmer, and Frances Trempe, who helped in the preparation of the manuscript, with research assistance, copyright permissions, and copyediting. I want to acknowledge publications where aspects of this book previously appeared: *Art Bulletin* (chapter 4) and *African Arts* (chapter 3).

Thanks to A.K. for always being there, literally and figuratively, with an umbrella. My deepest thanks to my family, who so patiently live with my work and projects. Thank you Ella and Anthony Thompson, Antonia and Andre Carey, Gabriella and Xavier Carey, and Chaz Thompson for supporting me throughout my endeavors.

INTRODUCTION

Of Shine, Bling, and Bixels

Genealogies of performance attend not only to "the body," as Foucault suggests, but also to bodies—to the reciprocal reflections they make on one another's surfaces as they foreground their capacities for interaction.
—**Joseph Roach**, *Cities of the Dead* (1996)

This is not counter-discourse but a counterculture that defiantly reconstructs its own critical, intellectual, and moral genealogy in a partially hidden public sphere of its own.
—**Paul Gilroy**, *The Black Atlantic* (1993)

It is eleven o'clock at night, and a bus christened Bashment careens down the streets of Kingston, Jamaica (fig. I.1). A rainbow of colors radiate from the front of the Route 39 bus in quick succession, reproducing in aerodynamic design its swift movement. These shimmering colors reflect the shine of the bus's rims, detailing, and arabesque insignia. On this night, the bus transports a group of dancehall performers, the MOB and Cadillac dancers, a videographer, and me to a stage show north of the city. We are late, so the bus blazes through the winding streets to make up time. Beaming with bright white and electric-blue lights, it appears to hover over the potholed streets, like an object from the future. Flat television screens built into its exterior give Bashment its glow. When red traffic lights bring it to a momentary halt, children approach with wide eyes, their faces lit by the flickering yet persistent light from African American hip-hop and R&B music videos emitted from the bus's HD panels. But before many of the accidental spectators can fully take in its music video offerings, Bashment is gone in a noisy flash.

I open with a description of Bashment because its display of the latest consumer electronics and music videos, featuring shimmering contemporary consumer culture, makes explicit a fact that animates this book: photographic and videographic expressions and even the

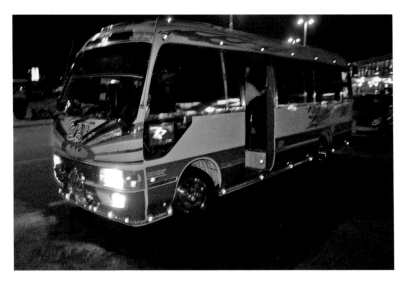

I.1. Bashment, a public bus in Jamaica with HDTV screens on its exterior. Kingston, Jamaica, 2009. Photo by author.

display of visual technologies like the camera or the HDTV screen and their shining effects are central among African diasporic communities, not only in Kingston but also in other parts of the Caribbean and the United States. Especially among young people, images—whether beaming from buses, animating miniature screens in taxis, radiating from local and foreign music-television channels, emanating from makeshift projector screens, or transmitted through cellophane-covered DVDs— dominate how people in the African diaspora experience culture, music, their sense of the world, and their places within it.

My point is not to argue for the uniqueness of the popularity of visual technologies in black communities in the United States and the Caribbean, even though studies suggest that it is especially pronounced among these groups, but to understand the distinct historical, socio-political, and ultimately aesthetic ways African diasporic communities take up photography, videography, and other forms of lens-based technologies at the turn of the twenty-first century.[1] What do these visual expressions—their content, form, and affect—signify for black producers and consumers, who often hail from the urban working-class communities of these post–civil rights and postcolonial societies? How do they offer the means for these subjects to reflect on, represent, and recast their relationship to the modern, the past, the commodity, the global, the diasporic, and the national? How do these expressions influ-

ence the ways people across the African diaspora think about their self-presentation, self-representation, visibility, and viewership in black public spheres in and beyond their communities?[2]

This book takes up these questions by considering contemporary popular uses of the camera in different parts of the African diaspora, primarily over the last twenty-five years. Specifically, it examines how lens-centered practices have informed both a representational system and a network of material and performative practices in the United States and two of its diasporic neighbors in the northern English-speaking Caribbean: Jamaica and the Bahamas.[3] This marks in the African diaspora a geopolitical and cultural space that has been described as the circum-Caribbean.[4] It is a region with intense and intimate historical ties maintained in the twenty-first century through lens- and screen-based technologies. Focusing on this area as a unit of analysis pries open national, geographic, and disciplinary boundaries between places bound together by networks of people, goods, and visual and performance practices. Analyzing the photographic and videographic genres that circulate across populations in the circum-Caribbean allows for a concentrated view of more widespread processes. These forms offer a glimpse of the way specific visual technologies mediate the ways disparate groups of people of African descent come to think of themselves as a transnational community.

While attentive to the photographic and videographic expressions these groups share, I am equally interested in the distinct ways that people engage photography and video in different locations. These representational practices are uniquely informed by the historical circumstances that forged the African diaspora in the Americas and by postcolonial formations of race, class, gender, sexuality, and culture in each place. They also respond to the ways African diasporic groups have precisely been defined as such through vision and visual technologies. The popular visual expressions inform performance practices, consumption habits, transnational aesthetic communities, configurations of economic and cultural value, contemporary art, and new modes of visibility—and "un-visibility"—that highlight shifting configurations of politics in the contemporary circum-Caribbean.[5]

This book offers a historical and critical analysis of several of the most widespread forms of photographic and videographic practice among black urban populations in this region. It also presents an art-historical analysis of the work of artists who draw on these popular expressions, including the late Charles H. Nelson, Ebony G. Patterson, Ke-

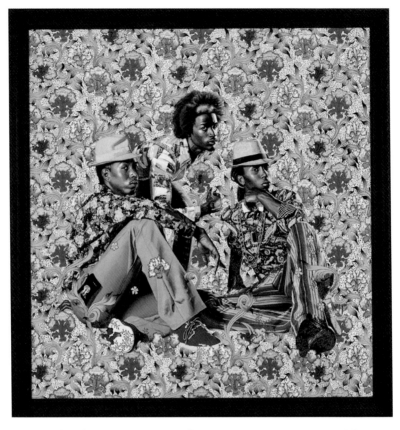

I.2. Kehinde Wiley, *Three Boys*, 2013. Oil on canvas, 92 × 92 in. Courtesy of the artist and Stephen Friedman Gallery, London.

hinde Wiley, and Luis Gispert. Like the artists of the popular genres, studio artists have developed photographic practices locally that they circulate transnationally. The US-based artist Wiley, for one, works in different locations and in 2013 produced a series of paintings, *The World Stage: Jamaica*, some of which featured Jamaican dancehall participants (fig. I.2). In the same year Jamaican-born artist Patterson worked on the art project *Illuminated Presence* with urban youth in Chicago.[6] The contrapuntal analysis of transnational contemporary art and popular practices offers a broader view of the social, political, and aesthetic contexts in which both forms flourish. At stake in exploring works of art in relation to popular culture is not simply an expansion of the sources art historians typically consider in interpreting contemporary art. Artists considered here use approaches to representation from black popular

visual culture to assess critically genres ranging from painted portraits canonized in the history of art to contemporary print advertising. Informed in part by their engagement with popular practices, many of these artists foreground the effect of light and the illusion of the real in the history of Western painting. In this way, they highlight distinct forms of image-making in the African diaspora and offer a critical and illuminating perspective on the history of Western art.

Performing Visibility and Popular Photography in Urban Communities in the Circum-Caribbean

The social significance and even predominance of the camera in contemporary African diasporic communities may be elucidated by describing what unfolded at the stage show after Bashment arrived in Santa Cruz. When Bashment finally appeared, ablaze both visually and sonically, it immediately brightened a disaffected atmosphere. Some of the headliners had pulled disappearing acts, and would-be partiers milled about outside the modest-looking club in disgruntled pockets. The bus's glowing entrance promised excitement, hype, and connectedness to a black transnational urbanity in this quiet country community. As the dancers stepped off the beaming bus, coordinated in dress and oversized rock-star shades, the fledgling affair came alive. While the fanciful dance moves of the performers and the break-dancing of their country counterparts warrant a separate analysis, I want to call attention to one particular member of the entourage: the videographer. With a large camera perched on his shoulder, like a searching mechanical bird, the videographer produced the party's visual charge. Entering the dimly lit club, he turned on his video camera and its bright light. As the DJ increased the music's volume, matching the light's intensity, the videographer scoped the room, coming to rest on the MOB dancers, who seemed energized by the camera's spotlight (fig. 1.3).

Since the late 1980s, the videographer wielding a large camera crowned with a searing bright white light (a harsh light without a diffuser) has become a fixture in Jamaica's urban dancehall and club cultures. Performers often compete, performing creatively, agilely, or sexually, to attract the videographer's attention and to bask in what is described locally as the "video light": the bright light from the video camera. An informal payola system exists, fights break out between performers, and dancehall attendees even bleach their skin (which purportedly prepares them for the video light), all in an effort to become

I.3. MOB dancers performing in the video light, Santa Cruz, Jamaica, 2009. Photo by author.

visible—to be made spectacularly present in the lens of the video camera.[7] Many seekers of the video light hope that the circulation of their images through DVDs, the Internet, or television will bring them fame and fortune.[8] Michael Graham ("Crazy Hype") of the MOB dancers expressed faith, for instance, that the video light would take the dance group "to the stars."[9] As veteran videographer Jack Sowah (Courtney Cousins) explained, "Light can do so much for them [dancehall participants]. If not in the video light no one will see them. . . . The more the light shine on you the brighter you get."[10] Light has the power to bring geographic transcendence and social ascendance. Photography and videography, as well as the spectacle of picture-taking, so evident in video light, have restructured and reoriented more long-standing cultural sites and expressions, like the half-century-old dancehall culture, and have been central to the creation of new aesthetic practices.[11]

The significance of these technologies was underscored that night in Santa Cruz. Some forty-five minutes into the festivities, the light on the videographer's camera went out, leaving only its afterimage ablaze, followed by a vacuous darkness. Although the dancehall beats continued to sound throughout the dimly lit hall, the dancers immediately dispersed and meandered away, seemingly released from the cam-

era's orbit. As the videographer worked feverishly to remedy the outage, one partier decided to take the video-light concept into his own hands. Holding his cell phone, equipped with a surprisingly bright beam of light, he stretched out his hand and cast the beam onto a woman standing next to him. Assured that the small light illuminated her, she started to dance amid the restless gazes of onlookers, a few of whom replicated the man's makeshift video-light technology.

This impromptu staging of video light was revelatory for me. It testified to the centrality of visual technology, to the fact that the dance could not take place outside its auspices. It also called attention to the dancers' state of waiting for visual technology to become active—indeed, to become subjects. The camera's substitution by a beam of light also highlighted some of the alternate uses and meanings of photographic and videographic technology evident in Jamaica's dancehall communities and across other populations in the African diaspora. The incident spotlighted, for one, the way participants in some popular visual practices in the circum-Caribbean emphasize the physical presence of technology and the display of objects associated with photographic or videographic representation—lights, cameras, screens, backdrops. Technology often becomes a prop in performances of visibility rather than or in addition to being a tool that produces a physical representation. In these practices the process of being seen being photographed constitutes its own ephemeral form of image-making. The pose, the gesture, and the choreography of the body before a photographic lens and an audience are types of representation that do not need the physical image produced by the camera.

For some, like the woman performing before the light of the phone, being illuminated in the aura of visual technologies is an intrinsic part of these practices. Indeed, the very term "video light" attests to this interest in and awareness of the optical affect and effect of light generated at the moment of photographic or videographic production. The expression brings into focus the visual and representational work of light within these diasporic photographic practices. The materiality of the photographic appears reconfigured in popular practices that emphasize the optical effect of the moment of being photographed as important in its own right.

Photography, Cultural Identity, and the Practice of Diaspora

This book focuses on several photographic and videographic genres in the circum-Caribbean in which light and the *effect* of being represented

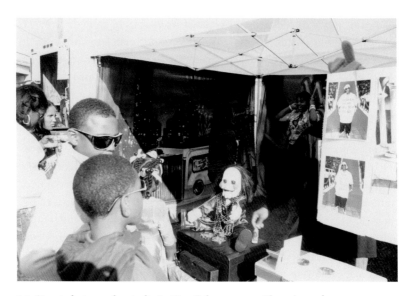

I.4. Street photography studio in New Orleans, 2009. Photo by author.

take center stage and explores some of the shared visual technologies that have informed such approaches to the camera and visibility in public space. Many of these practices have not been subject to scholarly consideration. I offer, for one, a history of video light. This visual practice has played a central role in the creation of local and African diasporic communities, which were formed around the distinct types of viewership that were produced through the rapidly moving video camera and its bright light in the dancehalls and through resulting videos and DVDs. Another popular photographic genre found across black urban communities in the United States and Jamaica is "street" or "club" photography (fig. I.4). Photographers such as Ivery McKnight, Greg Sanders, and Richard Sims popularized street photography in Washington, DC, in the late 1980s. In this genre clients pose for Polaroid or digital photographs before makeshift hand-painted backdrops, often in front of an audience and under bright lights. These backdrops, found at hip-hop concerts and festivals celebrating black culture across urban communities in the United States, often depict fantastical displays of wealth, from gleaming luxury items to Caribbean seascapes. Street photography gained currency in Jamaica in the 1990s when an individual known locally as "Sonny" became one of several photographers who introduced the form; the backdrops there are regularly found in the island's dancehalls.[12] The hand-painted backdrops provide one means by which signifiers of status

in hip-hop culture and black urban cultures in the United States become present in and configured through Jamaican dancehall culture. The very process of posing, of staging one's visibility for the camera as a display of social standing, has also traveled with the transient photographic studios. High school proms in the Bahamas present another local practice focused on public performances for the camera. These public events are the most popular and anticipated occasions for youths and their relatives in the capital, Nassau. Young people stage elaborate red carpet entrances—many inspired by hip-hop music videos—to produce events that will live on in spectators' memories. In addition to evincing spectacular forms of image-making, I examine how these practices take specific material forms—the Polaroid, the VHS tape, the digital print, and the projected video image.

All of the popular visual practices considered here circulate between or are influenced by different African diasporic groups or cultural forms. In the past, black intellectuals and political leaders, newspapers and magazines, oral histories, music, and sartorial styles profoundly shaped how modern African diasporic groups came to think of themselves as a community who shared political concerns, cultural routes, social values, historical experiences, and intertwined futures.[13] The writings of Brent Hayes Edwards and Paul Gilroy have been central in highlighting the role of print culture and vernacular music, respectively, in creating a poetics that was open and translatable to a range of diasporic audiences, across language barriers, geographies, and temporalities in the early twentieth century.[14] But there has been a relative neglect of the work of visuality in scholarship on cultural formation and exchange in the African diaspora, despite the fact that a key text on the subject, Stuart Hall's "Cultural Identity and Diaspora," takes film and to a lesser extent photography as its starting point.[15] Contemporary African diasporic formation across many black urban communities in the circum-Caribbean, I demonstrate, takes place in the light of technology, in the flickering, unsettled, reflective and bright surfaces, the pixels, of photographic and videographic representation.[16] How have the unfinished or "fantastic" qualities of music in the African diaspora been transformed when visual means of expression become primary modes of cultural circulation?[17] How do photographic and videographic technologies and the material and aesthetic effects of photographic and videographic forms newly articulate the joints and gaps formed between diasporic groups?[18] How is diasporic formation conducted through aesthetic formations and toward what end?[19] How do visual technologies expand, constrain, and

change the terrain through which diasporas are imagined and brought into being?

As visual modes of transmission have informed and transformed on-going processes of diasporic translation, the "practice of diaspora" has changed: ways of seeing and performative approaches to being seen and represented have become intrinsic to and constitutive of contemporary African diasporic communities. The circulation of photographic and videographic expressions has influenced how people across the African diaspora learn to see and assign value to being seen, to perceive and participate in viewership and spectacles, and to create forms of cultural production in which the camera—the video camera, the still camera, even the telephone camera—is central. These technologies facilitate a shared visual literacy and spectacular visibility, which is manifest in the way diasporic subjects engage in shared performances of visibility—practices that involve staging the act of being seen and being seen in the process of being seen. These expressions have created new forms of participation in black public spheres, even as the aesthetic communities of viewers and performers across the diaspora who use these expressions have transformed the political meaning of visibility in their respective societies. The camera, the right to be seen, the right to self-representation, might even confer what Paul Gilroy characterizes as the "dimensions of citizenship blocked by formal politics and violently inhibited by informal social codes."[20]

Recent scholarship has explored "photography's capacity to build or envision [an African diasporic] community across geographic location," to quote photography historian Leigh Raiford.[21] Photographic and videographic genres are mobile and mobilized, affective and effective, in picturing and producing notions of black community across geographies and cultures in the African diaspora. The ways photographic practices of diaspora work to create and secure attachments to broader communities, geographies, and cultures in the African diaspora might be elucidated by considering a street photography studio set up in Kingston, Jamaica, in 2010, that featured a backdrop portraying the Brooklyn Bridge and the United States flag in paint (fig. 1.5). The backdrop represented the bridge with sparkling white lights, from a bird's-eye perspective, portraying it as a visually accessible metropolitan landscape. Electric light, so emphasized by the use of white paint in the backdrop, became an essential part of representing the city, the modern, the cosmopolitan, the American dream, the dazzling possibilities of bright lights. By posing against the drop in Kingston, clients could have a cer-

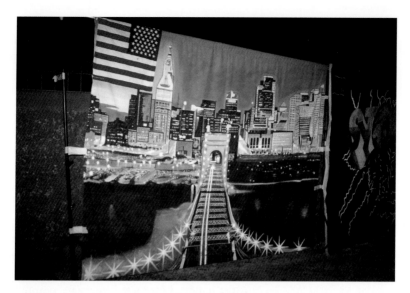

I.5. Photo Sonny's street photography studio, Kingston, Jamaica, 2010. Photo by author.

tain proximity to the New York borough, home to one of the largest and most diverse communities in the African diaspora.[22] Photographic forms like the street photography not only circulate particular iconographies and represent specific geographies, but the shared genres inform a sense of connection between diasporic groups, encouraging similar approaches to posing in public, to a photographic self-fashioning. They also offer the possibility of recognition by one's peers and diasporic counterparts as coparticipants, with different levels of power and visibility, in visual cultural expressions. The different configurations of diasporic spaces in the street photography studios highlight the way contemporary practices of diaspora, aided by visual technologies, involve forms of projection, of virtual extension into and imaginative dwelling in other geographies, communities, and temporalities.

The photographic medium, which often captures an unrecoverable moment from the past, allowing it to reside "freeze-framed" in other times and spaces, might have a special analogous relation to African diasporic communities who are often cut off or removed from spaces and times. As Christian Metz so eloquently describes it, "Photography is a cut inside the referent, it cuts off a piece of it, a fragment, a part object, for a long immobile travel of no return."[23] Metz's observation might be particularly prescient for African diasporic subjects, who use photog-

raphy at times to negotiate their conditions as African diasporic subjects. If African diasporas come to think of themselves as such through a memory of or consciousness of the experience of rupture, removal, the cut, then they might seize onto photographs because in some respects they ontologically reproduce and redress a diasporic condition.[24]

Often these photographic genres circulate across media and through informal and underground economies. Kingston's videotaped dancehall performances sometimes travel—as DVDs sold on urban streets, through YouTube, or on stations like HYPE TV—across Jamaica, the United States, the Bahamas, and more broadly.[25] It is not uncommon, as Sowah explains, for video footage from Jamaica to be copied multiple times by its producer in Kingston, counterfeited by a distributor in Flatbush, New York, and uploaded as a compressed file by a purchaser to a website.[26] At each stage the video (and more recently the DVD) can deteriorate, becoming visually marked or pixelated with each copy. Even with recent advances in Internet bandwidth speeds and video compression, in the case of dancehall videos in Jamaica there are literal gaps in translation of the image on screen. The brightness of video light and the rapid movement of the camera in the dancehall can result in streaks of light within the footage, in a visual noise materialized on the surface of video. This is evident in a video recording of the MOB dancers available online (fig. 1.6). The processes of duplication and reduplication reproduce a type of cultural formation in the African diaspora, one in which the form constantly changes over time and across space, bearing traces of and constituted by these processes of transformation and loss.[27] The formative role of visual technologies, of bytes and pixels, in the translation of African diasporic cultures is often visualized as viewers across the diaspora experience black culture through the matter, grain, and texture of visual technologies.

These popular visual technologies also cause interruption, disruption, and blindness that are equally significant in the formation of diasporas. What escapes translation and is lost if a primary means through which Jamaicans in the diaspora and African Americans experience dancehalls is through pixelated videos? How significant is it that street photography backdrops in Kingston picture the Brooklyn Bridge and a cityscape full of lights, while in Atlanta and New Orleans these backgrounds represent the Caribbean as a beach space devoid of streetlights or any signs of modernity and urbanism? How do these practices cause or reflect misrecognition and new forms of cognition that are intrinsic to the creation of diasporic communities?

I.6. The MOB dancers, Kingston, Jamaica, 2011. Video still from YouTube video, posted January 12, 2011, www.youtube .com/watch?v=Avj4jKvVuYY.

The exchange of visual media has also been a means through which performances of gender and sexual identities have been reinvented and reimposed in each context. Photographic practices offer modes through which normative ideals of gender and sexuality have been unsettled. For example, the prevalence of male dancers in hip-hop music videos, as Jamaican cultural historian Donna Hope has argued, contributes to the popularity of male performers in the dancehalls and to the presentation of new modes of masculinity.[28] In these popular expressions, signifiers of gender have become unmoored from the ways they historically produced meaning and remain in flux, in formation, refusing easy categorization and capture.[29]

To examine these expressions, this book puts photographic practices into conversation with performance studies. Sonjah Stanley Niaah and Joseph Roach have analyzed the way African diasporic and other social groups use performance practices to occupy, always imperfectly, the gaps in social-cultural networks. They explore the way these populations produce and enact counter-memories and counter-histories through performances.[30] Such performances, mediated through visual media, have increasingly come to be about staging one's visibility. Visual technologies occupy the spaces, virtually extend the worlds, and create the reflective surfaces of interaction between African diasporic groups.

In order to assess the social and sensorial effect of visual technologies and how they intercede in "performance genealogies," I did much of

the research for the book with and through a video camera or still camera.[31] In addition to taking my own photographs, I worked closely with videographers (like Jermaine Richards, whose video light went out in Santa Cruz) and photographers in Jamaica, Nassau, Washington, DC, Atlanta, and New Orleans.[32] I aimed to take seriously predominant aesthetic practices and technologies of representation in black communities. I sought to pursue an art history formulated not just in the archives but in the streets, sites where art historians typically do not look for their subjects. What are the tools, methods, and sites for the formation of alternate modes of writing African diaspora art history?

On Photographic Becoming: The In-Between State of Photography in the African Diaspora

These popular African diasporic expressions take specific forms that expand existing considerations of what constitutes photographic practice. The use of light produced through visual technologies generates distinct aesthetic, synaesthetic, physiological, and phenomenological effects, creating or denying types of viewership in particular performative and spatial contexts. The special preference for being within and producing a brilliant unrelenting white light, for one, in these popular forms of photography and videography can produce a blinding, even painful effect on both the subject before the camera and surrounding spectators (fig. I.7). In the context of the dancehalls, the video camera's light generates a form of representation at the moment of blinding, when the visual senses are inundated and exceeded. It induces a sublime state of visibility in which the subject is so hypervisible that it disappears from view. Video light and some of the other photographic practices inhabit the representational edge of hypervisibility and invisibility, optical saturation and blindness, presence and absence, blackness and white light. They produce a form of excess, a visual superfluity, that points precisely to the limits of vision or what lies just beyond photographic and visual capture.

In so doing, they create what might be described as "afterimages" that can be seen and felt after the moment of the photograph's production. Afterimages are typically defined as optical illusions that persist in one's vision after exposure to light or a visual stimulus.[33] I use the term here to refer to the way light from photographic and videographic technologies sears itself into the retinal memory of viewers after their exposure to a source of illumination has ceased. Afterimages are ephemeral, fugi-

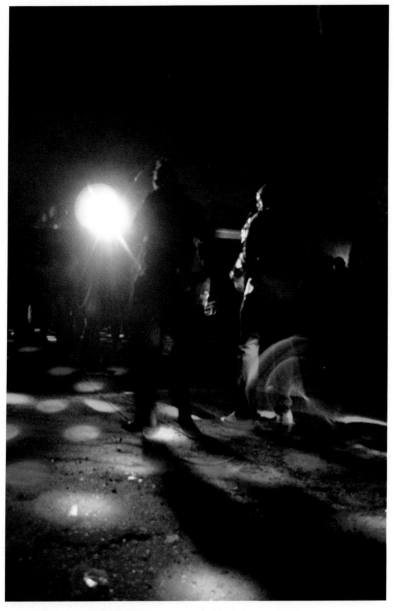

I.7. Performers at Uptown Mondays dancehall in front of the intense undiffused video light, Kingston, Jamaica, 2010. Photo by author.

tive, existing in what Walter Benjamin referred to as the "irrevocable instantaneity of a lightning flash" and the "now of recognizability."[34] Despite this fleeting nature, they can create an indelible embodied form of representation. Audre Lorde used "afterimage" to refer to representations, specifically photographic, whose "force remains within my eyes . . . etched into my visions" even after her eyes "are averted."[35] The use of blinding, visually inundating light in the popular photographic practices produces this lingering and forceful type of image that insists on occupying vision even if one looks away. Afterimages do the work of memory over and against the possibilities of disappearance or forgetting, shaping the very matter of memory and photography through their embodied forms.

In addition to focusing on the ephemeral effects of light, in these popular practices there is a notable refusal of or disinterest in certain physical forms of photographic record. Often when photographers and their patrons produce material images, as is the case with the photography studios set up on the streets and in public spaces in the United States and Jamaica, they use photographic technologies, like the Polaroid, that are singular. Even when street photographers produce digital photographs, they habitually erase the files after printing them, in effect creating nonreproducible images like Polaroids. These forms of picture-making are not solely bound to celluloid or built of pixels but appear both to invest in and to disavow, exceed, or eschew the material image. These expressions elude capture through photographic form. In the age of digital reproduction these popular photographic practices deny easy serial replication and dissemination. They linger in between representational states, appearing simultaneously like an analog and digital photographic form, like a still photograph or a moving image; they are about the pose and performance and about hypervisibility and emblazoned disappearance; and they are invested in image production and destruction.

Although these practices vary widely, in different ways they emphasize a process of representational becoming before the photographic medium settles into its more conventional material form.[36] Whether focusing on the emblazoned moment of picture-taking, disrupting the trace of the negative, or producing a photographic form with a painted backdrop, the popular urban diasporic photographic expressions remain at home in an unsettled and in-between state.[37] These African diasporic expressions often freeze, hinder, or prevent the conventional ways the vernacular photograph offers a likeness of something else, appears onto-

logically identical with what it depicts while detracting from its own surface and physical structure. These African diasporic practices prevent the photograph from turning to its referent (the person or thing represented in the image), which, according to one preeminent scholar of photography, Roland Barthes, defines what photography is and does.[38]

The ways these liminal representational forms call attention to and refuse the typical appearance, materiality, and seriality of popular photographs are notable, given the historical uses of photography by authorities, colonial officials, tourists, and criminologists to render black people legible as a group in the circum-Caribbean.[39] People with different agendas have employed the medium to define blackness and to deny the rights of blacks as subjects and citizens capable of self-possession or governance. This is typified in the use of a torn *carte de visite* on a reward notice for a runaway slave from Georgia in 1863. In this image the miniature photographic portrait, identified with the democratization of the image and mobility of the working classes in Europe and the United States, sought precisely to hold in place social hierarchies that defined blacks as property rather than free persons (fig. I.8).[40] Unlike the photograph's seemingly transparent surface, photographs of black people in these contexts often foregrounded black skin as a signifier, representative of more than surface: of a host of ever-changing characteristics inherent to black people. In this respect, black people's surface appearances (unlike the photograph's surface) often could *not* be seen through or beyond. Photography often delimited the ability to see black people as subjects with complex interior lives.[41]

In particular, contemporary African diasporic photographic forms may be understood in the context of the history of uses of photography to define criminals. Allan Sekula notes the way photography served almost from its inception as a tool to capture such types.[42] But what he defines as the repressive role of photography is not confined to the production of wanted posters or mug shots. More expansively, photographs — whether honorific studio portraits or composite photographs of criminal types — only make sense within a broader system that depends on assigning bodies places within social and moral hierarchies. Sekula terms this ordering of individuals through photography a "shadow archive." These multiple and mutually constitutive applications of photography provide a useful broader frame for understanding the urban contemporary practices under consideration here, which precisely involve communities defined variously as "urban" that have often been subject to oversight, in all its implications of surveillance.[43]

$ 50.00 Reward!!

Ran away from the Yard Corner of Jackson & Broad Streets, Augusta Ga. — on the evening of Tuesday 7th April 1863 a Woman "Dolly", whose likeness is here seen. —

She is thirty years of age, light complexion — hesitates somewhat when spoken to, and is not a very healthy woman — but rather good looking, with a fine set of teeth. Never changed her Owner, and has been a house Servant always. — It is thought she has been enticed off by some White Man, being herself a Stranger to this City, and belonging to a Charleston family. —

For further particulars apply to Antoine Poullain Esqr Augusta Ga. —

Augusta Police Station

Louis Manigault, Owner of Dolly

I.8. Reward notice for runaway slave, c. 1863. Manigault Papers, no. 484, Southern Historical Collection, Wilson Library, The University of North Carolina at Chapel Hill.

I.9. Ebony G. Patterson, *Di Real Big Man*, 2010. Mixed-media tapestry with wallpaper and flowers, 6.75 × 5 ft. Collection of National Gallery of Jamaica. Courtesy of the artist and Monique Meloche Gallery.

Notions of the carceral, the criminal, the socially aberrant, and the shadow archive haunt the popular expressions considered in this book. The artists I discuss bring popular photographic forms into proximity with state criminal photographic archives, stressing how they are intimately intertwined. Patterson, for example, reframes and embellishes mug shots of black men with aesthetic elements used to gain visibility in Jamaica's dancehalls (fig. I.9). Nelson used crime-scene photographs as the basis of his backdrops, while wanted posters in part motivate Wiley's photographic engagement with black male subjects in his photographic series *Black Light*.[44] More broadly, the popular diasporic expressions and works of art explored here both use and refuse certain ways blackness has been framed.

But I want to do more than suggest that popular practices merely offer new structures for being seen that exceed the representational containers fashioned for them by those in authority. Rather, I want to stress a point Tina Campt makes very succinctly: "The visuality of race and the indexicality of the photograph have been powerful twin forces in the deployment of the racialized index to produce subjects to be seen, read, touched, and consumed as available and abject flesh objects and commodities, rather than as individual bodies, agents, or

actors."[45] As such, it is significant that contemporary photographic expressions neither quite allow the photograph to materially secure its black subjects nor in some instances permit it to produce widely disseminated photographic records or archives. These expressions often remain in process, interrupting, if not undermining, the determinacy evident in many of the uses of photography to configure blackness in the past. Or they foreground what might be described as a photographic opacity, the highlighting of the materiality of the photograph's surface, the process and physiological effects of its making, the inability of photography to capture its subjects transparently.[46] The African diasporic use of blinding light, for one, highlights photography as a medium that induces blindness, exceeds the visual, rather than creating legibility or indexicality.

Light and the Culture of Celebrity

Some participants in the circum-Caribbean incessantly and narcissistically use the camera to partake in what Daniel Boorstin has described as "the white glare of publicity," "the specious brilliance" he associates with a US-styled brand of celebrity.[47] At least since the 1950s, well-knownness has increasingly become its own claim to fame, "an achievement that must be performed before an audience."[48] Photography, television, and film all played roles in creating a sense of the ubiquity of fame, which seemed "unbounded by time or space: constantly present, constantly recognizable, and therefore constantly existing."[49] This sense of the temporal and spatial unboundedness of celebrity may have facilitated the co-optation of ideals of fame in disparate locations, such as New Orleans, Kingston, and Nassau, where individuals and groups redirected the structures and visual technologies of celebrity to focus on themselves. These popular appropriations of celebrity culture— particularly in the case of video light and the red carpet performances at proms—testify to the pervasiveness, persuasiveness, and pluralist spread of Hollywood's culture of celebrity, as well as to its capriciousness, instability, and fungibility of meaning and the broadening scope of its subjects of illumination.

Numerous scholars have critically assessed the shallowness and simulated reality of celebrity culture.[50] Such criticisms are germane and generative here. Although investing in the luminous effects of picture-taking might be the height of mystification, "the authentication of illusion as more real than the real itself," the fervent attentiveness to celeb-

rity in these local contexts may reveal a certain fixation with status in societies where fame and fortune increasingly appear to be achieved on the basis not of merit but of the mastery of skills related to techniques of the visual and the production and dissemination of one's image.[51] By examining these distinct local manifestations of celebrity, we may glimpse structures of longing in post–civil rights and postcolonial contexts—local people's efforts to negotiate the political, economic, sociological, and aesthetic spheres that make possible, maintain, or constrain their ability to transcend their social status and the fixity of their station, space, and time.[52] These forms offer the possibility of mobility and transcendence.

As attentive observers of the power and possibilities of performing celebrity, participants in these African diasporic practices cast a spotlight on the constitutive components of global visual media, the effect and affect of its production of fame. They invest in but dissect structures by putting the illusion of celebrity on view. Using lights, cameras, and red carpets, they make a spectacle of the spectacle of celebrity, perpetuating, picturing, and performing the gestures, sights, and visual apparatuses used in the manufacture of fame. The spectacle of stardom becomes an end in itself, testifying to the way these practitioners simultaneously reconstitute and reify notions of celebrity as both conscripts and transformers of its visual machinations, possibilities, and limits— its power of persuasion and illusory effects.

These African diasporic popular lens-destined practices also highlight photography's role as a technology of race in which light has played an intrinsic role. My primary interest in light lies less in its physical properties than in how it has become refracted into Western epistemes of representation since the Enlightenment. Since 1666, when Isaac Newton studied the color spectrum and postulated "it was white light that contained all other colours, rather than, as had been believed before black," whiteness has increasingly been associated with the meaning of representability.[53] Through the work of Newton and others, whiteness came to seem invisible and universal, the ground on which representation took place. The ideals that surrounded whiteness became manifest in lighting techniques and photographic and cinematic technologies. Richard Dyer details how photographers pictured white women in ways that associated them with celebrity, glamour, spirituality, universality, ideality, and moral and aesthetic superiority.[54] Intriguingly, he also observes that photographers used lighting to create a sense of white femininity as disembodied, not of the flesh, while they typically lit nonwhite

subjects to create the appearance of shine and sweat—a glistening that highlighted the body and its surface. Photography long privileged and universalized particular constructions of race and gender without appearing to do so.

The "racial character" of photographic technologies, as Lorna Roth and Dyer point out, directly informed the appearance and illegibility of black people.[55] Roth, for instance, examines light-skin bias in color-film stock emulsions, in "flesh-tone" reference cards used to achieve skin-color balance in analog photography, and in the digital-camera technologies.[56] The different popular photographic practices in the African diaspora explored here intervene in these histories of technologies of light and the production of race, making different claims on and investments in the photographic effect of white light.[57] How can black people, through popular practices, create different forms of legibility through photographic and videographic technologies, given the historical relation between whiteness and light and the very notion of the representable? How might they differently shine, glow, or bling through the photographic and videographic medium and in the public sphere?

Skin bleaching in Jamaica's contemporary dancehalls, which increased in popularity with the rise of the video camera and video light in the early 1990s, is a revealing case in point. In this complex practice, subjects often lighten the surface of their faces with chemicals. Some dancehall participants believed that having lighter skin readied them to be in the scope of the video light and in the videos or photographs that might result from them.[58] Many factors contribute to this practice, but I want to call attention to skin bleaching as a response to and as a form of visual technology. That skin bleachers lighten the surfaces of their bodies to appear on video and in the video light, to be representable, testifies to the ways photography privileges whiteness and to the drastic, body-altering lengths to which some people go to be representable, registered, and recognized, given the historical facture and uses of the medium to image race.

But photography as a technology is not simply imposed and engaged in a hegemonic way in the locations examined here. It is transformed in the process. The bodies of men and women, manipulated to reflect light, become a new form of photographic surface, absorbing and reflecting light, appearing permanently marked by the light of representation. Bleachers make their skins sensitive to light through the application of a variety of chemicals.[59] These substances make their bodies reflect and absorb light the way photo emulsion makes photographic paper sensi-

tive to the impressions of light. In this way the bleached subjects transform their skins into photographs, becoming both what we might think of as the subject of the photograph and its material matter. Skin bleaching is an example of what we might describe as a body of photography, the result of and transference of the effect of photographic technologies on the body and part of a broader creation of a social body through vision, light, and visual media.[60]

Skin bleaching, video light, street photography, and the contemporary art that engages these complex practices all raise questions about what constitutes photography in these and other cultural and geographic contexts. In this way these expressions form part of "photography's other histories."[61] This is Christopher Pinney and Nicolas Peterson's prescient term for scholarly analyses of the medium that take into account a range of geographic locations and a variety of different media that inform how photography is rethought across cultural contexts and over time. These practices expand notions of photography beyond understandings of the photograph as "a three-dimensional thing . . . [that] exist[s] materially in the world, as chemical deposits on paper," as Elizabeth Edwards and Janice Hart describe it.[62] While lens-centered African diasporic expressions at times take more conventional forms, these expressions also emphasize the moment of the photograph's taking, the pose, the performance for the camera—ephemeral processes and effects that elude or do not privilege forms of material capture.[63] These representational practices put pressure on assumptions about materiality and reproducibility that very much undergird most histories of photography. In this respect, they highlight what might be described as other ontologies of photography—photographic practices that precede and exceed the material forms conventionally associated with the medium. Perhaps the pose, the staging of the photographic event and its spectacular effects, and the body as photograph complicate and refuse notions of the ontology of photography because the material image is often beside the point. What matters instead is how people use the camera in conjunction with other technologies to construct a complex set of relations to their local, transnational, and diasporic communities.

The Visual Life of Things: Materialism Reconfigured through the Visual Economy of Light

Photographic and videographic expressions created by black urban populations in the circum-Caribbean also offer an opportunity to ex-

plore African diasporic perceptions of and approaches to global consumer culture. Across these representational practices people choose to be pictured with particular consumer goods and often engage in displays of conspicuous consumption. There is a distinct aesthetic of material excess or what Kobena Mercer characterizes as "too-muchness" evident in many of these expressions.[64] They manifest a "bling-bling" aesthetic—"bling" being a word that in its doubling highlights the spectacular display of material surplus. Such expressions involve not only the possession of material things, but their embellishment or appearance alongside signifiers of wealth and prestige. Bashment, the pimped-out public bus, epitomizes a bling-bling aesthetic and its ability to transform the ordinary into the spectacular. The most audacious participants in these practices seem to be poster children for identity formation in the society of the spectacle, who engage in consumerism for the purpose of being seen and in some instances are turned into products to be displayed and consumed through photography, video, or digital technologies.

While many people who participate in the representational and performance practices studied here portray their personhood and prestige through consumer goods, they simultaneously produce other forms of value and status that mitigate, take on, and transform the shimmering world of consumer culture. People in the African diaspora who engage in these practices have created their own visual economy, a shared system of value that circulates across geographic boundaries and that revolves in part around the visual production and recognition of light. I use the term "visual economy," as Deborah Poole does, to be attentive to the circulation of objects and images in local political economies and across global networks—to emphasize the industries and economies surrounding image production.[65] The phrase as employed here also stresses the way aesthetic qualities or ephemeral visual effects inform the local, transnational, and diasporic circulation of goods and their broader social life.[66]

In the practices considered here not just any expensive luxury item has currency. Objects have value and are circulated if they exhibit certain aesthetic characteristics. Things that bling, shine, or shimmer, that emit light, are especially privileged. Such investments in the visual economy of light abound in hip-hop, where rappers often boast of the blinding effects of their bling or the status they accrue through the effect of light.[67] Indeed, "bling" is often attributed to the New Orleans-based rapper B.G., who purportedly coined the word in 1998 to charac-

terize "the sound light makes as it hits a diamond."[68] The *Oxford English Dictionary* would later define "bling" as "representing the visual effect of light being reflected on precious stones or metals."[69] This attentiveness to producing (or "sounding") light is amply evident in the backdrops of street photographs, which often portray material things with an attention to starbursts, reflect light through mirrors, or use words attesting to the different qualities of light: "shimmer," "shine," and "bling." As such, although many participants in popular photographic practices may appear to be deeply invested in the appearance of material wealth, this consumerism is based on luminous effect—on the intangible and ephemeral visual qualities of commodities.[70] This is not to suggest that material wealth does not matter—it can matter with deathly consequences—but to call attention to how it is mitigated and even negated by the aesthetics of light. Bling and its local variants as such may be seen as a mode of transmission in the contemporary African diaspora, one that informs the ways communities of viewers differently recognize and interpret value in their local and transnational contexts.

In other words, cultural forms associated with conspicuous consumption in some ways reject or refashion notions of materialism, privileging the shine of things as constitutive of value. What I describe as a visual economy of light is in part a product of everyday aspirational practices of black urban communities, who make do and more with what they have, creating prestige through the resources at hand. But these very processes can have a critical valence because they have the potential to disrupt notions of value by privileging not things but their visual effects. These popular expressions make conspicuously hypervisible the economy of late capitalism and how it creates objects of desire through technologies of light. Such practices complicate simplistic assumptions about conspicuous consumption, "pecuniary emulation," and black urban populations. The display of flashy objects or the effects of the performative moment of being photographed matter most within this visual economy.[71] Through a range of different types of photographic and videographic images, objects, spectacles, and the verbal re-creation of the moment of the picture's taking a new, ever-changing, and unpredictable community of viewers is created who reconstitute and reenvision value.

This consideration of the value of light adds another voice to considerations of materiality by emphasizing the way aesthetics shape material practices.[72] It also speaks to scholarly critiques of historical materialism offered from the perspective of the African diaspora. Theorists

from Cedric J. Robinson to Fred Moten have examined the way histories of diasporic formation, particularly racial slavery, allow us to expand and put pressure on our understandings of modernity, capitalism, materialism, and Marxism and offer alternate ways of thinking about notions of the commodity, value, property, and humanity.[73] Bling and related notions of shine may be understood as part of a black popular cultural and scholarly approach that is attentive to diasporic peoples' intrinsic place within, estrangement from, or relationship to modern capitalism and Western societies' definitions of citizenship.

Bling has historical precedents in the African diaspora. The folk hero known as Shine bears this out. In African American and Caribbean oral traditions recorded since the 1930s and 1940s in the United States and the Bahamas, Shine was a heroic figure who worked in the bowels of the *Titanic* (the ill-fated luxury liner, which was racially segregated).[74] According to legend, it was Shine who first noticed water filling the supposedly unsinkable ship. He warned his dismissive captain several times over, to no avail. "Finally," as historian Lawrence Levine summarizes the many oral accounts, "perceiving the captain's blindness, Shine jumps overboard, withstands a series of temptations and threats, and with superhuman skill swims to shore, the ship's only survivor."[75] Shine turns down several offers of material wealth and sexual favors from passengers (who want him to rescue them) before successfully swimming on. There is much to be gleaned from the popular account of Shine and his experiences on the *Titanic*, which in its day was a beaming symbol of modernity, luxury, and Western technological advances and progress. I focus on Shine because this folk hero is related to ideas of blackness and light, African diasporic subjects' locations within modernity and Western nations, and African diasporic ways of seeing and coming to terms with consumer culture and technology. Shine importantly sees the fatal flaws of the modern ship because of his vantagepoint in the belly of the vessel, even though his insights at first go unrecognized. Shine is symbolic of an African diasporic location within and visual perspective on modernity, Western capitalism, and notions of citizenship from an interior of Western society. Shine—whose very name calls attention to the effect of light—quite literally represents this eye, this vision into modern and consumer society.[76] The story of shine, and by extension bling, crucially is not confined to a study of the African diaspora but is an assessment of and a reflection on processes of consumer culture, capitalism, and the modern more broadly: their aesthetic, political, and social effects and their often unrecognized perils.

Citizenship and Visibility in the Post–Civil Rights and Postcolonial Eras

In every local context considered here, populations who engage in the various manifestations of the visual economy of light have solicited widespread rebuke as examples of crass materialism, individualism, and narcissism, if not nihilism, by politicians, government officials, newspaper columnists, an older generation of entertainers, and academics.[77] The populations participating in these forms and in many instances the practices themselves have been the foci not only of moral panics but of social policing. Curtailments have ranged from cable companies restricting access to music video channels and governmental efforts to curb proms in the Bahamas to deadly police raids of dancehalls in Jamaica.[78] These popular representational practices have become central in public discourses about rights to and within public space and what the responsibilities of citizens are in contemporary black and post–civil rights and postcolonial societies.

These expressions have been subject to controls in part because they do not appear to buy into configurations of nation, culture, blackness, respectability, and class that have been articulated since the civil rights movement in the United States and the independence movements in Jamaica and the Bahamas of the 1960s–1970s.[79] Indeed, critics often lament that expressions like video light or proms manifest a detour from, if not an end to, the black nationalist agendas that informed cultural and political life across these communities a generation ago.[80] They seem antithetical to the expressions designated and financially supported as "culture" in the 1960s–1970s by black leaders.

Many producers and users of these popular expressions came of age in and after the 1980s — after the social, political, historical, and economic shifts of the 1960s–1970s. Local communities also splintered along lines of class, party affiliation, and color in this period. In the United States this era, which started in the 1970s and early 1980s and continues to shape African American communities in the United States, has been described as postindustrial.[81] It was a period marked by deindustrialization, desegregation, the suburbanization of the black middle classes, Reagan-mandated cuts to the welfare state, the AIDS crisis, the commodification of black popular expression, the cocaine and heroin trade, and a rise in the culture of individualism and materialism, all of which transformed and fragmented black communities. In Jamaica, in 1980, the neoliberal Jamaica Labour Party came to power, opening up the

I.10. Hank Willis Thomas, *Black Power*, 2008. Lightjet print, 20 × 30 in. Courtesy of the artist and Jack Shainman Gallery, New York.

island's market to global capital. To deal with steep cuts mandated by the International Monetary Fund, the Jamaican government decreased spending on transportation, health, and education, contributing to a rise in unemployment and poverty and the expansion of an informal sector of the economy.[82] This period, marred by violent bipartisan party politics, saw the rise of a brown middle class in the business and political realms and the deepening of an economic and cultural gulf between the classes.[83] In the Bahamas in the 1980s, the black populist Progressive Liberal Party government officially embraced a policy of Bahamianization. It retained national control of utility companies and attempted to limit foreign control of businesses, jobs, and land, as the predominance of tourism, the offshore banking industry, and the illegal drug trade evinced the islands' integration into global economies and financial markets that catered to very wealthy foreign clients. The early 1990s saw the removal of many barriers to trade and land ownership, which contributed to an increase in land prices, crime, and the maintenance of a regressive tax system that burdened the poor. Many blacks also remained shut out of the business sector, still controlled by white Bahamians.[84] In these neoliberal environments, consumer goods freely circulated, and urban populations had limited means to acquire many of these things.

I.11. Satch Hoyt, *From Mau Mau to Bling Bling*, 2005. Ebony, zirconias, key, velvet-lined case, and audio components, accompanied by a soundscape, 38 × 19 × 7 cm. Courtesy of the artist and the Charles Stewart Mott Foundation.

Several contemporary artists draw on urban practices in their work to address these shifts and reconstitutions of black politics and culture. They invoke the icons and slogans of black nationalism from the 1960s–1970s but highlight the ascendancy of a new representational moment in which a bling-bling aesthetic dominates the contemporary social, political, and artistic landscape. This tendency is evident in Hank Willis Thomas's photograph *Black Power* (2008) (fig. I.10). This image comes from his *Branded* series, in which he used print advertisements from 1968 to 2008 that capitalized on black culture and black bodies, from which he removed explicit references to the brand or object for sale. In *Black Power*, for example, the words "BLACK POWER" appear to be composed of diamonds or rhinestones on the gold grill worn by a smiling black man.[85] The closely cropped image of the male figure's face calls attention simultaneously to the appearance of conspicuous consumption in black culture after the black power era as well as to the way blackness functions readily as a container of consumer culture more broadly. Satch Hoyt similarly weds a globally inflected symbolism of people power and working-class rights from the 1970s to contemporary consumerism in his 2005 work *From Mau Mau to Bling Bling*

(fig. I.11). The piece features a carved ebony Afro pick in the shape of the iconic clenched upraised fist, which is inlaid with zirconias and embedded in an opened plush velvet case. Thomas, Hoyt, and several other artists, particularly in the way they juxtapose images or texts associated with black nationalism from the 1960s–1970s with bling-bling materials from the 2000s, heighten the question of the relation between these two eras.[86] Is the contemporary focus on materialism an outgrowth of the civil rights and independence movements or metastasis of its aims and imaginative possibilities? How might the political be rethought today and what symbols might be effective in mobilizing affiliation in the era of individualism? What is or might be the relationship between citizenship and consumerism for black subjects at the turn of the twenty-first century?

The works of art discussed in this book highlight the way the acquisition and display of material wealth may indicate the changing and complex ways that the ability to gain access to consumer goods interfaces with contemporary notions of citizenship and informs the way groups and individuals think about their representation within democratic societies. Making this case in relationship to different Latin American cities, Nestor Canclini acknowledges the importance of viewing programming from Hollywood, Televisa, and MTV: "Especially [for] youth, the question[s] specific to citizenship, such as how we inform ourselves and who represents our interests, are answered more often than not through private consumption of commodities and media offerings than through the abstract rules of democracy or through participation in discredited political organizations."[87] In other words, private consumption may be seen as indicative not of the demise of the political but of the changing ways people represent their interests in the face of widespread disenchantment with long-standing political institutions, which have changed the meaning and possibilities of politics.[88] I read the visual economy of light employed and deployed by the subjects under consideration here as taking up and reconfiguring this right to consume as a crucial aspect of contemporary belonging that is mitigated by the relations provided by image culture and not by the state. Further, urban subjects' ability to occupy the frame of the video or still camera and to picture themselves having access to particular consumer goods has become one means through which they see themselves as represented within civil society. The popular visual practices generate new subjectivities and configurations of the political in what might be considered

a post-rights era, when the expectations surrounding rights fought for in the immediate postcolonial and post–civil rights eras seem to some unfulfilled.

Historically, since Emancipation in 1833 in Jamaica and the Bahamas and 1863 in the United States, consumption has played a complicated role in the formation of black citizenship. Colonial rulers used the allure of consumer goods as a tool in the transition from slavery to freed labor in the Caribbean and the United States. In Jamaica and other places, for instance, British lawmakers encouraged recently emancipated slaves to desire material acquisitions because they hoped that the desire for things would transform them into productive and disciplined workers.[89] Some colonial administrators and imperialists even advocated Emancipation so as to increase the number of possible consumers.[90] In more recent history, as Gilroy points out, in the United States blacks were conceived as potential consumers before they could freely participate in the sociopolitical system as citizens.[91] They had rights (even though these were negated sometimes) to buy into forms of freedom and mobility afforded by consumer goods like the automobile, to discover "themselves and their agencies through their social life as consumers."[92] Gilroy suggests that "there is evidence to suggest that, at times, forms of conspicuous consumption contributed to the strategies that the minority pursued in order to win and to compel recognition as human beings, as fellow citizens."[93] Despite this history, he remains skeptical of materialism in contemporary African American hip-hop culture, arguing that "consumerism has largely superseded the rights and responsibilities of citizenship."[94]

Some contemporary art practices that focus on conspicuous consumerism intriguingly locate this phenomenon within this broader history of black people's long-standing and complicated relationship to notions of the commodity in the Americas, one that goes back to modern racial slavery. This is underscored in Robert Pruitt's 2004 work *For Whom the Bell Curves* (fig. I.12). Creating a map occupying five feet across a wall, Pruitt represented the transatlantic slave trade by draping twelve fake gold chains. This glimmering minimalist sculpture draws a connection between chains as a black urban accessory and global economies of enslavement, highlighting a complicity and continuity between bling-bling and racial slavery. Such a return to the history of slavery as imagined through shiny consumer goods and representational practice also abounds in popular culture. The rapper Kanye West, for one, makes

I.12. Robert Pruitt, *For Whom the Bell Curves*, 2004. Twelve gold chains, 47 × 60 in. Collection of the Studio Museum in Harlem. Courtesy of the artist. Photograph courtesy of the Renaissance Society at the University of Chicago.

the case in the song "All Falls Down": "We shine because they hate us, floss cause they degrade us. We trying to buy back our 40 acres." Here, he connects contemporary instances of shining to the broken promises of Emancipation. The contemporary artwork and rap lyric are but two examples that elucidate that bling is a form through which diasporic people return to and reenvision the memory, the time-space, of slavery and the unfulfilled promises of full citizenship after Emancipation and the civil rights and independence eras. Bling, then, is central as a mode of transmission between contemporary diasporic cultures and the particular formative moments in the past that diasporic people hoped would transform their status in modern Western societies. Bling also reflects the way blackness, as Saidiya Hartman points out, was and is inextricably related to the "use of, entitlement to, and occupation of the captive body."[95] This cutting back to and highlighting of slavery raises and returns to the question, how do people whose forebears were defined as property use objects to negotiate and represent their personhood and citizenship in the contemporary context?

The focus on shiny things and the photographic spectacle of consumption in black urban practices in the circum-Caribbean might con-

structively be assessed within this longer history of the relationship be-
tween black people and the commodity, a relationship that continues to
persist in global capitalism in the twenty-first century. The visual econ-
omy of light shows up the way blackness continues to connote fungi-
bility. Recent studies suggest that blacks are so associated with con-
sumption that when asked to imagine themselves in different social
roles, white students were more inclined to desire "high-status prod-
ucts" if they were role-playing as black characters.[96] This study empha-
sizes how conspicuous consumption among black urban populations re-
flects a broader culture of consumption in the circum-Caribbean and
globally, even as it is often identified with or seen as visible on certain
segments of the population by critics of materialism among black urban
populations.

In many respects, we might see the fascination with adorning and
picturing the body's surface in jewels, the taking-on of the shine of
things, as a type of screen. A screen in its basic common definition refers
to a surface onto which images are projected, displayed, or attached. A
screen may also characterize something that separates space or shel-
ters or protects someone or something, serving to obscure or conceal
it.[97] Jacques Lacan's influential formulation of the cultural screen is ger-
mane here, particularly as interpreted by Kaja Silverman.[98] For Lacan
the screen refers to the external representations or the image repertoire
that one aims to assimilate into and through which one structures one's
visual identity or ego. Those deemed "different"—whether because of
gender, sexuality, or race—may have a negative relation to their bodily
ego because of this cultural screen.[99] In the case of the flaunting of shiny
material things in black popular expressive cultures, we might see these
urban practices as mimicking the image repertoire that mainstream so-
ciety has of blackness that long wedded it to consumption, whether the
association of persons seen as black with property or the use of black
culture to sell the latest commodity. The ostentatious display of things
might be interpreted as a protective means. We might understand the
use of material goods and the production of blinding light as a shield
or apotropaic, simultaneously reflecting and deflecting the deidealiz-
ing gaze on black subjects. Moreover, the photographic effect of light,
bling, visually suspends that which is not of the subject, the cultural
screen. The popular expressions analyzed here, with their attention to
the reflection of light off of surfaces, highlight a space just beyond the
surface, lingering on the gap between the viewer and the subject. This
taking-on and holding the gaze in abeyance is precisely the space/site

that African diasporic subjects negotiate in their photographic and expressive practices.

Describing photographs as structuring a relation to the screen, Kaja Silverman maintains that many people pose themselves and attempt to be seen as they are imaged through the gaze. Many of the practices examined here do not rely on the physical image as a source of alignment with ideality. Afterimages, created in the body, are precisely not subject to some of the kinds of negative responses or refusals of recognition that black people have often experienced.[100] What participants in these popular expressions strive for is the reification provided by the moment of photographability itself, and the witnessing of that moment by present and future audiences. This offers reification through a different image, a memory image or an ideality achieved through that which is always fleeting, in the now, in the moment, complete in its ephemeral form.

Contemporary Art and the Aesthetics of Bling

Several contemporary artists describe African diasporic urban visual expressions as formative in their artistic approaches to representation. They came of age using and consuming popular photographic and videographic technologies, as in the case of Wiley's and Nelson's experiences with street photography and Patterson's engagement with dancehall. Many grew up in what Mark Anthony Neal describes as the postsoul era in the 1980s, when televisual representations of black culture were omnipresent for the first time and many globally marketed consumer products were branded through blackness. These artists' formative teen years took place in front of television screens beaming MTV and the cable channel Black Entertainment Television (BET) (founded in 1981 and 1980, respectively). Artists across the circum-Caribbean, including Ras Kassa, Rashaad Newsome, and Wiley, cite the influence of music video director Hype Williams (Harold Williams), known for his flashy hip-hop and R&B music videos and his film *Belly*.[101] Williams came to be recognized for a form of music video shot with a fish-eye lens that saturated its subjects with bright lights and emphasized reflective surfaces (fig. 1.13). This was also the era when hip-hop in the 1980s and dancehall in the early 1990s achieved global visibility through visual media like the music video.

The contemporary artists examined here create figurative work, often centered on the black male body, in an era when black male subjects appear ubiquitously and in hypervisualized form in advertising, hip-hop,

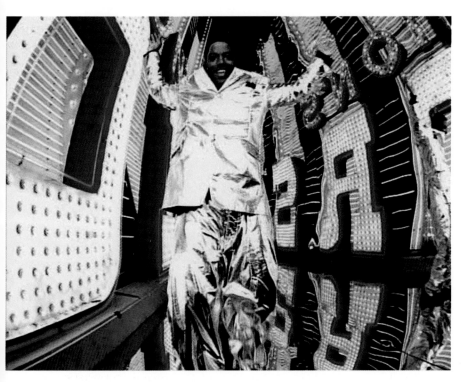

I.13. Hype Williams, video still from *Feel So Good* by Mase, 1997. Bad Boy Entertainment, New York. © Harold [Hype] Williams.

dancehall, and other forms of popular culture. They do so by using aspects of popular practices to stage their subjects. Many draw their models from the streets, highlight the process of being seen as its own form of image, create work at the interstices of photography and painting, and examine the effect of light and its relation to beauty, prestige, objecthood, subjectivity, race, blackness, the modern, and the representable. They variously highlight the haptic, opaque, performative, and luminous character of their photographs. They present their subjects in ways that call attention to notions of surface—the embellished surface, the reflective surface, the surface of the body, the surface of the photograph or screen, the backdrop and green screen. While modern artists working globally since the early twentieth century have long emphasized the surface of their canvases or sculptures in their artistic practice, these creators who draw on African diasporic practices call attention to what might be described as the surface of the surface—the effect of light reflecting off of surfaces—as the representational space for figuring black subjects.

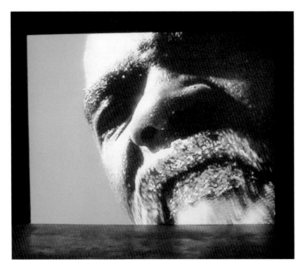

I.14. Kori Newkirk, video still from *Bixel*, 2005. Single-channel video. Courtesy of the artist.

Kori Newkirk highlights this attention to surfaces in his single-channel video art piece *Bixel* (2005) (fig. I.14). In this five-minute work, the artist pictures himself partially clad, and eventually covered in a glittery silver substance, whirling in a lush green landscape. One scene presents a close-up showing the glimmering silver gushing from his mouth. It covers his upper torso, creating a sparkling second skin, a surface that reflects lights and appears to pixelate across the video's screen. The artist chose glitter as central medium of figuration, visibility, and concealment in his first excursion into video work and into self-portraiture.[102]

Newkirk explains that he was compelled by the word *Bixel* because it sounded "like a lot of other things."[103] While for the artist the term is indeterminate, the word and the subject and media of the video simultaneously evoke the ideas of pixel and the black body. What might it mean to bring the pixel, the discrete unit of representation that composes the surface of an image on a digital television or computer screen, into proximity with blackness, which has long been so intrinsically defined through the surface, through black skin? "Bixel"—if understood as a composite of *pixel* and *black*—would seem to foreground the partiality of vision and visual representation. It frames blackness as a fragment that often comes to stand for the whole and insists that blackness be understood as a surface constructed through vision and visual

technologies. Bringing together the constitutive elements of images or highlighting the pixelated composition of video and foregrounding the black body as another sparkling pixelated surface, bixel connotes a form of blackness that remains unsettled—suspended in the representational possibilities of bits and bytes. Bixel also captures how African diasporic urban culture often circulates through visual forms that call attention to the material makeup of visual technologies; the subject presented is marked by the bytes and pixels that bring it into being.

Bixel hints at the representational processes through which many urban African diasporic subjects bring themselves into visibility through visual technology, joining prosthetically with photographic and video media. Through their engagement with photography and video they become part technology and part flesh, inorganic and organic, a subject partially revealed and concealed within multiple skins, surfaces, and screens. Anne Cheng's insightful discussion of light and sheen in photographs of Josephine Baker seems generative for a discussion of bixel.[104] Cheng makes the case that the harsh shine of Baker's body made her appear almost inorganic and inconsumable in some ways. The focus on her gleaming skin did not simply objectify her but rendered her visually impenetrable: "Baker's ability to escape into surfaces paradoxically allows her image to deflect misogynist and racist logic."[105] Newkirk's literal acts of consumption and the silvery substance that issues from his mouth, the artist stresses, "from the inside" and covers a part of his body seem another act of escape, of slipping into and out of surfaces that might overdetermine, hypervisualize, and visually consume blackness and obscure any sense of an interior life. I want to suggest more broadly that through the bixel, by merging always partially with the matter of the screen or photographic surface, black urban subjects in the circum-Caribbean come into visibility but seek to remain unfixed, indeterminate, sparkling in the transformative possibilities of visual technologies.

The emphasis on the surface in contemporary African diasporic popular and studio art may be seen as part of a long artistic and scholarly engagement with the surface in the history of art. Scholars studying a range of artistic genres, from seventeenth-century Dutch *vanitas* paintings to African studio photography from the 1950s to 1970s, have analyzed how attention to representing the surface often coincided with global changes in the market economy and modern life. Some have been attentive to how slavery, imperialism, and responses to colonialism informed an emphasis on surface aesthetics or "surfacism."[106] This term, as delineated by Christopher Pinney, refers to an emphasis on the ma-

teriality or visual texture of objects within or of the picture plane: "the elaborately wrought and highly finished representations of objects that are themselves elaborately wrought and highly finished."[107] Several of the contemporary artists discussed in this book re-create paintings from the history of Western art and place black subjects at their center (at times choosing work from periods when surfacist aesthetics were prevalent). These subjects underscore how the representation of black figures and modern slavery at times literally provided the background and formed the flesh against which the surfacist aesthetics could be staged. Such approaches, whether manifest in the representations of black subjects or slaves as accessories in Dutch landscape painting or in Baker's influence on the surfacist aesthetic in the work of Adolf Loos and Le Corbusier, underscore the historical relation between the surface in modern art and blackness. The contemporary studio practices that I explore here emphasize the bounce of light off the reflective surface, the space where visibility and invisibility come together, the edge of that which is representable and unrepresentable in modern art.[108]

While considering works of art in the context of urban popular photographic forms, this book also addresses where such practices come together and diverge, the tensions and critiques generated when they are brought into proximity in artworks and art-historical scholarship. Notably, studio artists have frequently turned to black popular culture as a subject in the last decade, even as opportunities for the public presentation of black popular expressions in the public sphere have diminished in places like Jamaica and the Bahamas. The issue of gender and sexuality is another aspect that comes to light at the interstices of these artistic and popular practices. As a gay black male, Wiley describes feeling cast out of the performances of masculinity or hyperheterosexual bravado common in expressions for the camera and in public space and seeks to highlight forms of visibility and subjectivity that are occluded. Nelson, too, in his backdrops put pressure on misogynistic images of the black female bodies that often circulate in backdrops and music videos. And Patterson explores new performances of masculinity that have come to light in dancehalls. These practices, which use or address issues of public space, underscore how urban popular photographic forms are often sites where conservative conventions of gender and sexuality manifest throughout society meet the transformative space of the bixel, where gender identities are constantly being reframed.

Importantly, we can see the investment in the spectacularized visibility evident in popular practices as offering a new take on an approach to politics widely espoused since the 1960s–1970s: the long-standing faith placed in visibility as a proxy for or path to political representation. Peggy Phelan's observation that we need to interrogate the "implicit assumptions about the connections between representational visibility and political power which have been a dominant force in cultural theory" is relevant here.[109] Investments in representational visibility have been mainstays of modern black politics since the early twentieth century. One may interpret W. E. B. Du Bois's belief that artistic representations of blacks would bring political rights or British-born Jamaican artist Edna Manley's insistence on making blackness representable in Jamaican art in the 1920s as early manifestations of the equation of black visibility and representability with political uplift.[110]

Such strategies increased in the lead-up to the civil rights and independence eras, when the racially denigrated presence and histories of black citizens gained new visibility.[111] Ralph Ellison's novel *Invisible Man* (1952), the prologue to which centers on a protagonist illuminated by siphoned electricity and 1,369 lightbulbs, has been seen as a precursor to and emblem of the ways visibility delineated a black political agenda in the mid-twentieth century. It may also be interpreted, for present purposes, as an early precursor to the contemporary emphasis on the technology and effect of light. The incessant focus on claiming visibility that is manifest in black popular practices captures a more long-standing emphasis on visibility as a mode of social and political representation. The case could be made, however, that the orchestration of contemporary cultural practices in which those who continue to find themselves on the social and economic margins seem to demand visibility more than anything else points to the limited effectiveness of strategies of visibility—their failure to produce the political power they were supposed to assure and secure.

But these twenty-first-century practices nevertheless reveal much about the possibilities of the politics of visibility for different constituents in postcolonial, postblack, circum-Caribbean societies. In particular, different social groups have been rendered "un-visible" within the structures of visibility forged since the 1960s–1970s and in an era in which media and technology have facilitated what some refer to as a state of "hypervisibility." The term "*un*-visible" comes from Elli-

son's introduction to the 1981 edition of *Invisible Man*.[112] He describes blacks in US society as so hypervisible that they have been rendered *un*-visible—a phenomenon that has increased exponentially since the 1980s. Un-visibility describes the state of not being seen or not being recognized, as well as the "moral blindness" toward the "predicament of blacks."

The contemporary performances and photographic practices examined here not only address efforts to be visible but create new communities and communal public spaces through forms of viewership.[113] These practices produce sites of visibility, where spectators are active and engaged.[114] Through these expressions different groups negotiate what Gerard Aching refers to as the "degrees of recognition, misrecognition, and nonrecognition" in these post–civil rights and postcolonial societies. Popular visual practices are particularly significant, given that some of the cultural expressions and sites that the popular classes once used to attain a level of visibility in the Caribbean, like Carnival, have rendered certain "native subjects invisible today in the islands that have assumed various modes of political autonomy."[115] The representational practices studied here forge spaces of visibility outside the domains used historically by the popular classes, many of which are now those claimed and celebrated by the nation-state and by the middle classes who have emerged since the 1960s–1970s. Black urban communities in Nassau, for instance, create prom spectacles that incorporate aesthetic and musical aspects of Junkanoo but do so outside the designated space and time of that celebrated festival.[116] Street photography studios offer another mode of costuming and performance at Mardi Gras, taking place in close proximity to the masking traditions of New Orleans (fig. 1.15). I make the case that traditional masking practices have been reconstituted and relocated in these popular performances of visibility.[117]

But these practices are not simply alternate strategies of visibility aimed at creating greater representation in postcolonial societies. These expressions, with their emphasis on effecting a blinding, bright white light, may produce modes of visibility quite distinct from political investments in being socially visible. Indeed, we might see the black urban expressive practices as constituting what Phelan characterizes as an "active vanishing, a deliberate and conscious refusal to take the payoff of visibility."[118] In other words, the production of blinding visibility may be interpreted precisely as not investing in existing "representational economies" tied to certain investments in visibility. It is

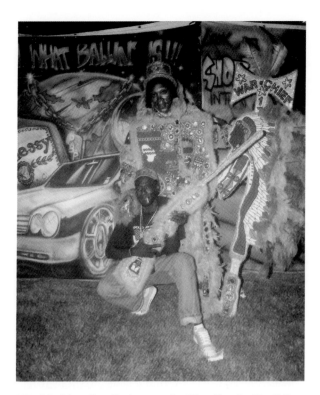

I.15. Sthaddeus Terrell, photograph of Terrell and a Mardi Gras
Indian chief posing before Terrell's backdrops, New Orleans,
n.d. Courtesy of the photographer.

not clear what the payoffs of un-visibility are. They may be in line with
Richard Iton's description of the fantastic possibilities of popular cul-
ture, with their "willingness to embrace disturbance, to engage the ap-
parently mad and maddening, to sustain often slippery frameworks of
intention that act subliminally, if not explicitly, on distinct and overlap-
ping cognitive registers, and to acknowledge meaning in those spaces
where speechlessness [and, I would add, illegibility] is the common cur-
rency."[119] These practices are political in that they refuse existing struc-
tures that define more formal political activity, highlighting the limits
of these structures. Further, we might see the production of represen-
tational disappearance in these black urban practices as performing a
state of un-visibility, as tacitly producing the state of being unseen, or of
making the un-visible's disappearance seen. In sum, these expressions
highlight a certain visual opacity that emphasizes the spectacle of the
un-visible as a mode of representation in postcolonial societies.

Chapter Summaries

Chapter 1 analyzes the genre of street photography. In street photography, as in video light, clients place a premium on the process of posing, so much so that some commission dozens of photographs so as to prolong the spectacle of their picture-taking. This response highlights how, as photographer Darrin Clark describes it, "being at a picture booth is definitely . . . a status thing. . . . To be at the picture booth you definitely will be recognized and be seen."[120] Posing and being seen inhabiting sites where one is photographed are significant aspects of the genre. In this genre, the Polaroid remains a favored photographic technology. This photographic form involves capturing the now, the moment, but facilitates a temporal return to the 1960s–1970s and the unfinished project of civil rights. Indeed, in the 1970s a group calling themselves the Polaroid Revolutionary Workers Movement, in their black-revolutionary and diasporic efforts to actualize civil rights, targeted the Polaroid Corporation.

This chapter also focuses on the contemporary art of the late Charles Nelson, who was based in Atlanta. One of the first artists to take up the form, in 1999 he started creating his own backdrops, placing them outdoors in highly trafficked black urban locations from Atlanta to New York (fig. I.16).[121] His *Backdrop Project* series investigates the form and function of street photography, as well as notions of pictorial realism in Western painting and photography.

Chapter 2 focuses on the use of video light in Jamaica's dancehalls, allowing further consideration of a place where street photography resides but where video predominates. This discussion moves from considering more recognizable and conventional forms of photography to examining the afterimage and bleached skin as types of photographs. It centers on Jack Sowah, the first videographer to introduce video light and screens into dance venues, and on the circulation of his footage as well as instances in which his images did not circulate. In part by analyzing the photography-based, multimedia art of Ebony G. Patterson, I explore a broader set of visual practices—from queer sartorial styles to skin bleaching—engaged in by dancehall-goers who seek to be "inna da light." Patterson's critically acclaimed work has extended the visibility and global circulation of dancehall's visual economy. This chapter makes the claim that video light has democratized access to being on-screen and serves as a mode of claiming visibility as citizens in contemporary Jamaica.

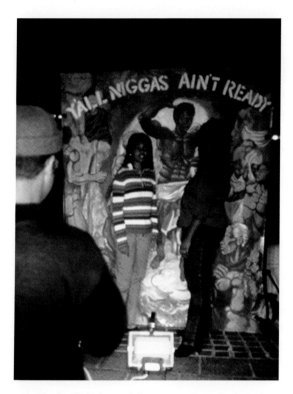

I.16. Charles H. Nelson, *Y'all Niggas Ain't Ready*, from the
Backdrop Project series, December 1999. Public artwork,
Atlanta. Courtesy of the family of Charles H. Nelson, Jr.

Chapter 3 shifts to the Bahamas to discuss a local practice in which
performing for the camera is central and as valued as the physical
photograph: proms. Here, young people stage elaborate entrances that
are projected onto screens within the prom venue. One famed prom
entrance in 2004 featured a young woman who arranged for faux papa-
razzi to line the red carpet for the event. She did not hire the photog-
raphers to produce photographs (and in fact she did not retain a single
photograph of the entrance) but instead to highlight her own visibility
and representability. Such prom practices draw on and reconfigure
other diasporic cultures, local masquerade traditions, and global cul-
tures of celebrity.

Chapter 4 focuses squarely on how black urban aesthetic and repre-
sentational practices reverberate in contemporary art. It considers the
work of Kehinde Wiley and Luis Gispert, two artists who explore the
nexus between urban popular expressive practices, photography, and

visual constructions of status, prestige, and personhood in the history of art. This chapter analyzes Wiley's paintings and his photographic series *Black Light* (2010), which foreground issues of black visibility and technologies of light (fig. I.17). For this series, Wiley sought black male models on the streets of urban communities across the United States using a small contingent of photographers and videographers—his own team of "paparazzi." Further, he looked for men who moved through public space as if they were on a runway, as if they possessed a sense of their own prephotographic photographability. These models assume poses from paintings found in art history books. I contrast this series with earlier efforts by African American artists in the 1970s to give black light visual form.

This chapter also considers the work of the Miami-born, New York–based artist Luis Gispert, who focuses on what he describes as the "urban baroque" aesthetic of black and Latino urban populations in his photographs and video art. These works drive home the point that some of the aesthetic practices in the African diaspora are shared with other groups who tune in to the same visual technologies and share the same urban landscapes. Finally, this chapter discusses works by Hank Willis Thomas and Paul Pfeiffer, who engage photography, light, and the spectacularity of blackness in global consumer culture. This chapter emphasizes that popular representational practices and ways of seeing offer an optic on a range of representational practices at the center of Western culture, from globalized consumer-oriented media to European portraiture.[122]

African Diasporic Art History in a New Light

I locate this project within the field of African diasporic art history. I acknowledge that the visual economy of light in contemporary diasporic cultures has many sources and is related to broader artistic, visual, cultural, and political histories in and beyond the diaspora. Robert Farris Thompson in his often-cited *Flash of the Spirit* as well as Henry J. Drewal and John Mason in *Beads, Body, and Soul: Art and Light in the Yoruba Universe* (1998) have understood light in part as representative of the spirit of Africa that remained ignited in the diaspora. Although multiple historical influences and modes of circulation and translation of the visual economy of light are often difficult to trace precisely, this book does not outline a flash of something intuitively or innately diasporic but highlights how African diasporic communities are created through networks

I.17. Kehinde Wiley, *The Annunciation*, from the *Black Light* series, 2009. Archival inkjet print on Hahnemühle fine art paper, 30 × 24.531 in., edition of six. Courtesy of the artist and Roberts & Tilton, Culver City, California.

of shared visual media and visual technologies and consumer culture that inform ways of seeing at specific historical junctures. In the case of the expressions examined here, photographic and videographic cultures that emphasize light begat cultural forms invested in being on camera, on the screen, and in the light. This book envisions African diasporic art history more broadly as a field that explores how African diasporic communities are, and have been, constituted through a shared attentiveness to how they are seen and how they respond to the ever-changing states and stakes of visibility and disappearance that inform the histories and contemporary realities of these communities.

The aesthetic practices and visual networks explored here often go undocumented and unarchived.[123] One of the challenges and opportunities that art historians of the African diaspora might take up is to put pressure on the forces, institutions, and disciplinary structures that might erase, discount, and render certain African diasporic practices un-visible in academia. This having been said, the project does not make the claim that an archival or institutional visibility is needed or necessary. This institutional illusiveness (that is, that these forms are often not archived in institutions) and the ephemerality of these forms and their documentation are also parts of what these practices are and enact.

Finally, this book tries to move away from an investment in the politics of visibility evident in the field of African diasporic art history, which has strategically been invested in inclusion and recognition in more conventional art-historical paradigms, to explore the possible alternative formations of image- and art-making in the diaspora. In addition to charting an art history that responds to popular types of creative expression in parts of the diaspora, analyzing Western modes of visuality from a diasporic perspective, and looking at contemporary representational spaces available for the figuration of the modern black subject, this book highlights how the objects and subjects of study in this field may take unique forms. It brings studio art into conversation with popular representational practices and considers a variety of media from still photography to video across a range of practitioners and creators to create a shared space of visibility within the pages of the book. In doing so, it offers one possible model of African diasporic art history.

1

"KEEP IT REAL"

Street Photography, Public Visibility, and Afro-Modernity

The observer thought he was seeing. Changed into the observed, he enters into an "astonishment" which is not accompanied by any representation. The experience of the gaze is a surprise without an object. The gaze of the other excludes the possession of an image. It deprives of sight, it blinds.
—**Michel de Certeau**, "The Gaze: Nicholas of Cusa" (1987)

We [black people] don't have no fucking wealth. . . . I'm not talking about rich, I'm talking about wealth. I'm talking about the white families that own all the Similac and own the color blue. . . . Wealth will set us fucking free. Wealth is empowering. It can uplift communities from poverty. . . . It's not all white people's fault that black and brown people don't have any fucking wealth. Maybe if we didn't spend all our money on rims we might have some to invest. Black people, we love rims.
—**Chris Rock**, *Never Scared* (2004)

I first saw the street photographers in Atlanta in 1996, during the African American spring break event known as Freaknic. They had set up makeshift photography studios along the main site of the annual Sweet Auburn Festival. They lined their booths with brilliantly painted backdrops against which they invited passersby to take Polaroids. Three years later I encountered the photographers again, but in New Orleans. They had built and were operating (until the police arrived) temporary photography studios in a vacant parking lot near a route where a black Mardi Gras krewe filled an overcast day with a trail of music and color. Young men and women in particular enthusiastically posed before the photographers' lenses and created another space of performance at the parade. In contrast to the comparatively modest surroundings in both locations, the backdrops, which floated like clothes hung across the horizon line of the urban landscape, portrayed either landscapes of leisure or high-end consumer products. In the street-side studios, grand

1.1. John Davis, street photograph, Atlanta, 2009. Digital print, 6 × 4 in. Courtesy of the photographer.

1.2. John Davis, street photograph, Atlanta, 2009. Digital print, 7 × 5 in. Courtesy of the photographer.

entryways of majestic mansions gleamed (fig. 1.1), sports cars sparkled against shimmering lakes and on tropical beaches (fig. 1.2), the lights of Times Square electrified the night sky (fig. 1.3), and monumental dollar bills, diamond rings (fig. 1.4), and silver watches "bling blinged"—to use a term that appeared on one backdrop portraying a single glimmering timepiece (fig. 1.5). Also on that day in New Orleans, the image of local rapper Juvenile of the Cash Money Millionaires, a group emblematic of a flashy black urban culture, stared from one of the backdrops, his visage appearing among the other symbols of wealth.

Since the mid-1980s, street photographers, who are with rare exception men, have unfurled their backdrops across black urban communities in the United States. Not confined to any single geographic location, street photographers erect their portable studios at festivals, music concerts, strip malls, sporting arenas, parties, parking lots, storefronts, and other venues throughout the country. They are particularly popular in black metropolitan areas on the East and West Coasts and

1.3. Edward Robinson, street photograph, New Orleans, 2009. Digital print, 6 × 4 in. Courtesy of the photographer.

1.4. Edward Robinson, street photograph, New Orleans, 2009. Digital print, 6 × 4 in. Courtesy of the photographer.

in the South, but street photographers also operate in Jamaica.[1] It is difficult to overstate the ubiquity of street photography in contemporary African American urban communities or to overestimate the large number of street photographs created yearly. One photographer from Atlanta, aided by three assistants, boasted of netting over $25,000 in a single night at a concert by creating an estimated three thousand photographs.[2] Not surprisingly, the potential profits to be earned through street photography have inspired the genre's growth.

This chapter examines the history, aesthetics, and economics of street photography, as well as the closely related genre of club photography. It demonstrates how black urban populations use these contemporary picturing practices to present, indeed to emblazon, their images of personhood, prestige, and pictorial immortality. The chapter explores a broader history of the painted backdrop highlighting the street photograph's distinguishing characteristics. Street photography is characterized by the public process of posing before dazzling hand-painted backdrops. The re-

1.5. Street photograph, New Orleans, 1999. Polaroid,
4¼ × 3½ in. Collection of author.

sulting images emphasize the visual registers of painting and photography, of fantasy and the real. Street photography studios are sites where conceptions of Afro-modernity are projected and developed. Michael Hanchard uses the term "Afro-Modernity" to characterize "a particular understanding of modernity and modern subjectivity among people of African descent."[3] He explains: "At its broadest parameters, it consists of the selective incorporation of technologies, discourses, and institutions of the modern West within the cultural and political practices of African-derived peoples to create a form of relatively autonomous modernity distinct from its counterparts of Western Europe and North America."[4] Afro-modernity entails, too, the negotiation and appropriation of concepts of time by African diasporic individuals and groups.[5] Street photographs offer sites where contemporary Afro-modern subjectivities are formed through the selective use of photography and visual technologies. The practice of street photography, in particular, reveals how black urban communities, while very aware of what constitutes social and economic status in modern society, participate in what I term a visual economy of

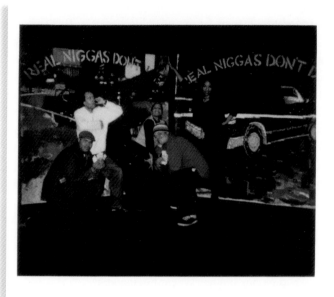

1.6. Charles H. Nelson, *Real Niggas Don't Die: Tupac and Biggie (Call and Response)*, from the *Backdrop Project* series, Five Points MARTA Station, Atlanta, July 3, 1999. Courtesy of the family of Charles H. Nelson, Jr.

light, in which they generate and circulate distinctive approaches to photography, public visibility, the performative moment, memorialization, the spectacle of consumer culture, the real, and death. The backdrops spotlight, for one, an aesthetics of prestige in black youth culture: how certain formal, optical characteristics of luxury goods, as they are represented, convey value. Specifically, light, as it emanates from commodities or as it shines from the mirrors fastened on some backdrops, is intrinsic to the visual production of wealth in the photographs. But the shiny world of commodities is not simply a visual substitute for the material things pictured in the street photographs. The photographs, what and how they picture, are precisely about and representative of the reconstitution of "the real" and "the artificial." Among the work considered in this chapter is that of the late contemporary artist Charles H. Nelson, who set up his own version of a street photography studio in 1999 in public and gallery spaces from Atlanta to Harlem, through which he examined the formal, social, and cultural aspects of this visual economy (fig. 1.6).

Street photographs also reveal particular approaches to time—to the past and future—through their form and subject matter. This chapter outlines, for one, how the preference for the Polaroid in street photography invokes and returns to the unfinished projects and ambitions of the civil rights and black power movements of the 1960s and 1970s. The backdrop artists also draw stylistically from science fiction, producing what might be described as Afro-futurist settings for picture-takers to inhabit. Different senses of time and temporality are also created and mobilized by producers and patrons of the genre in the emphasis on the moment of the photographs' production and the creation of indelible images through ephemeral photographic forms. The images that appear on the drops and the photographs produced against them constitute a fantasy made real, or more specifically a science-fictional, even Afro-futurist, world made present, through the medium of photography.

Making Memory and Money through Street Photography

Consisting of hand- or spray-painted bedsheets or canvases, street-photography backdrops typically measure ten by eight feet and hang on four collapsible metal rods. Depending on the venue, photographers drape one to six backdrops, giving clients choice. Sometimes photographers create a field of backdrops, as Sthaddeus Terrell does annually for Super Sunday, a Mardi Gras Indians event in New Orleans (fig. 1.7). He typically lines the fenced circumference of a sports field with forty colorful backdrops.[6] Often the photographers set up outdoors at night, illuminating their studios with two bright standing lights placed about eight feet in front of the backdrops. While many photographers work as licensed vendors at festivals, in concerts, or on the street, some build their studios without the sanction of authorities. They place their backdrops in public, knowing that the police may close down their operations and confiscate and later auction them off.[7] Their studios, as highly visible as they are, are designed to disappear easily.

Many street photographers who maintain extensive collections of backdrops, which cost between $350 and $800 each, travel widely throughout the United States. The backdrops have their own mobile social lives and are sold and swapped between photographers in different locations.[8] In the case of Jamaica, backdrops travel around the circuit of the nightly dancehalls, appearing most frequently at the entrances to outdoor music and performance venues. No matter where photographers hang the backdrops, they transform different spaces into public

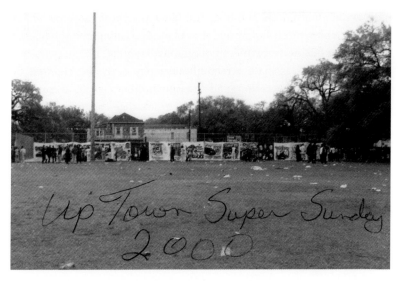

1.7. Sthaddeus Terrell, photograph of a field of backdrops at the Mardi Gras Indians event, Super Sunday, in New Orleans, 2000. Courtesy of the photographer.

photography studios. They become screens or portals cloaking physical environments with painted scenes of imagined geographies. They unite diverse spaces, transforming them into sites of performance and representation.

"Get your photography souvenirs here," photographers often declare to passersby. "Only five dollars," his assistant's voice trails after potential customers, quoting a price at the bottom range of the photographer's offering. For this sum patrons may purchase a small Polaroid against a backdrop. Each photograph, including the border, measures about three by four inches. Increasingly standard since the early 2000s are digital photographs, which are four by six to eleven by fourteen inches and sometimes larger. These typically cost between $10 and $25. Photographers can produce digital prints within two to ten minutes from the battalion of printers they bring to the site. One cameraman using the newest wireless computer technologies boasted print times of 2.8 seconds.[9] Or, in the instance of artist Charles H. Nelson's street-side studio, clients take part in the production of their images, eagerly shaking the Polaroid pictures until their image emerges from and fills the glossy surface.[10] Photographers sometimes present the photographs in small white folded cardboard or wooden frames.[11] Clients range across age, gender, and to a certain extent class, but young people, defined by the photographers as persons between the ages of eighteen and thirty,

most actively keep these photo studios filled, the photographers' lenses snapping, the printers humming, the Polaroids shaking, the lights blazing, and the business of street photography booming.

Many clients associate street photography with the creation of memories of special occasions and describe the photographs as conduits of memory. Some clients use them to "chronicalize," as one photographer put it, their attendance at an event.[12] For others, the act of having one's photograph taken connects them to past times posing before the camera. In 2009 one young man in New Orleans explained to me that he and his two male friends, who had been apart for fifteen years, took a photograph because it was a tradition in which they had long engaged (fig. 1.8).[13] They and many other clients come to the form not simply to produce a photographic memento, but to reproduce a bodily and visual memory of the past that has already been formed through the process of taking the picture.

Some clients even see street photographs as a means to preserve time. For example, a young woman in New Orleans, when asked why she had decided to take a photograph, emphatically stated: "Look what happened in Katrina. You have to treasure and preserve every moment."[14] For her, taking a photograph is an act of preserving time against natural and human-made disasters. Intriguingly, one photographer, Eddie Robinson, echoed this sentiment when he described his role as a "keeper of time."[15] His words suggest that he sees himself not only as engaged in chronicling time but also as possessing it. Associations of photography with preserving time, memory, or the past are by no means unique to street photographs. The photographers may indeed contribute to such explanations by touting their images as "photographic memories" or "photography souvenirs" to passing waves of potential customers. Even so, given that clients have access to numerous means of photographic production, from their digital cameras to their cell phones, it is significant that they identify street photography with this purpose and continue to patronize actively the genre. These photographs—with their own distinct forms of materiality and relationship to temporality—give memory particular form.

Setting the Scene: The Distinct Features of the Street Photograph

To develop an understanding of the particularities of street photography, I returned to the Sweet Auburn Festival in 2008 and followed several photographers around the network of events they attend across

1.8. Edward Robinson, street photograph, New Orleans, 2009. Digital print, 6 × 4 in. Courtesy of the photographer.

the southern and eastern coasts of the United States.[16] John Davis, a Maryland-based photographer, had set up his photography studio at the event, where about five hundred thousand people meandered around over two days. Within the hustle and bustle, he tethered together three backdrops to create an open cube that resembled a giant, unbound, foldout picture-book insert. His studio closed out the visual noise of the rest of the festival (fig. 1.9).

The backdrops in Davis's studio offer a snapshot of the more iconic images that populate the genre and the types of settings they provide for clients to inhabit. It is difficult to speak in broad strokes about the backdrops because diversity is how photographers claim a competitive advantage. But generally they foreground a consumer product displayed against a rural landscape or urban setting as if it were set on a theatrical stage.[17] This convention was evident in several of the backdrops in Davis's studio, which featured luxury cars—by far the most popular subject—at night near bodies of water. One pictured a black Phantom (fig. 1.9). Depicted at night with its headlights on, its wheels turned slightly inward, and its winglike doors uplifted, the vehicle appeared like an object from the future, which is how Davis described it—one in which cars could be animate even though the driver's seat remained empty. Backdrops aim not simply to reproduce the trendiest cars but to present clients with, as one photographer put it, "vehicles that have not been seen or invented yet."[18] Next to the Phantom backdrop was its tropical mirror image: a glossy red sports car on a twilit beach framed by a silhouette of palm trees. Coincidently, the backdrops stood directly below a billboard advertising cars, which towered above them in the historically black Auburn Street community, once the home of Dr. Martin Luther King Jr. The image of the red car visually echoed the vehicles on the billboard, reproducing their "three-quarter pose" and gloss.[19] The backdrops, which appeared to bring down to earth the consumer products that tantalizingly hovered on the billboard, highlight how their creators both respond to the larger social landscape of consumer culture and operate in its shadow.

One of the backdrops in Davis's studio featured an image of an eight-foot-tall bottle of Rémy Martin cognac—one example of the popularity of the ever-changing inventory of fashionable consumer goods esteemed by rappers in their lyrics, in music videos, in advertising, or across the blurred boundaries of these formats (fig. 1.10). If not the drink du jour, the latest diamond-encrusted jewelry, jet plane, or yacht, backdrops foreground brand-name products blessed by rappers, celeb-

1.9. John Davis's photography studio with backdrops by James Green, Atlanta, 2009. Photo by author.

rities, or corporations, from Nike shoes to Prada boots to Louis Vuitton bags (fig. 1.11).

While artists typically render vehicles and the landscape in ways that take account of human scale, they often enlarge other luxury and brand-name products to such an extent that they appear gigantic. This is evident in a photograph featuring the larger-than-life Rémy Martin bottle, which was so big that it dominated the two young men who confidently struck poses before it. These supersized representations of consumer products, which appear like architectural structures, give visual form to their overblown exchange value. Another popular subject on backdrops is money, ranging from $100,000 bills with Barack Obama's face as president (before he had been elected) to actual dollar bills collaged to the surface to towel-sized wads of cash (fig. 1.12).[20] While some clients playfully claimed ownership of the things that appeared on the

backdrops (as he passed Davis's studio, one man boasted, "That's my car, that's my car. I want that"), one could make the case that backdrops in general present some products as unobtainable, as explicitly within the realm of the fantastic, in their aggrandized states.[21]

The Aesthetics of the Backdrop

The backdrops picture worlds of conspicuous consumption in a style that several creators describe as "realist." A cadre of painters hand- or spray-paint the backdrops, often in consultation with the photographers.[22] Some painters make a living solely by producing backdrops, while others see themselves as studio artists who have been pulled reluctantly into the trade for the income. Counting himself among the latter is the artist James Green, who made Davis's backdrops. Green has been working as a backdrop creator for twenty years and autographs his works with the initials "GQ." In a common style, he uses bright, vibrant colors against a muted dark ground, which visually produces a luminous, Day-Glo, tactile appearance reminiscent of black velvet paintings or light-box images.

Artists like Green achieve volume and depth by attending carefully to the depiction of light.[23] They described at some length how crucial the re-creation of light is to the backdrop aesthetic. Green's backdrops, for example, exhibit a luminescent quality achieved through the use of white paint to depict reflective surfaces (fig. 1.9). In the Phantom backdrop he made for Davis's studio, the car's rims emit such a strong light that they produce a glare on the ground. Light emanating from cars, moons, sunsets, and other sources of illumination is key.

I will return to the visual economy of light and to the "realism" of backdrops later, but for now I would like to call attention to the settings. Although artists describe the landscapes depicted in backdrops as secondary to the luxurious items that are foregrounded, these settings help conjure a sense of fantasy. The alternate worlds they present

1.10. John Davis, street photograph, Atlanta, 2009. Fujifilm FP-100C Color instant print, 4¼ × 3¼ in. Digital photo of Davis photo by author.

1.11. Backdrop featuring brand-name goods by artist identified as Len, New Orleans, 2008. Photo by author.

1.12. Street photography studio backdrop by artist identified as Len, New Orleans, 2008. Photo by author.

imagine a range of spaces and places. More often than not, backdrops picture urban geographies, cities of light with sparkling skylines, electrified bridges, and neon signs (fig. 1.13). In this respect they serve as screens where ideals of modern urban landscapes are projected onto black urban environments. The landscapes range from the metropolitan to the tropical picturesque. Many artists describe the often-depicted coconut tree silhouetted against the sunset as representing a "Caribbean" or "summer island" landscape (fig. 1.9).[24] Tellingly, this Caribbean landscape does not appear in Kingston's studios. Representations of American urban landscapes are more popular settings there (fig. 1.5).[25] Backdrop scenes offer screens through which picture-takers can virtually reside within other sites in the African diaspora and beyond and call attention to the socially specific visions of diasporic imaginaries. Tropical and urban backgrounds may also be sites where ideals about where African diasporic groups fit on a modern continuum—what Brent Edwards describes as different and relational modernities and temporalities—are figured.[26]

The style of the settings is also revealing. Unlike the "realism" common in the depiction of the main object, artists often represent the landscape in a comparatively flat manner, which often calls attention to the image's painterliness (fig. 1.14). Some scenes recall the bucolic landscapes with foliage highlighted through brushes of white paint produced by popular artists like Thomas Kinkade. Other scenes composed of arching palm trees against a dusky sky may also be understood as drawing on the genre of the picturesque tropical landscape. This visual quotation of painted genre scenes reflects the desire to execute an easily renderable landscape. A part of the fantasy that backdrops offer is not simply a proximity to rustic or tropical scenes; rather, patrons become central inhabitants of a "picture"—a well-known and recognizable mise-en-scène brought into being through the materiality of paint.

Given that street photographers can easily enlist any photographic enlargement as a backdrop, as is so common in studio portraiture in general, their insistence on using paintings points to a constitutive and even definitive aspect of street photography: it is a set of practices surrounding the public staging of a photograph produced on a painted ground. The privileging of the painted backdrop is particularly significant given the availability of visual technologies such as the green screen or chroma key. This technique, the prototype of which was developed in the film industry in the 1940s, allows the subject pictured before a green background to appear illusionistically in different loca-

1.13. Street photography studio backdrop, New
Orleans, 2009. Photo by author.

1.14. Darrin Clark's street photography studio,
New Orleans, 2009. Photo by author.

1.15. Street photography studio using green-screen technology, New Orleans, 2009. Photo by author.

tions. Software replaces this background with a countless number of digital backgrounds. The screen creates what is described as a hole that allows the person or thing foregrounded before it to be keyed into different sites. The green screen has the potential to create a more realistic sense of location than a painted backdrop does.

In the early 2000s, some street photographers started to replace or supplement painted backdrops with green-screen technology. In 2009, for example, one studio in New Orleans featured a bright green swath of fabric fastened over a metal frame that extended several feet on the ground (fig. 1.15). Using chroma-key technology, the photographers offered their clients a choice of ten or more photographic backgrounds, many of which were in keeping with the subjects of their painted counterparts. As of 2008–2009, however, photographers and clients had not embraced green-screen technology. Given the greater selection of backgrounds and potentially lower costs made possible through digital technology, as well as the comparative ease of transportation and installation, the preference for painted backdrops reveals something more than hesitation to embrace the new. The continued dominance of painted backdrops highlights how street photography derives its meaning and representational form from its nonphotographic, nonindexical, nonvirtual backdrops, which retain an explicit pictorial sense of a re-

created fantasy world. Describing a backdrop he painted of a luxury car, Green stated: "You know it's not a real Phantom but . . . I think that's why the hand-painted backdrops work so well, because . . . it's not. But I guess it allows them [clients] a minute to fantasize . . . to dream."[27]

Street photographs also invariably picture a full-bodied view of individuals or groups (figs. 1.1 and 1.2). When I was pulled into service at the studios, photographers stressed this feature. Picturing the entire human body, especially the subject's pose and gestures, suggests that in this genre subjectivity and status are rendered through the whole person, not just the face. This is notable, given that since the mid-nineteenth century in Europe, as Allan Sekula has detailed, there has been a belief across photographic terrains, from images of celebrities to the criminal, that the "surface of the body, and especially the face and head, bore the outward signs of inner character."[28] In street photography, the body—clothed, tattooed, performing—fully occupies the photographic frame.

This preference for picturing the body in its entirety produces a particular compositional effect: it necessitates a wide, vertical perspective on the scene that brings into the frame not just the client and his or her desired backdrop but also a substantial slice of the actual environment where the studio is located. Often, as in several of Davis's photographs, the cropped painted and two-dimensional world of the backdrops frame subjects at the top of the photographs while the surrounding landscape, which can constitute as much as a third of the photograph's background, extends into three-dimensional space.

Street photographs are both painterly and photographic and both two-dimensional and three-dimensional. They shift between multiple backgrounds and foregrounds, and they put on display the edges or seams of these visual registers. In one of Robinson's photographs, for instance, a white grocery bag edges into the image, as does the downcast shadow of a man who teasingly had begged a group of young women to let him appear in their photograph (fig. 1.16). In a photograph by Davis young people preen against the fantastic painted backdrops visible in the upper part while a murky puddle leaks into the frame at the bottom (fig. 1.17). Notably, neither photographers nor clients appear to be concerned with the seepage of the real world into the photograph's fantasy-scape. There is no pretense at making invisible the everyday environment in which the backdrops are sited, in contrast to the green screen, for which total coverage, the absence of shadows, and evenness of light are paramount to creating the image's illusionistic effect. In-

1.16. Edward Robinson, street photograph, New Orleans, 2009. Digital print, 6 × 4 in. Courtesy of the photographer.

1.17. John Davis, street photograph, Atlanta, 2009. Fujifilm FP-100C Color Instant print, 4¼ × 3¼ in. Digital photo of Davis photo by author.

deed, in some of Davis's photographs, as in an image of the four young women, the large orange clamps used to tether the backdrops to the frame are visible. Clients comfortably and confidently straddle the representational worlds of the backdrops and the real worlds where those backdrops are placed.

Public Visibility and the Street Photograph

The four women who posed against Davis's tropical backdrop, with their dress and hair color-coordinated, call attention to another distinguishing feature of street photography: the very public process of posing. For many clients the act of taking a photograph is seldom a onetime event but instead consists of striking multiple poses to the soundtrack of the camera's shutter before an audience. Immediately after the young women posed in pairs with arms akimbo, they automatically rearranged themselves, without missing a beat, for another photograph in which they assumed identical poses turned slightly to the side (fig. 1.18) and then for one in which they lined up to show off their posteriors (fig. 1.9). Another group of three young women at Sweet Auburn also engaged in a fluid performance before the camera. They took no less than twenty photographs, as a group and individually, against every backdrop, spending about $300 in the process. One striking image shows all three with their backs toward the camera (fig. 1.19). They resemble a girl-group trio turning to face their audience after having taken the stage. A New York–based photographer, Larry Reid, suggested that the repertoire of movements seen in music videos, which are infamous for their focus on the sexualized black female body, inspired the most common women's poses.[29] Although some female clients seem to reanimate the objectifying poses seen in these videos, they also arrange their bodies in certain formations to affirm their connection to each other through shared gestures and clothing. Their performances are staged for themselves as well as for passing spectators.

Men also take multiple photographs in which they assume stances that might be described as cool poses of black masculinity. In their study *Cool Pose* (1992), Richard Majors and Janet Mancini Billson maintain that black males "use posing and posturing to communicate power, toughness, detachment, and style-self"—a carefully crafted persona that is key to the negotiation of black urban environments.[30] In many regards, the poses that men strike personify what photographer Reid described as "photographic swagger."[31] Men stare directly at the pho-

1.18. John Davis, street photograph, Atlanta, 2009. Fujifilm FP-100C Color Instant print, 4¼ × 3¼ in. Digital photo of Davis photo by author.

1.19. John Davis, street photograph, Atlanta, 2009. Fujifilm FP-100C Color Instant print, 4¼ × 3¼ in. Digital photo of Davis photo by author.

1.20. Edward Robinson, street photograph, New Orleans, c. 2009. Digital print, 6 × 4 in. Courtesy of the photographer.

tographer, their heads slightly elevated and tilted to the side, their arms folded protectively and assertively across their chests. Many throw up signs with their hands that refer to specific states of being, neighborhoods, wards, gangs, or rappers (fig. 1.20).[32] One man closed his eyes, surrounded by a group of other gesturing men. Another popular posture is one in which men crouch down with one knee bent toward the camera and one hand lowered just below the bent leg, often flashing a sign with their fingers.[33] Many of these poses embody the men's toughness and recognition of their "seenness."

Highlighting how conspicuous display is central to photographic performances, the poses of some clients emphasize consumer products. Men point at cell phones, and male teenagers gesture at their shoes. One man turned his back entirely on the camera to showcase his jacket (fig. 1.21). Others throw money in the air in a gesture reminiscent of rap videos. As Reid describes, young people have "50,000 different poses." "I mean, like okay, this is not a photo session here," he would silently

1.21. Edward Robinson, street photograph, New Orleans, c. 2009. Digital print, 6 × 4 in. Courtesy of the photographer.

quip as his clients assumed yet another stance. "They want to drop it, they want to show the back, then they want to hit it from the side. And I'm like, how many poses you have? . . . So it gets crazy sometimes. You are standing there, like, are we done? You know, I have got a line here. It's funny. You are saying, I don't believe this. Like, how many pictures you took?"[34] These serial posers highlight how the genre is a type of still photography of the moving subject that centers on the arrested pose and performance, that seems cinematic or videographic as well as photographic. This may explain why photographers refer to themselves as "cameramen"—an appellation more common for video camera professionals than studio portrait photographers.

What is striking about many of these clients is not simply their choreography of poses but how they luxuriate in the process of being seen by spectators. Indeed, the public nature of street photography sets it apart from many other forms of studio portraiture that use backdrops. Here, backgrounds are stages on which clients perform their visibility

for real or imagined audiences. Through different poses, many clients, who typically stare directly at the camera, acknowledge being seen yet appear impervious to the gaze of others. They theatrically solicit and meet the look of the photographer and passersby, but they appear not to need their recognition.

The clients' emphasis on photographic becoming, on inhabiting and enacting the part of photographic subject before a community of viewers, is intrinsic to the genre's popularity. This may explain why when I asked one of the four photographic starlets what she planned to do with the photographs she and friends had created that weekend, she responded with a shrug and replied, "I just love to have my picture taken."[35] Follow-up inquiries about where the photographs might be displayed and to whom they might be given were met with the same response. Her explanation that she loved having her photograph taken thus may be distinguished from any desire to possess, collect, or circulate the photographs. Her words focused on the making of the photographs; their afterlives were beside the immediate point.

This emphasis on being seen being photographed is made most explicit by male clients, who go to great lengths to monopolize studios, as the comments of Reid, quoted earlier, suggest. Many photographers described encountering men who would declare their desire to buy out all the remaining film or paper the photographer had.[36] Of course, in the age of digital cameras, such an order could amount to countless images. But the gesture, made publicly, was less about obtaining hundreds of photographs than it was about commandeering the studio—about becoming the sole focus of an ever-growing and increasingly impatient line of spectators. These men sought to secure the right to occupy the photographer's lens, to remain in the visual heat of the bright, white lights of his studio, to assume a new series of poses before a crowd of onlookers, to flash dollar bills against the background of bling. They sought to capitalize on being seen as a photographic subject, to perform their social status. Although one would think that photographers would welcome such grandstanding, most viewed these men as disruptive, ever mindful of the growing line of disgruntled potential clients consigned to the role of spectator. Perhaps such grandstanding disrupted the fluidity between the subject of the photograph and the spectator, a democratic access to visibility and representation that is part of the genre.

That some clients ritualistically preen before the camera but never collect (or pay for) their photographs, which happened on several occasions at the Sweet Auburn Festival, further demonstrates how the act of

1.22. John Davis's street photography studio, Atlanta, 2009. Photo by author.

taking photographs has its own meaning apart from the actual photo-
graph. Terrell had a collection of images of a young woman who took
numerous photographs on different occasions, paid for them, and then
gave them to him.[37] The reasons behind these practices vary. In the
words of Darrin Clark, a veteran photographer from Washington, DC,
for many clients the experience of producing street photographs is "as
important as having the picture."[38] Indeed, the public practice of posing
constitutes its own form of image-making. Status comes through the
process of inhabiting the site of photographic production, dwelling in
the moment of representational becoming. Richard Simms, one of the
earliest photographers from the Washington, DC, area, came to this
realization when he opened a permanent studio in the city after years
as an extremely successful street photographer. He recalled: "The whole
year nobody walked in the door. I didn't make a dime with that."[39]

This emphasis on public visibility and luxuriating in the moment in
which one is seen is reflected in a popular subject in backdrops: entry-
ways (fig. 1.22).[40] Davis displayed one of these backdrops on the final day
of the Sweet Auburn Festival in 2009. This backdrop portrayed a purple-
carpeted stairway, if not a celestial entryway, with golden rails ascend-
ing over two bodies of water. Entryways—whether the grand front of a
mansion, a roped red carpet, a spiral staircase, or an entryway without
a surrounding architectural structure—do more than extend the picto-

rial inventory of luxurious things that suggest great wealth. They under-score how being seen offers its own prestige. The entryway, the space that signifies the transition from private to public space, is a site about the initial moment of visibility, where one makes an appearance—where viewers can visually take in the occupant of the space for the first time. The entryways visualize what the studios facilitate more broadly: the very moment of public visibility.

The Polaroid and Capturing the Performative Moment

While being photographed has become its own form of ephemeral image-making, the pictures created take a distinct material form. Many photographers produce instant pictures reminiscent of Polaroids. They use a professional 600SC camera and use instant film produced by Fuji because the Polaroid Corporation stopped making instant film in 2008. The small-format photographs translate the oversized images of objects and places represented on the large backdrops into intimate and possessable objects that can fit in the palm of the hand. The Polaroids also present the vivid backdrops in a form some clients identify as clear and bright.[41] With their glossy surfaces that reflect light, Polaroids complement the backdrops' bling-bling subjects as well as the bedazzling clothes or jewelry of some clients (fig. 1.19).

The Polaroid is perhaps the medium of preference because some clients and photographers view it as both true to life and able to capture the moment. The Polaroid has been marketed since the 1970s in black magazines for its capacity to produce an immediate snapshot of a moment. A 1970 advertisement for one of the more popular models, the Polaroid Colorpack II, trumpeted the fact that the image would emerge in "60 seconds flat."[42] Charles H. Nelson suspected that the Polaroid has remained popular because it is not subject to postproduction alteration. As he explained, "In the age of mechanical reproduction or digital manipulation, it's something that cannot be faked, basically. . . . It captures that essence of the moment, and that's what people like about it. . . . They are paying for an image of themselves in the moment."[43] In his outdoor studios he allowed clients to dwell in the moment of photographic becoming by watching themselves emerge as subjects in the Polaroid. Such associations make the form ideal for street photographs, which privilege the moment and the uncropped spaces outside the conventional frames of studio portraiture.

The Polaroid, importantly, does not produce a negative, which again

calls attention to the emphasis on the moment the photograph is taken rather than on the image's subsequent reproduction. The instant form of picture-making resists the visual afterlives made possible through digital technologies and constitutes a certain representational enclosure. It may also be viewed as changeable, if not ephemeral, because it physically transforms over time in color and clarity. Indeed, since at least the late 1970s and early 1980s, businesses have encouraged consumers to reproduce or restore their Polaroids through other photographic means.[44]

Intriguingly, even as more photographers use digital photography, most reproduce the singular finality of the Polaroid: they routinely erase the digital images they shoot after they print them. Many do so as a matter of efficiency in the printing process. Reid noted, too, that some clients want assurances that their photographs would not be saved. Such preferences recall Cauleen Smith's film *Drylongso* (1998), in which the female protagonist, who photographs what she considers to be the endangered species of black males in the streets of Oakland, insists on creating Polaroids. Her rationale: "Don't nobody want no negatives of themselves floatin' around."[45] Although this statement is made in a different context, suspicion of the possible afterlives of the photograph haunts street photography. Of the scores of photographers I interviewed, only three kept some of their photographs, and only one, Terrell, retained and digitally archived every photograph he took—a practice he began in 2005 after Hurricane Katrina.[46] In this way, while photographers create numerous singular photographs, the images retain an ephemeral quality by being continuously consigned to a digital void, a realm of representational disappearance or unbecoming. I do not want to overstate the case, but in both the emphasis on being photographed and the de-emphasis on the physical image and its possible afterlives, street photographs foreground the moment of being photographed as the focus of representation. How might we understand this complex relationship between the backgrounds of materialistic things and the dematerialization of photography? What form do image-making, memory, and Afro-modernity take at the interstices of these practices?

Real Niggas Don't Die: Charles H. Nelson
and the *Backdrop Project*

So far I have laid out some of the distinguishing features of and engagements with street photography. I would like to shift to the work

1.23. Charles H. Nelson, *Real Niggas Don't Die: Tupac (Call and Response)*, from the *Backdrop Project* series, Five Points MARTA Station, Atlanta, July 3, 1999. Courtesy of the family of Charles H. Nelson, Jr.

of Charles H. Nelson (1970–2009), who spent much of his career exploring and critiquing the social, aesthetic, and political significance and signification of street photography. After finishing his MFA in 1995, Nelson turned to street photography so as to ground his studio art in popular African American aesthetic practices. From 1999 until his untimely death in 2009 he placed his own versions of backdrops in highly trafficked black urban locations. He created his first backdrop, and draped it without permission, in downtown Atlanta. He hung this backdrop, provocatively titled *Real Niggas Don't Die* (1999), which he painted on canvas, in Five Points, an area a few blocks away from the Sweet Auburn district, where the city's MARTA rail lines cross (fig. 1.23). Having grown up in Houston, where he saw public murals by John Biggers and others, Nelson envisioned his *Backdrop Project* (1999–2009), of which *Real Niggas Don't Die* was a part, as an opportunity to take his studio production to the city's walls and streets. More specifically, he selected a medium that he saw as central to the visual and aesthetic life of every black community in which he had lived. Backdrops were popular in Houston; in St. Louis and Washington, DC, where he obtained his BFA at Washington University and MFA at Howard University, respectively; and in Atlanta, where he subsequently moved. His fascination

with the genre began when he was an undergraduate and he and a group of friends funded a spring break road trip by erecting a backdrop of St. Louis's Gateway Arch in random locations along their route. From St. Louis to Bowling Green, Kentucky, to Atlanta, and to Florida and back, wherever they installed the backdrop people came with a ten-dollar fee in hand and posed. The capacity of the painted backdrop to transform space and to attract clients across communities who shared a vested interest in and performative knowledge of the genre intrigued Nelson.

At first glance the subject and setting of *Real Niggas Don't Die* appear similar to the many backdrops that feature high-end vehicles: the work pictures a black luxury car in an urban landscape. To many festival-goers who streamed busily by Nelson's studio on a July 4 weekend, the young man with the Polaroid camera and painted backdrop would have been a familiar, indeed pedestrian, sight. To those who stopped to gander or were arrested by the unusual enticement of a free photograph, his back-drop was anything but standard. It represented the crime scene, set off by yellow tape, of the murder of the rapper Tupac Shakur in Las Vegas in 1996. Shakur was a popular subject on backdrops before his death and remains so. A photograph of a street photography studio in Harlem taken in 1997 by Jamel Shabazz, a chronicler of urban life in New York, offers an example of such backdrops, one almost contemporaneous with Nelson's (fig. 1.24). Nelson, however, portrayed the car Shakur died in, its frame riddled with bullets, its tires deflated, its doors flung open in urgent abandon. Departing from the attempts at polished photorealism evident in backdrops produced by other artists, he expressionistically applied broad swaths of a single color onto the matte canvas, leaving evidence of dripping paint. His abstract application of paint into geometric shapes was influenced in part by the image's source: he downloaded the photograph from the website of MTV, which he knew many young people turned to for visual evidence of Shakur's suspicious death. He painted the scene in ways that highlighted the pixelation or bixelation of this media image and emphasized the distortion created by its mediation through multiple forms of transmission.

Despite Nelson's decidedly anti-bling-bling subject and his stylistic deviations, when he draped this backdrop in public, he found that few passersby lingered on its content. Although some took offense over the stenciled word "nigga," the automobile and urban setting seemed acceptable and even familiar. "People," Nelson reflected, "were [more] interested in getting their photographs taken than [in] what they were standing in front of."[47] As they typically did, clients used the back-

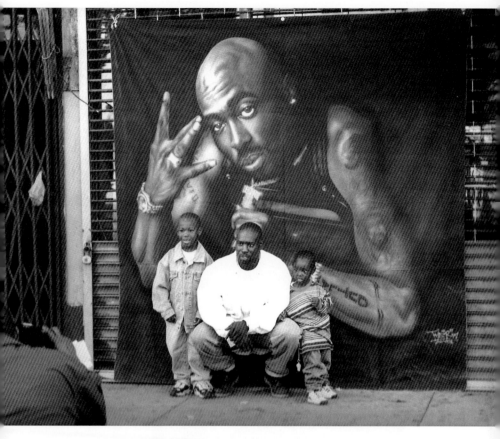

1.24. Jamel Shabazz, photograph of a Harlem photographer documenting a young father with his sons, Harlem, New York, 1997. Gelatin silver print, 11 × 14 in. From the archives of Jamel Shabazz.

drop for their photographic performances (figs. 1.25 and 1.26). Groups of "Versaced up" men struck "tough guy" poses reminiscent of Biggie Smalls (The Notorious B.I.G.), who was shot to death the year after Shakur was; a young man dressed like Juvenile, in camouflage and with a bandanna, threw up the bird. "You could tell . . . the people who had been watching rap videos" by their clothing and poses, Nelson recalled.[48] The artist hoped that if he handed participants a Polaroid picturing them preening against his painted crime scene they would reappraise the backdrop's subject and "realness" and their interaction with it and the bling-bling aesthetic more generally: they would consider, "What does that pose say in front of this image?"[49]

Nelson decided to take two Polaroids of each pose and let his models

1.27. Charles H. Nelson, *Novus Ordo Seclorum*, sketch for backdrop, [1999–2009]. Courtesy of the family of Charles H. Nelson, Jr. Photo by author.

keep the one of their choice while he retained the other (although some insisted on keeping both). In this way he retained the imperfect double of the singular image, which he could not reproduce.[50] As clients posed they simultaneously performed for the artist's videographer, who documented the proceedings some distance behind Nelson.[51] The cameraman's lens thus registered the models' consciousness of two cameras. The video's eye on the makeshift studio was like a physical manifestation of an audience in the manner that is so integral to the spectacle of picture-taking in street photography, and it exemplified the almost videographic serial production of photographs common in the genre. Indeed, after Nelson's first public foray into street photography, he designed a backdrop featuring a giant video camera without a setting, for which he produced a sketch (fig. 1.27). That the camera takes the place of more coveted consumer products spotlights the artist's awareness of how being photo-

1.25. Charles H. Nelson, *Real Niggas Don't Die: Biggie and Tupac*, January 18, 2002. From the exhibit *Reverberation*, Brooklyn Information and Culture, Brooklyn. Polaroid, 4¼ × 3½ in. Courtesy of the family of Charles H. Nelson, Jr.

1.26. Charles H. Nelson, *Real Niggas Don't Die: Tupac*, January 29, 2000. From the exhibit *Eyedrum "C.U.M.,"* Atlanta. Polaroid, 4¼ × 3¼ in. Courtesy of the family of Charles H. Nelson, Jr.

graphed or videotaped has its own value. The drawing foregrounds his thinking about the relationship between video and still photography, which would be intrinsic to his subsequent stagings of the backdrops. This work also features the words "Novus Ordo Seclorum" (A New Order of the Ages). Printed on the US dollar bill since 1782, this phrase when cited by Nelson in the drawing of a backdrop calls attention to the types of currency created through being seen: the new visual economy.[52]

Nelson's video of his first installation of *Real Niggas Don't Die* offers a glimpse of another aspect of street photography that is related to its focus on the performed moment or flash of visibility: death. Throughout the video an older woman tries rather aggressively to distribute Christian literature and to compete with Nelson for the attention of passersby. In defiant response to the many people who brush past her, she arrestingly calls out behind them, "If that's all the time you have for God today, don't die." There is something uncanny about this woman, who occupies the same physical and representational space as Nelson's backdrop of a slain rapper with its not-so-tongue-in-cheek title displayed in bold yellow stenciled text. Nelson's backdrop makes death unapologetically present as part of the world of street photography. The backdrop re-creates the site where one of hip-hop's brightest stars, whose fourth studio album was titled *All Eyez on Me*, made his final appearance. It also draws on the haunting 1930s crime scene photographs of New York photographer Weegee (Arthur Fellig). Indeed, Nelson's application of paint in the backdrop recalls the bloody aftermath of violent death that Weegee's camera recorded.[53]

At the heart of Nelson's project is an explicit critique of all the worldly things that glimmer in hip-hop culture and in US society in general, from consumer products to intangible commodities like fame. What haunts these scenes of spectacular visibility, Nelson reminds us, is the specter of disappearance, ephemerality, and death. The heightened and insistent visibility afforded by street photography takes place against a tacit awareness not only of the transience of things but of how race differently inflects each subject's sense of mortality.[54] Nelson's crime scene as photographic setting unveils the intimacy between the bling-bling lifestyle and what Cornel West refers to as nihilism in black America.[55] I will return to the theme of death and memorialization in the context of black urban life later, but here I would like to suggest more broadly that street photographs may be seen as a type of memento mori. The images reflect how clients desire to be remembered given the precariousness sometimes of black life. That Nelson staged his *Backdrop Project*

on a July 4 weekend sets the popular photographic practice within a broader social and historical context of American Independence and foregrounds and returns to the following question: what does July 4 mean to black Americans in the twenty-first century?[56] What is the status of citizenship and freedom for black subjects in urban communities, and how is it exercised through things and in black public spheres?

The History of the Backdrop

To understand why street photography assumes the form it does, it is useful to contextualize the genre within a broader history of the use of the painted backdrop in photographic portraiture. The daguerreotypist Antoine Claudet patented the painted photographic backdrop in 1841. He did so just three years after Louis-Jacques-Mandé Daguerre in France, William Henry Fox Talbot in England, and Antoine Hércules Florence in Brazil announced the invention of photographic processes.[57] Painted backdrops, however, did not become commonplace in studio settings until the 1860s and 1870s.[58] Their popularity is typically credited to Americans Henry Ulke and L. W. Seavey.[59] Seavey made backdrops portable by placing them on light and durable materials and patented a frame system for their display, storage, and transportation (fig. 1.28).[60]

Several aspects of the history of backdrops in western Europe and the United States are germane to street photography. For example, the year before Seavey invented his frame system in 1887, he patented a new form of theatrical scenery made of lightweight, flexible cotton.[61] His work at the intersection of theater and photography foregrounds historically how the backgrounds developed in tandem with equipment designed for a performance setting: the theatrical stage.[62]

The backdrop's popularity was likely informed by the public's fascination with new forms of visual entertainment available in the mid- to late nineteenth century. Photography historian James Wyman points out that "perhaps the human desire to be photographed amidst painted scenes, props or constructed environments emerges less out of photography's technological evolution and more out of the theatrical, dioramic, panoramic and pedestrian mall experiences of the nineteenth century."[63] Through painted backdrops, patrons could insert themselves photographically into the painted scapes that formed the ground of many popular visual technologies. Wyman makes the case that backdrops may be considered a "precursor to computer-age 'virtual reality'; a fanciful means of being someone or somewhere else."[64] The relation of

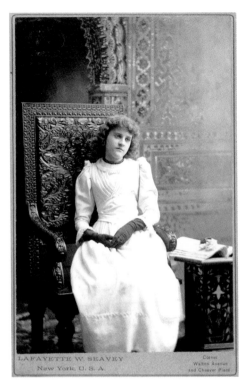

1.28. L. W. Seavey, photograph illustrating the use of Seavey's background, the Alcazar, New York, [c. 1890–1903]. Courtesy of Special Collections and Archives, Merrill-Cazier Library, Utah State University.

backdrops to window shopping and other popular pastimes is also pertinent.[65] I highlight these aspects not to draw a direct genealogy with this history but to stress that painted backdrops, both historically and today, can only be fully understood along with a broader consideration of contemporary visual technologies and popular cultural pastimes that inform approaches to visuality.

Photographers working in black communities across the United States and Jamaica used painted studio backdrops. The authors of the exhibition catalogue *African American Vernacular Photography*, organized by the International Center for Photography in 2005, argue that backdrops were "especially prevalent" among African American communities.[66] As they note, backdrops in studio photographs from the 1920s through the 1940s often "feature idealized landscapes such as . . . waterfall[s] or architectural views that transport the sitters into different class, geographic, or historical realities."[67] Several backdrops illustrated in this catalogue also feature sitters in front of painted depictions of the domestic realm, such as armoires set with vases or colonnades revealing

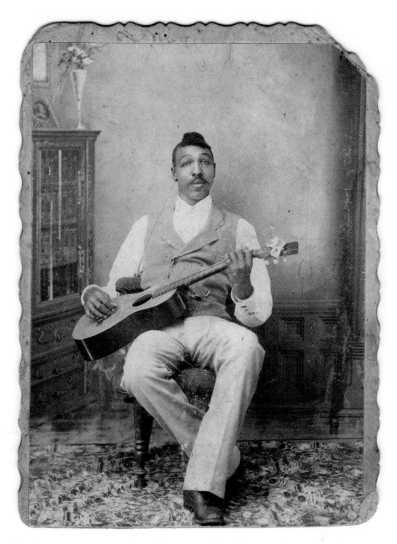

1.29. Unidentified photographer, [Mr. Lewis Young of Monroe City], c. 1910. Albumen silver cabinet card, 5⅜ × 3⅞ in. New York, International Center of Photography, Gift of Daniel Cowin, 1990.

garden views (fig. 1.29). The well-known photographs of Harlem-based James Van Der Zee had backdrops painted by the artist and photographer Eddie Elcha that depicted the hearth or the draped interior windows of the home.[68] Photography studios in Kingston also lured clients by advertising their backdrops. The photographer J. W. Cleary, for example, advertised "new backgrounds" in his studio in 1885, and another photographer advertised himself as a creator of studio backdrops as well as theatrical sets.[69] While the photographs of painted representational backdrops have a long history in black American and Jamaican communities, unlike the street photographs, many were taken in the privacy of the photographers' studios and depicted the domestic realm.

Painted backdrops gained popularity in many other parts of the world, and scholarly analyses have largely focused on India and West Africa.[70] For example, Steven Abiodu Thomas, a photographer from Ghana, began copying European backdrops in the 1940s. He subsequently customized and traded them with photographers throughout the region.[71] Philip Kwame Apagya, also from Ghana, is often identified with contemporary forms of the painted backdrop. Apagya takes photographs in his studio against colorful painted backdrops of living-room dividers that showcase the latest consumer products or modern urban spaces.[72] His *Francis in Manhattan* (1999), in which a man gestures in close proximity to a painted backdrop of New York, is reminiscent of the cityscapes found on street photographs in the United States and Jamaica (fig. 1.30).[73] Both backdrops exemplify what Arjun Appadurai describes in an early influential essay as the "increasingly central role in the work of the imagination, in consumer-driven images of subjectivity and socially mobile practices of self-representation and class-identification."[74] But street photography backdrops differ from those in Apagya's works in that the Ghanaian photographer pulls his backdrops into the space of his studio so that they are contiguous with the ground the photographic subject occupies. While this quality is common in studio portraiture using painted backdrops, it is less common in street photography.

Appadurai understands backdrops as forms that reveal much "about how the medium of photography is contained, contextualized and sometimes contested."[75] He and other scholars have also viewed these objects as manifestations of how people from different classes, places, genders, races, and ethnicities "experiment with" modernity. For scholars such as Tobias Wendl, Lucy Lippard, and the authors of

1.30. Philip Kwame Apagya, *Francis in Manhattan*, 1996/2000. C-print, 69.5 × 49 cm. © Philip Kwame Apagya. Courtesy of Fifty One Fine Art Photography, Antwerp.

African American Vernacular Photography, photographs featuring representational backdrops offer clients and viewers a fantasy of proximity to metropolitan locales and modern consumer culture.[76] They interpret the relationship between the individuals pictured and the subjects of the backdrops as one of distance and desire, such that the backdrops, particularly in postcolonial contexts, function as a means of imagined mobility.[77] As Lippard notes, "The backdrop setting presents a place in which the photograph's subjects occupy new, often inappropriate, 'realities.'"[78] One could make the case that in street photography backdrops allow clients to momentarily transform realities of class, gender, race, and place. As Green observed after years as a backdrop artist, they are popular in part because clients "want to feel as though they are in [a] different place."[79] Or perhaps the very public visibility of street photography mitigates the ways that race, class, and gender inform and hinder social mobility and public visibility.

In the rest of this chapter I lay out the recent history of street photography backdrops, being attentive to when their central features developed and what these characteristics reveal about the relationship of the genre to modernity, photography, and reality. Recasting Appadurai's scholarly frame, I maintain that street photography might be seen within the context of Hanchard's concept of Afro-modernity: "the development of alternative [African diasporic] political and cultural networks across national-state boundaries" that "critique the uneven application of the discourses of the Enlightenment and processes of modernization by the West, along with those discourses' attendant notions of sovereignty and citizenship."[80] In street photography, however, backdrops serve less as proxies for unobtainable yet coveted consumer products or landscapes than as grounds for recasting the real and the fantastic. Rather than simply displaying desirable things, backdrops are part of a broader visual economy that constitutes, to use Hanchard's words, "relatively autonomous forms" of value, prestige, the real, and the photographic.[81] Further, street photography offers a platform where the material makeup of photography is reconfigured to include the public process of picture-taking, which has its own currency. The genre, too, might usefully be understood in the context of Afro-modern negotiations of modalities of time, whether highlighting the now of visibility, representing the Afro-futurist landscape, or creating ephemeral forms of visibility and immortality.

Picturing Africa and Staging Black Nationalism:
Club-Photography Studios in the 1970s

Coincidentally, given the focus on the United States in Apagya's back-drops in West Africa, the immediate precursor to US street photography studios in the late 1960s presented a diasporic imagining of Africa. Early photographic studios became sites where photographers pieced together an iconography of Africa as a setting for black modern subjects. While photographers had roamed the clubs of black cities since at least the 1920s, capturing the music scene through photographs,[82] in the 1970s they started to operate semipermanent, miniature studios within the clubs themselves, signing exclusive contracts with club owners. Washington, DC, was a key center of these activities, with photographers such as Ivery McKnight, Greg Sanders, and Richard Simms working at nightclubs such as the Coliseum, Howard, Presidential Arms, and Willard.[83] Photographers also worked in Harlem, New Orleans, and Houston, where they set up semipermanent studios in clubs, charging $3–$5 for a Polaroid or a print that would be mailed to clients.

Several Polaroids taken by Simms picture the early studios, which consisted primarily of a high-backed fan chair made of wicker and an animal print decorated with other "African motifs" as a backdrop (figs. 1.31 and 1.32). Simms and other photographers composed these backdrops by cutting out elements taken from bedsheets and throws found in department stores to create an Afro-kitsch pastiche fashioned through commodities.[84] Curtains, palm trees, fans, and animal-print carpets were all part of the photographer's pictorial repertoire. "It was a safari look," McKnight, a former police officer who started taking pictures in the 1970s, explained. "It comes with the African style, the king and the queen, the warrior."[85]

The wicker chair was ubiquitous in the 1960s and 1970s, but it had particular political resonance in the context of the nascent visual iconography of black nationalism, pride in African heritage, and the black power movement. Huey Newton, minister of defense for the Black Panther Party, famously sat squarely in a similar chair in a photograph that Eldridge Cleaver, the Black Panthers' minister of information, orchestrated in May 1967. Taken just six months after the Black Panther Party formed in the San Francisco Bay Area and as the group sought to increase its visibility in cities like Baltimore, New York, Chicago, and Washington, DC, the photograph became one of the most reproduced images of the era. It pictures Newton in a leather jacket and black beret

1.31. Richard Simms, club photograph, Washington, DC, [1970s]. Polaroid, 4¼ × 3½ in. Courtesy of the photographer.

1.32. Richard Simms, club photograph, Washington, DC, [1970s]. Polaroid, 4¼ × 3½ in. Courtesy of the photographer.

1.33. Blair Stapp, photograph of Huey P. Newton, c. 1967. *Black Panther Black Community News Service*, vol. 2, no. 1, March 16, 1968, 4.

in a nondescript interior (fig. 1.33).[86] The chair appears as prop and back-drop, halo and throne. Newton holds a rifle in one hand and a spear in the other and sits on a zebra-skin rug on which bullets rest. The photograph also features an African sculpture and shield, both references to "the motherland" and to the need to shield black America from "the imperialism, the decadence, the aggression, and the racism in the country."[87] According to Simms, from the late 1960s through the 1970s the wicker chair so prominently featured in the club photo studios was also associated with Ralph "Petey" Green, the outspoken popular DJ, activist, and television host.[88]

Some of Simms's Polaroids from the 1970s, in which subjects in wicker chairs pose resolutely before the camera, resemble variations on the Newton photograph. (The chair also appears in studio photographs from Jamaica and the Bahamas in the 1970s.)[89] These photographs do not so much reflect a direct relation to the Newton photograph as underscore how club photography emerged in the late 1960s and 1970s at a particular historical moment when a visual lexicon related to reevaluating, valuing, and visualizing blackness—particularly black masculinity—emerged. In Simms's estimation, the wicker chair also represented quite simply what was cool.[90] Historian Nikhil Pal Singh makes the point that the Black Panthers were "practitioners of an in-

surgent form of visibility, a literal-minded and deadly serious guerilla theatre in which militant sloganeering, bodily display, and spectacular actions simultaneously signified their possession and real lack of power."[91] Simms's 1970s photographs, in which people often exhibit dramatic poses, appear to partake in and promote these insurgent forms of visibility, the theatrical, and the cool through photography. Popularizing picture-taking in public contexts, studio spaces in clubs became sites through which photographic portraiture moved out of the private realm of the studio into the public sphere.

Intriguingly, Polaroids became central within a black revolutionary and African diasporic politics in 1970, when a small group calling itself the Polaroid Revolutionary Workers Movement (PRWM) protested against the company. Led by Kenneth Williams, an African American photographer employed by Polaroid, PRWM spearheaded one of the earliest, if not the first, boycotts of a US company over the issue of black rights.[92] It accused the company of supplying South Africa's apartheid government with the instant film used in its identification books. Under apartheid, nonwhite citizens had to carry passbooks that contained identification photographs, and Polaroid film and equipment were used to take many of these pictures. In a new twist on its advertising campaigns, the PRWM printed leaflets proclaiming "Polaroid Imprisons Black People in 60 Seconds."[93] The group held demonstrations outside the company's headquarters in Cambridge, Massachusetts, called for a worldwide boycott of all Polaroid products, demanded the company's pullout from South Africa, advocated that stores refusing to ban the company's products have a white X painted on their windows, and called on Massachusetts citizens to refuse to have their identification photographs taken if the state used the Polaroid product.[94] The black press and other international news outlets covered this campaign.

Pressured by PRWM but not wanting to cave to the demands of black revolutionaries for fear that such protests might spread to other companies, Polaroid remained in South Africa but increased pay and job training for nonwhite workers and established an Association for Education and Cultural Advancement. It did so until incontrovertible evidence surfaced in 1977 that the company's South African supplier was selling Polaroid supplies to the South African government.[95] The company subsequently left South Africa, becoming the first US company to do so for "ideological reasons," and did much to try to repair the company's image among African American communities."[96] Before this period the company had actively promoted itself as an equal-opportunity employer,

sponsored an inner-city job-training program, and funded the news program *Black Journal*.[97] In the wake of the protests the company increased the percentage of black employees in managerial positions and continued its training programs, highlighting that it was part of liberal political and economic changes for black communities in the United States and abroad.[98] Through the PRWM an emergent form of black revolutionary politics was attached to a photography company and to recognition of the uses of photography to suppress black rights. African diasporic in scope, this movement cast suspicion on the potential use of photographic archives by states abroad and at home to diminish black rights. Williams recognized that "we see South African apartheid as a symbol of the many inhumanities in the United States" and believed that similar uses of instant pictures could happen next in the United States: "To control the world, you have to have a means of doing it, and the [Polaroid] ID-2 is a proven system. If it works in South Africa, it will work here."[99] The Polaroid thus was implicated in a mode of revolutionary struggle where strategies for moving black protest into the business world and translating insurgent forms of revolutionary action to rights and opportunities for black subjects were developed.[100]

From Chair to Backdrop, Club to Street: Street Photography in the Age of Hip-Hop

In the early 1980s the round-back chair and props receded into the background of the makeshift studios. According to photographers' accounts, they were incorporated into and replaced by painted images on backdrops. Sanders, Simms, and cameramen with names like Nat the Cat, Charlie B, and James the Cameraman in Washington, DC, started to spray or hand-paint backdrops or hired artists to do so.[101] Some of Simms's photographs show transitional backdrops with cardboard cutouts of cars, palm trees, and fans placed behind wicker chairs (figs. 1.34 and 1.35). Subsequently, he started drawing vehicles and palms directly on backdrops. Sanders notes that when he introduced the "fancy cars" in his backdrops, "my business tripled."[102] Photographers also took the form out of the clubs and into the streets, setting up at busy intersections such as East Capitol Street and Benning Road in Washington, DC, and on Forty-Second Street in New York.[103]

By the mid- to late 1980s street photography had undergone another transformation, which continues to inform the content of backdrops and broader approaches to consumer products and photographic rep-

1.34. Richard Simms, club photograph, Washington, DC, [1980s]. Polaroid, 4¼ × 3½ in. Courtesy of the photographer.

1.35. Richard Simms, club photograph, Washington, DC, [1980s]. Polaroid, 4¼ × 3½ in. Courtesy of the photographer.

resentation. Many club photographers met and formed contractual relationships with local entertainers, some of whom were part of a scene that would become known as hip-hop.[104] Street photographers toured with rappers on their regional and cross-country pursuit of stardom, particularly as hip-hop gained visibility within the mainstream during the mid-1980s, in part through live concerts. Photographers set up their backdrops at these concerts and offered a ministage where concertgoers could obtain images of themselves in front of backdrops that featured larger-than-life painted representations of their favorite rappers, some of whom were depicted striking their own poses. Or backdrops pictured popular lyrics, album titles, and themes. In short, they "follow[ed] what the rap industry is doing."[105]

Hip-hop music was part of an expansive culture that included emceeing, DJing, break-dancing, and graffitiing, which gained popularity in the South Bronx in the late 1970s and in other black urban communities by the early 1980s. Hip-hop's multiple forms emerged out of the complex intersection of a number of African diasporic and Latin American musical and performative traditions, from Parliament-Funkadelic to Jamaican toasting. Some of the early backdrops came out of the graffiti movement, as artists applied styles they used on urban walls onto portable sheets and canvases.[106] In addition to graffiti, some of the dramatic poses made in the street photography studios recalled the freeze movements of break-dancing.

Hip-hop gained popularity among black youth at a time when African Americans were experiencing what cultural critic Mark Anthony Neal characterizes as a form of de facto racial segregation more insidious than that prior to the civil rights movement.[107] This type of segregation confined black working classes and the working poor within the "living space of poverty," a confinement exacerbated by the departure of the middle class from urban areas, the loss of manufacturing jobs in the postindustrial economy, high unemployment (reaching 40 percent among black youth in places like New York), the rise of crack cocaine, and the decimation of many black communities during urban renewal and relocation campaigns and the institution of state housing programs.[108] Neal also notes how black working-class populations became confined to certain urban enclaves, where they were both highly visible and heavily surveilled, and socially isolated and ostensibly un-visible.[109] Scholars have analyzed at length the social, economic, and political conditions that hip-hop spoke to and sought to transcend, and I do not aim to replay their arguments. But I do aim to elaborate on what often gets

lost in scholarly accounts: visual and photographic practices. Backdrops exemplify hip-hop's visual aesthetic and its impact on notions of visibility and visuality.

By the early 1990s, when hip-hop had become a global phenomenon, street photographers traveled with many stars who were to become behemoths in the industry. For example, the Texas-based photographer Robinson traveled with Tupac, the Ghetto Boys, Ice-T, A Tribe Called Quest, Naughty by Nature, Bone Thugs and Harmony, Master P, and 50 Cent; and Terrell traveled with the New Orleans–based group Cash Money Millionaires.[110] These alliances between street photographers and hip-hop artists resulted in the production of distinct forms of hip-hop concert souvenirs in a concert-merchandising world that typically trades in the mass-produced object. Polaroids and digital photographs did not just offer concertgoers images of rappers and the subjects of their music. They also highlighted how the experience of being photographed with a backdrop was intrinsic to the memory of the musician and the concert, wherein "performer and audience alike strive to create pleasures that can evade capture and sale as cultural commodities."[111] Entertainers reified their status by offering a stage that concertgoers could momentarily occupy. In some instances club photography studios literally flanked the stage where musicians performed, providing smaller and parallel venues where audience members could pose, perform, and preen in the spotlight for the photographer and concert audiences.

Some street photographers, deemed "hustlers" by their peers, often worked without copyright agreements from rappers and merchandising companies. They disseminated the entertainers' images on "unauthorized" backdrops outside the concerts and other public venues. "You look Hollywood today," one photographer with a background of Lil Wayne beckoned to a group of women blocks away from a concert arena in New Orleans in 2009. His sales pitch highlights the capacity for street photography to bring visibility to rappers by multiplying the sites for the everyday production of celebrity. While the relationship between rappers and street photography is as complex as the experiences of concertgoers and the camera, the close connection between hip-hop, with its changing notions of celebrity, status, and visibility, and picture-taking may have helped to popularize further the process of posing in public spaces within black urban environments since the 1980s.

Recent scholarly attention has focused on the over ten thousand photographs that Brooklyn-born photographer Jamel Shabazz took in the streets of New York, starting in the late 1980s, of African Americans

and Latinos/as, some affiliated with the emergent genre of hip-hop. As Nicole Fleetwood has remarked, the individuals in his photographs exhibit "deliberate, determined, and yet often playful poses, facial expressions, and stares" (fig. 1.36).[112] The images capture an emergent black urban subject who comes into full being before the photographer's lens in public space. Shabazz and street photographers were formative in turning the streets into urban photography studios and in developing new forms of community through public visibility and viewership at a historical moment when black subjects increasingly occupied a terrain defined by surveillance and un-visibility. In this way street studios may be interpreted as modes of expression that claimed urban space, created new codes readable to specific viewers, crafted new forms of social prestige, and configured new communities in and through public space.

Money and the Power: The Visual Economy of Light in the Postsoul Era

I would like to turn now to the most prevalent forms of contemporary backdrops, because herein lies the crux of my argument about Afromodern or alternate approaches to consumer products, the real, and time. Depicting imagery popular in the genre of hip-hop, street photographers and their artists create what street photographer Clark describes as "a visual soundtrack" to rap. Although from the inception of hip-hop certain rappers critiqued the capitalist conditions that institutionalized black underdevelopment, others have celebrated materialism. By the 1990s hip-hop artists increasingly staged ostentatious displays of wealth, donning flashy jewelry, boasting about their brand-name possessions, and touting their luxury and designer goods. Backdrops of the period increasingly pictured the lyrical worlds of riches about which some rapped.

A photograph taken by Terrell in New Orleans in the early 1990s is a revealing snapshot of how the hip-hop industry's focus on conspicuous consumption informs street photographs. In this image, a man sits with legs crossed and holds a machine gun poised upright in his right arm. Looking over his nose, he coolly regards the photographer (fig. 1.37). He appears before a backdrop showing a clenched, bejeweled fist with the phrase "Money and the Power" rendered in a flat yet reflective gold script. This photograph offers a striking contrast to the Newton photograph. Both images share certain props—the rifle, the wicker chair, the black-and-white patterned floor, and embodied gestures like

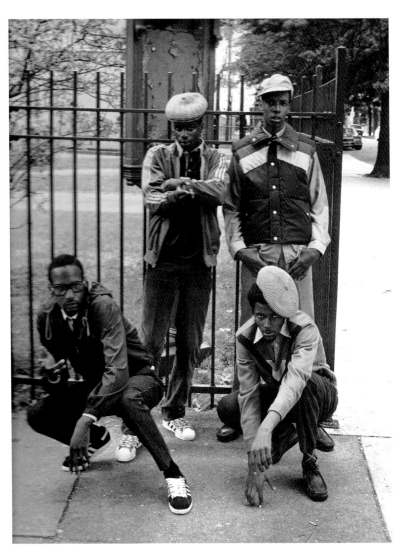

1.36. Jamel Shabazz, photograph of four young men, East Flatbush, Brooklyn. 1980. Gelatin silver print, 11 × 14 in. From the archives of Jamel Shabazz.

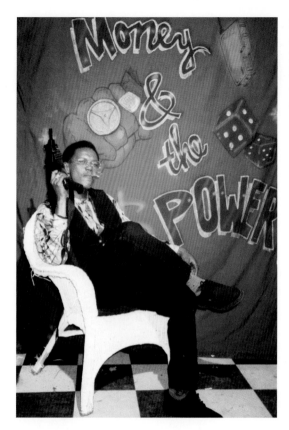

1.37. Sthaddeus Terrell, club photograph, New Orleans, c. 1991. Photographic print, 7 × 5 in. Courtesy of the photographer.

the clenched fist. However, Terrell's backdrop makes explicit how money has increasingly become the ground for new figurations of blackness, power, visibility, and masculinity in the 1990s. The phrase "Money and the Power" echoes a rap song written by Houston-based rapper Scarface in 1991 but spotlights a broader moment in the United States when its population, to quote Neal, "generally faced a barrage of commodified images of wealth and consumption via television, film, and other organs of mass culture," and "self-worth increasingly came to be defined by the ability to consume."[113]

Nelson called attention to this shift in the signifiers of personhood in his backdrops featuring painted versions of the photographs of the assassinated African American leaders Malcolm X and Martin Luther King Jr. (fig. 1.38). These backdrops of iconic figures in the civil rights and black power movements foreground how the era of conspicuous consumption might be seen to signal the death of the particular historical moment when these movements held sway in the United States. Or

perhaps Nelson was hinting at how materialism and conspicuous visibility occupy the space left unfulfilled by these movements, resulting from the aims of these movements not being fully realized. Conversely, he may have been underscoring how performed visibility represents the exercise of a certain civil right within the social, political, aesthetic, and visual-cultural terrain of the twenty-first century.

In the early 1990s, when consumer products and an iconography that associated money and power dominated backdrops, Sonny, the photographer from Jamaica, encountered the genre in New York and re-created a local version of the public photography studio in Kingston. He set up his backdrops outside local dancehalls on a nightly basis and created Polaroids and digital photographs. His backdrops became associated less with hip-hop musicians than with dancehall promoters and DJs. He reproduced some of the same subjects found on backdrops in the United States, even though in some of his photographs the commodities seem more modest in scale and the objects appear set afloat in a world not bound by the laws of perspective. This is evident in one

1.38. Charles H. Nelson, *Real Niggas Don't Die*, [1999–2009]. Acrylic on canvas, 8 × 8 ft. Courtesy of the family of Charles H. Nelson, Jr.

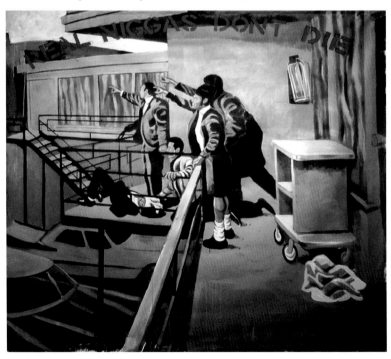

1.39. Photo Sonny's studio, Kingston, Jamaica, 2010. Photo by author.

of his backdrops featuring depictions of shiny bottles of liquor: they appear diminutive next to the name of the weekly dancehall, against which a young woman strikes a pose (fig. 1.39).

But Jamaican backdrops, which are not as popular or omnipresent as in the United States, offer one means through which a culture of conspicuous consumption has gained ground. The photo studios have become an arena where what Deborah Thomas refers to as radical consumerism, influenced by black culture in the United States in particular, has gained currency.[114] Through street photographs, dancehall attendees could pose with flashy accoutrements or the drink de jour in front of painted signifiers of wealth. But, moreover, through the studios a bling-bling aesthetics was practiced and performed through staging oneself for the camera. When I asked Sonny whether he noticed a similarity between the poses assumed in street photography in the United States and in Jamaica, he suggested that the studios became sites for the invention of new poses, the presentation and reinvention of new selves.[115] His observations suggest that street photography offered means for the production of new forms of public visibility executed through the camera. These representations of riches and status through photography be-

came popular just as, to cite anthropologist David Scott, "the signifiers of moral sanction, of the symbols of social solidarity [the church, the family, and the school] that are understood to give coherence and cohesion to the social and political order" ceased to serve as "the generative source of the authoritative signifiers of an approved life."[116]

Backdrops also present a means through which strident forms of public visibility are taken up, encouraged, and performed in the Jamaican context. Studios provide a public stage on an island where until recently, as local filmmaker Esther Figueroa has observed, people were reluctant to be photographed in public by photographers they did not know.[117] Street photography studios are one among many forms of media that have facilitated new approaches to the camera. The circulation of backdrops to Kingston exemplifies not only the marked shifts in how black subjects represent themselves through conspicuous consumption, materialism, and individualism but also how public forms of photographic production transcend national boundaries.

Although the drops, whether in New Orleans or Kingston, appear to aid fantasies of object possession, they may highlight more complicated relationships to consumer goods. Indeed, it is telling that the backdrops are often hung in or over sites of consumption, in parking lots that have been vacated or on store grills of businesses that have been shuttered in the United States and in places that support various informal economies in Jamaica. The street photographers repurpose these spaces, adding to and concealing them with other notions of value.

Some of the subjects and formal aspects of contemporary backdrops also reflect alternate approaches to consumer products. These perspectives may be understood in light of a concept that has dominated hiphop and the aesthetic formation of backdrops since the late 1990s: bling-bling, the words appearing on the first backdrops I saw in New Orleans. B.G. (Baby Gangsta), a New Orleans rapper from the group Cash Money Millionaires, coined this term in 1998 to describe expensive jewelry. "Bling" quickly entered common parlance, and by 2003 the *Oxford English Dictionary* defined it not only as a "piece of ostentatious jewelry" but also as any "flashy" accoutrement that "glorifies conspicuous consumption."[118]

Terrell, who worked as the street photographer for the Cash Money Millionaires in the late 1990s, offers an early example of how the concept of bling has been translated into backdrop imagery. In one photograph a young man stands before a spray-painted sheet featuring a black car and a larger-than-life diamond Rolex, next to the graffitied

1.40. Sthaddeus Terrell, club photograph, New Orleans, late 1990s. Photographic print, 7 × 5 in. Courtesy of the photographer.

words "bling bling" (fig. 1.40). The backdrop appears cut off: its bottom reveals much of the actual physical ground occupied by the man, who holds a stance that, Terrell observed, differs greatly from the reserved poses of his parents' generation.[119] But what is particularly pertinent about bling is that it also describes a certain visual effect of light. More specifically, it characterizes, according to B.G., "the imaginary sound that light makes when it hits a diamond."[120] Bling calls attention to the moment when commodities display their opulence in the visual field, when they emit a shimmering light from a luminous surface. Indeed, in the track "Bling, Bling," B.G. boasts of bling's blinding power: "Girls wear shades just to stand on [the] side of me. They say 'Take that chain off, boy, you blindin' me.'"[121] The concept of bling and its blinding effect has become a central lyrical and visual trope in hip-hop, as rappers convey their prestige through the number of shiny jewels they display. In these iterations, bling is about the conspicuous consumption of riches but also captures the central moment in hip-hop when consumption becomes conspicuous, when the object is undeniably seen. The light of bling creates afterimages, ephemeral forms of representation produced

1.41. Terell Hawkins, photograph of a street photography backdrop, 2009. Digital photo. Photo by author.

physiologically. Bling then resides as a mediation point between hyper-visibility and blinding un-visibility, between visual surplus and disappearance, conspicuous material consumption and optical immateriality.

I dwell on the concept and how the visual effect of light matters because it foregrounds a visual economy in black urban cultures that is not simply materialistic but values goods on the basis of their ephemeral aesthetic qualities and effects. The concept of bling is particularly germane to understanding backdrops because their creators speak explicitly about their efforts to represent light. As Terell Hawkins (known as Hawk) observed, to produce a desirable backdrop, he had to represent its subject in ways that created a "bounce in your eyes, a vibrancy."[122] Often he sought to achieve this effect by manipulating the surface of the backdrop to make it "smooth," "slick," and luminous. To model his depiction of light and its vibrant reflection, he draws in part on magazine advertisements (fig. 1.41). He is especially attracted to advertisements saturated with light, images likely created during shots in which flares and back-lighting were used to illuminate the featured products. Hawkins also draws on the depiction of light in science-fiction and fantasy book and magazine covers. To re-create what he described as the "pizzazz," "pop," and "spark" of these sources, he uses white paint as the background for the objects depicted and has developed a technique in which he "sanded

my picture all the way down until it was so smooth it was slick as this table. And when I did it, it just—it just glided, it just smoothed right on out, and that is what you need to make things translucent."

Green's backdrops echo this attentiveness to representing the reflective quality of light. Interestingly, Green has also aimed to re-create the effects of light that he saw in car-magazine advertisements, and he has used a projector to transfer these advertisements onto backdrops. Green explained that he aimed to master the effect of light so that he could "mak[e] it look as real as possible."[123] Hawkins, too, characterized his style as constituting "the reality zone"—the real without the "masquerade of a shade over it." For Hawkins, the ultimate compliment he could receive was that one of his painted backdrops looked like an advertisement. In addition to underscoring the artists' interest in the reproduction of light in print media, these remarks speak to a broader visual economy in which the effect of light has its own value. Backdrops are not merely surfaces on which images that serve as substitutes for unobtainable real things lie; they are also zones where light and light's effects constitute their own version of "the real."

In addition to reproducing the effect of light in print advertising, artists use other formal, material, and linguistic means. One backdrop I saw in New Orleans in 2008, which displayed an aesthetic close to that of graffiti, depicted a car set in a New Orleans landscape and surrounded by bags of money; the words "Shinin n grindin," composed of gold glitter, dominated the top (fig. 1.42). Other backdrops I encountered used glitter; pictured hands holding multiple hundred-dollar bills and featured tiny square mirrors to create the appearance of light reflecting from diamond rings (fig. 1.43); and portrayed a black man with shiny chains, pendants, and bracelets standing before sparkling letters (fig. 1.44). In this last backdrop, the artist used white paint to create the effect of starbursts of light. Wearing a cap emblazoned with the name of the rap group NWA, the man holds sacks of cash and wears a pendant bearing the word "Shine." Anthropologist John L. Jackson Jr. has observed that in rap music a mutuality exists between form and content, between the phonetic materiality of language and its discursive forces.[124] The same might be said for bling and its form and content on backdrops, which artists represent through both images of extreme wealth and the material facture of light. While each of these backdrops is different, all represent light in its various modes of affect, from bling to shine and all the reflective states in between.

Photographers further enhance the luminosity of backdrops by liter-

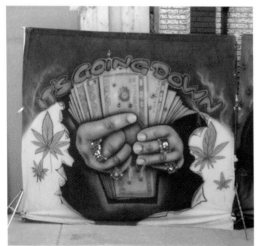

1.42. Perry's street photography studio, New Orleans, 2009. Photo by author.

1.43. Eddie Robinson's street photography studio, New Orleans, 2009. Photo by author.

1.44. Backdrop of Shine by W. Jackson, New Orleans, 2009. Photo by author.

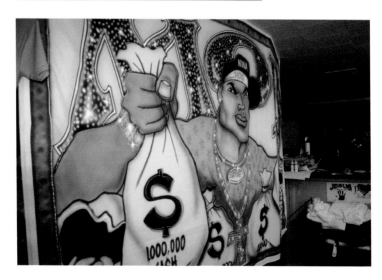

ally illuminating them. Studios are most popular at night, when stark white lights provide an unflinching visibility. The whiteness of the light gives the studios a spectacular charge. At times clients hold up their jewelry to capture the light, creating a visual symmetry between the objects pictured and the way they are represented. Davis recalled a young man who positioned his "Christian bling," a pendant with Christian iconography on his chain, so that it caught and directed light at the camera.[125]

This interest in the visual economy of light stems less from a conscious desire to display light than from an acute awareness of the visual means through which prestige and power are visualized in a consumer-oriented society. The focus on shine in contemporary black urban culture may represent a keen, watchful, Afro-modern perspective on all that glitters, on the sites and objects that represent status. Hawkins's close study of the light from car advertisements may also be considered as one example of this attention to how consumer products come to be represented as valuable—how the bounce of light and other visual effects create this impression.

This interest in shine may be interpreted in different ways. On its surface, participants in street photography seem complicit in the spectacle of consumer culture to the point where physical objects matter less than the effects they produce. Specifically, they represent the massive penetration of the society of the spectacle that Guy Debord critiqued, in which reality and human relations are thoroughly mediated by representations, through spectacles.[126] Attentiveness to light might be viewed as buying into the conditions of the society of the spectacle, which has had detrimental effects on black communities in particular. In Gilroy's estimation, for example, this penetration has blinded black communities to real and meaningful modes of social and political participation.[127] The spectacle contributes to a false sense of status through riches that can be displayed rather than *wealth*, which can lift up black communities. Cornel West argues that the saturation of market forces and moralities has shattered black civil society and produced a generation seduced by images and the momentary "personal pleasure and bodily stimulation" they appear to offer.[128] Such pleasure, which seems to be epitomized in the moment of visual stimulation produced by bling, has "little to do with the past and views the future as no more than a repetition of a hedonistically driven present."[129] Bling might be perceived as a mirage created at the horizon of consumer culture that has railroaded the aims and possibilities of politics in the twenty-first century.[130]

That prisons and correctional institutions across the United States use backdrops in visitor waiting rooms speaks to this issue. Little research has been published on the use of backdrops in prisons, so their relationship to street photography is not clear. Some visual similarities exist between the subjects on the backdrops, which range from painterly representations of bucolic landscapes to dazzling cityscapes with bling-bling and other landscapes that represent "fantasies of freedom."[131] Street photographers suggested that some of the "tough guy" poses in street photography, particularly the pose in which a man crouches down with one knee bent and flashes a sign at the photographer, come from the poses popular among prisoners.[132] Intriguingly, prison backdrops, which are created by inmates, offer the only opportunities for prisoners to take photographs of themselves.[133] These backdrops cover over the actual physical interior of the prison, a space often hidden from view. In other words, the prison-industrial complex becomes another infrastructure of segregation that retreats from societal visibility. Prison backdrops deserve their own separate consideration and will not be further explored here, but they represent the shadow archive of street photographs, which stridently announce visibility and presence in the public sphere.

Conversely, one could make the case that bling is an example of "out fetishizing the fetish," to use Michael Taussig's words: creating systems of value and economies that exceed the spectacle of consumer culture in which value is unmoored from the exchange value of consumer products.[134] Participants in the backdrops and the visual economy of light constitute a distinct type of viewer in contemporary consumer culture. Traditionally, scholars have characterized spectators in late capitalism as passive subjects seduced by the simulacrum of the spectacle, immobilized "before an appearance in a state of ignorance about the process of production of this appearance and about the reality it conceals." But the visual economy of light demands an alertness to how the spectacle produces its simulated reality—how advertisements create their reality effect.[135] This economy facilitates a type of visual literacy that helps individuals decode how objects are invested with value and how prestige might be effected by other means, whether mirrors, lights, or the process of picture-taking. This genre, in which spectators can become actors, suggests that street photographs are closer to ideals of engaged and participatory spectatorship evident in some forms of theater. Clients and photographers become what Jacques Rancière describes as "active interpreters" who choose backdrops that are about the fantasy

of consumer culture, who move from spectator to creator, who shift between "those who act and those who look," who use the studio environment to create and expand community.[136]

Street Photography and the Reality Effect

The preference of photographers and clients for painted backdrops also privileges and makes visible the illusory effects of photographic representation. Clients create photographs that call attention to the constructed and even fantastic character of the medium. If photographers used only green-screen technology or software to make these photographs, viewers might be less attentive to the representational means that create an indexical effect through photography. In addition, the subjects that artists paint reinforce this sense of counter-realism, from the depiction of consumer products that are impossibly large to the familiar landscapes in which they are set. That some backdrops (aimed at children) depict Disneyland further confirms that backdrops are fantastic environments known and recognized as such. The emphasis on the pose, too, highlights notions of artifice. As Appadurai points out, pose has dual meanings: "posture as deception and posture as stance." The process of posing before backdrops, central in club photography, provides an interesting additional key to understanding how backdrops constitute a culturally variable counter-realism.[137] By drawing attention to the seams between background and foreground, between the painterly imagination and the photographic one, between indexicality and fantasy, street photographers turn viewers into active participants and interpreters of representation who are alert to how images create their effects.

The fact that some backdrop artists draw on the pictorial worlds of science fiction underscores how street photographers play with notions of the real. Hawkins, for instance, was inspired by the well-known work of science-fiction and fantasy artists Boris Vallego and Frank Frazetta, who from the 1950s through the 1980s created popular paperback covers, comics, and posters.[138] Frazetta's action-packed, arresting, and often nocturnal scenes of other worlds served as a source for Hawkins's landscape settings and light effects. Green, too, turned to science fiction as a source for his landscapes, citing Vallego's rendering of light and shadow. Given these sources, backdrops may be interpreted as versions of the alternate realities conjured through science-fiction illustrations. The genre of science fiction is often interpreted as a realm where

"metaphor becomes literal"—where phrases like "she lost her head" enter the realm of plausibility.[139] Such understandings of how science fiction transforms notions of the real may be applied to backdrops that draw on these sources. Indeed, the representation of light in these backdrops might not simply represent an imaginary counter-realm of value or prestige, but might constitute a shifted space-time where the depicted subject matter enters into a different realm of possibility. What I am trying to suggest is that not only do backdrops reflect a visual economy in which light has value but also their settings bring into being landscapes that reconfigure the terms on which we understand the real and the fantastic.

In contrast to those who see backdrops as prototypes of virtual realities, street photographs deny the ways that virtual reality might be constructed digitally. They insist that if sights and moments take visual form, they do so through material means that are not immediately translatable into digital modes of representation. In other words, they reject several means by which photographs achieve the effect of realness. This concept may be understood in light of Kara Keeling's arguments about what new-media scholars identify as the "identity crisis" of photography after digital technology: the perception that cinema no longer represents a prefilmic reality.[140] She maintains that long before the digital era, black spectators critiqued the fact that the images of blacks that appeared on the cinematic screen had no corresponding prefilmic reality. Her observations highlight a longer history in which black subjects troubled the relation between visual technologies and prefilmic or prephotographic realities and had an interest in destabilizing any indexical reading of cinema and photography. Street photographs do similar work by existing within, emphasizing, exploiting, and exacerbating the identity crisis of photography.[141]

One of the backdrops Nelson produced for his *Backdrop Project* calls attention to how backdrops trouble notions of the real. This backdrop features a painted image of realist painter Gustave Courbet's *Stone Breakers* (1850) (fig. 1.45). Nelson chose a work by Courbet, who created some of the earliest monumental paintings of working-class subjects in French art, because to him backdrops were potent larger-than-life sites for representing black working-class people. He underscored the artifice of realism by presenting a very painterly rendition of *The Stone Breakers*, in which the means by which Courbet created the "reality effect" in his painting are disrupted by Nelson's use of drips of paint, planes of unblended color, and evidence of the two-dimensional support of the

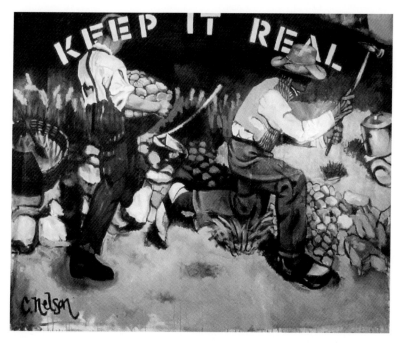

1.45. Charles H. Nelson, *Keep It Real*, [1999–2009]. 8 × 8 ft. Acrylic on canvas. Courtesy of the family of Charles H. Nelson, Jr.

canvas.[142] In addition, he framed the painting with the hip-hop mantra "Keep It Real." As Jackson has remarked, "Hip hop's preoccupation with realness is predicated upon deep-seated doubts about what usually passes for real, skepticism toward social performances/presentations offered up as indexical links to realness. If anything, hip hop reads the real upside down . . . : bad means good, cold means hot, and new world orders are anything but."[143] Nelson's backdrop effectively foregrounds this preoccupation.

Perhaps its most radical destabilization of the photographic and refusal of its indexical possibilities and of the visual production of the real is the emphasis on the pose and the viewership of posing, which eschews the material formation of the photograph altogether. Indeed, in addition to not taking stock in digital modes of representation, the street photograph facilitates the generation of representation outside of pigment, pixels, outside of physical representation. The emphasis on the moment of visibility, of being seen, of emblazoned visibility, functions as its own form of representation, shedding a physical armature and becoming an image, an afterimage, in the body's memory.

Given street photography's newly configured terrains of the real and fantastic, I would like to return to Hanchard's notion of Afro-modernity and its relation to notions of temporality. For Hanchard, African diasporic communities, in response to their conscription into the time-structures of the West since slavery, often forge a political community and collective identity through shared notions of time that "exist autonomously from (albeit contemporaneously with) the temporality of their former masters."[144] Through their material and ephemeral forms, street photographs become shared means of evoking different time periods and senses of temporality and of negotiating time's inevitable passage.

Street photographers and backdrop painters call attention to notions of time in their insistence that backdrops represent objects from the future—that they visualize things that have not yet been imagined. These artists continually anticipate the next fashionable product or lyric for the backdrops because success in the business depends on being ahead of the next trend. They constantly exchange backdrops with other photographers in different locations to keep them fresh. By traversing geographies, they seek to keep ahead of time.

That some backdrop artists turn to the pages of science fiction further reveals how backdrops engage with different times and futures. The world of science fiction often conjures futuristic places and times. Afro-futurism is a term used to describe literary, musical, and artistic forms of an "African-American signification that appropriates images of technology and a prosthetically-enhanced future" despite histories that challenge reconstructions of the past.[145] Afro-futurist worlds imaginatively brought into being through science fiction often construct a sense of displacement, alienation, or "out of placeness"—conditions familiar to blacks in the Americas. As Greg Tate puts it, "Black people live the estrangement that science fiction writers imagine."[146] Backdrops allow clients across urban locations to inhabit Afro-futurist settings and to assume roles as protagonists in other landscapes, made present in a changed time and space, which is brought into being through the backdrops.

Today clients may see street photographs as vestiges of the past associated with the visual tinge of a faded era or with a photograph bearing the sun-bleached effects of time's passage. Specifically, the Polaroid may invoke the 1970s, when it reached its height of popularity. Advertisements in newspapers with black readerships featured snapshots of friends and family leaning into the frame and urged black consumers:

1.46. Ronnie Kelly's street photography studio, New Orleans, 2009. Photo by author.

"The next time the group is making a great scene, get it together on film."[147] Through these early promotions, the Polaroid might be associated with postsoul ideals about black communities that existed before the political, social, and cultural shifts of the postindustrial era. In other words, the Polaroid, and even the bodily memory associated with posing with friends and family, of constituting community before the camera's lens, harks back to the 1970s: it is the picture of the moment associated with that moment. Further, the Polaroid brand may continue to be associated with a form of black revolutionary politics that seemed possible in the 1970s, an era when black subjects imagined and agitated for new opportunities and futures. Street photographs simultaneously mark a return to and departure from the moment of imaginative futures. One example of this shift is a 2009 backdrop featuring newly elected president Barack Obama alongside Martin Luther King Jr.; it bears the words "A Dream Come True" (fig. 1.46). While this pairing occurred across different media, from lacquered plaques to T-shirts, on the backdrops the

1.47. Sthaddeus Terrell, funerary backdrop, New Orleans, n.d.
Photographic print, 10 × 8 in. Courtesy of the photographer.

juxtaposition not only speaks to broad expectations that Obama ful-
filled King's legacy, but spotlights how backdrops involve temporal re-
turns to the imagined futures of the civil rights and black nationalist
eras. Backdrops and Polaroids facilitate shifting temporal terrains that
open the doors between fantasy and reality and past and present.

Finally, another contemporary use of painted backdrops draws at-
tention to themes of temporality and mortality. Some photographers
use backdrops as memorials at funerals, particularly in New Orleans
(fig. 1.47). Photographers and artists create backdrops featuring painted
likenesses or symbols of individuals who have recently died—that are
not photographic likenesses of the deceased but painted iconic repre-
sentations instead. Friends and family take photographs in front of
these backdrops at gatherings after funerals. In this respect, backdrops
have become incorporated into more long-standing traditions for bury-
ing and memorializing the dead. Indeed, Terrell has begun to serve as
a community archivist for families seeking photographs of loved ones

for the purpose of creating backdrop murals and other commemorative images.[148]

Through these new uses, the genre of street photography, which highlights visibility and emblazoned appearance, simultaneously marks disappearance and death. Funerary backdrops bring us full circle to the notions of mortality that Nelson foregrounded in *Real Niggas Don't Die*, highlighting how the flash of bling and the performance of visibility for the camera are about much more than spectacle. These ephemeral photographic forms are metaphors of death or the often too-short lives of black urban subjects. The insistence on performing visibility involves the creation of an indelible future image, one not bound to material structures of photography that can fade away. Street photographs emblazon images in the memories of clients and viewers that can transcend time. Backdrops enable memory by facilitating the remembering of the past experiences of taking photographs with the deceased and the forms of community brought into being thereby. Through memorial backdrops, those who have died continue to be included in the process of picture-taking and -viewing. In this respect, the genre of street photography itself produces embodied memories that include and extend beyond the deceased's moments and simultaneously invoke the instant of the photograph's creation, the past, and the future.

2

VIDEO LIGHT

Dancehall and the Aesthetics
of Spectacular Un-visibility in Jamaica

Does the blindness held in the aversion of the eye create an insight that is manifest as a magnification or intensification of the object—as if memory as affect and the affect that forges distorted or intensified memory cascade off one another, each multiplying the other's force?
—**Fred Moten**, *In the Break* (2003)

What determines me, at the most profound level, in the visible, is the gaze that is outside. It is through the gaze that I enter light and it is from the gaze that I receive its effects. Hence it comes about that the gaze is the instrument through which light is embodied and through which . . . I am *photographed*.
—**Jacques Lacan**, *Four Fundamental Concepts of Psychoanalysis* (1978)

In the late 1980s, Jack Sowah (Courtney Cousins), a local videographer working in Kingston, Jamaica, popularized the video camera and accompanying television screens in the space of the island's main urban entertainment venues, its dancehalls.[1] Sowah did not simply videotape the proceedings in these sites; the bright glare from his camera's light as it moved fluidly around the arena dramatically transformed the experience of the space, making the music-centered events increasingly about visual spectacle. This technology became widely known locally as *video light*, which refers quite literally to the light that some videographers mount on top of their handheld video cameras. A distinguishing feature of video light is that, because videographers do not use filters or diffusers on their lights, its visual texture is harsh and burning white. The camera scopes around the venue, at times moving in synergy with the music, casting its bright light on dancers and spectators. Video light also encompasses a broader set of related performative and representational practices, social interactions and transactions, through which dancehall attendees seek to achieve visibility and transformation

2.1. Video light at Wedi Wedi dancehall, Kingston, Jamaica, June 2010. Photo by author.

2.2. Dancers before a videographer and in front of a screen at Wedi Wedi dancehall, Kingston, Jamaica, June 2010. Photo by author.

through the state of lightedness. Since the 1990s, reaching new heights of popularity in the early 2000s, numerous videographers have replicated the video light. Performers vie to be illuminated by the camera's bright white light, which can be seen and felt as it saturates the visual senses of congregants (fig. 2.1). Sometimes a closed-circuit system projects what comes into the light of the video camera within screens placed within the dancehalls (fig. 2.2). Video light, I maintain, has been intrinsic to the creation of a sense of community among dancehall participants through the modes of seeing and of blindness that it produces and makes visible.

This chapter offers a history of this visual technology, which is one of the most widespread forms of visual representation in Jamaica's urban communities and its diaspora. I will look at the development of this genre, concentrating in part on Sowah. He was central in the popularization of video light and has uniquely used the video camera in the dancehalls for over thirty years. This chapter also explores a history of local approaches to the camera that might be pertinent to understanding how the video camera was taken up in dancehalls from the

late 1990s. I call attention too to some of the various businesses, markets, and networks through which images produced through video light travel (or are imagined to circulate), as well as the ways different participants come to see their own social and economic mobility as possible through the momentary capture by the video light or the subsequent circulation of their images as DVDs or through the Internet. For many participants, the light of the camera represents or seems to assure a virtual audience. It becomes a material and ephemeral means through which dancehall participants seek to constitute a national, diasporic, and global community.

The recent rise in the practice of skin bleaching among women and men in Kingston's dancehalls, I postulate, is related in part to video light. While skin bleaching had occurred in Jamaica and other geographic locations before this time, it became prevalent in the space of the dancehalls precisely as male performers began to seek the attention of videographers in the early part of the twenty-first century.[2] This controversial practice, in which dancehall participants make their faces and other exposed parts of their bodies lighter and light sensitive through chemical means, stems in part from an effort to be more visible in the scope of the video light, to be rendered legible through videographic technologies and technologies of light.[3] Skin bleaching, I suggest, makes the effect of being in the light of the camera semipermanently visible on the skin of dancehall participants.[4] It is an embodied way of taking the visibility, un-visibility, and status afforded one in the dancehall into the broader black public sphere and into practices of everyday life. In this way the dancehall participants who bleach their skin make their bodies into photographic surfaces, which manipulate the reflection and absorption of light. Their practices might be viewed as responses to the ways light complexions have been privileged historically in Jamaican society and more broadly and the way social hierarchies based on skin color have been reinforced and reproduced through photographic and videographic technologies. As such, skin bleaching may be interpreted as another visual technology that intercedes into and literally reflects and records histories where photography and race intersect, while remaking and relocating the material constitution of the photograph. These practices also destabilize notions of the skin as an index of race.[5] Through skin bleaching, the "skin" of video (the material and multisensorial experience of film) and the flesh of black urban subjects come into intimate proximity.[6]

Bleached skin, the body's surface that is permanently "lit up," may be

understood as a contemporary manifestation of long-standing efforts by Jamaica's urban classes to have their rights as citizens recognized through appeals to the camera. Since at least the 1970s, protesters from the island's black communities have often sought redress by taking up residence at local television stations, where they have waited for cameramen to enable them to air their grievances.[7] Indeed, I suggest that public visibility through visual media—through one's appearance on-screen—has become a sought-after way of asserting one's right as a citizen. Video light and skin bleaching are expressions that relate to these social practices of seeking visibility and recognition as citizens in black public spheres in Jamaica and beyond it through appeals to the camera. It is a practice in which the desire to be seen through video technologies and the exposure of the body to the camera appear to coalesce. The media of photographic representation and of the skin's surface collapse, and this happens in distinctly gendered ways. Or we might say they bixelate, to return to the notion of blackness and the pixel or the substance of representation combining. This chapter explores the multiple effects and affect of these strategies. These expressions simultaneously aid and impede the possibilities of legibility within postcolonial Jamaican society and globally.

This chapter also examines the work of Jamaican-born artist and US-based university art professor Ebony G. Patterson, who since 2007 has addressed the subject of skin bleaching in her paintings, photographs, and multimedia work. I concentrate on Patterson's large-scale photo-based mixed-media tapestries, which feature male subjects posed in a photographic studio (fig. 2.3). The young men are shown dressed in fashions inspired by dancehall's eye-catching sartorial displays. Patterson has emphasized skin bleaching by portraying these costumed figures with faces lightened by makeup or covered in glitter. She then has had the photographs made into textiles and has embellished them with rhinestones, glitter, and sequins. The pieces call attention to and re-create different reflective surfaces, from the surface of things and bodies, as they are pictured in and constituted materially on the surface of her art. Through an exploration of Patterson's photographic tapestries, the complexities of skin bleaching, and expressions of visibility in dancehall culture in postcolonial Jamaica more broadly, will further come to the fore.

I will consider Patterson's series because it offers critical reflection on dancehall and its representation in public discourse and is a part of the visual economy, proliferation of images, and consumer culture that

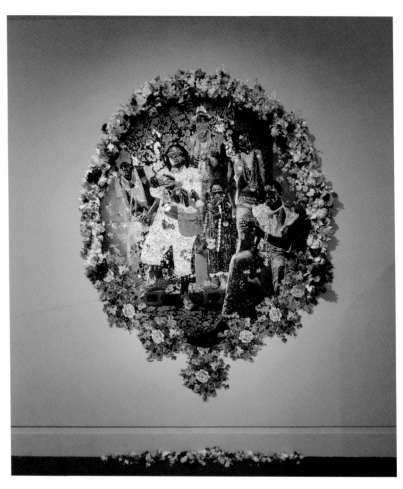

2.3. Ebony G. Patterson, *Wi Oh So Clean*, from *The Fambily Series (Revisited)*, installation in the exhibit *Contemporary Jamaican Art*, c. 1962 / c. 2012, Art Gallery of Mississauga, Mississauga, Ontario. Mixed-media photo tapestry, approx. 8 × 9 ft. Collection of National Gallery of Jamaica. Courtesy of the artist and Monique Meloche Gallery.

surround the genre. Indeed Patterson's work has become one prominent means through which the subject of bleaching and dancehall has been foregrounded in Jamaica and in the international circuits and markets where her much-celebrated dancehall-inspired work has traveled. The artwork emphasizes the aesthetic characteristics of dancehall culture, offering a counterpoint to the mainstream media's coverage of dancehall, which often deems it as outside of or a corruption of the realm of art and culture. Her work also highlights how, despite efforts by participants in dancehall for recognition, predominant social configurations of race, class, and gender continue to impede their visibility among the mixed-race brown political and mercantile elite in contemporary Jamaican society.[8] The aesthetic practices in the dancehall, as presented in Patterson's tapestries, negotiate the states of un-visibility, the status of being hypervisible yet unseen by the middle classes, and create spectacular dazzling presences among different communities of dancehall viewers.

I will begin with a historical outline of dancehall over the last thirty years, detailing when the camera entered and transformed its space and cultural practices. I explore how Patterson's work highlights the aesthetic practices and approaches to the camera and visuality that are evident in the dancehalls. I will then consider some of the responses to dancehall and video light in the local press and by authorities. I argue that the practices surrounding video light in the dancehalls call attention to the processes of seeing and being seen within local and transnational communities, in contradistinction to the Jamaican media's descriptions of dancehall that often overlook these forms, viewing them as the antithesis of a productive Jamaican society. Dancehall is constantly obscured by media and scholarly accounts that frame it as representing the vacancy of the ideals of nation, race, and sexual propriety and of the notions of modern citizenship and the political that have come into being since the anticolonial movements in Jamaica in the 1930s and 1940s. These visual technologies and photographic practices in the dancehalls create networks and visual economies that extend beyond those made available by the state. The chapter ends by asking: What are the possibilities of the political in the era of video light? How might the camera confer what Paul Gilroy characterizes as "dimensions of citizenship," as well as forms of belonging and self-representation in and across African diasporic communities, that formal political institutions and structures fail to fulfill?[9]

"Dancehall" refers to entertainment spaces within urban communities in Jamaica and the forms of music, dance, and sartorial styles that these social groups cultivate and produce. "It is at once a venue (where the popular is constituted and performed) and a style of (sartorial and linguistic) self-fashioning," as David Scott succinctly describes it.[10] Numerous dancehalls take place in a variety of spaces every night in communities surrounding the Kingston Metropolitan Area (which includes the parishes of Kingston and St. Andrew) and around the country. Many of them occur on neighborhood streets that dancehall participants repurpose, using a tower of speakers and turntables (fig. 2.4). These participants reconfigure public space through soundscapes that are transient. The dancehall known as Passa Passa, which was held on Wednesdays from midnight to early morning in the West Kingston garrison of Tivoli Gardens, famously took place on Spanish Town Road, which led into a farmers' market.[11] Dancers would literally make way for the vehicles going to market or incorporate them into their performances. In such instances, older modes of production in the island's economy—in this case the farmers' market—ran into the new informal economies that surrounded these dance venues. The dancehalls provide a platform for an estimated US$31–35 million industry in which sound system operators, selectors, artistes, DJs, dancers, dancehall queens, vendors, alcoholic beverage suppliers, corporate sponsors, photographers, and more recently videographers all have stakes.[12]

Dancehall has been a part of the Jamaican landscape since at least the 1950s and 1960s, when a form of toasting or talking over music generated in sound systems began.[13] These spaces resounded with the musical genres of mento, ska, dub, rocksteady, and roots rock reggae throughout the 1960s and 1970s. It was in 1981 when a form of music that came to be labeled dancehall emerged. The albino Yellowman (Winston Foster) popularized this new genre, introducing a form of music that used computer-based digital technologies to mix one digital rhythm with different voices to produce what is called a sleng teng rhythm.[14] He overlaid the music with brash lyrics about his sexual prowess and material possessions. (Yellowman's status as an albino in a society in which skin color is central to social status—as I will discuss—is intriguing, given the subsequent rise in skin bleaching years later.)[15] Shabba Ranks (Rexton Gordon) and Ninjaman (Don Gorgon) rose to prominence in the

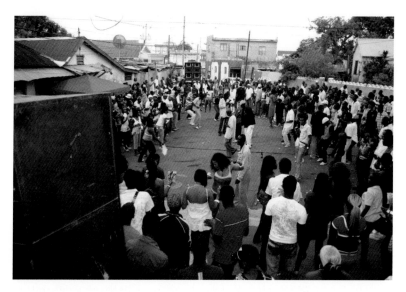

2.4. Dutty Fridaze dancehall, May Pen, Jamaica, August 2007. Photo by author.

1980s and eventually significantly contributed to dancehall's chart-topping crossover in the United States by the early 1990s. But what I want to emphasize is that Yellowman, Ranks, Ninjaman, and the dancehall music of the 1980s spoke to an era when material gain and gun talk were celebrated in the spaces of the dancehall.[16] Male dancehall DJs often reinforced their masculine personas through boasts about their sexual conquests of women or appeals to homophobia.

One might describe the music and public personas associated with dancehall as focused on an aesthetics of the surface, on lyrics that spoke explicitly about sex and sexuality, on status based on the display and appearance of consumer goods, on music that expressed the harsh material conditions and corporeal existence of life as negotiated within inner cities in Jamaica two full decades after the island's independence in 1962.[17] The music and modes of self-fashioning enunciated the desires of a new generation of black modern subjects, who celebrated individualism, consumerism, and "slackness," an overt approach to sexuality that ignored middle-class rules of decorum.[18] The black nationalist, Rastafarian-leaning, anti-imperial, and politically conscious expressions that had often been identified with roots rock reggae music and Bob Marley (who died in 1981) a generation earlier appeared to give way to the promotion of social status through things. This "decline of radical reggae" has been lamented locally and among theorists of the African

diaspora, such as Paul Gilroy, because of its lack of an anticolonial, anti-capitalist, and black radical politics.[19]

Dancehall emerged in the 1980s in Jamaica at a time of political, social, and economic change. In 1980, the neoliberal Jamaica Labour Party came to power, effectively ending prime minister Michael Manley's social democratic and anti-imperialist policies of the 1970s. After an election campaign marred by sectarian and political violence (which led to a death toll of between 980 and 1,000 people), the party intensified the implementation of structural adjustment policies mandated by the International Monetary Fund and removed many restrictions on imports and foreign trade, opening up the island's market to global capital. Under the Jamaican Labour Party (until it was voted out of office in 1989) the country's already crippled economy saw the cost of living and unemployment in the formal sector increase and government spending on transportation, health, and education contract. The informal sector, which was given economic force by the various income-generating opportunities created through dancehalls, expanded.

The fascination with consumer culture in the dancehalls seems in line with the changing neoliberal landscape of the island and other parts of world in the 1980s and early 1990s. Black urban musicians, dancers, profilers, and spectators in the dancehalls often turned their bodies into sites of display for the latest fashions and consumer goods, from the latest brand-name clothes to the most opulent accessories. The newly opened markets and local women known as informal commercial importers facilitated the increased circulation of goods from the United States, which in part inspired aesthetic expressions in the dancehalls. Women's fashions ranged from the heavily adorned to the scantily clad, a dressing by revealing parts of the body's surface.[20] From mesh tops to patches of stretched spandex, from transparent leggings to gold jewelry, women foregrounded a particular aesthetic preference: it was, as Bibi Bakare-Yusuf describes it, in "the surface of adornment that the creative subjectivity and agency of women at the core of the phenomenon can be understood."[21] These sartorial expressions presage an emphasis on surfaces in dancehall, whether the surface of the skin, flashy fashions, or screens.

Women from Jamaica's urban communities were central in the performances of dancehall in the 1980s through the early 1990s. They often arrived at the venues together, formed their own performance circles, and constituted a semiautonomous community among other dancehall attendees.[22] Men could be partners within the dancehall spaces, but they

seldom occupied the center of the performance stages. Dancehall queen competitions—immortalized in the film *Dancehall Queen* in 1997—were other popular events where women occupied the center stage.[23]

From "Picture Man" to Video Cameramen:
Visual Technology and Dancehall Culture

The still photographer, called the "picture man," captured these earliest scenes in the dancehalls in the 1980s.[24] Two picture men who worked in the venues at this moment were known as Sonny and Photo Morris.[25] These photographers roamed the spaces of the dancehalls offering attendees Polaroid pictures, and eventually digital photographs, of themselves. In the transitory spaces of the dancehalls, where people constantly refashioned their public personas, these photographs offered visual records for personal collections.[26] These images could also have public lives as posters used to advertise upcoming events across the urban landscape (fig. 2.5).[27] The process of posing for the camera likely formalized an aspect of the dancehalls that would become increasingly central. Dancehalls were becoming "stand halls" and "fashion shows," as people invested much labor and expense into presenting themselves to be seen.[28]

In the late 1980s, three men, Devon Clark, Victor Johnson, and Jack Sowah, began to use video cameras in the dancehalls.[29] They worked at first as freelance videographers, recording the goings-on in the entertainment spaces. Sowah, a self-taught videographer, never used a still camera. Rather, he came to videography after working as a maker and distributor of audiocassette recordings. He viewed the video camera as a means to extend and transform the circulation of dancehall music in the analog sound recording tradition, which has long been intrinsic in the formation of African diasporic communities.[30] His first camera was an 8mm video camera given to him by Bunny Wailer, a stalwart of the island's reggae era. Sowah's recollection of his introduction to the video camera is interesting, given that critics often cast dancehall as antithetical to reggae music.

Sowah formalized his work in the dancehalls with the creation of his business, Sowah Productions, in 1996. By the mid-1990s, he was one of an increasing number of invariably male videographers—including Night Rider and Scrappy—who worked in these venues. The video recordings, recalls Night Rider, offered a means "to remember it [the dance], how wonderful it was," and represented a "hype thing."[31] The

2.5. Poster advertising stage show in Santa Cruz, Portmore, Jamaica, 2009. Photo by author.

very presence of the camera made "everybody start feeling the hype," signaling to partygoers that they were at an event worthy of remembering and representing. The tapes promoted future dancehall events.

Sowah notes that the demand for VHS videotapes took off in the early 1990s in part because of interest in the dancer known as Bogle (Gerald Levy).[32] Bogle became the first male performer in the dancehalls to create a name for himself locally and globally on the basis of his innovative dance moves (fig. 2.6). Dancers continue to view video cameras as an important means of circulating and copyrighting new dances.[33] The reigning dancehall queens, such as Carlene, also increased the clientele for the dancehall videos.[34]

In the beginning, the video camera was "just associated with the innocence of dancing," the dancer Keiva recalls.[35] Videographers would roam around the space, fixing momentarily on talented dancers and dressers. They created videos that looked partly like community documentaries of participants in the space and partly like music videos.[36] But these early tapes also came to be sought after for their more salacious

2.6. Jack Sowah Video Productions, video still of dancehall dancer Bogle at Fiesta La Roose, Kingston, Jamaica, 2000. DVD of Fiesta La Roose. Courtesy of Jack Sowah.

subject matter. Some women seeking to attract the attention of videographers started to perform in sexually provocative ways, sometimes flashing—revealing breasts, buttocks, and crotches—for the cameras.[37] The tapes resulting from such responses to the camera often centered around, as Night Rider put it, "the hot part . . . when girls are brukkin out and going on."[38] Rider interestingly described this practice of exposing as much of the body as possible through sexualized performances as "skinless" or "skinout."[39] The word "skinless" in particular suggests that the camera penetrates beyond the skin. It implies a maximum exposure, openness for the camera, an aperture produced through the body, which affords visual access beyond the surface. The sometimes close-up views of women's bodies seem to fetishize the fetishization of the female body, which in these videotapes can appear excessively visible and seem nothing but seen. At the same time, the camera can allow a gaze so near that the body can appear abstract and too close to be viewed.

These sexualized performances and their staging for the camera by black urban women have been interpreted and debated by a number of scholars. Often-cited academic Carolyn Cooper maintains, for one, that the performances offered "a radical, underground confrontation with the patriarchal gender ideology and the pious morality of fundamentalist Jamaican society."[40] For the urban females to flaunt their bodies, to present themselves for a starring role on camera, disrupted long-standing societal ideals in Jamaica that privileged "a white look: slender, restrained, calm, long flowing (straightened) hair and light or brown skin."[41] Some scholars frame these practices as liberatory or as fashioning "personal tools of liberation and avenues towards obtaining personal freedom."[42] They highlight, too, the limits of such "eman-

cipatory" strategies, which appear to reproduce ways of seeing women as sexual objects and to confirm existing gender hierarchies.[43] These academics make different claims regarding the agency, pleasure, and play women take from and create through their actions and point to the complex and changing gazes of men and women of different classes both in and beyond dancehalls. All these dynamics are at play simultaneously in the venues.[44] For the moment I want to underscore something not analyzed at length in existing literature: that what united and mediated these skinless or skinout practices was their execution by means of the video camera. Early on, the camera functioned in gendered ways, with male videographers focusing on women. These female performances for the camera simultaneously seemed to defy and embody, to reflect and deflect, societal norms surrounding skin color, class, and femininity.

The VHS videos that featured Bogle, dancehall queens, and other dancers circulated widely in the 1990s. Indeed Sowah credits his videos with "exporting" local dancehall participants "to the world."[45] "If videolight don't touch him," Sowah muses about Bogle, "he'd still be nobody."[46] Videographers peddled the tapes on roadsides in Jamaica. Sowah initially sold his videos, for instance, in Mandela Park. On the morning following the dance Sowah promptly couriered the tapes to businesses and emcees in different cities, including JDs in Toronto and Moodies Records in New York.[47] Beth-Sarah Wright, one of the few scholars to examine the videotapes of dancehalls, describes encountering the footage of the dances in Brooklyn, where they were played on the outdoor screens of a music store.[48] Through these sources, dance venues in Kingston gained public visibility on the streets of Brooklyn. Videographers also distributed the tapes in other cities, especially those with a substantial population of Jamaicans, such as Miami, Nassau, and Brixton, England.[49] Jamaicans living abroad who came to town for several days to attend the dancehalls provided another means through which the footage circulated quickly transnationally, Sowah highlights.[50] Dancehall events in Jamaica could be available for visual consumption in several cities within twenty-four hours, before the widespread use of the Internet and digital technologies.[51] These tapes in their heyday in the 1990s cost approximately $1,500–$2,000 in Jamaican dollars, but by 2011 they could be found locally for as little as $50.[52]

The Internet later provided another medium through which the proceedings of the dancehall circulated globally. Websites, such as www.dancehallreggae.com or www.Dancehalltv.com, developed in the late

1990s. They catered to Jamaicans living abroad, offering them a view of the latest trends in the dancehalls.[53] The footage also provided a way for resident Jamaicans to send images of themselves and shout-outs to relatives elsewhere. These websites, explains Felicia Greenlee (who spent decades around the business of video light), allowed "people who were illiterate, who can't read or write on a postcard, to send images abroad."[54] Sometimes unauthorized persons distributed the dancehall recordings online, profiting from the footage. Sowah, for one, had someone copy and sell his collection of tapes of a particular weekly dance on a website, demonstrating how financial profits, whether for the videographers or the subjects of the videos (who were very seldom directly paid), can be elusive. Sonjah Stanley Niahh, writing in 2010, notes that dancehall DVDs also circulate globally and may be purchased in Germany, Brazil, South Africa, Kenya, Canada, and Japan.[55]

As a result of the copying of VHS tapes and more recently their distribution on Internet sites, it has not been uncommon for the community of viewers of dancehall videos to experience footage marked by image deterioration, a visual noise produced through repeated processes of reproduction (fig. 2.6). When dancehall traveled primarily through VHS tapes, it often did so as copies and copies of copies, which at times bore visible traces of their transnational and transgenerational reproduction histories.[56] Such processes continued even after the Internet offered a means of distributing dancehall content. In the early days of the Internet, video footage on the Internet was often compressed. Internet users accessed low-resolution files over slow bandwidths. This had particular repercussions for the viewership of dancehall footage online. As video producer Delano Forbes Jr. explains, heavily compressed files are particularly sensitive to the camera's movement or shaking.[57] The swift movements of the camera that are common when it is used in the dancehalls often did not translate well. The result was pixelation, literal gaps in the translation of the image onto the screen or a skipping of frames—of time, as it was presented in the videos. The very processes and networks that allowed transnational viewership also produced image loss, disruptions in visual translation. This is an example of *bixelation*, the visual modes of practices of diaspora in which emphasis is placed on the composite parts of the image, in this instance on the surface appearance and material makeup of video and its digital reproduction. I call attention to this because the notion of the screen's and the photograph's surface may inform expressive practices, such as skin bleaching, surrounding the camera.

While some of the dancehall videos have active social lives and transnational viewership, for a number of reasons, Sowah explains, "many things [have] never been shown."[58] Certain dons, who sometimes sponsored the dancehalls, would on occasion confiscate Sowah's master tapes and his equipment. Dons are nonelected figures who often govern in garrison communities through a system of patronage and intimidation. In one instance, Sowah's videocassettes were publicly destroyed by one such garrison leader who precisely did not want the footage to have an afterlife, fearing what such community videos might make available to future audiences. Some promoters kept all the videos in their private collections, as was the case with Uptown Mondays dancehall in 2010.[59] One freelance videographer I met at Uptown Mondays in 2010, Josh Chamberlain, also took footage without any immediate intention of distribution.[60] Thus, while the video camera can afford a broader audience through local and transnational circulation, the only audiences that are assured are the videographers and the witnesses to the process of the video camera's spectacular light.

Camera, Screen, and the Emancipated Spectator in the Era of Video Light

By the late 1990s and early 2000s, the videographers had gone from being visual recorders of the dancehalls to even more central instigators of their happenings. Indeed, the term "video light" came into currency to describe the video camera and its interaction with its subjects in these spaces. It is unclear who coined the term "video light," but the dancehall artiste Frisco Kid used it as the title of a popular song he performed in 1996.[61] The term did not gain currency in the local press, however, until around 2002.[62] It was used to characterize the video camera and the illumination from its mounted camera light and was associated with a desire, willingness, and readiness to be seen.[63]

By the early twenty-first century, the ephemeral illumination of the video camera had reoriented the dancehalls. In this period it was common for dancing to take place only after the videographer turned on the light to his camera or after the proceedings seemed activated in the space delineated by the camera's light (fig. 2.7). In the estimation of several dancers, there was "no point of dancing" without the video light.[64] They also thought that videographers had become more indispensable to the dancehalls than DJs. In some spaces, like Uptown Mondays, the video light would be the only source of illumination. While

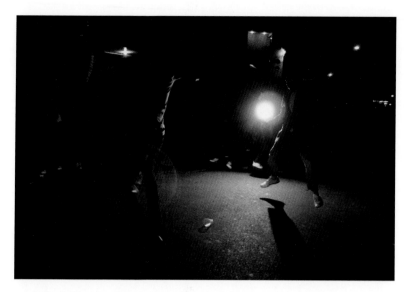

2.7. Video light at Passa Passa dancehall, Tivoli Gardens, Jamaica, 2009.
Photo by author.

in the early 1990s dancehalls had commonly had a single videographer, a decade later they could contain as many of five, who divided the space into different electrified zones.[65] The videographers were typically from Jamaica's urban communities but by the 2000s could be from as far away as Japan.[66] Typically, videographers and still photographers (who continue to have a presence in the venues) would follow the videographer who had the brightest light, trailing after him like a mini-paparazzi following.

The decade of the 2000s was a period marked by fierce competition for the cameraman's attention. Many dancers aimed to debut creative moves to lure the video light (fig. 2.8). On occasion fights broke out between rivals who sought the camera's illumination. The local tabloid the *Jamaica Star* reported on one such incident, involving two women, that wound up before a judge.[67] An informal payola system even existed through which some videographers received contributions (in dollars and pounds) from dancehall attendees seeking the touch of the camera's spotlight.[68] Sowah recalls one dancehall attendee who offered him US$20 every time his camera strayed from him, eventually spending $200 to remain in the light.[69] Many people who crowded before the videographer's camera and before my videographer's lens often addressed or talked into the video light (fig. 2.9). They offered a series of shout-

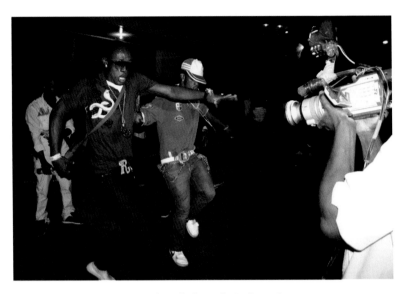

2.8. Video light at Passa Passa dancehall, Tivoli Gardens, Jamaica, 2009.
Photo by author.

outs to audiences far and wide, living and dead, in the present environ-
ment and in the future. The light seemed itself to represent and bring
audiences into being. It also represented elsewhere, locations way be-
yond the island nation. This range of responses highlights how inhabit-
ing the light of the video camera, the luminous moment of videographic
capture, was intrinsic in the dancehalls.

The very term "video light" calls attention to the importance of the
technology of light in the dancehalls. Sowah, when asked what ac-
counted for his popularity as a videographer in the dancehalls, identi-
fied the intensity of his camera's light.[70] He powers his camera's light—a
three-hundred-watt bulb—through electricity. Choosing not to rely on
a battery, this veteran videographer plugs in to ensure the quality, con-
sistency, and longevity of his light. Often the cords from his video cam-
era bifurcate the space, making everyone navigate around his visual
technology. The light from Sowah's video camera and that of many other
dancehall videographers is an electrifying bright white light not tem-
pered by a filter (fig. 2.10). In commercial videography and still portrait
photography, filtering equipment is typically attached to the front of
video camera lights or standing lights to soften and diffuse lightening
and shadows.[71] Without such diffusion, video light is relentless in its
intensity. One journalist aptly described the video light as "a lance of

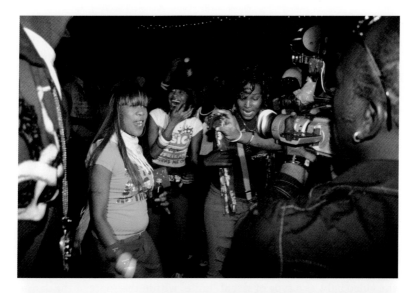

2.9. Video light at Wedi Wedi dancehall, Kingston, Jamaica, June 2010. Photo by author.

2.10. A woman before the video light at Wedi Wedi dancehall, Kingston, Jamaica, June 2010. Photo by author.

bright light . . . [that] cuts the darkness like a white knife."[72] The video light is especially harsh for persons immediately in front of the camera's lens; they can be momentarily blinded as they come into the spotlight. Emitted from a continuously moving camera, this light throws a stark white illumination across the mainly black bodies of dancehall attendees, creating an interplay of brightness and shadows across the often nocturnal environments of the dancehalls. The light unflinchingly saturates the scene, unfiltered, unmediated, unyielding, and uncontrolled. It selectively makes parts of the dancehalls scopically open and available as it sweeps and scopes around the space. As Sowah put it, "The video light catches everything."[73]

Video light is often so intense that it cannot be directly looked at for very long. It demands visual attention, yet it can induce blindness. It creates a form of visual experience that is felt and experienced in the body, sometimes painfully so (as suggested in the description of the video light as a type of visual "knife" within the space of the dancehalls). If the still camera and video camera had previously played a role in recording the activities of the dancehall for the purpose of memory, video light functioned by burnishing images, afterimages, in the body.[74] Laura U. Marks uses the term "the skin of the film" to characterize the way film and video created by artists living in diasporic communities evoke the memory of their cultural experiences through an appeal to the senses or through a haptic visuality, a mode of visual perception that can exceed and extend sight alone to create a sense of touch.[75] She argues that certain transcultural videos and films can produce a form of contact with viewers through the materiality of film, its skin, which can be touched "with one's eyes."[76] Such a description seems an apt characterization of the visual experience of video light, which creates a form of haptic visuality that seems to exceed the sensory limits of sight. Arguably, the blinding brightness of the light, especially when viewers directly encounter it, precisely highlights the limits of visual perception. The intense video light produces a felt or an "embodied experience," to use Marks's words—ephemeral afterimages that live on in the memory of dancehall attendees.[77]

The videos produced in the dancehalls have a particular material character because of the videographers' use of the bright video light, which adds further to the visual noise evident in some dancehall footage. In these videos, light blurs and streaks across their subjects as well as across the screen, affecting the subsequent viewing experience of the footage. This is in part the result of video technologies that are "optimized" to

focus on Caucasian skin. Light-based cameras can flatten darker-skinned complexions because of a narrow chromatic range designed for white skin, a technological constraint whose effects seem to be exacerbated by video light. This is evident in a video still of the La Roose dancehall taken by Sowah in 2000, in which Bogle directly engages the video camera (fig. 2.6). A light from a second video camera appears in the lower left of the darkened frame, registering as an impressionistic stroke of light. Bogle's face reflects the bright lights. It is so saturated with illumination that only the slightest contours of his eyes, nose, and mouth remain decipherable between bixelated planes of white and mauve that represent his skin. His jewelry is the most legible feature of his body. His upper body is captured in blurred movement in the still. The image is but one instance of the distortions, the blurriness, the visual disruptions effected by the video light and video technologies. In the image the skin of the subject and the surface of the video conveyed through light merge.

Another challenge the video light poses to the production of footage is that even more recent digital video technologies have not been calibrated to achieve color balance promptly in conditions when black and white colors appear in close proximity.[78] Such ever-shifting contrasts in light and darkness are often produced through the use of video light. Resultantly, from the moment of production, the video cameras capture black subjects in the dancehalls at night in ways that produce visual distortions and image loss. The strains and the limits of the technology are visually evident in the footage. In the dancehall videos, often "detail is destroyed as realist representation fades into pulsating light," to quote Brian Larkin's words describing pirated videos in Nigeria.[79] Marks's characterization of "the skin of the film" seems literalized in some dancehall footage. The presence of undiffused bright light on black skin of varying hues and the reflection of light from some types of clothing and accessories all draw attention to the multiple surfaces in the dancehall. These shining elements appear across the material surface of the screen on which the footage is viewed.

Another component of video light—one innovated by Sowah—is the use of screens, or what he describes as "live video," to project the camera's view within the space of the dancehalls (fig. 2.11). Sowah recollects that initially he "suffered many embarrassments" because people did not want to be recorded or were annoyed by his bright video light.[80] What was eventually key to the acceptance of and integration of his video's light in the dancehalls, he believes, was his introduction of televisions and later video screens into the venues. Sowah notes that he

2.11. A loose-fitting sheet forms a screen used by Sowah in the Wedi Wedi dancehall, Kingston, Jamaica, August 2011. Photo by author.

would put up two televisions, one near the entrance and another directly across from the selector. It was the combination of the video camera, its light, and the public display of the television screen that led to the popularity and proliferation of video light.

Video light was intrinsic not only in recording and projecting the various spectacular appearances and occurrences in the dancehalls but also, I would maintain, in the creation of a community formed around the experience of seeing, the visualization of the process of seeing and being seen. It allowed many people to experience themselves on television or projected on a larger-than-life screen. Persons before the video light went from feeling themselves being seen within the heat of the video light to almost instantaneously seeing themselves being seen on the screen. The trio of visual technologies offered a doubled sense of one's visual presence as well as a view of a broader network of representation of which dancehall attendees were at the center. It brought a prestige, becoming "a paparazzi thing," as Prince Sowah (Jack Sowah's son and fellow videographer) describes it.[81] The selector, located directly across from the screen, at times offered further verbal affirmation of the person looming large within the screens, "bigging up" that person over the speakers. It made individuals in the dancehalls momentary celebrities and likely offered some people the first opportunity to see themselves represented on television or on a "big screen."

Sowah stresses that the video light did not solely focus on the queens of the dancehall but captured everybody: "It highlight a whole set of people."[82] The street woman Medusa, who became famous in dancehall videotapes and would receive remittances from abroad from people who viewed her in the footage, highlights how video light was in many respects democratic in whom it featured in its frame.[83] The dancer Kendrick Brown (known as Sick in Head) noted too that through the screens, notions of center and periphery were constantly destabilized.[84] The screens made people share the same visual space, often making those on the margins more visible and shifting those in the center of the dance floor to the periphery.

But what is strikingly evident in the screens in the dancehalls is that in addition to providing dancehall-goers with technological confirmation of their visibility, the projected images call attention to the very process of seeing. On the night I met Sowah, for instance, at the dancehall Stone Love before the event reached its height, the videographer from his company scoped around the side of the dance floor's ill-defined perimeter, appraising dancehall attendees one by one. The cameraman literally scanned the woman next to me, who turned her face slightly to the side, simultaneously appearing to ignore and confidently invite the attention of the camera. The camera moved slowly up her body, taking in and showing everything from her stylish shoes to her pierced glossy lips, and then lingered on her face. It then turned to a young man next to her, moving from his alligator boots to the brim of his cowboy hat, which somewhat shielded his face. He did not physically acknowledge the camera, but the second it left him he glanced at the screen, seemingly hoping to catch a glimpse of himself. Just then the selector's voice started to boom over the loudspeakers and the videographer's attention seemed lost. The screen showed an erratic moment of the camera across people, parts of their bodies, the ground, the wall, blurred objects that appeared too close to be rendered legible on the screen. When Sowah arrived and took ownership of the camera, dancers seemed to gravitate toward him and his light and he and it toward them, in part because he is an affable and recognized figure in the dancehalls (fig. 2.12). In his hands the camera was even more mobile and projected a view that moved in response to the sonic experiences of the space.

While the video light often centers on individuals or groups of dancers, a part of what the video camera and screens do is to make the very process of viewing visible to the people in the dancehalls. It makes the process of looking, of scoping out, of selectively focusing in

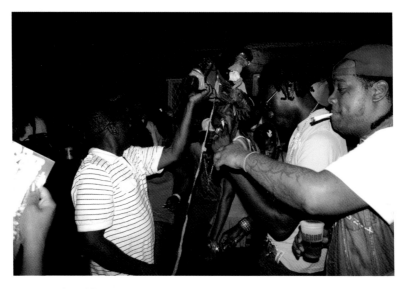

2.12. Sowah and his video camera, Wedi Wedi dancehall, Kingston, Jamaica, August 2011. Photo by author.

or cropping visible in the venues or in the transformed public streets. The bright light from the camera also enhances this awareness of the camera, of the technology of video, by calling attention to the process of seeing through its searing illumination. The makeshift screens, wrought sometimes out of loosely secured plastic, also draw attention to the surface of the projected image. In these ways, the video camera and screen unite dancehall attendees in this active process of looking, inscribing themselves into the simultaneous and constantly changing roles of videographic subject and communal spectator.[85] Rancière's description of the emancipated spectator, coined in his analysis of critical modes of engagement in contemporary art, may have bearing here. Video light produces a mode of "emancipation," which according to Rancière means "the blurring of the boundary between those who act and those who look; between individuals and members of a collective body."[86]

Screens in Public Space in British Colonial and Independence-Era Jamaica

Screens and projection were used in public spaces in Jamaica from 1947, when the British government's Central Film Organization projected educational films—sometimes in the open air—to facilitate "education

by seeing" and to "elicit understanding and willing cooperation."[87] As a correspondent for the *Times British Colonies Review* observed, for "unsophisticated" colonial subjects, the "screen has the prestige of being the first medium of mass communication to become a part of their lives. For them, consequently, literacy and book-learning, however practically useful they may be found, may never have the aura, symbolic of new freedoms, that they had in the West."[88] The earliest of these mobile units (composed of cinema vans, speakers, and silent projectors) in Jamaica showed primarily films from England and Canada.[89] The same journalist recognized, however, that the Colonial Film Unit aimed to encourage local production, to "show the people themselves," to increase the acceptance of the subject matter featured in the films: "The film medium is once and for all accepted as something which touches recognizable and real things."[90] They set up a "training school for local talent" in Jamaica in 1950 to create local documentaries.[91] The Jamaica Film Unit expanded the public screenings across the country, bringing "the experience and spectacle of electric light" to communities that had no electricity.[92] Many of the Film Unit films focused on adult education, as a school report prescribed, without "glamour," "radiant stars," "glittering cars," or "publicity stunts."[93] The Film Unit — through the use of the camera and screen in public space and the aura of electric light — sought to teach better agricultural skills or support public health campaigns all aimed at the cultivation of healthy and illustrious colonial citizens. In other words, the aura and electric charge of the camera and screen in public space predates those of video light, even though in the case of the Film Unit they were employed for the purpose of creating productive colonial subjects.

Another early example of the communal viewing of screens in public spaces in urban Jamaica came at Independence in 1962. The *Gleaner* and the Philips Corporation set up public televisions in Gordon House and television receivers and speakers in Victoria Park that allowed people to view live the first session of Jamaica's Parliament, which was attended by Princess Margaret of England.[94] These televisions offered many Jamaicans "their first acquaintance" with the medium. In addition, people's earliest impressions of the practice of representative democracy in an independent Jamaica came through these publicly displayed televisions.[95] These earliest uses of the spectacle of electric light and of the communally viewed projected films and televisions were very different from the uses of screens in public space in the dancehalls. The history of these technologies in the early and mid-twentieth century offers

interesting points of comparison and contrast with video light. If the prestige and aura of visual technologies were associated variously with eliciting the cooperation of colonial subjects, symbolizing new Western freedoms (to cite the aforementioned *Times British Colonies Review*), as well as projecting the ideals of the productive citizen and of representative democracy, is video light in keeping with or does it stray — and how far — from those early uses of the screen in public space? If the early emphasis on local documentaries aimed at shoring up the "veracity of film" by showing local scenes, does video light do other work when it visualizes and highlights the work of the camera and light, which often disrupts a faith in video's veracity?

Male Crews, Skin Bleaching, and the Body as Photographic Surface

Several transformations happened in the space of the dancehalls precisely as video light reached its new ascendancy in the early 2000s. During that decade, male performers started to dominate the dancehalls. Also in this period, skin bleaching became newly prevalent among male dancehall participants. It was the era, too, when what was described locally as a "bling-bling" aesthetics became explicitly manifest, that is, was often performed for the cameras in the dancehalls. Each of these phenomena suggests how the dancehall participants came to be increasingly invested in and transformed by video light.

When videographers illuminated the dancehalls in the early twenty-first century, they cast a spotlight on venues that were increasingly dominated by numerous groups of male dancers (fig. 2.13).[96] While Bogle had been immortalized in videos since the 1990s, it was not until late 2002 that a large number of crews of male dancers started to perform in the dancehalls. Male dancers whom I interviewed cited Bogle (who was killed by gunmen in 2005) as central in making dance a professional possibility for them as men, and they often touted a professional link to him as a dancer.[97] These men started to perform choreographed dance moves and often dressed in a coordinated fashion. As had been the case since the 1980s, sartorial displays of material excess among artistes, dancers, models, and other attendees also dominated the more male-centered spaces of the dancehalls.[98]

That fashionably dressed male performers started to "shark" and "overcrowd" the video light drew criticism from DJs of an older generation and from female dancers. In 2007 the DJ Admiral Bailey, for one,

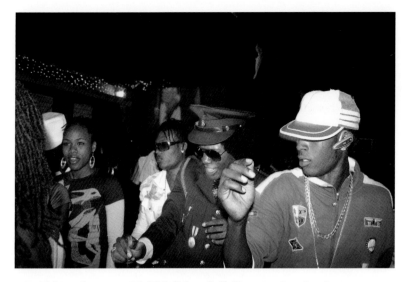

2.13. Male performers at Wedi Wedi dancehall, Kingston, Jamaica, June 2010. Photo by author.

maintained that in the past "men were seen as rude boys. Dem a stand up inna di darkest corner of the fete. Back then women tek centre stage, nowadays men a tek over the dance and video light."[99] Former dancehall queen Carlene also recognized in 2006 that men were "dominating the field."[100] To her mind "it doesn't look right, so many men dancing and carrying on. They do not look masculine doing it, but I guess society is changing and we are accepting it." A female dancer I interviewed, Kisama McDeod, who was in the company of many male dancers, also reiterated that "video light was for women."[101] These remarks reflect a more widespread criticism of the dominance of male dancers and indeed suggest a society still unwilling to accept the changing demographics of the video light. Carlene's complaint that the male dancers did not look masculine and Admiral Bailey's assertion that a male presence—a rude boy presence—was performed in the dark parameters of the dancehalls suggest that these observers understood video light as a technology that often lingered on women, its ephemeral illumination reflecting a male videographer's gaze on a sexualized female body.

In addition, Bailey and other dancehall DJs accused some male performers of not dressing in masculine ways and of wearing "tight pants, pink shirts and with bleached out skin."[102] They associated such aesthetic and sartorial practices with women. Such public policing of appropriate male dress and concerns about men not looking masculine

reflect in part an entrenched homophobia that animated dancehall music and performance practices, as well as a broader fear—as Donna Hope suggests—of the "feminine."[103] Rather than narrowly interpreting the video light as historically focused on women, as some critics did, however, one might understand the history of the visual technology as one in which societal norms and expectations of gender, race, and class have long been reconfigured. The space of video light, too, is the site of the new and the now. It creates the possibility of alternate forms of embodiment. The male dancers spotlight another instance in which the video camera offered a site for the constitution of new subjectivities or the unsettling of signifiers historically attached to ideals of gender.

If baring skin had previously dominated the dancehalls, from the late 1990s to the contemporary period, another skin-related phenomenon became foregrounded in the venues: skin bleaching. Some men and women used a variety of epidermis-transforming means to lighten their skin. Products ranged from manufactured ones, like Ambi, Nadinola, and Neoprosone, to homemade recipes composed of toothpaste, bleach, cornmeal, curry powder, or milk powder.[104] The practice of skin bleaching was so pervasive that Jamaica's Ministry of Health initiated public health campaigns against the practice in the late 1990s and again in 2007. They warned of "killing the skin"—the dangers of chemicals on the body's surface—and banned the sale of some skin-bleaching creams.[105] The medical dangers of lightening products ranged from severe acne, stretch marks, increased risk of cancer, and lesions to the interference with skin cell growth.[106]

Skin bleaching has a long and complex history across different geographic contexts where social status and the rights of citizenship and personhood have been bestowed or denied based on skin color. In Jamaica and other parts of the West Indies during slavery, British colonialists, colonial officials, and plantation owners institutionalized white hegemonic social hierarchies, which privileged fair skin.[107] The very justification for plantation slavery rested on the ideology that race existed, was visually discernible, and was readable on the body's surface. But skin bleaching cannot be reduced simply to a desire for a white appearance and the prestige it afforded historically. As Natasha Barnes persuasively maintains, in the context of Jamaica, many people who bleach often aspire to be "brown," or to become a "browning"—a racial designation associated with the upper classes and with the appearance of mixed-race Jamaicans.[108] Brownings garnered many privileges not available to black people in the social structures in colonial Jamaica, and they con-

tinue to enjoy more access to jobs in the banking and retail sectors and more opportunities for social mobility.[109] Two persons quoted by Donna Hope who bleached and who aspired to browning status said they did so because brown skin brought social visibility: "Yuh get more attention," and "[It's a] way out of the ghetto, cause people see you more when you brown."[110] Or, as another young woman, who appeared in the video "Skin Bleaching and the Dancehall," opined, "People no look pon black people again."[111] While being a browning may be a desired ideal related to color and class aspirations, many persons who bleached their skin thought they achieved a state of racial mutability because the bleached epidermal surface temporarily unfixes the skin as a racial signifier.[112]

In the 2000s, skin bleaching in dancehall gained renewed attention when a number of dancehall artistes, most notably Vybz Kartel (Adidja Palmer) and Lisa Hype (Felicia Gooden), publicly espoused the practice. Hype even offered recipes of sorts for transforming the skin's surface in her song "Proud ah Mi Bleaching," and Kartel eventually marketed his own line of bleaching products (fig. 2.14). Kartel boasted in his song "Straight Jeans and Fitted" (featuring Russian) that "gyal dem a watch me like ah stage show," and he credited the fact that he "washed mi face wid di cake soap" for his permanent state of stage show–like visibility.[113] Cake soap is a product that lightens skin. Kartel's lyrics suggest that he constantly felt like a celebrity being watched onstage because of skin bleaching. This artiste credited skin bleaching for his sex appeal, at a time when critics took him to task for engaging in what had been associated with a female beauty rite. He sought to shield himself from such accusations of being feminine and homosexual by touting the ways bleaching indeed supported his hypervirile heterosexuality. Kartel's public stance on bleaching came at a time when more men, including some male dancers, engaged in it.

Skin bleaching was more than an aesthetic practice that could be seen on dancehall attendees; it was a mode of preparation for the events and for the video light in particular. A dancehall-goer, for instance, explained to a *Gleaner* reporter that she only bleached her skin for the big dances and stopped immediately afterward: "Mi do it only like when mi a go a one big dance and mi know she mi have three weeks fi bleach and then from the dance cut mi just stop bleach."[114] Dancehall queen Stacie matter-of-factly explained, "Ah girl haffi look good, and if she not hot, she affi bleach and go all out, x-rated clothes, loud ting and all just to get attention."[115] In her description, bleached skin seems just another accessory to be worn to gain recognition in the dancehalls. Dance-

2.14. Advertisement for Vybz Kartel's Vybz Cake Soap. *Weekend Star*, May 20–22, 2011.

hall researcher Sonjah Stanley Niaah found that bleaching was a "technology of the body" focused specifically on being in the video light: "If you bleached your skin, it was thought that you would become more ready for the video light. That you come into the light, almost, with the clearing of whatever pigment that was . . . darker in tone or whenever — it was thought to be obscuring the image, in a sense."[116] Greenlee noted too how some people who bleached would concentrate on the face only (and not their necks), where they thought the video light was most likely to linger.[117] These observations suggest that skin bleaching might represent a desire not simply to become "lighter" but to be more legible as a subject for the video camera. Bleaching allows dark skin to be more fully visible in the unfiltered video light that searches through the dancehalls at night. It allows black skin to be read through videographic technologies calibrated to focus on and represent an ideal of white flesh.[118] Such strategies to be rendered legible under the intense illumination of the video light call attention to the broader un-visibility of darker-skinned subjects in contemporary Jamaican society. Sowah noted, though, that bleached black skin sometimes did not show up well on camera. Rather, the bleached faces (surrounded by darker hair and necks) and harsh video light resulted in a "white out," an illegible glare, on video.[119]

Might skin made "bright" by bleaching, as it is sometimes described,

also enable dancehall-goers to carry the momentary visibility affected by the video light beyond the space of the dancehalls?[120] Does bleaching reproduce and inscribe the effect of light on the skin's surface? A member of the bleaching community, identified as Winston in a television interview, indeed explicitly described the effect of bleaching in the following terms: "It mek yuh look like yuh come inna di light."[121] Bleaching in his estimation reproduced the effect of being in the video light on the bodies of dancehall participants.

Taking Winston's words a step further, I would postulate that chemically treated skin not only reproduces the effect of light from the video camera but also indeed becomes like a photographic surface. The process of bleaching makes the body into a medium that absorbs, reflects, reproduces, and records the impressions of light. Indeed, as health professionals have warned, many of the products used in bleaching literally make the skin light sensitive. Some bleachers had to cover their skin in the daylight because of this heightened sensitivity to the sun.[122] Different bleaching treatments also control the way the body reflects light. Hope intriguingly notes, in describing the material effects of cake soap on skin, that the product since at least the 1970s and 1980s has been considered in Jamaica a "dermatological wonder" capable of reducing "the dreaded 'shine and greasy' or 'tarry' look, leaving your face 'cool.'"[123] Her words highlight this ability of skin-bleaching agents to affect the skin's absorption and reflection of light. In this way bleaching affects not only the physical appearance of the skin's color but also its reflective capacities. Through these practices dancehall attendees not only readied themselves for the video camera but made their skin into photographic surfaces, into visual technologies, in their own right, that manipulated and recorded light. They made their bodies into a form of corporeal photograph. Bleached black skin became its own means and unit of photographic representation.

Much has been written on skin bleaching among Jamaica's urban communities as a form of self-hatred, as a manifestation of a racial inferiority complex or an expression of loathing the lived experience of having black skin.[124] Lightening the body's surface has been interpreted as a response to the cultural memory of skin color prejudice, or colorism, a reaction that arguably reinscribes racial hierarchies and ideals of beauty that privilege whiteness and brownness.[125] Some scholars maintain, however, that people who engage in different bleaching practices have high self-esteem and construct a range of nonwhite identities. They transform their skin rationally to attempt to secure and maintain

power, and destabilize understandings of race as naturally manifest on the body.[126] I want to expand the frame in which one might understand these practices by suggesting that they engage and intersect with a history of visual technologies and commodities and their production of ideologies of race. Skin bleaching appears to embody and reconfigure the ways bodies have often been racialized and gendered through the flesh and through the technologies of light, like photography and video, and the techniques of lighting.

In Jamaica specifically, in the late nineteenth to mid-twentieth century, black subjects often inhabited the shiny surface of photographs, the grain of textured postcards, and the luminous projections of lantern slides as ardent, disciplined agricultural and domestic laborers. A controversial and contested studio photograph taken around 1906 by Jamaican photographer J. W. Cleary that featured "a native washerwoman" next to a pail inscribed with the words "SUNLIGHT SOAP" offers one prescient example of such images (fig. 2.15).[127] The postcard is part of a broader imperial economy that promoted new commodities, middle-class social values, and British colonial ideals of civilization, cleanliness, and whiteness.[128] In the island such early photographs taken by local, British, and American photographers also pictured black Jamaican subjects in ways that recall Richard Dyer's observations regarding photographic depictions of nonwhite and working-class women in American print media. These subjects appear with "light bouncing back off the surface of the skin," producing "the mirror effect of sweat."[129] He contrasts such representations with the creation of a glowing and glamorous effect of light in photographs of white upper-class women from the early and middle twentieth century, as epitomized in advertisements for soap, which associated white women with notions of purity, cleanliness, beauty, and civilized culture.[130] Video light produces quite a different visual effect from that of the soft haloed lighting of such soap advertisements. My synopsis here of the ways light historically was associated with particular notions of gender, class, race, labor, and consumer culture is not meant to suggest that people who bleach aim to explicitly embrace or eschew the complex visual cultures that flesh out notions of race. These skin-bleaching practices surrounding video light represent "a redirection of what those technologies were supposed to be and the subjects they were supposed to produce," as Jamaican filmmaker Esther Figueroa (who worked with me as a videographer in Jamaica) has put it.[131]

In some respects, the dancehall participants who bleach seem to

Port Antonio, Jamaica
Nov. 26, '06

2.15. J. W. Cleary,
A Native Washerwoman,
Jamaica, c. 1906. Postcard.
Inscription on pail (right):
"SUNLIGHT SOAP."
Collection of the author.

A native washerwoman, Jamaica.

claim the light of the video camera so as to produce a modern black subject who is precisely not the laboring black body that sweats, who is depicted in a harsh light that emphasizes her or his "physicality, the emissions of the body and unladylike labour."[132] It is revealing that one of the touted abilities of cake soap is that it reduces shine. It produces, as Kartel would assert, a "coolness."[133] Bleaching and video light may be read as efforts to use light in such a way that the black urban Jamaicans who do so may be seen as glamorous, beautiful, and "clean"—to use another word often associated with bleaching. One woman who bleached her skin, Sheri Roth, explicitly expressed her desire to "walk into dance halls and feel like a movie star, a white one."[134] Her qualification that she wanted to feel like not just any movie star but a white one speaks perhaps to a sensitivity to the prestige associated with whiteness and white subjects and a desire to re-create that "feeling" of celebrity. Dancehall participants like Roth transform visual technologies of light as they relate to race and glamour—even materially so—but also firmly reinscribe and affirm them.

Skin bleaching, I am contending, may be viewed as a process of making the body into a visual technology, in which the skin functions as negative and print, source of and recorder of light, subject matter and material of the photograph. But what does it mean to achieve a photographic objecthood, to have skin marked by the light of visibility or a body functioning like a photographic surface? What kind of subject comes into being in the glare of the video light? What is the desired effect of such strategies in the broader public sphere? What, if any, political end might such strategies gesture toward?[135] Or do these expressions mark an end to or reformulation of the ideals of civic participation?

While these questions cannot be answered definitively, in the remainder of the chapter I will look at how lens-based technologies from the United States, particularly related to hip-hop's visual culture, as well as local expressions of popular protest surrounding the video camera, may have informed the lens-based practices and photo-corporeality in the dancehalls. I will then sketch how the press, public intellectuals, the Jamaican police, and producers of contemporary art, particularly since the mid-1990s and in part through the circulation of images made possible through video light, started to scrutinize more broadly the expressive cultures surrounding dancehall. I maintain that the forms of visibility created by participants in the dancehalls—whether the visualization of being seen by means of the screens, the blinding light of the camera, or the seeming merging of skin and photographic surface—contrast with and might respond to the "degrees of recognition, misrecognition, and nonrecognition" of dancehall culture within wider postcolonial Jamaican society and indeed reject a legibility within the political, social, and cultural structures of its ruling class.[136]

Bling-Bling, the Visual Economy of Light, and the Lens-Based Transmission of Hip-Hop Culture

The late 1990s and early 2000s—the period when the video light, male participation, and skin bleaching increased—was also the era when cultural expressions associated with dancehall were described locally as a bling-bling aesthetics. An article published in the *Gleaner's Best of Jamaica* supplement in 2000 indeed declared bling-bling "the best Jamaican slang for the year."[137] As Hope puts it, bling became synonymous with and "intertwined with ideas of the flashy and pervasive urban, working class popular music of the day—dancehall." "If it

is 'bling,' it is dancehall and if it is dancehall it is 'bling bling.'"[138] Hope traces the etymology of "bling," starting in the United States, noting that the term likely stemmed from the sound of a cash register or was an "ideophone intended to evoke the 'sound' of light hitting silver, platinum, or diamonds." She points out subtle differences in the way bling signified in Jamaica but concludes that among working- and lower-middle-class Jamaicans, bling retained its emphasis on the "public and conspicuous nature of this ostentatious consumptive aesthetic."[139]

The camera, still and moving, and the television screen were intrinsic in how bling-bling was transmitted and transformed in Jamaica. These forms of media resulted in the manifestation of their own version of conspicuous aesthetics in the island, of which video light was a key expression. One of the routes and networks through which a bling-bling aesthetics became foregrounded in the island was street photography studios in the dancehalls.[140] As discussed in chapter 1, in the late 1990s Sonny set up temporary street photography studios in dancehalls (often in the same spaces as Sowah) and started using hand-painted backdrops that often replicated pictorially the emphasis on conspicuous consumption and the aesthetics of light and bling in hip-hop in the United States (fig. 2.16).[141]

But the most widely available source through which hip-hop culture gained visibility was television, and the music video. Government-regulated cable television came to Jamaica in 1995, bringing with it popular music television programming, with high viewership among Jamaica's urban poor.[142] By 2002 the cable channel BET, known for its hip-hop and R&B music video offerings, was ranked as the most-watched channel among young people in Jamaica. More broadly, Jamaicans mainly tuned in to foreign stations for the purpose of watching music videos.[143] These stations were not intermittent sources of entertainment but formed the soundtrack of everyday life in the island. Music videos flicker across public spaces in Kingston; they animate the backs of headrests in taxicabs (fig. 2.17), the interiors of the public buses known as "hype buses," and in a few rare instances the outsides of them. Music videos also often provide fillers in between programming on local stations. Several dancers I interviewed cited the influence of BET and MTV music video programming on their styles and performance repertoires.[144] Indeed male dancers may have come to dominate the performance spaces of dancehall because they were influenced by music videos from the United States, which featured male dancers.[145] Bogle himself was featured in local and American music videos and even

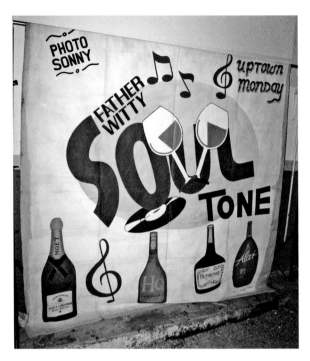

2.16. Photo Sonny's backdrop, Uptown Mondays dancehall, Kingston, Jamaica, 2009. Photo by author.

starred in the film *Belly* (1998), directed by famed hip-hop music video director Hype Williams (Harold Williams). This summation of hip-hop's televisual appearance in Jamaica aims to underscore the modest point that an urban aesthetics of conspicuous visibility was transmitted and experienced through the frame of television, the screen, the pixel. The particular public omnipresence of music videos in Jamaica formed part of a media-scape that likely informed approaches to the video camera and video light, as well as the process of making oneself available to—and making one's body serve as—a visual technology that became so intrinsic in the practice of a bling-bling aesthetics in Jamaica.

What is important to keep in mind is that for many people in the dancehall community, hip-hop and its bling-bling expressions were not seen as foreign, American, or black American or as neocolonial expressions. Rather, they viewed hip-hop and dancehall as different articulations of the same diasporic routes. As Wayne Marshall documents, such understandings were likely facilitated precisely through music video stations in the United States.[146] These stations regularly high-

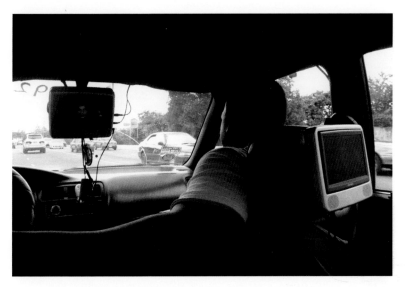

2.17. A cab in Kingston playing music videos, 2009. Photo by author.

lighted Jamaican pioneers, like DJ Kool Herc, who brought aspects of early dancehall to Brooklyn, as originators of hip-hop. Hip-hop was thus not simply representative of contemporary diasporic exchange but signified something of a return of and reclamation of a cultural expression already seen as Jamaican and as a shared transnational and modern African diasporic urban culture.

"Show Sowah di Brand Weh Youh Have On": The Performance of an Ostentatious Consumptive Aesthetic

As in the street photography studios, video light offered a medium in which a black urban aesthetics of conspicuous consumption was performed for the camera. As Lady Saw described it, "Dancehall encourages people to be bling. Bling is part of reality."[147] The showing of one's fashions and brands to the videographer came to be so entrenched that dancehall tunes explicitly came to encourage dancehall participants, as Elephant Man did in his song "Signal de Plane" (2003), to "show Sowah di brand weh youh have on."[148] The videographers in turn often focused on the hype thing, the belt buckle, the shoes, the cell phone, the clothes worn by different attendees, at times freeze-framing an image of standout parts of the attire of dancehall participants in the screens of the dancehall. Such still shots, however, presented people through parts,

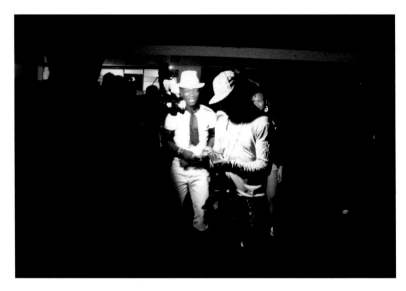

2.18. Dancer counts money before the video light at Passa Passa dancehall, June 2010. Photo by author.

with consumer goods standing in for the individual in their larger-than-life projection. Interestingly, bleaching products became prestigious commodities in the dancehalls, as the most effective lightening notions could only be procured at some expense.[149] In the space of the dancehalls, flashy clothing and bright, eye-catching colors seemed to be a reigning aesthetic, one that created a certain reflective synergy with the video light and the dazzling surface of the screen. Dancers will often offer an inventory of their wardrobe choices, noting the lengthy preparation they went through for the video light. Dancehall attendees could spend weeks saving and coordinating, designing clothes, and getting the right accessories or type of hair to be ready for the dancehall's spotlight. They recognized, however, that once they appeared on camera, the outfit had in essence been visually consumed and therefore could not be worn again. As a dancer at Passa Passa, Ian Dice Charger, explained, "There is no repeating in the video light."[150] Some dancehall attendees not only displayed their expensive-looking clothing but also counted money before the video light (fig. 2.18).

On its face, video light facilitated conspicuous consumption among those with the least financial means to buy into its systems of status and prestige. Indeed it encouraged some participants to go to great expense to be in the video light, which in turn transformed them into commodi-

ties that could be sold locally and transnationally.[151] Dancehall artiste Bounty Killer wryly pointed out the ironies of such consumption practices in urban communities in Jamaica when he asked "how Jamaicans can [be] talking about bling bling and 'ice' when most Jamaicans don't even have refrigerators."[152] His comments reiterated concerns often expressed in the press in Jamaica about the misplaced priorities of dancehall participants and about the detrimental effect on youth who were, as local commentator Ian Boyne put it, "socialized by the dancehall and American consumeristic and hedonistic culture via cable television."[153] One might add that these materialistic practices may stem from the local ways corporate sponsorship and ownership dominate the downtown communities in Kingston, with billboards and posters forming a skin on the urban landscape, and from broader consumer-driven global economies. But this seeming investment in bling-bling as if it were a necessity calls attention to the limited opportunities in the formal economy, as well as to the complex visual economies and systems of prestige and personhood in the dancehalls.

Many dancers invested in their appearance in the video light because they believed it to be the most viable means to transcend their geographic environments and social status. Some expressed a fervent belief that if their images were transmitted globally and were seen by the right person—whether by a potential lover, local or foreign music video producers, stage show organizers, overseas suitors, commercial directors, or remittance givers—they could dramatically transform their fortunes. They identified several levels of possible social ascent through video light, from being featured in local music video to appearing in stage shows on the island outside Kingston (one of the few opportunities for dancers to get financial rewards immediately) to touring in Europe. As such, to use Sowah's words, investing in being in video light was like "putting money in the bank."[154] Indeed, a part of the reason some dancehall participants transform their bodies through light and become like photographic images stems from their belief that photographic and videographic images have a mobility that bodies do not. By becoming like a unit of representation, a visual technology, they can transcend the constraints of daily life and be transmitted and transported elsewhere, to other spaces and states. They can become diasporic subjects by becoming photographic.

This faith in bodily transcendence is arguably also manifest in bling funerals in black urban communities in Jamaica. At these affairs, funeral directors trick out fairy tale–like glass coffins or chariots and

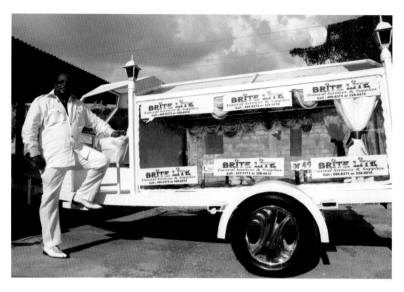

2.19. Peter Dean Rickards, *Tommy Thompson (Owner, Brite Lite Funeral Home)*, 2012. Digital photo (Canon 7D), 2268 × 1512 pixels. Courtesy of the artist.

organize opulent funerary spectacles.[155] Mourners at times dress in dancehall splendor before video cameras, reproducing from the dance-halls the dynamics of being seen. One proprietor, Tommy Thompson of Brite Lite Funeral Services and Supplies, is well known for such funer-als. An image taken by Peter Dean Rickards, a photographer attentive to the aesthetic practices and modes of self-fashioning in Jamaica's urban cultures, shows Thompson striking a pose next to one of his glass cof-fins, which is supported on sparkling rims (fig. 2.19). The very name of Thompson's business, which is repeated many times over at the top and bottom of the coffin, may point to a certain faith in the transformative possibilities of bright light, whether in the dancehalls or at the bling funerals. Through these aesthetic practices, through bling-bling and a spectacular display of things, people in dancehall's communities could achieve otherworldly transcendence, one manifest through light.

Dancehall participants, however, aspire to more than international celebrity and wealth through material means. Rather, "in their own eyes, and perhaps also in the eyes of others, these subjected people be-come different in the light of their heavily branded visibility."[156] Gilroy uses these words in the context of hip-hop culture, but his choice of the words "light of branded visibility" foregrounds again how being seen dif-ferently through the visual effect of light, the haptic visuality created in

the dancehalls, was central to notions of status in the venues, not simply to ideals of capitalist accumulation. The visual transaction between performers, video light, and witnesses indeed cannot be fully reproduced. Video light illuminates subjects, who are, to recall Anne Cheng's work, "commodified, yes, but also strangely unconsumable."[157] In some ways dancehall participants' focus on the body as its own photographic image appears to make them into forms of representation that deny certain forms of reproduction, commodification, and replication that are so intrinsic to capitalism and its image worlds. As the dancer Crazy Hype (Michael Graham) asserted, his face "could not be owned."[158]

Status within the video light was generated as much by consumer goods as talent, in a society "divided into social layers that are largely created by the social structures we have inherited and not by talent," as a local politician, Pearnel Charles, put it.[159] Specifically, many dancers aimed to perform in ways that "had never been seen before" in front of the cameras.[160] In this way the performers felt a need to be ahead of the times and ahead of what the video light had previously made visible. They aimed to perform in ways that had not been commoditized and fossilized by the video camera. The dancers, however, seemed caught in a perpetual process of outrunning the visual and being bound for its capture.[161]

While some dancehall participants listed the impressive number of music videos or stage shows they had appeared in, for most the video light had not led to a substantive transformation of economic status, geographic location, or racial or gendered designations. The photographs taken by New York–based, Jamaican-born photographer Radcliffe Roye seem to capture the momentary possibilities and limited efficaciousness of video light. The documentary photographer often follows in the trail of the video light when in the dancehalls. He represents some of his subjects the instant the light passes (fig. 2.20).[162] The light in his photographs is bright yet soft, unlike the brighter glare it follows. Some of his subjects appear to adjust physically to the darkness that follows the piercing video light. The photographs capture an in-between state, in between the still camera and video light, and in between the possibility of video light and the melancholia of its passage.[163]

The Proliferation of Dancehall On-Screen and Its Abatement in the 2000s

In the 2000s, as dancehall music gained increasing attention locally and internationally, the screens on which the street-based dancehall ses-

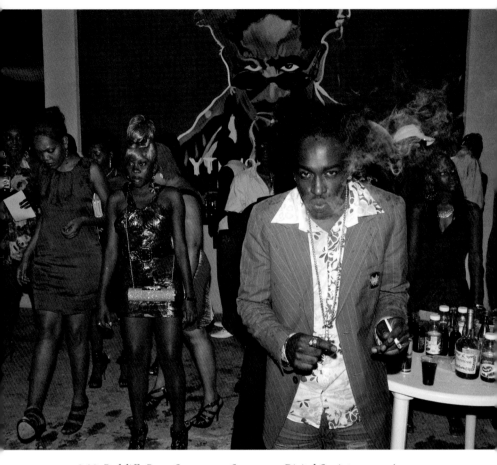

2.20. Radcliffe Roye, *Stars among Stars*, 2011, Digital C print, 30 × 40 in.
Courtesy of the artist.

sions appeared multiplied exponentially, through local television, in Jamaican society.[164] Footage that had once visualized the community of dancehall participants to themselves and to those who sought out the videotapes became more widely available across classes in Jamaica. Starting with the formation of the Jamaica-based cable channel HYPE TV (How You Picture Entertainment Television) in 1999, and followed in 2003 and 2005 by the launch of the Reggae Entertainment Television and the Dancehall Channel, the activities of the dancehalls garnered a larger national and international audience.[165] These channels followed on the heels of existing popular weekly programs devoted to dancehall, like *Entertainment Report* and *On Stage*. As one local writer noted in 2004, "Similar to how America feeds itself on MTV, BET, and other pop culture stations, the entire world of dancehall is pumped into thousands of television sets in Jamaica."[166] Through these sources, dancehall increasingly became, as one local newspaper characterized it, "a product that is packaged, promoted, and presented to those who did not wish to attend the sessions."[167]

The interest in dancehall was replicated in print media. In 2004 Rickards started producing the glossy magazine *First*, which featured many photographic essays on Jamaica's diverse population, including dancehall personalities. Newspapers also featured sections devoted to dancehall photographs; for example, the tabloid *Chat* featured photographs taken by still photographer Marlon Reid. Interestingly, as dancehall gained national visibility, at least two image-makers whom I interviewed described how they refused to reproduce the images of male subjects who did not properly "present themselves as men."[168] One suggested that this censorship was for the protection of these men. These efforts highlight how in the process of dancehall's visual proliferation, heteronormative and homophobic expectations of gender were reasserted, and the unfixed aesthetics of some dancehall participants that defied mainstream configurations of race and gender were cast out of the photographic frame—were not visualized in mainstream media outlets.

In the 2000s, as the cultural expressions of the dancehalls were transmitted nationwide through television, DVDs, and the Internet, they were increasingly subject to scrutiny and cast in an unflattering spotlight, particularly in the local press. Such coverage was in stark contrast to the early years of dancehall in the 1980s and early 1990s, when dancehall rarely appeared in the *Gleaner*, the island's longest-running newspaper. When dancehall did register in the printed media, commentators

invariably took issue with the use of improper language in the lyrics and with the "slack" behavior of young women. By the 2000s, dancehall was the subject of ongoing criticism and debate and was often viewed as both a precipitator and a product of many societal ailments, most crucially crime, violence, sexism, and homophobia. In 2008, a telling debate took place between reggae veteran Freddie McGregor and anthropologist Herbert Gayle over whether dancehall was a "trigger" versus a "root cause" of violence in Jamaica.[169] Both commentators associated dancehall with violence. Practices like skin bleaching, as Winnifred Brown-Glaude documents, and video light were also viewed in the *Gleaner* as social problems and framed within discourses of pathology.[170] Donna Hope, who has been a great public supporter of and cultural historian of dancehall, too, refers to the interest in the camera in the dancehalls as the "video light syndrome." Her use of "syndrome" seems in keeping with processes Brown-Glaude outlines in media discourses surrounding dancehall, in which nonmedical problems become defined and treated as illnesses or disorders.[171] The ongoing debates highlight the ways that dancehall became a central trope of reflection on postcolonial Jamaican society. At the moment of dancehall's heightened visualization, when it seemed omnipresent, it was often evoked to discuss many things deemed social problems. It was like a lens that many critics and supporters looked through to see a host of societal concerns and issues.[172]

The venues also increasingly caught the attention of the state in the era of video light. Dancehalls became subject to another form of light, one directed on them by law enforcement officers. The dancehalls had been subject to surveillance and raided by the constabulary forces since the 1960s.[173] Such practices intensified in the 1990s and 2000s with the imposition and enforcement of curfews on the dancehalls. In 1993, Buju Banton described raids with officers "wid helicopter inna air, bright light a shine a ground."[174] Some of these very raids were videotaped and shown on television.[175]

The 2000s saw the active enforcement of the Noises Abatement Act (1997), which provided a legal framework for the curtailment of dancehalls.[176] (One wonders, however, whether "noise" as described in the legislation refers not only to the sonic but to the visual as well—whether dancehall's aesthetic practices represented the visual equivalent of an incomprehensible noise.) In particular, during the course of my research in 2010, authorities frequently shut down the dancehalls. The sound system would fall silent, the video light would be extinguished, and dancehall-goers would file out of the space. The frequent

raids took a toll on the events. One promoter, Wayne "2 Gran'" Bartley, ended the popular Dutty Fridaze dancehall for a time because of police raids in which officers "come 1 o clock, dem kill di video, and for the past four weeks, the video ting get a blow."[177] He noted, too, the financial effect of this quelling of the video light. When I asked Sydney Bartley, the principal director of culture in the Ministry of Youth and Culture, if the closures were part of a government policy, he replied that "dancehall has its adversarial positions, and some here reacted to it as a counter-culture and some seem threatened by it, so it has developed a state response in some instances because we are concerned sometimes about vulgar lyrics. We are concerned sometimes about how women are portrayed. We are concerned about the way sometimes there is a promotion of violence within dancehall music . . . and yes, so therefore instinctively it gets a state reaction . . . as society tries to achieve what is perceived as order and discipline."[178]

Tellingly, the suppression of dancehall through the Noise Abatement Act reproduces strategies used in the British colonial era to criminal-ize Jonkunno, which was the central Afro-Jamaican masquerade prac-tice on the island, and to assert control over public space. In 1911 a law (number 31) called "the Noises (Night) Prevention Law" (amended in 1944) and half a century later a law (number 6) to "Regulate Marches and Processions in any Public Place and to Prohibit such Marches and Processions at Night" (1946) provided the legal framework for the regu-lation and control of the expressive practices of the black population in the interest of "good order or public safety."[179] In 2009 such measures expanded beyond the clamping down on the dancehalls to the control of their transmission through visual media and radio. Jamaica's Broad-cast Commission banned the transmission of materials of "explicitly sexual and violent" nature in the dancehalls, deeming them a violation of the Television and Sound Broadcasting Regulations against indecent music.[180] These measures to control the spaces of dancehall and their public visibility and noise occurred just as the expressive forms sur-rounding dancehall were proliferating in the public realm through the televisual. Countervailing policies diminished this widespread presence of dancehall across different media, extinguishing the video light.

The Art of Dancehall

In addition to the television screen, dancehall entered the broader pub-lic sphere through another surface that packaged the cultural expres-

sion: contemporary art. In the mid-2000s, several artists, including Ebony G. Patterson, Peter Dean Rickards, Radcliffe Roye, Storm Saulter, and Kehinde Wiley, started creating dancehall-inspired work. I will focus on Patterson's work, which has garnered much local and international attention, achieving a level of international visibility and mobility that is unique among Jamaican artists of her generation. She explores the aesthetic practices and demographic changes that emerged in the dancehalls from 2002. Patterson's multimedia pieces draw attention to the formation of distinct aesthetic practices, from its surface aesthetics and its economy of light and from bling-bling to "blinging the skin," as Patterson describes skin bleaching.[181] But this work, I contend, does not so much represent dancehall as it engages the broader public discourses that surrounded the aesthetic forms, spaces, and communities associated with the black urban expressive culture of the early twentieth-first century, precisely as it was projected more broadly to a Jamaican public through video and television. Patterson's art, materially and in its choice of subject matter, calls attention to how strategies of visibility in dancehalls were often mitigated by critics who framed dancehall as representative of criminality and sexual deviancy and as a dangerous deviation from prevailing ideals of race, culture, gender, sexuality, and economy that had been formulated since the 1930s. Thus the visual practices in dancehall, Patterson's work highlights, were often not seen—were rendered un-visible in Jamaican society more broadly.

Patterson's earliest works on the subject of dancehall were the drawings on white paper of her series *Gangstas for Life*. As evident in the drawing *Untitled II* (2007), they center on the closely cropped, fleshy faces and the elongated necks of black male subjects who seem to stare directly at the viewer (figs. 2.21 and 2.22). The artist made delicate incisions in the surface of white paper, rendering their visages and the surrounding backgrounds through the same delicate patterning. The work, in its subject matter and form, calls attention to the skin as a malleable surface. The use of the incised paper to represent bleached skin also recalls Kartel's claim, in defending skin bleaching, that his skin represented a "coloring book."[182] In effect, it was a form of paper, which could be any color or serve as a canvas for his tattoos. His assertion that his skin functioned as a blank canvas or coloring book and Patterson's own representation of bleached skin as paper foreground the epidermis as a medium of representation that is changeable, transferable, and a work in progress.

Patterson's awareness of bleaching in the dancehalls emerged in the

era of increased state surveillance and as bleaching and video light came under scrutiny in the press. She first became aware of skin bleaching among Jamaican men and turned to it as a subject of her work when an article appeared in the *Star* in 2007 associating the practice with police evasion.[183] While numerous articles had appeared before this time bemoaning the racial pathology of "bleachers," this article explicitly framed the practice as a strategy that wanted men used to hide from the police and their enemies. According to the newspaper story and its accompanying cartoon, men manipulated their skin to undermine the indexicality and the authority of the photograph, the wanted poster, or the written description aimed at their capture. Responding to the article, Patterson used photographs in Jamaica's criminal databases as the sources for the faces of the men in the series and embellished the visages with glitter and sequins, which she associated with other luminous surfaces in dancehall. Patterson's use of the criminal archive highlights how the public discourses surrounding skin bleaching, and other practices associated with dancehall and black urban cultural practices more generally, framed them as criminal and socially deviant.

Patterson created another series, *Disciplez* (2009), which foregrounds the intersections of dancehall aesthetics and the ways they registered in public discourses in contemporary Jamaican society. For *Counting Money HaHa (The Counting Lesson Revisited)* (2010) (fig. 2.23), a large, intricately made tapestry, she created a photographic set on which male models acted and dressed like participants in a dancehall. The backgrounds were wrought of colorful floral wallpaper. The men's colorful outfits compete with the aesthetic intensity of the backgrounds. The backdrops and stage sets recall the street photography studios as sites of performance, of a bling-bling posturing. But Patterson framed the men against a ground that does not suggest a "rude bwai" aesthetics.[184] Rather, her framing foregrounds "elements that might be associated with the feminine," whether floral patterning or brilliant pink colors.[185] Her situating of the men against signifiers that might easily be interpreted as feminine seems to reproduce the ways male subjects in dancehalls were circumscribed by suspicions regarding heteronormative understandings of masculinity.

Patterson based the staged scenes in the series on paintings that hang in the collection of the National Gallery in Jamaica, works that have a constant public visibility in the gallery and are framed as important parts of Jamaica's artistic canon. The painting *Counting Money HaHa (The Counting Lesson Revisited)* takes its title from a song by a

2.21. Ebony G. Patterson, *Untitled III*, from the *Gangstas for Life* series, 2007. Mixed media on handcut paper, 3.5 × 5.25 ft. Courtesy of the artist and Monique Meloche Gallery.

2.22. Detail from Ebony G. Patterson, *Untitled III*, from the
Gangstas for Life series, 2007. Mixed media on handcut paper,
3.5 × 5.25 ft. Courtesy of the artist and Monique Meloche Gallery.

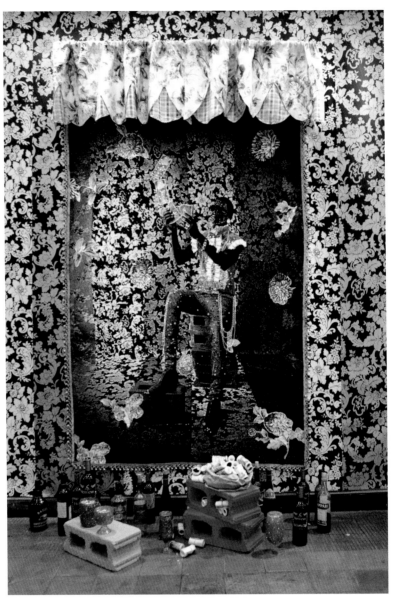

2.23. Ebony G. Patterson, *Counting Money HaHa (The Counting Lesson Revisited)*, 2010. Mixed-media tapestry with bottles, money rolls, wine glasses, and valance, 101.5 × 58.5 in. Courtesy of the artist and Monique Meloche Gallery.

2.24. Albert Huie, *The Counting Lesson*, 1938. Wallace Campbell Collection, Kingston, Jamaica. Courtesy of the Estate of Albert Huie and Wallace Campbell.

dancehall group, Merital Family (featuring Vybz Kartel), in which they boasted about their wealth and how it gave them bragging and laughing rights. It features a figure in the tapestry counting his money, amid a studio environment populated with accoutrements of a bling lifestyle. The painting hung above spray-painted fluorescent pink blocks and liquor bottles that were part of the artwork. The piece is based on the painting *The Counting Lesson* (1938), which was created by Jamaican artist Albert Huie (1920–2010) (fig. 2.24). This painting is an interesting choice for several reasons beyond its National Gallery of Jamaica pedigree. It was part of some of the earliest efforts by artists in the island in the 1930s to make black Jamaicans representable and indeed to render black skin as subjects of art.[186] Huie sought to transform the pictorial configuration of black subjects in touristic postcards, photographs, and drawings.[187] This artistic imperative came out of a particular period associated with the nascent cultural nationalist and anticolonial movements of the 1930s and 1940s. It was also a moment when art began to garner value and visibility as national expression. Patterson's pairing of dancehall's bling aesthetics with Huie's work is intriguing, since critics often deemed dancehall not representative of national culture and bleaching a betrayal of ideals of blackness that had come into being in the anticolonial and cultural nationalist era.

The subject matter of Huie's *Counting Lesson* makes this painting a prescient choice, too, because the work speaks to predominant social, cultural, and political strategies surrounding the formation of black modern citizenry in the 1930s and 1940s, an era that saw challenges to British colonial rule on the island. Through counting—the educational system—blacks in Jamaica could prove capable of governing themselves. Many of Huie's paintings later focused on agriculture, another mode of economic uplift and opportunity touted by the island's first national leaders. The films shown by the mobile film units of the 1950s continued to promote and project this ideal of modern subjects as constituted through their agricultural labor. Patterson's revisiting of *Counting Lesson* is also striking, given that from early on when criticisms of dancehall started to appear in the early 1990s, many newspaper contributors lamented the passing of the ideals of work, of citizenry, of culture, and of politics that had emerged in the 1930s and 1940s. One writer, for instance, described dancehall's departure from the social work and political activism of Amy Bailey, who in the 1940s created a center aimed at empowering underprivileged girls through training in crafts. The writer lamented that "what impressed Amy Bailey is dragged in the mud by every loud mouth who can get near to a dancehall microphone and women of this generation thrill to the barking sounds of their abusers."[188] In a letter published in the *Gleaner* in 1990, another observer urged dancehall listeners to use their money to get into the agricultural industry and not waste it on chains, on the unproductive visual economy of dancehall. She lamented (after seeing a "dazed and bleary-eyed" man listening to dancehall music) that there were too many "unemployed idle persons . . . [and] many of them have access to land from which they can not only feed themselves but also earn enough money to make them independent of their parents another man or woman the drug baron or the politician [sic]."[189] Another writer to the newspaper, André Fanon, put it this way: "Dancehall becomes a danger when dancehall syndrome is made into a way of life. . . . [It] under-develops our women who feel that they must learn to 'wine' and 'cock out' their posteriors as champion bubblers. Dancehall as a way of life emphasizes the unproductive elements in society. If not channeled, dancehall will create a class of people which is incapable of doing anything productive."[190] This small sampling of local commentaries highlights how for many observers outside the community of dancehall-goers, the cultural expressions often generated lamentation over the passing of particular ideals of productivity and progress. Dancehall's bling aesthetics generated a

mode of reflection and desired return to an earlier era when the pathways to the production of a modern black citizenry were being drawn and imagined. But video light and the visual economies surrounding it speak to the contemporary radical changes in both Jamaica's and the global economy in the late twentieth century, which are structured around the real and imagined opportunities afforded through visual technologies. Dancehall dancers present new modes of production and personhood that refuse to be the subject brought to light in touristic postcards, lantern slides, and the publicly projected work of the film units. They engage in what David Scott describes as a *"ruud bwai* self-fashioning [which] constitutes a practice of the self by means of which the (typically) young, working-class male refuses the disciplined body of post-colonial order, refuses to be a 'docile body' available to be worked over by capital, to be worked over by the police, or to be counted by the statistical ideologues of representative democracy."[191]

The critiques also reveal how dancehall was often framed in the press for what it was not, for its departure from a national script. As such, dancehall culture is continually subsumed, misrecognized in these discourses. I suggest that this is something Patterson's work foregrounds and enacts. Patterson's photography-based pieces—using models in costumes inspired by dancehall fashions or visages from criminal databases—highlight how dancehall participants are often precisely not seen in the public sphere, are disappeared in the discourses of aberrant sexuality (and slackness), homophobia, materialism, violence, and criminality that surround them. Patterson's work underscores this point by representing dancehall subjects through their absence, through an explicitly posed proxy. This feature of her work contrasts with other contemporary artistic interpretations of dancehall, such as Kehinde Wiley's series of paintings *The World Stage Jamaica*. Wiley's *Three Boys* (2013) is one work this US-born artist produced using subjects in part from the island's dancehalls, wherein he sensed a palpable desire to be seen and present in the space (fig. I.2). The painting presents three fashionably attired men posing against a floral backdrop, not in the fluid performance styles evident in the dancehalls but assuming the more staid poses derived from eighteenth- and nineteenth-century British imperialist portraits. I discuss Wiley's work at some length in chapter 4; here I want to underscore his expressed fidelity to representing people he encountered on the streets or in the dancehalls. Patterson's costumed and staged models (who are indeed not dancehall participants) and her use of public domain photographs of criminals enacts a sense

of remove, a substitution that underscores how the culture and community of dancehall participants remain allusive subjects in the media and in the public sphere in Jamaica.

Patterson's work further calls attention to the ambivalent ways dancehall is both seen and un-visible in the black public sphere through her use of embellishment. Her work foregrounds, I suggest, how dancehall subjects are always at risk of disappearance through the very technologies they use to bring themselves into visibility. The ornate pieces produce an aesthetic overload, with figures sometimes getting visually lost in the backdrops, in what they wear, in the ground of the photographic setting. Sometimes the male figures in her work are also covered over the entirety of their skins in glitter, making their bodies into reflective and glittering surfaces among other surfaces. These subjects are so embellished that they are barely legible. In works such as *Goffa* (2012), from the series *Out and Bad*, the human subjects of the photo-based textiles literally disappear (figs. 2.25 and 2.26). Ornamented clothes and accessories acquire their own human forms. Patterson worked with the photographer Marvin Bartley, an artist and a commercial photographer in Kingston, in the series. Bartley uses the lighting techniques of commercial advertising to light up Patterson's spectacularly adorned subjects.[192] As if the resulting photographs were not already saturated enough with the play of light and surface, she sends the work off to Walmart to transform the photographs into textiles and then further embellishes the work with sequins, rhinestones, and glitter. The resulting pieces are intricate, excessive, dazzling, and tactile. They create what might be described as a form of haptic visuality. The work appears to come to terms with dancehall's prevailing bling-bling aesthetics and what it effects visually. Her work underscores how a certain visual saturation within the aesthetic practices of dancehall can produce both hypervisibility and disappearance, a condition in which the figures appear both spectacularly present and illegible: disappeared in the different, collapsing, and exchangeable, bedazzling surfaces of skin, screen, and shimmering objects. Her work highlights how, despite dancehall participants' efforts to attain recognition, predominant social configurations of race, class, and gender continue to impede their visibility, resulting in a form of spectacular un-visibility in postcolonial Jamaican society.

In this context I want to return to some of the prevailing characteristics of video light. Given the ways that dancehall culture is often rendered un-visible in mainstream media in Jamaica, it is striking that one of the phenomena video light produces is the process of seeing and

being seen. The camera moves through space, zooming in, focusing, blinding, and projecting, all of which might be interpreted as a dramatic enactment of visibility, an almost extreme insistence on being seen and seeing oneself being seen. The community in the dancehall is constituted as such through that experience. The ways many people talk to the camera, addressing an audience that cannot be seen, also seem to insist on an audience, on a community of viewers that transcends the nation-state, and on a recognition and visibility that is often denied dancehall participants in the mainstream. The transformation of the skin through bleaching so as to permanently mark the body as visible, as representable (and extending the temporality of the photographic), also speaks to dancehall participants' desires for recognition within and outside the spaces of the dancehalls.

Despite being cast as against the politics of the 1930s or 1940s or as a detour from models of citizenship and civic participation and engagement, however, being on camera has a history, one with political resonance and one that is associated with a variety of rights within Jamaica's representative democracy. Since at least the 1970s, black urban Jamaicans have turned to cameramen to make their claims visible in the nation-state. Persons with grievances have often congregated not at the politician's doorstep but at the gates of the Jamaica Broadcasting Corporation, the government-owned television station (launched in 1959). "When they had a protest they found themselves at the gate with their placards, and the JBC [cameramen would] run out with the cameras and [start] filming them," filmmaker and cameraman Chappie St. Juste recalls.[193] The practice of "voic[ing] their dissatisfaction with a variety of topics" before cameramen is one instance of the ways working-class and the working-poor Jamaicans identified the camera and being on-screen decades ago as an important agent, not just a tool, in political mediation and redress. Such strategic appeals to the camera have become even more widespread in the contemporary period in Jamaica as cameramen have ventured beyond the gates of the Jamaica Broadcast Corporation. As communications researcher Hume Nicola Johnson documents, in postcolonial Jamaica, people from the disadvantaged classes who feel neglected by the state often solicit the attention of television cameras, particularly in the streets through protest. Such citizen protests are such popular strategies that they constitute, in Johnson's estimation, a "performing art" that people use to catapult themselves, their communities, and their causes to national visibility.[194] It is a popular mode of political participation, which blurs the lines between the right to be

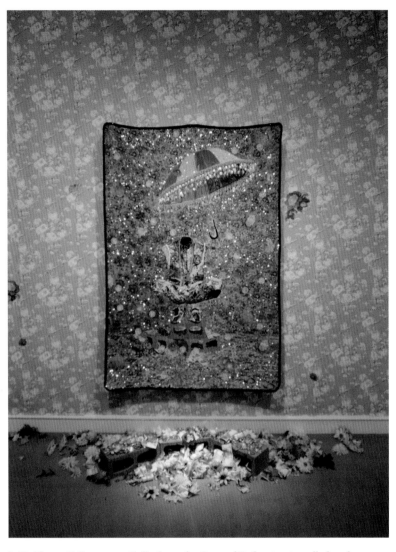

2.25. Ebony G. Patterson, *Goffa*, from the *Out and Bad* series, installed at the National Gallery of Bermuda, Hamilton, 2012. Mixed-media photo tapestry with toy money, varied dimensions. Courtesy of the artist and Monique Meloche Gallery.

2.26. Detail from Ebony G. Patterson, *Goffa*, from the *Out and Bad* series, installed at the National Gallery of Bermuda, Hamilton, 2012. Mixed-media photo tapestry with toy money, varied dimensions. Courtesy of the artist and Monique Meloche Gallery.

visible on camera and the exercise of one's rights (or the decrying of the lack of rights) in postcolonial Jamaica. This has been an important means that Jamaica's disenfranchised population has used to further their interests.

This history of appeals to the camera is recalled here not to draw a direct parallel between the popular use of the television camera in the island and the video light but to ask how video light might uniquely generate a different political realm at the nexus of public space, the camera, and light. This reconfiguration of the political should be seen against the backdrop of the many grievances aired through uses of the television camera and broadcast media that testify to a chorus of quarrels with the state, the unfulfilled promises of the government in the post-Independence era. The video camera and its light in dancehalls foreground the generation of different subjectivities and the formation of distinct forms of self-representation in an era in which many avenues of political representation, in the more conventional sense of state institution and party politics, seem limited. The broader practice of video light may indeed offer a popularly construed system that allows widespread access and is responsive to and reflective of communities who have been disenchanted by the system of representative democracy. The video cameraman, his camera and its light, and the screens have installed an entire system of representation in the dancehalls in which different people have shared access to the technologies that represent them, which reflect their presence in and through a transparent visual feedback loop. The video light and its material and ephemeral manifestations are simultaneously about an insistent visibility and unvisibility, about the possibilities and limits of representation, political and visual. New formations of community have been visualized and created locally and globally through video light bringing to light specific individuals and groups. At the same time, the camera and video light do not shine on everybody or in the same way, and visibility through the technology has been tempered depending on gender, sexuality, and skin color. However, video light brings with it the possibility of the new, the never before seen, the transforming and in-formation subject that arguably opens the space for the disruption of the status quo. Through the visual light in the dancehalls, notions of center and periphery, local and diasporic, race and gender, body and photographic image, and excessively visible and un-visible remain in flux.

3

SHINE, SHIMMER, AND SPLENDOR

African Diasporic Aesthetics and the Art
of Being Seen in the Bahamas

Blackness would come to rest in the eyes; blackness a way of seeing
and being seen.
—**John Edgar Wideman**, *Sent for You Yesterday* (1983)

The spread of commodities into new areas often creates new economies
of prestige and undermines traditional social hierarchies.
—**George Lipsitz**, *Dangerous Crossroads* (1994)

In the summer of 2004, a young girl emerged from her limousine in
front of a grand hotel amid a hail of blinding flashes. Stepping onto the
red carpet, she raised her gown ever so slightly so that it would swirl
gracefully around her like a satin cloud. As she strode forward, a sea
of photographers parted. Their shutters snapped at her heels, creating
a barrage of light and sound. Suddenly a young man pushed through
the army of photographers and lunged at the young starlet. As she at-
tempted to fend off her assailant, the roar of a motorcycle engine inter-
rupted the scene. Its rider, in a few swift moves, tossed the offender
aside. He then extended his arm to the young damsel, and they walked
into the hotel together under a bright canopy of camera flashes.

Although reminiscent of celebrities' red carpet arrivals at the Oscars
or the choreographed theatrics of a music video, this dazzling entrance
took place far from the bright lights of Hollywood. It occurred at a high
school prom in Nassau, Bahamas. In years past, students attended
their proms there without fanfare. Since the late 1990s, however, prom
entrances—students' arrivals at the prom venue—have become theatri-
cal happenings. Prom-goers stage grand entrances: preceded by motor-
cycle motorcades, atop decorated vehicles, or helicoptered from on high,
often at great expense (fig. 3.1).[1] Entourages of attendants, trumpeters,
dancers, or photographers frequently accompany the extravagantly

3.1. A prom attendee arrives at the hotel, St. Augustine's College prom, Nassau, 2008. Photo by author.

attired prom attendees, who are typically seventeen or eighteen years old. The entrance is not simply the dramatic staging of one's arrival but also involves a pageant-like parade down a red carpet before entering a hotel. Inside, the prom-goers join their peers and watch the remaining arrivals on wide-screens, eventually bestowing on one of them the title of "best entrance." Clearly, the entrance is in fact the prom's main event.

These glittery cultural manifestations invite a number of questions. What factors account for the recent popularity and pageantry of the proms in the Bahamas, especially "the entrance"? What exactly do prom-goers enter into when they stage these public presentations, these elaborate performative self-portraits? What visual cultural models do they draw on to stage an effective entrance? What might the spectacularization of the proms reveal more broadly about structures of visibility and their obverse in postcolonial Bahamian society?

While local and global influences, including celebrity culture in America, dancehall culture from Jamaica, and masquerade traditions in the Bahamas, inform the pomp and pageantry of the proms, one cultural source is most audible and visible at the event: black Ameri-

can hip-hop culture. Not only does hip-hop provide the literal sound-track for many of the entrances—with hip-hop music boomed from car sound systems—but hip-hop's visual cultural expressions are especially pronounced, as prom-goers emulate the displays of conspicuous consumption found in contemporary expressions of the genre. Young male prom-goers don fashions made popular by hip-hop stars, stepping out, as one local newspaper put it, "in pimp daddy suits looking richer than these rappers."[2] Prom participants arrive in luxury automobiles, stretch Hummers, or rides that have been "pimped out" with butterfly doors and shiny rims, all popular vehicles of visibility and prestige in hip-hop. As young people in the independent nation consciously draw on the cultural expressions of their African American neighbors to the north, the entrances provide points of departure for considering contemporary types of African diasporic formation—the ways people of African descent across national boundaries gain knowledge of, and express affiliation with, other diasporic groups. This chapter considers the distinct expressions born out of the conjuncture of African diasporic urban cultures in the twenty-first century.

The proms have also become flash points of anti–African American or anti-hip-hop sentiment.[3] Indeed, government officials have sought to discourage the more spectacular manifestations of the proms, urging parents to practice "prom temperance," in part because many prom-goers appear to emulate displays of materialism and conspicuous consumption common in contemporary expressions of hip-hop.[4] From the press to the pulpit, critics lambaste the extravagance of the affairs, accusing the students—many of whom attend the free public school system and come from the more economically disadvantaged classes on the island of New Providence—and their parents of emphasizing spectacle rather than scholarly substance. The entrances, and the controversy surrounding them, explicitly illuminate how visual forms from the African diaspora can challenge, circumvent, and newly configure postcolonial formations of nation, culture, art, morality, and blackness. More specifically, the proms reveal how visual expressions of hip-hop offer black Bahamian youth a model of visibility, a spectacular way of being seen that dramatizes their tenuous position in local hierarchies of prestige and spectacles of national culture, such as the much-celebrated festival of Junkanoo.[5]

In this chapter I will contextualize these proms in relationship to other visual practices in postcolonial Africa and in former British colonies. The staging of the photographic moment in some prom entrances

will be considered in light of the work of Olu Oguibe and Christopher Pinney, who have explored postcolonial representational models in parts of Africa and India, respectively, particularly through photography.[6] I will also draw on film historian Manthia Diawara's analysis of how youth in independence-era Bamako, inspired by African diasporic aesthetics (particularly those from black America), inhabited photography in more theatrical, almost cinematic, ways.[7] In light of these theoretical perspectives on postcolonial picturing and performance practices, I posit that the proms may also be demonstrative of young Bahamians' search for a new means of self-representation that draws on representational vocabularies from the African diaspora, especially from black America. The proms, unlike Oguibe's and Pinney's examples, which the scholars view as a response to colonial forms of image-making, are not so much anticolonial as postnational, manifestations of a turn away from national expressions of visibility, culture, and blackness.

Performing Visibility and the Visual Practices of the African Diaspora

These prom entrances underscore the intrinsic importance of specifically visual modes of representation in contemporary formations of the African diaspora. I build here on the work of scholars who have explored how music and sound are intrinsic to what Manthia Diawara describes as a "diaspora aesthetic . . . because it was defined beyond a national boundary and it united black youth through a common habitus of black pride, civil rights, and self-determination."[8] What happens, I ask, to processes of African diasporic formation when musical expressions circulate through visual forms? When the image becomes intrinsic to processes of diasporic translation, how are practices of diaspora transformed?

An act of censorship in the Bahamas that occurred in 2004 supports the idea that visual forms of expression are primary vehicles of communication between groups in parts of the African diaspora. Under pressure from the Bahamas Christian Council, a powerful council of religious leaders, and another group calling itself Members of the Radio Cabinet, the local cable company removed the BET network—an American channel targeting African American audiences—from its basic cable offerings. Members of the Radio Cabinet maintained that the content of the channel, which primarily plays hip-hop and rap music videos, was "not in keeping with the mores of The Bahamas."[9] "Our children's develop-

ment," they feared, was being "[put] at risk by exposure to some of the events of BET."[10] I will sidestep for a moment the questions of morality and who is able to define and defend these ideals in the context of the Bahamas so as to focus on the authorities' specific targeting of the "video portion" of BET—the *visual* transmission of music—as the source of the social contagion or corruption of the nation's youth.[11] This singling out of black American music video programming, without any corresponding effort to ban the broadcast of hip-hop on radio or its availability in record stores, suggests that authorities perceived something many scholars have not—that young people across black urban communities consume hip-hop not lyrically but visually, or through a powerful combination of the visual and the auditory. The censors recognized the primacy of the visual in contemporary formations of the African diaspora.

While I maintain that visual expressions, such as music videos, the street photography studios, and CD covers, are primary means through which contemporary African diasporic expressions circulate, I aim to go further than merely making the case that "the master signifiers of black creativity, sound and hearing[,] have been supplanted by eyes and visuality," as Gilroy acknowledges.[12] In this analysis I will take up Gilroy's largely unexplored supposition that "the comprehensive dominance of video and visuality" will likely "produce different subjects differently."[13] Diasporic subjects are indeed produced differently through visual means and express themselves through visual practices. Black urban cultures throughout the circum-Caribbean engage in shared "performances of visibility," practices that are about staging being seen and, more specifically, being seen in the process of being seen or represented. Performance acts that capture the optical effect of being represented, the moment of being photographed, are part and parcel of this contemporary visual language of the African diaspora.

These approaches to visibility are encapsulated in the paparazzi entrance described earlier. The young woman, Eartha Hanna, who staged an appearance on the red carpet flanked by photographers and crazed fans did so primarily to create a spectacle of being photographed. She aimed to be seen while being the subject of the photographers' flashing lights, the enviable focus of their snapping shutters, the prestigious occupant of a space where images are made and stars are illuminated. Remarkably, given that she enlisted professional photographers and photojournalists on the island to line her red carpet, the material documents of the event that these professionals might have provided—actual photos—were beside the point. When asked for photographs of the red

carpet entrance, she replied that she had none and was unconcerned about whether any photographs had been taken.[14] Rather, because her choreographed entrance was about *being seen being represented*, the performance of being photographed was its own representational end. Many other prom participants, with or without hired paparazzi, have expressed the same apparent indifference to the idea of capturing their spectacular entrances in actual photographs or video.[15] Cisco McKay, a prom-goer who staged a grand entrance that included fifteen outriders, for instance, did not have or desire photographic images of it.[16]

On occasion, prom organizers hire videographers to film students as they arrive at the prom venue. The videographers' primary task is not simply to record the moment but to project the entrances onto wide screens that are displayed to spectators (who often, restrained by police barricades, crane to see the entrances) and to participants inside (who congregate around the screens to observe their peers). The videographers' cameras allow for a choreography of visibility in all the entrances. Participants may watch themselves being seen—filmed—and luxuriate in its effects. They make a spectacle of spectacularity at the event. Such performances of visibility without accompanying investment in material visual representations suggest that while the prom-goers are clearly tuned in to the cult of celebrity in America's mainstream media, they approach image-making differently. Their desire to produce the effect of being represented yet lack of interest in images of the entrances and their use of paparazzi who take no pictures is reflective of more widespread approaches to visuality among black urban cultures, particularly among young persons tuned in to the visual frequencies of hip-hop and local public displays of prestige. The logic of the visual in hip-hop, I maintain, informs this interest in the visual effect of being photographed as its own form of representation.

Bling: Art of Conspicuous Consumption

The form and content of the prom entrances take many of their cues from contemporary hip-hop: specifically, manifestations of this forty-year-old genre that have been popularized since the late 1990s, when the more spectacular proms began. Many rappers, particularly those who have gained unprecedented global visibility in the last decade, have fashioned their personas and prestige through performances of conspicuous consumption. Such spectacular performances have included Diddy's famed red carpet entrances by yacht or helicopter, the pimp

stylings of bejeweled and chinchilla-wearing rappers like Snoop Dogg, and the over-the-top displays of foot-high gold medallions in the self-stylings of rappers like Ghostface Killah.[17] Some critics and scholars bemoan these recent materialist, individualistic, and even hedonist manifestations of hip-hop's bling-bling aesthetics.[18]

Materialism in hip-hop has a long, complex, and still evolving political history.[19] The wearing of flashy jewelry in black performance, of course, has precedents. In the early 1970s American soul singer Isaac Hayes draped himself in gold chains, "taking a symbol that had for so long meant slavery, entrapment and turned their meaning around," he said.[20] Queens-based rappers Run-DMC made a fashion statement wearing rope chains in the 1980s. Slick Rick, a British-born rapper of Jamaican descent, also became identified with a copious amount of jewels in the late 1980s. But it was in the late 1990s, I would suggest, when rappers highlighted their jewelry not just as accessories but as products that affected vision. These more recent manifestations of conspicuous consumption may be different from earlier expressions in that they do not simply convey excessive wealth but constitute an optics. Rappers, through lyrical, performative, and visual means, have formulated a distinct visual language that frames how they and their possessions should be seen by audiences, and how the particular formal qualities of these commodities represent prestige. This way of creating status visually informs the practices and politics of diaspora in the Bahamas.

An example that encapsulates how practices of conspicuous consumption in contemporary hip-hop frame a set of approaches to consumer goods and representation may be found in images related to rapper (and CEO) Jay-Z (Shawn Carter). In the early 2000s, Carter popularized a signature use of a hand gesture, the "ROC" sign, which simulates the shape of a diamond.[21] Carter first started using the diamond shape as a symbol for his company, Roc-A-Fella Records, and its three partners, but the sign soon became his trademark, a sign that he flashed on the red carpet or onstage and that audiences repeated in performative call-and-response. The cover art of Jay-Z's single "Show Me What You Got" (2006) suggests how the rap mogul's symbolic display of the diamond evokes the effect of light and frame of visibility (fig. 3.2). In the image a radiating orb of light emanates from the middle of fingers held in the shape of a diamond, suggesting that the gesture is about the imaginary possession of a jewel and about the evocation of its visual effects. The gesture also recalls an impromptu framing of a view with one's fingers — a snapshot without a camera, a picture momentarily en-

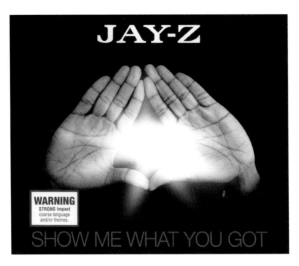

3.2. Cover art, "Jay-Z: Show Me What You Got," single, 2006. Roc-A-Fella Records and Def Jam, LLC, New York.

framed. This aspect of the gesture is suggested toward the end of the music video for the song, in which the rapper looks through the ROC sign out at viewers, framing them within his fingers. The viewers, in essence, see themselves being seen, virtual inhabitants of the frame of Jay-Z's hand, as they simultaneously see the rapper enframed, the center of the diamond. The gesture serves as another example of how visuality, both the diamond-like visual effect of light and the interest in being seen or being represented, are common in the visual languages and practices of contemporary hip-hop.

The ROC sign, involving gesture, pose, diamond, and light, is part of hip-hop's bling culture. While bling pervades the gestures, lyrics, album covers, and magazine photos of later forms of hip-hop, it perhaps most explicitly took visual form—came quite literally to light—in music videos. Cultural critics often credit the influential cinematographer-turned-director Hype Williams with creating a particular look to hip-hop music videos, precisely by using the aesthetics of money, flash, and shine.[22] Starting in the late 1990s, Williams began to direct videos that used light as a central subject and form, and his visual brand came to define hip-hop for more than a decade. He often focused on shiny objects—the glossy curves of luxury automobiles, the sparkle of jewelry, the shimmering surface of black female skin. Indeed, in some music videos the reflective surface played a leading role. In the video "Drive Slow," for example, which Williams directed for the Chicago rapper

3.3. Hype Williams, video still from *Drive Slow*, music video for Kanye West, 2006. Courtesy Roc-A-Fella Records.

Kanye West in 2006, the narrative unfolds as a sequence of images reflected on the surface of a car (fig. 3.3). The video takes viewers on a tour of a brightly illuminated cityscape at night as it appears reflected on the rapper's automobile.[23] In other words, not only are objects that display bling's shine the focus of representations in hip-hop, but the shiny surface is, in some instances, the very site of visual production.

While the optical effect of light and surface reflection are intrinsic forms in the projection of power in hip-hop, the diamond and its dazzling effects are also sites of critical reflection in rap music and its visual manifestations. For instance, in his lyrics and music videos, Kanye West (a Roc-A-Fella Records producer and a rapper) calls attention to the ironies of hip-hop's shine. Most explicitly, in the remix of the song "Diamonds from Sierra Leone," released in 2005, West highlights the sordid connection between the "diamonds, the chains, the bracelets, the charms" that shine in hip-hop and a global economy that consumes blacks and makes them into consumers, whether the diamond trade in Sierra Leone or the drug trade in the Americas.[24] Against the graphic depiction of violence in the diamond mining industry in the video for the song, which Hype Williams, the master of shine, directed, West lays bare his conflicted relationship to his desire to "keep shining." "It's in a black person's soul to rock that gold," he contends in the song. "Spend your whole life trying to get that ice. . . . How can somethin' so wrong make me feel so right?" Lyrically, he suggests that the aspiration for gold is in the soul of black folks and questions how a yearning that brings so much satisfaction could simultaneously be so unethical.[25] As presented in West's video, bling's aesthetics are simultaneously about soul and

gold, about structures of diasporic feeling and sentiments of personal desire, about diasporic aesthetics and global markets. In this case, the optics of shine in hip-hop expresses a diasporic politics that highlights the connection of African diasporic populations to each other and to the global economy.

"Shinnin', Shimmer, and Splendour" and the Practice of Diaspora in the Bahamas

Despite some local groups' efforts in the Bahamas to unplug hip-hop, many young people in Nassau tune in to the genre, especially its visual expressions that are beamed in music videos, presented in the glossy pages of American magazines like *Vibe* or the *Source*, or represented in the entertainment sections of local papers like the *Punch* or the *Confidential Source*.[26] Young prom-goers specifically identify hip-hop music videos as favored and influential forms of popular culture.[27] They have been able to access music videos freely on the Internet and other music channels since cable came to the island in 1995 and local video shows such as *Electric Air* (1989–2000) started being shown on the local station. Prom participants on occasion play music videos inside their vehicles during their entrances, using the source of their imaginings and ideals about black America as the literal and figurative backdrop of their performances. At the C. R. Walker Senior High School prom in 2006, for example, a video of Lil Wayne, a rapper from New Orleans (originally partnered with B.G. of the Cash Money Millionaires), played on the multiple television screens inside an Excursion limo (which looked like a stretch Hummer) as part of a grand entrance. Many prom participants also incorporate objects that sparkle in hip-hop videos—from shiny cars to (cider-filled) champagne bottles—as props in their performance repertoires. What is most pertinent here, however, is not simply that youth see and emulate hip-hop music videos but also that these forms translate approaches to visibility—the efficaciousness of the effect of light and the prestige of the frame of representation.

While the prom entrances are certainly about showing one's status through the fashions, fancy cars, and outré displays of conspicuous consumption found in the rap industry, the performances demonstrate that many black young people are conversant with the deeper structures of visuality inherent in hip-hop. Prom-goers convey or enhance their distinction by creating bling's spectacular effects. A banner that appeared at a preschoolers' prom in Nassau brilliantly reflects how

3.4. Dandy Lion Preschool float with the words "Shinnin', Shimmer, and Splendour," Stapledon Gardens, Nassau, 2006. Photo by author.

prom-goers speak to and through hip-hop's visual aesthetics and illuminates how the culture of proms and hip-hop is pervasive among even the youngest Bahamians and their parents. The preschool banner read "Shinnin', Shimmer, and Splendour," in gigantic glittered cardboard letters (fig. 3.4). The words appeared on the lead float of a motorcade that moved slowly and noisily, blaring hip-hop, through the streets of Nassau one bright June afternoon in 2006. The motorcade with its sparkling banner served as a precursor to, and more visible extension into public space of, the prom entrances. The words emblazoned on the banner, I maintain, literally spell out the broader purpose of the entrances: what the young prom-goers and their parents aimed to produce. The children, like their teenage counterparts, participated in the entrances, dressed like "pimps" (as one mother described her preschooler's attire), or appeared in shiny automobiles with the intent of producing bling's shine (fig. 3.5).[28] Indeed, it is possible that the abbreviated slang term in the banner, "shinin'," aimed to represent both the spoken and the visual vernaculars of hip-hop. The banner's pronouncement and the medium of its message, involving glitter and a shiny surface, suggest that prom-goers and organizers were schooled not only in which objects garner prestige in hip-hop but also in how the shimmering effects of light convey splendor.

3.5. Young participant in the Dandy Lion Preschool float, Stapledon Gardens, Nassau, 2006. Photo by author.

Although prom-goers and their parents may spend hundreds or even thousands of dollars on the entrances and months if not years planning the occasion, some of them achieve bling's optical effects through creative and not necessarily costly means. Dressing choices, for instance, may be tailored to shine at prom. Local dress and fabric stores highlight these aesthetic preferences when the materials they advertise for the occasion are "beaded sequined fabrics," "iridescent taffeta," or "lamour."[29] Young women wear a "tiara and rhinestones or glitter," as one hairstylist observed, or, less commonly, braid flashing lights into their swept-up 'dos.[30]

Prom-goers' dramatic production of shine is not limited to personal appearance but extends to the entire mise-en-scène of their performances as well. At the 2006 C. R. Walker Senior High School prom, for instance, one young couple heralded their entrance with the use of dry ice, which their car's headlights dramatically pierced. Another couple arrived in a stunningly bright green car that was "tricked out" with spinning rims and gift-wrapped in red ribbons, its butterfly doors raised up like the wings of a futuristic bird. These doors, which contained many of the speakers of the car's elaborate sound system, not only filled the space with a sonic vibration that spectators could feel but put sound—and its means of production—on view. Following a performance by three young

male dancers, the couple that emerged from the car made an equally loud statement (figs. 3.6–3.10). The young woman wore a shimmering, shocking-orange outfit with a high collar and headdress, reminiscent of Carnival costumes and Jamaican dancehall stylings, while her date sported pimp fashions. Through a combination of visual, sonic, and performative means, these prom-goers shined in their entrances.

A young woman who arrived at the 2006 C. R. Walker Senior High School prom on a bus provided a playful example of prom-goers' use of hip-hop's shine as a source of prestige (fig. 3.11). She appeared not on just any old Route 10a jitney, a local mode of public transportation; rather, the bus was decorated over the length of its broad square windows with car wax applied in deliberate circular motions over its surface—a method of application that recalls the 1980s, when cars routinely traversed the streets of the capital in this mid–car wash condition. Arguably, the use of wax, a signifier of an automobile's sparkling potential, aimed to both participate in and parody bling's aesthetics. It spoke to bling's language of shimmer and splendor in an innovative way that called attention to the surface of the vehicle, metonymically alluding to that more conventional purveyor of prom shine, the reflective exterior of a car.

The jitney entrance and the general production of bling's aesthetics at the event suggest that the prom appearances, which politicians and media have decried as "the most extravagant displays of materialism and unbridled hedonism," are only in part about conspicuous consumption.[31] Hip-hop's circulation has inspired "new economies of prestige," to use George Lipsitz's term, that may be generated through optical or metonymic means, even in the absence of expensive commodities.[32] While "shinin'" in the Bahamas may be compared with "faking that floss" (the practice of flashing fake jewelry or grills) in the United States, within the Bahamian context, simulating the effects of shine has its own authenticity. By producing bling's optical effects, prom-goers seek to accrue social currency.

The Gender of Light: Queens and Pimps

While male prom participants, even the preschoolers, reflect bling's shine, females tend to convey their splendor and prestige in ways not directly related to hip-hop's aesthetics. The teenage female prom participants typically appear to be much more inspired by the dresses worn by characters in fairy tales than by the pimp stylings of hip-hop. The

3.6–3.9. Entrance of a car at the C. R. Walker Senior High School prom, British Colonial Hilton Hotel, Nassau, 2006. Photo by author.

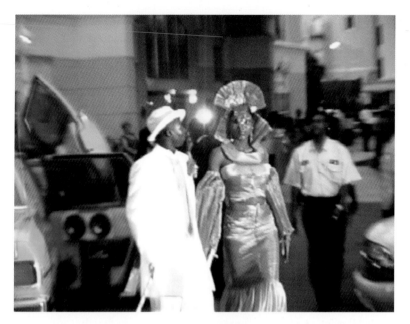

3.10. Young couple at the C. R. Walker Senior High School prom, Nassau, 2006. Photo by author.

3.11. Entrance of wax-covered jitney at the C. R. Walker Senior High School prom, British Colonial Hilton Hotel, Nassau, 2006. Photo by author.

preschool float, in part, speaks to gendered economy of bling. The words "Shinnin', Shimmer and Splendour" were punctuated by a female figure with pink skin and golden hair, who appeared in a shimmering pink bell-shaped dress with long gloves (fig. 3.12). The cardboard figure seems to have floated out of the preschool's fairy tale books to preside as the patron saint of prom or fairy godmother at the event. The fairy tale theme is not confined to little girls' appearances at the preschool proms. At the high school proms young women, outfitted in what a local dress-store manager described as "Cinderella-styled dresses," may fit their feet into glass slippers held on satin pillows by kneeling dates (fig. 3.13) or may appear in horse-pulled carriages transformed into pumpkins. Other young women, modeling themselves on Snow White, arrive in coffins, to be awakened by their Prince Charming.[33] In many respects the paparazzi entrance evoked at the beginning of this chapter can be viewed as a modern-day version of a fairy tale, a female-choreographed performance of rescue and romance.[34] The light from the fairy god-mother's wand, the light of magic, and the light of Prince Charming's smile all offer an alternate paradigm of visual splendor that intersects with that of hip-hop. It is another manifestation of the luminous and transformative effect of light.

The fairy tale aesthetics at prom can also be related to local and Caribbean-wide traditions of crowning queens in such contexts as friendly societies, beauty pageants, or Jamaican dancehalls. Numerous critics have remarked on the limited role of women in hip-hop and its visual manifestations; women often figure as one among rappers' many shiny possessions. It is perhaps unsurprising, then, that many young women turn to or incorporate a different aesthetics of light in their self-idealized performances at prom. Moreover, the performances of fairy tale endings at prom offer strikingly different narratives from those presented in hip-hop's image world. Many scholars have noted the dis-tinct absence of romance in contemporary forms of hip-hop and R&B: in these contemporary forms of black music, in Gilroy's words, "the love is gone."[35] Some young couples participating in the proms, however, re-write hip-hop's script, giving romance a starring role in the entrances.

Hip-hop bling and fairy tale shimmer were both in evidence in an en-trance I filmed in 2006 as part of a documentary on the proms (fig. 3.14). For this arrival, a male attendee stepped out in a hip-hop-inflected de-signer suit—that "look of P. Diddy, or Puffy," popular at the time, ac-cording to one stylist.[36] The young man also sported a diamond-studded

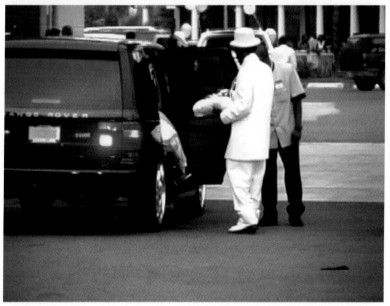

3.12. Dandy Lion Preschool float, Stapledon Gardens, Nassau, 2006. Photo by author.

3.13. A Cinderella-style prom entrance, Nassau. Video still, 2006. Video by author.

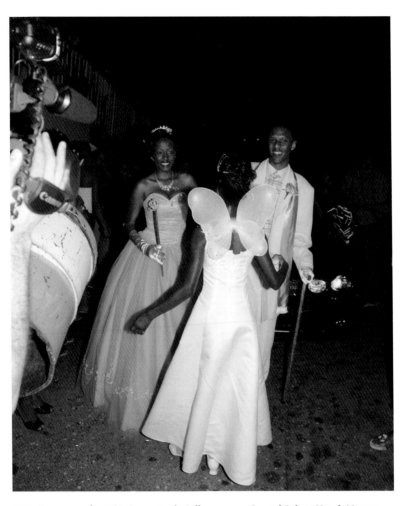

3.14. Young couple at St. Augustine's College prom, Crystal Palace Hotel, Nassau, 2006. Photo by author.

cane, a popular prop in hip-hop. His date appeared in a shimmering bell-shaped dress that made her look, as she described it, "like a princess."[37] Before the young couple emerged from a Rolls Royce, a little girl outfitted like Tinkerbell with delicate sequined wings emerged from their vehicle with a basket of glitter that she scattered in an arc into the crowd, like fairy dust. Bling and fairy dust were, in effect, participating differently in the gendered aesthetics of shine.

Ironically, I became aware of, and indeed a facilitator of, the manipulation of the visual effects of light during the course of the shoot when a relative of the pair pulled me and my small camera crew, despite our reluctance, into the very path of the entrance. Unwittingly, we ceased to document the event and were instead co-opted into the entrance. The lights from our cameras brought further illumination of the prom-goers' shinin' appearances. The orchestration of our cameras as parts of the entrance brings into view how being seen and being seen being represented, how being at the nexus of photographers' lens and snapping shutters and the center of onlookers' stares and cheers, the subject of photographic representation and representational inscription, are intrinsic to the performance frame of the proms.

Lights, Camera, Action: The Photographic Afterimage as Representation

The transformation of the prom entrances from "subtle social events" into "what can only be described as a spectacle," as one newspaper put it, has typically been attributed to overexposure to America's celebrity culture.[38] Local observers often view the spectacularization of the proms, which started in the late 1990s, as attempts by youth to mimic the "Oscars or Grammies."[39] One newspaper, for instance, drew comparisons between the "exorbitant [prom] pageantries," which some spectators arrived hours in advance to see, and "Hollywood movie premieres."[40] It also laid blame for the pageantry of the proms closer to home, chastising a local cable channel for promoting the elaborate proms by hosting the program *Prom Idol*, a Bahamian version of the US-based *American Idol*.[41] A local cartoonist, Jeff Cooper, created a more sardonic take on the spectacle of the proms, likening the red carpet entrances to a "circus" in which the prom-goers aped American styles of dress (fig. 3.15).[42] The male figure in Cooper's cartoon notably dons a top hat in the spirit of Uncle Sam, with a star and stripes, while his female companion's ap-

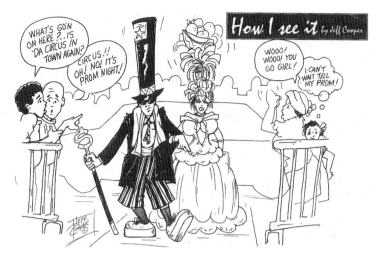

3.15. Jeff Cooper, "How I See It." Editorial cartoon. *Tribune* (Nassau), June 22, 2004, 5.

pearance invokes simultaneously Carmen Miranda and "national" dress across the Anglophone Caribbean. In other words, the way the cartoonist sees it, the spectacle, the prom circus, was a response to and reflection of American fashions and forms of visual culture, from Barnum and Bailey to the contemporary media circus.[43] That America's media and celebrity culture influences Bahamian prom is undeniable, especially when some students, as a local newspaper feature described it, "mimic Hollywood productions, involving 'secret police' men pulling up in black suvs, a 'crazed fan' dressed in camouflage, [with] throngs of paparazzi."[44] But arguably, the prom-goers do not so much mimic Paris Hilton as model themselves (as hinted at in the cane mounted by a dollar sign in the cartoon) on Diddy's staged appearances or Jay-Z's or West's diamond. They do not simply set out to occupy an imagined red carpet but use the carpet, drawing on or inflecting the conceptual and perceptual strategies of hip-hop, as a space to bask in the splendid light of visibility, to make a spectacle of being seen and being represented. Prom-goers produce the visual effects of their moment of dazzling visibility. Unlike conventional Hollywood event entrances, which afford the production and dissemination of images of the red carpet, at prom the photographers' flashes are their own representational ends. Prom-goers approach the entrance as a space of representational becoming and produce the aftereffects of their emblazoned visibility—shine—as its own image, its own pro-

nouncement of status. They aim to be bathed in or produce shimmering light, illuminated by the cameras' blinding flashes, surrounded by the approving sounds and sights of their visibility. While not all prom-goers epitomize the process of making one's visibility visible as much as the dramaturgy of the paparazzi entrance does, prom attendees often express an interest in being seen being seen or represented.

Dress stores capitalize on this fascination with inhabiting the frame of representation, advertising that their fashions are "paparazzi-approved," sure to elicit the self-assuring sounds and effects of visibility, while other ads simply promise prom-goers "the look."[45] In short, hip-hop provides the lens through and in which youth view, reenvision, and project themselves through globalized American structures of celebrity culture. It is this desire to occupy the site of representation and to display its optical effects, to make a performance within and out of the light of visibility, producing the moment of shinin' as its own end, that, I maintain, participates in the logic of the visual in hip-hop.

The influence of black American visual expressions on youth in the Bahamas recalls Diawara's analysis of the impact of African American culture on young people in Bamako, Mali, in the 1960s. Focusing on the photographs of Malick Sidibé, he argues that the poses of soul music icons like James Brown not only inspired new approaches to fashion and self-fashioning but radicalized the ways youth thought about and inhabited representation, most notably the photograph.[46] This is evident in Sidibé's photograph *Soirée de Mariage Drissa Balo* (1967), which portrays a young man posing with a 45 (fig. 3.16). He appears to be in the midst of movement, indeed heading to the left of the photograph, with his action centered around the record. In contrast to the staid and composed studio portraits their forebears had arranged, like those orchestrated by Seydou Keïta, Diawara explains, the youth in Sidibé's photographs, who were energized by the sounds and sights of the likes of James Brown, wanted to be represented in and inhabit photographs in an active, almost filmic way. They eschewed the artifice of the studio photograph, which they associated with the pretensions and bourgeois aspirations of an older generation. They demanded instead "a new photography that portrayed them as actors in situations," favoring more animated, candid snapshots of themselves.[47] A half century later, the visual cultures of hip-hop generate another diasporic aesthetic, informing and transforming black youths' understandings of their relationships to representation, and specifically to photography. Prom-goers in

3.16. Malick Sidibé, *Soirée de Mariage Drissa Balo*, 1967/2008. Gelatin silver print, image size 20¾ × 14 in., print size 24 × 20 in. MS09.025. Courtesy of the artist and Jack Shainman Gallery, New York.

the Bahamas use the approaches to visuality in hip-hop to inhabit the photographic medium in a dynamic way, as did youth in Bamako, but they use the entrances to produce the effects of being the photographers' subject.

The prom-goers' staging of the infrastructure and mechanics of photographic representation also bring to mind Olu Oguibe's and Christopher Pinney's discussion of the "substance of the image" and "surfacism," respectively, in the African context—how photographers and clients both valued and visualized the material and illusionistic properties of photographs in vernacular picture-taking practices.[48] Both scholars highlight how in different African and Indian contexts the ability of photography to create illusion through its constitutive components—surface and light—was intrinsic to local understandings and uses of the medium in many parts of West and East Africa. Pinney cites Seydou Keïta's celebrated studio photographs of mid-twentieth-century Malian society as archetypical of surfacism. The patterned back-

3.17. Seydou Keïta, untitled, 1956/1957. Gelatin silver print. Courtesy CAAC — The Pigozzi Collection, Geneva. © Seydou Keïta / Truck Archive.

drops of Keïta's photographs were often combined with the clothing of his clients to form a single visual plane, one that results in an image that seems simultaneously flattened and bursting forth through the surface of the photograph (fig. 3.17).

Young people in the Bahamas express, in very different ways from the surfacism Pinney describes in Mali, an interest in the constitutive material qualities of the photograph and its aftereffects, but their modes of representation often reside outside the physical properties of the photograph. By creating afterimages — the fleeting, evanescent effects of being seen being represented — and by using the substance of images and objects, light and shiny surfaces, as props, they produce a new type of image and self-representation.

The Substance of the Image and Colonial and Postcolonial Critiques

The proms also respond to and reflect social structures and visual traditions in Bahamian society. The remainder of this chapter demonstrates that the premium placed on spectacularizing visibility in hip-hop not

only informs performance and picturing practices in Nassau but also highlights for young people the domain of visibility as a sphere that matters, socially, politically, and aesthetically. It has made black youth cognizant of how they can and *that they should* assert their visibility in their local surroundings. While youth in Nassau may draw heavily on hip-hop's lexicon, they do so in ways that speak to and through local visual languages in postcolonial Bahamian society.

Pinney again provides a particularly useful counterpoint for examining the relationship between the substance of the image and post-colonial formation. He suggests that the emphasis on tactile surface effects in photographs, seen in photographs like that of Keïta, offered an alternative to, if not eschewal of, colonial forms of representation. He contends that "what all these surfacist strategies [in India, Africa, and Latin America] have in common is their emergence in specific postcolonial contexts as expressions of identities that in complex ways repudiate the projects of which Cartesian perspectivalist images are a part."[49] He interprets the foregrounding of surface as a repudiation of colonial representational traditions and the broader sociopolitical practices from which they stemmed. Diawara, in what might be viewed as an expansion of Pinney's arguments, views youth's reenvisioning of photography in Bamako as a rejection of both colonialism and the "teachings of independence, nationalism, and tradition."[50] The photos from the 1960s, he maintains, reflect how youth approached newly the habitus, modernity, and (precolonial) African culture, often at odds with the state's conceptions of and policies surrounding these ideals.[51] Youthful Bahamian prom-goers, who also engage in practices that mobilize the "substance of the image," similarly use diasporic aesthetic strategies to reconfigure post-Independence ideals of nation, modernity, and black cultural traditions.

To understand the recent spectacularization of the prom entrances and the ways they respond to the island's postcolonial politics, it is necessary to understand something about the uniqueness of the proms in the English-speaking Caribbean and their connection to the island's colonial history. The Bahamas is the only former British colony in the Caribbean where local people celebrate school proms. Geographic proximity to the United States (the islands lie just off the coast of Florida), the presence of an American expatriate community, and the popularity of American television all likely influenced the adoption of this American custom.[52] Young people in Nassau, the islands' capital, started participating in the events soon after the Bahamas gained independence

from Britain in 1973.[53] Although these early proms were held in hotels, they otherwise lacked the fanfare, fancy cars, and financial costs of their more recent manifestations.[54] Students commemorating the event had their photographs taken in makeshift studios set up inside the prom venue. Not coincidentally, Bahamian youth started to celebrate the prom—a rite of passage into maturity—precisely when the long-dominant British colonial social and cultural values were losing their prestige, when newly independent young Bahamians sought new models of modernity, modes of self-fashioning, and means of imagining the nascent nation. In the context of the Bahamas, the institution of the prom was explicitly linked to a national coming of age.

Given this history, how might the more recent shift in the proms from an American model to a decidedly African American one be explained? If the origin of the proms may be related to a break from colonial rule, a turning away from British to American models, what, if anything, can be made of the spectacularization of the proms, their hip-hop-inflected aesthetic? I will suggest that the recent change in how youth represent themselves in the event—reminiscent of the early proms, which responded to anticolonialism and emergent nationalism—signals what Anthony Appiah describes as a "space-clearing gesture," a shift away from if not repudiation of the national project.[55]

The Bahamian government's recent efforts to censure or curtail the extravagant entrances highlight the seemingly antithetical relationship between the proms and the nation-state and the set of values that purportedly define postcolonial Bahamian society. In 2004 (the same year the cable company took BET off basic cable), the minister of education, Alfred Sears, denounced the proms at a press conference, decrying the thousands of dollars spent on the entrances, rather than on education, as displays of "misguided priorities."[56] "My view," he continued, "is that we have to always maintain a disciplined view as a country and maintain an element of proportionality."[57] Nicolette Bethel, anthropologist and then director of cultural affairs at the Ministry of Youth, Sports, and Culture, subsequently qualified the government's position. She explained that the government was not necessarily trying to stop the proms but was urging students and their parents to make them "less elaborate."[58] In essence, they sought to lessen the financial and social investment in the entrances. While the government's concerns might not be unwarranted, the ministry's antiprom mandate seems an unusual—and arguably disproportionate—target of governmental policy or policing. It underscores just how much the proms, recalling

the minister's words, appear to trouble national "priorities" and principles of "discipline." The government's coming out against the proms had a notable repercussion; it politicized the form as antiauthoritarian. Many entrance debutants or prom spectators whom I filmed in 2006 were cognizant of the government's desire to "stop" or "ban" the proms, as they invariably characterized it, and perceived their participation in the event as decidedly counter to the government's position and, perhaps, its national priorities.

The governmental response to the entrances must be contextualized in the more generalized criticism of the proms in newspapers, on radio shows, and by educational leaders, who have invariably characterized the "trappings and glitter" of the proms as reflections of nothing short of a moral crisis.[59] As one principal dramatically put it, "This [the prom] is a moral issue that is impacting the school system. This is a reflection of the moral decay of societal values."[60] An editorial similarly bemoaned that the prom "brings into clear, but frightening focus, the changing values in our society and may explain, in part, the basis for some of the more vexing socio-economic problems in our youth community."[61] The newspaper argued that Bahamians had to "change our focus immediately from the extravagant materialism to truly developing positive values for our youth." In all instances, critics thought the extravagant prom entrances brought into view—into "frightening focus"—the disappearing values of Bahamian society, often identifying prom attendees as working-class youth who attended the island's public schools.[62]

The criticisms of the proms, taken together with Sears's words, throw into relief the "positive values" seemingly diminished in the entrances. As the latter editorial implored, "If we are to instill in our youth the tried and true values of hard work, discipline, integrity, fair play and an honest day's pay for an honest day's work, would it not be more meaningful to expend instead [of on proms], the same effort, time, energy and resources (both human and monetary) in helping them raise their grade averages?"[63] These comments, emphasizing the virtues of hard work, discipline, integrity, fair play, education, and an honest day's pay, are all in keeping with the mores of middle-class "respectability," the overused yet indispensable term that encapsulates so well the pillars of Caribbean middle-class society, the "tried and true" British-instilled ethics of work, thrift, discipline, education, and "purposeful self-construction," as anthropologist Peter Wilson describes it.[64] Local critics contend that the positive and purposeful values of education are essential to developing the nation and its global competitiveness and cast the "frivolous"

investments in the momentary spectacle of the proms as portraits of and precipitators of a decaying modern and national society.

Observers who denounce the proms as embodiments of qualities that are decidedly not "respectable" may in fact have identified an important aspect of their meaning. The prom entrances, I would argue, can be interpreted as self-constructions that circumvent local social structures of respectability by projecting social status and material worth through the optics of hip-hop. Recalling Diawara's work on how diasporic aesthetics provided a model for youth in Bamako to inhabit and invent a sense of personhood outside of colonial and national models, hip-hop's visual language and American celebrity culture more generally offers Bahamian youth a form through which to reenvision and emblazon their identities outside of the "tried and true" strictures of respectable postcolonial Bahamian society.[65] At an occasion that is precisely about presenting themselves as young adults, youth at prom come out in ways that veer from and even upstage the national script.

This negotiation around, and perhaps negation of, the national moral economies and social hierarchies through American and African American visual expressions resonates with anthropologist Deborah A. Thomas's findings in contemporary Jamaica, where she found that "people of the poorer set" saw America generally as a place that allows for a social mobility that is not achievable in the more rigid social structures of Jamaica.[66] Jamaica's black working classes often used American consumer goods as "a partial eschewal of colonial and nationalist respectability."[67] Historian Harvey Neptune makes a similar point in regard to Trinidad. He argues that America, and black America specifically, has historically provided a "resource for . . . subordinate locals" to draw on as they seek to "transgress communal borders . . . [and] subvert local authority."[68]

More recently, Neptune suggests, hip-hop has offered Trinidadian youth this resource. This was most publicly manifest in 2000, when Hype Williams shot a music video for Jay-Z in the island's capital, Port of Spain, using the island as a backdrop—a tropical green screen—on which to stage a performance of bling, or "Big Pimpin'," as Jay-Z's track was called. The video's evocation of bling caused controversy when the rapper appeared on a float during the island's annual Carnival and tossed US dollar bills into the crowds. His antics came less under fire than did the response of some young spectators who eagerly pursued the money, like "dogs in heat," as calypsonian David Rudder so plainly described it.[69] To some local guardians of the island's respectable cul-

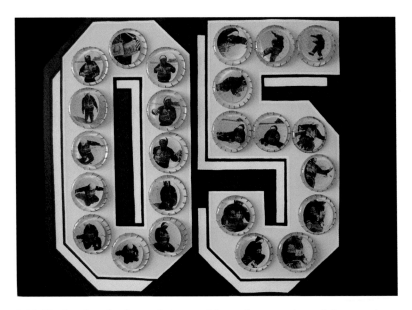

3.18. Che Lovelace, "05," 2001. Latex emulsion, polyester resin, and photographs on canvas, approx. 36 × 48 in. Courtesy of the artist.

ture, this spectacle of Trinidadian youth seemed apocalyptic: "The nation's youth had abandoned their own culture to prostitute ["pimp"] themselves for American money."[70] That the scene occurred at Carnival, the most formidable expression of "national culture" and most public visual spectacle, made the culture clash even more pronounced. The young Trinidadians' naked materialism unmasked, like the proms in the Bahamas, a crisis of national proportions—one that highlights again how the cultures of hip-hop came to occupy or trouble the sites of popular masquerade and carnival. Both the Jay-Z and prom controversies attest to a social phenomenon across the Anglophone Caribbean wherein, as anthropologist David Scott puts it, "the symbols of social solidarity that are understood to give coherence and cohesion to the social and political order" no longer serve as "the generative source of the authoritative signifiers of an approved life."[71] In both instances, the flash of bling, the cascade of money, upstaged the approved signifiers of respectability or sanctioned national culture.

A year after the controversy erupted surrounding the shooting of Jay-Z's music video, Trinidadian artist Che Lovelace created a work that playfully highlighted the ways the spaces and sites where contemporary hip-hop and the postcolonial Caribbean met were filled with contradic-

3.19. Detail from Che Lovelace, "05," 2001. Latex emulsion, polyester resin, and photographs on canvas, approx. 36 × 48 in. Courtesy of the artist.

tions, ones that belied processes of recognition and blindness in the transmission of black urban cultures. The piece, "05" (2001), consists of twenty-four small resin medallions, each containing a small photograph of the artist posing on the beach as if he had just stepped out of a video on *Yo! MTV Raps* (fig. 3.18). The medallions are placed on the number "05," which is printed in yellow on a black background, as on a popular sports jersey. Dressed in the latest hooded hip-hop athletic gear, in each image Lovelace strikes a pose, frequently flashing a comically oversized pendant on a gold chain or designer labels for the camera (fig. 3.19). Dressed in his layers of clothing, the artist as hip-hop devotee at first seems decidedly out of place in the blazing sun, and the fashions and poses appear unfitting on the sand. In this hip-hop fashion shoot, the young hip-hop adherent does not appear on the East Coast or West Coast but on the coast, the geographically nondescript beach turned photo studio. The tropical backdrop similarly seems a product that stands in contradistinction to the man's attire. This work foregrounds the relationship between local culture and the American dollar, between hip-hop culture and its fantasies of the Caribbean, between Trinidad and the wider black diaspora, between the nation-state and the global world, in the wake of Jay-Z's big pimpin'.

Many twenty-first-century youth in the Bahamas use the proms the way their forebears in Nassau did in the era immediately post-Independence: to pursue and present modes of self-representation that transcend the prevailing signifiers of ruling society. While manifestations of conspicuous consumption among young people in the Bahamas (and elsewhere in the region) may be viewed as a capitulation to American capitalism, as a demonstration of a false sense of value, and as an affront to national models of progress and propriety, these expressions may represent what Thomas characterizes as a desire "for a particular kind of modernity that in specific social realms is 'co-produced' with other diasporic communities."[72] The prom entrances are products of this particular kind of modernity, or its reconfiguration, that is created between urban diasporic communities. Hip-hop has transmitted a set of visual languages and bodily practices to black urban populations that they use to participate in "a type of modernity," through which they can be global and modern by being illuminated by light, by inflecting global structures of representation, by sharing in the choreography of visual practices that offer prestige in the African diasporic context. The optics of hip-hop provide a luminous framework that black urban communities across the African diaspora can use so as to see themselves and have themselves seen as modern and global subjects and consumers, a perspective that looks horizontally across the African diaspora rather than upwardly at local social hierarchies. The diasporic dream work of hip-hop's visual cultures in this way brings "a community into being through performance, and it maps out real and imagined relations between people that speak to the realities of displacement, disillusion, and despair created by the austerity economy of post-industrial capitalism."[73]

One of the local criticisms of the proms is that Bahamian students, because they are not following the approved values of the nation, are failing to become prepared to compete globally—to be citizens of the world.[74] It is clear, however, that hip-hop offers both real and imagined ways of being (or appearing to be) global through capitalism and the effects of the commodity. This process of cultural formation may also be encapsulated in the concept of bling, not only because of its centrality to diasporic aesthetics but also because "bling" may be thought of onomatopoeically, like "ka-ching," to evoke a commercial transaction. Bling is the sound of cultural exchange through commodities and the sound of diasporic cultures' interactions with global capitalism. Although consumerism is at the heart of this coproduction of diaspora, it is crucial

to note that hip-hop's aesthetics, while seeming on its surface a hyperbolic version of late capitalism, results in a visual economy wherein one's social capital comes in part through the aesthetics of light. Shinin' generates its own social currency and expression of value through optical effect, with or without commodities. Indeed, this alternate system of prestige may be what authorities in the Bahamas find so troubling or threatening to national values, and so incomprehensible and incalculable.

Shining a Light on Local Structures of Prestige

While youth in the Bahamas use hip-hop's visual language to imagine and represent themselves as visible, diasporically and globally, in ways that appear to circumvent local structures of status, their practices also shed light on the performances that do afford visibility and prestige in postcolonial Bahamian society. Bling, we recall, characterizes both the threshold of absolute visibility and utter blindness. As such, while its aesthetic practices seem on their surface to be about the production of glaring visibility, they simultaneously call attention, implicitly, to that which is rendered invisible at the moment it is seen. The prom entrances, which so explicitly make visibility visible, highlight the constitutive relationship between that which is hypervisible and that which is consequently un-visible in postcolonial Bahamian society.

The entrances make a spectacle of hypervisible signifiers of the "approved life," those performances of status through material goods that take place routinely in contemporary Bahamian society but frequently go unrecognized as such. In contrast to their criticism of public school students for their ostentation at prom, the media or ministers of Parliament seldom remark on the everyday displays of conspicuous consumption in Nassau by the island's middle and upper classes or winter residents.[75] For example, while critics decry the flotillas of Rolls Royces and Lexuses at proms, these vehicles are sometimes borrowed or rented from wealthy Bahamians who use them on a daily basis.[76] Indeed, one newspaper reported that it was common for residents of affluent communities, such as those of the Eastern Road, to get knocks on their doors during prom season from persons wanting to rent their cars.[77] In other words, the prom entrances actually put everyday symbols of wealth on display, incorporating them in ways that highlight their commodity status, their enviable shine.[78] By using, literally and figuratively, everyday vehicles of social visibility in Bahamian society in their entrances,

the prom-goers render visible the routine exhibitions of conspicuous consumption to which Bahamian society usually turns a blind eye.

Moreover, the prom entrances highlight not only the most visible structures and symbols of prestige but their inverse, the blinding disappearance of persons who do not possess symbols of the "approved life." In these stagings, bling denotes spectacular wealth and, simultaneously, illuminates the condition of *not* being seen—the condition of working-class youth who are not typically recognized in approving ways locally. In this regard, the entrances may be contrasted with the spectacles in the postcolony: "the occasions which state power organizes for dramatizing its own magnificence" that Achille Mbembe describes in the case of Cameroon.[79] In his assessment, the state "furnish[es] public proof of its prestige and glory by a sumptuous (yet burdensome) presentation of its status, displaying the heights of luxury in matters of dress and life style" for "its 'subjects' (cibles) to watch."[80] The prom performances offer a very different constellation of the "aesthetics and stylistics of power" in the postcolonial setting.[81] For one thing, the island's working classes make the frame or structure of the spectacle their own through the entrances. They do not simply watch the spectacle; they appropriate its structure and its power. Indeed, they literally throw light on and make light of its form, taking the constitutive parts of the spectacle, the effects of displays of wealth, and making them intrinsic to their entrances. More pointedly, the entrances allow working-class youth, in their rented high-visibility vehicles, to inhabit the center of spectacles of prestige.

By virtue of their location in the island's hotels, the prom entrances literally make a spectacle of the daily parade of tourists, the focus of the island's postcolonial economy. When tourists pull up at the hotel during the proms, crowds cheer raucously, co-opting the invariably bewildered tourist into the performance frame of the event. Within the small island, travelers, whether peering out of stretch limousines or sightseeing by foot in tropical-themed shirts, represent luxury and privilege. Not only are tourists, whose yearly arrivals greatly outnumber the local population, highly visible on the island as individuals who can afford a life of leisure and pleasure but also, because of the overwhelming dependence on tourism in postcolonial Bahamian society, the local government encourages residents to afford tourists privileged treatment. No matter what their class (if not race), tourists can transcend their usual social station when they are on the islands in ways that many local people cannot.[82] Prom spectators, by incorporating tourists into

the spectacle as elements on view, mock the national dependence and fixation on tourism by reversing its social dynamics, which more conventionally involve sightseers' photographing local people and their environment.

Moreover, the prom entrances allow young people to garner prestige and status through structures of visibility typically reserved for tourists in postcolonial Bahamian society. By arriving in limousines that typically carry tourists around the island, with "Rich and Famous" etched in cursive letters on the back windshield, the entrances allow young people to inhabit the privileged role of tourist in the Bahamas. Indeed, the entrances sometimes take place at all-inclusive hotels that bar local residents from entering them throughout the year.[83] The preoccupation with "the entrance" at the proms may stem from the importance of the hotel entrance as a symbolic space of social ascension in the Bahamas' tourism-driven economy. By inhabiting the entrances of hotels, local residents can claim the same possibility of social transformation that the hotel entrance promises tourists. It represents a site where, if only momentarily, they can be transformed into the affluent subjects that they appear to be at a prom. That the theme of the C. R. Walker Senior High School prom in 2006 was "a night in paradise" suggests as much. The event allowed prom-goers to reside for a night in an allusive "better Bahamas" (to quote the Ministry of Tourism slogan), which they had typically viewed from the outside, through closed hotel doors and through tinted limo windows in which they had only seen their own reflections.

The proms also offer a glimpse at hierarchies within the island's working classes. The entrances provide platforms for Haitian and Haitian Bahamian youth to make visible their otherwise "strategically invisible" presence in postcolonial Bahamian society. By strategically invisible I mean that many Haitians in the Bahamas, whether legal or illegal, attempt to some degree to blend into Bahamian society, because persons identified as illegal Haitian immigrants may be subject to detention and repatriation. Within Bahamian society, the estimated sixty-thousand-strong Haitian population (among three hundred thousand residents in total) is both highly visible and frequently in a state of readiness to disappear, if the need arises. Therefore, when a young Haitian woman arrived at the 2006 C. R. Walker Senior High School prom in a respectable vehicle displaying four waving Haitian flags, a hush fell over the crowd of spectators, followed by the sucked-teeth sounds of disapproval (fig. 3.20). This young woman very notably did not follow her grand entrance with a promenade down the red carpet. Indeed, of all the entrances I

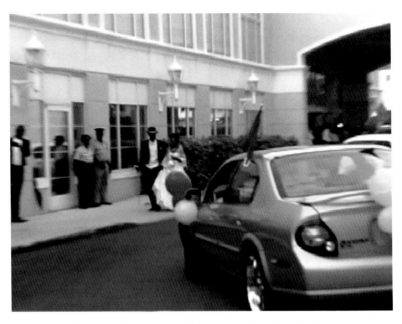

3.20. Car with Haitian flags arrives at C. R. Walker Senior High School prom, British Colonial Hilton Hotel, Nassau, 2006. Video still. Video by author.

witnessed that summer season, she was one of the few prom-goers to forgo her moment of red carpet visibility. Perhaps she was apprehensive of the demonstrative crowds, or maybe her flag-waving arrival, to her mind, made her grand entrance complete. Following the same logic as her Bahamian peers, who used local and diasporic forms that bring visibility in their performance repertoires, she displayed a sign of Haitian visibility, one that had been flown in the recently commemorated Haitian Flag Day.[84] The young woman's entrance calls attention to different prom-goers' use of varying strategies of visibility and individual creation and their inhabiting of their own vision of social ascent. That entrance also calls attention to precisely which African diasporic forms gain currency among youth in the Bahamas. At this particular historical juncture the Haitian flag—once the preeminent emblem of black possibility and freedom within and beyond the boundaries of the Bahamas—does not have the symbolic African diasporic currency that shine has accrued. The overarching investment in bling by Bahamian youth may testify to the changing content and character of African diasporic freedom dreams in the twenty-first century.[85]

Gay participants are another constituency who are afforded limited visibility at prom and in Bahamian society more generally. For the most part, the prom performances by couples reproduce heteronormative gender roles and might even be seen as dress rehearsals for a traditional marriage ceremony. A young woman who dressed in male prom attire and her female date at an elite school, St. Andrews, were exceptions to the tales of past prom appearances. It is possible that the privileges of class allowed a space of visibility and safety that was not allowed the young women with the Haitian flag.

Junkanoo Paparazzi and Changing Forms of National Culture in the Bahamas

The proms not only refract hip-hop's shine through the lens of postcolonial social and political structures but do so in ways that reflect local aesthetic traditions. Indeed, hip-hop's visual culture may have appealed to prom-goers in part because shine, shimmer, and splendor are intrinsic to local costuming traditions, particularly that of Junkanoo. The biannual parade locally known as Junkanoo—which Bahamian historian Arlene Nash Ferguson has characterized as "an annual spectacle in our nation that is unparalleled in splendour"—may have informed young Bahamians' predilection for hip-hop, above all other contemporary diasporic visual cultures, as a source to draw on in creating their prom entrances.[86] While critics in the Bahamas deplore the "foreign values" on display at the prom entrances, prom-goers' attention to the visual economy of light as a strategy of social visibility may have a precursor in the local festival. In other words, hip-hop may be inspiring these youth not simply to demand visibility through its aesthetic expressions but to do so in ways that resonate locally. They coproduce a visual expression that is capable of inflecting recognized Bahamian artistic practices.

Junkanoo is most present at the proms through the inclusion of small groups of Junkanoo musicians in some of the entrances. A photograph taken at the 2006 St. Augustine's College prom shows a Junkanoo troupe, all notably sans traditional costume, playing the brass instruments that resound at Junkanoo parades (fig. 3.21). The group formed part of a prom entrance. The troupe paraded past a couple and formed, with their bodies and instruments, an archway through which the couple walked as the finale to their entrance. In the majority of instances when prom-goers explicitly incorporate Junkanoo, they do

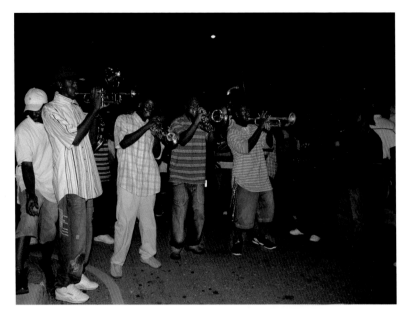

3.21. Junkanoo band performing for entrance at St. Augustine's College prom, Nassau, 2006. Photo by author.

so, as evident in the fairy entrance, through sound and not through the colorful, fringed-crepe-paper costumes that are characteristic of Junkanoo.

In the context of Nassau, the centuries-old costuming tradition of Junkanoo has an interesting historical relationship both to the politics of visibility and to photographic practices. The Bahamas' black populations have participated in Junkanoo since at least the late eighteenth century. Whereas in many parts of the southern United States and West Indies the masqueraders in the Christmas festival went to the plantations or homes of ruling elites to perform and collect alms, in Nassau the masqueraders congregated, without remuneration and often without permission, in the main business district of the city, a predominantly white-owned and racially stratified commercial area, tourist port, and governmental center.[87] Up until 1956, the business owners and staff in many of the shops and hotels in the Bay Street district either practiced racial segregation or treated blacks who entered their premises as second-class citizens. On Boxing Day every year, under the cloak of night, black working-class Bahamians made their way into this part of town and celebrated Junkanoo. The festival provided the rare occasion when these black residents, wearing costumes made of found

materials—fringed newspapers, banana leaves, or sponges—and with goatskin drums and cowbells noisily in hand, had a formidable visible presence, albeit in disguise, in Bay Street.[88] The island's British colonial administration, local white mercantile elite, and colored middle classes often expressed consternation over the event, which they recognized as a symbolic takeover of the area by the celebrants.[89] Throughout the first half of the twentieth century, authorities and the local press decried this parade as antithetical to the colony's values and fretted over how to control or curtail the festival, at times banning it, at others attempting to promote it as a picturesque tourist spectacle.[90]

In the earliest decades of the twentieth century, for reasons that are difficult to discern, Junkanooers tended to have a complicated, even adversarial relationship to photography. Very simply, some masqueraders did not want to be photographed. Indeed, in 1917, a local woman warned a would-be picture-taker that the last person to produce a camera at the event had been physically attacked by a masquerader.[91] It is uncertain why Junkanooers, who are often disguised with wire-mesh masks or charcoaled or floured-white faces, did not want the camera to capture their moment of visibility. It is possible that they saw it as antithetical to their practices or as too revealing of their masked identities. Regardless of the cause, taboos surrounding photography at the event suggest an interesting awareness of the power of the camera or the photographic image and its possible detrimental effects. Historically, then, Junkanoo may be seen as an event that afforded working-class black Bahamians social visibility but did so explicitly outside of the realm of photographic technologies.

After independence in 1973 Junkanoo took on a very different life, becoming an icon of national culture, or what the National Junkanoo Committee has described as "the central symbol [of] the nation."[92] In the young nation, ruled by a black majority for the first time in 1968, the festival emerged as the foremost example of the resiliency of African Bahamian traditions in the face of colonial rule. In the postcolonial era it did not simply serve as one cultural manifestation among others but became synonymous with culture in the Bahamas (a culture that was being redefined after Independence as black).[93] Junkanoo gave Bahamianness a recognizable visual form. No longer confined to the space and time of the biannual Bay Street festival, this expression of national identity was paraded at every state function, political party rally, and national commemoration. Indeed, politicians who sought to portray themselves as "of the people" often participated in the parade or demon-

strated their Junkanoo dance skills. Again, in a departure from the politics of performance in the postcolony that Mbembe describes, rulers in the Bahamas emulated the public performance practices of those they governed. Moreover, Junkanoo groups were trotted out before tourists at summer festivals, in the midst of visitors sipping umbrella-garnished cocktails, and in front of the photographers who produced tourism advertising in all its forms. The media and government officials characterized any expenditure on Junkanoo as "money well spent" and an investment in the purest personification of Bahamianness, even as they portrayed the prom entrances as frivolous spectacles and manifestations of the bankruptcy of national values.[94]

In the post-Independence era, what could be characterized as the nationalization of Junkanoo informed new approaches to visibility in the manifestations of the festival. Parade participants' relationship to photography, to being represented and being seen, changed dramatically at this time. Participants no longer prohibited photography; indeed, many of them seemed to gear their performances toward the still and moving cameras. Junkanooer Anthony Carroll, for instance, evokes "the thrill of seeing our creations on our local television screens" as a "benefit" of and "reward" for participating in the parade.[95] These changes did not come overnight; indeed, they may date to the 1930s, when colonial-era tourism promotional boards started offering prizes for costumes and photographing winning Junkanoo performers.[96] Photographs of prize recipients, without their masks on, appeared on the front page of local newspapers. But arguably, in the postcolony, when the parade started to be nationalized and shortly thereafter televised, politicians were not the only ones to angle to be seen participating in the event that Nash Ferguson described, in a take on Barnum and Bailey, as the "greatest show on earth."[97] The late Junkanoo leader Jackson Burnside surmised that Junkanoo offered participants international visibility and enhanced skills that made participants competitive globally.[98] It is possible that over the years Junkanoo performers ceased to wear masks in part because they would hinder the performers' ability to appear on the national and even the world stage. In the postcolonial era, for members of the island's working and middle classes, being seen as a performer at Junkanoo was intrinsic to one's sense of belonging to the nation, to the (precolonial) African past, and to the global future.

Since the mid-1990s, the importance of being seen in Junkanoo has been most dramatically and literally manifest at a particular part of Bay Street on the parade route known as Rawson Square. Judges of

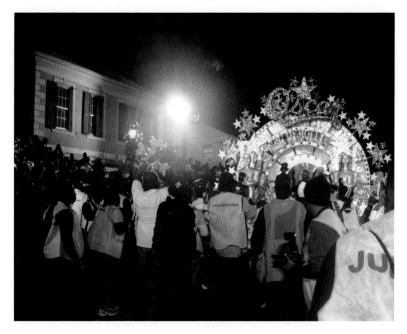

3.22. Junkanoo parade group with Oscar theme, Nassau, 2008. Photo by author.

the best costumes and musical performances in the event congregate in this area, increasing participants' awareness of being viewed and inspected within the space. In the late 1990s, governmental restructuring of spectatorship at Junkanoo heightened the visual significance of Rawson Square. The Ministry of Culture started to charge spectators to watch the parade from Bay Street and placed a premium on the view from the dizzying heights of the bleacher seats on Rawson Square. The seating area, near where a statue of Queen Victoria looks down at the parade, also included a deck reserved for VIPs—politicians and business elites.[99] In complicated ways one's vantage point for watching the parade became a form of commodity that bestowed social distinction and political identification with the people, the citizenry.

From the perspective of the performers, to be seen in Rawson Square was to be acknowledged and even admired by very important eyes; it was also the space where photographers and television camera crews readied and aimed their cameras (fig. 3.22). Cameramen literally electrify the event, not simply through their flashes and video camera lights but also through daylight-bright klieg lights that illuminate the space like an outdoor stage, making even tiny particles swept in the air visible. In multiple ways, then, Junkanoo, especially as the performers moved

through the luminous space of Rawson Square, represented the ultimate space of visibility in Bahamian society, for working- and middle-class performers and also for spectators.

Nash Ferguson provides a description of the movement of a Junkanoo group that vividly illustrates the importance of being seen in the light of Rawson Square. She re-creates the scene from the perspective of a performer: "In the distance you glimpse the floodlights as you approach Rawson Square. For as far as you can see, costumes are bobbing up and down in the lights. People on the rooftops and balconies are screaming. Bay Street is a kaleidoscope of action and colour. . . . You are on the main street at 1:00 A.M., completely covered in cardboard and paper, and thousands of people are watching you. This could only be Junkanoo!"[100] Nash Ferguson's words capture the sense of Rawson Square as a destination in the overall event; it is the limelight that the performers literally move toward. She also communicates a sense of the continued importance of being on the "main street"—Bay Street. Nash Ferguson evokes the way light animates the parade, becoming intrinsic to the form of the costumes, the way they look as they move through and within space, and the performers' awareness of how viewers experience the kaleidoscope of light and color. Since the mid-1990s, Junkanoo participants have produced a dazzling display of light and color with the aid of what they describe as "tricks": mirrors, sequins, jewels, shiny cloth, and flashing lights, all of which make explicit use of the optical effect of light when incorporated into the costumes (fig. 3.23).[101] Drawing on the circum-Caribbean masquerade practices of Trinidad's Carnival and New Orleans's Mardi Gras Indians, many of the Junkanoo pieces also use feathers around the frame of the costume, which against floodlights give the cardboard structures a weightless and ethereal quality (fig. 3.24). Most significant, however, Nash Ferguson conveys a sense of performers' awareness of being watched, of having "thousands of people . . . watching you," an experience that her concluding words suggest could only happen within the performance frame of Junkanoo. Nash points to the uniqueness of Junkanoo in creating a luminous and vital frame of visibility.

In 2008, a group participating in the Boxing Day Junkanoo, the Valley Boys, highlighted how the parade, particularly within the visual nexus of Rawson Square, offers a site of intense visibility and instant celebrity. The group portrayed the theme of the Oscars, with costumes depicting a range of celebrities, from the Bahamas' own Sidney Poitier to Marilyn Monroe. The lead float consisted of a crepe-papered white vintage car,

3.23. Detail of Junkanoo costume with Junkanoo tricks, Nassau, 2005. Photo by author.

3.24. Junkanoo performers at the Boxing Day parade, Nassau, 2005. Photo by author.

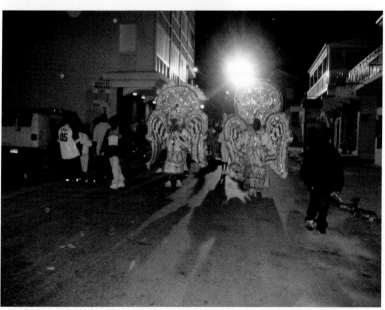

its wheels covered in glitter, from which dangled a large cardboard camera, swiveling indiscriminately between performers and spectators (fig. 3.25). Once the group reached Rawson Square, they rolled out another trope of Hollywood, the red carpet, before the judges, photographers, and local VIPs congregated in Nassau's center of emblazoned visibility. In a break from the parade format of the event, which typically consists of free and choreographed dancing, members of the group enacted the role of Hollywood celebrities appearing on the red carpet (fig. 3.26). They stopped and posed, preening dramatically and enthusiastically for the photographers and videographers in Rawson Square. While the theatrical staging of the red carpet aimed to approximate and parody Hollywood's red carpet, the location of the performance also called attention to Rawson Square as another site of spectacle. Indeed, this Junkanoo group depended on the lights and photographers present in the space to complete the staging of the red carpet. The moment the leaders of the group careened down the red carpet, the battalion of photographers and videographers typically stationed in the area instantly took up the role of paparazzi. Their calculated incorporation into the spectacle highlighted their usual roles as Junkanoo paparazzi—as producers of local celebrity and visibility in their lens.

For many young prom-goers, this more contemporary televised form of Junkanoo, with revelers floating down to Rawson Square, using "tricks" that produce visual illusion through light, is the most prominent manifestation of Bahamian "culture." Many prom-goers have only experienced Junkanoo in its Rawson Square–centered, camera-centric form. Coming largely from the working- and middle-class communities who participate in Junkanoo, they may identify the festival as a practice that brings social visibility, as a form that places its performers quite literally in the national spotlight. This being the case, even when costumes are absent at the prom entrances, the contemporary aesthetics of Junkanoo may still be visually in effect. Hip-hop's stylings and visual grammar offer these youth another lexicon they can use to enable themselves to speak to and through local articulations of visibility and social value. Bling makes available another language of visibility through light. This is not to make too easy or smooth a correlation between the two aesthetics but to stress that in the context of the Bahamas, costuming practices in Junkanoo have likely informed young people's understanding of ways of being seen. This understanding in turn enables them to recognize, respond to, and represent hip-hop's shine.

Might the paparazzi entrance that opened this chapter, then, have

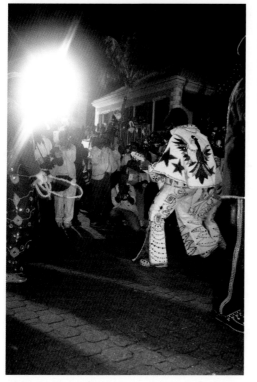

3.25. Junkanoo parade with Oscar theme, Nassau, 2008. Photo by author.

3.26. Junkanoo parade with Oscar theme, Nassau, 2008. Photo by author.

been informed not only by the visual cultures of celebrity in America's globalized entertainment industry and the light of hip-hop culture but also by the floodlights of Rawson Square and Junkanoo's "all eyes are watching you" performance frame? Tellingly, a local photographer has started advertising his work with signs across Nassau's urban communities using the website address www.junkanoopaparazzi.com, highlighting the increased camera-centeredness of contemporary Junkanoo and its ability to confer instant celebrity status. The staging of the paparazzi prom entrance, which incorporated many of the same local photographers who shoot the parade, may have been attuned to Junkanoo's "paparazzification": what photography promises within the contemporary context of the parade.[102] Moreover, prom-goers' investment in the evanescent spectacle of the proms, without regard for a lasting memento, may also be informed by costuming practices at Junkanoo, in which costumes are typically abandoned after the event, despite the considerable expense and labor that go into their creation, suggesting that the use-value of the costumes expires after the parade. Prom-goers' financial investment in the night, in being within the performance frame, and in the optical effect of being seen as its own end may have a visual cultural precedent in the Junkanoo parade.

Despite prom-goers' familiarity with Junkanoo, they decidedly part ways with Junkanoo performers' routes (and roots) to visibility. Returning to the idea that practices of surfacism often appear in postcolonial contexts in refutation of colonial systems of representation, might the surface effects of the proms—the self-representations outside the photographic frame and the clichés of national culture—signal a repudiation of national formations of culture and strategies of visibility? Given that, historically, proms first appeared at the twilight of British colonial rule, might the spectacular changes in the proms in the last ten years mark a waning of the representational potentialities of national forms such as Junkanoo?

The government may have contributed to young people's ambivalence toward Junkanoo, their inability to see themselves in the hypervisible manifestations of the contemporary parade. Since the early twenty-first century, the police have blocked access to the parade route for non-ticket-buying spectators, measures that have disproportionately affected working-class youth's ability to watch or participate in Junkanoo from Bay Street.[103] Parade officials started to prohibit anyone who did not possess a ticket, which cost between $25 and $100, from viewing the parade from the main thoroughfare. The move came in part

as a response to the behavior of "gangs" of uncostumed male teenagers who would run alongside the parade on the sidewalks, making passage along the pedestrian corridors difficult. These young men would characteristically make their own music, banging enthusiastically on the signs and storm-shuttered windows of Bay Street businesses. Newspapers and authorities decried the lawlessness of these teens in ways that bear striking resemblance to early twentieth-century accounts of Junkanoo. The authorities, in response, restructured spectatorship at the event to curtail and control these young men.[104]

In pointing to the marginalization of youth from the parade, I do not mean to argue that those who cannot participate in Junkanoo perform at the proms instead. Rather, the prom entrances may be considered alternative spaces of visibility in postcolonial Bahamian society. Hip-hop culture offers youth another type of spectacle, of seeing and being seen, a way to be in the national spotlight and the global limelight beyond the floodlights of Bay Street. Hip-hop also provides a more individualized form of public presentation, in contrast to the state-controlled and more collective expression of Junkanoo. Hip-hop also makes available a form of black culture in an environment where "culture" takes specific visual forms. Moreover, returning to Diawara's idea that African diasporic aesthetics moved the youth of Bamako to reject the artifice of older photographic practices, hip-hop's frame of visibility may inspire young Bahamians to imagine themselves outside, and reject, forms of self-representation afforded in the camera-centered Junkanoo. Indeed, youth may be using the spectacular entrances to generate new possibilities of representation precisely at a time when Junkanoo, in its institutionalized and hypervisualized form, increasingly represents the status quo and those who aspire to be recognized within the state's configuration of modernity, nation, culture, respectability, and blackness. In the age of "Junkanoo paparazzi," who or what does Junkanoo represent? What is lost from view in the splendor of its aesthetics? How do the working-class population and a new generation gain visibility outside this historical form, outside the blinding floodlights of Bay Street? What could be described as the problem of the visual in the era of the hypervisibility of Junkanoo brings to mind Earl Lovelace's moving evocation of "the impotence of dragons," the inability of masquerade characters, who once signified defiance to colonial rule, to be powerful and purposeful in the post-Independence era. Aesthetic expressions like the dragon costume, whose significance was so wrapped up in the opposition to colonial rule, struggle to find mean-

ing and purpose in the postcolonial era. The proms appear to respond to the complexities of forging strategies of visibility in the postcolonial Bahamas now that the historic forms that once facilitated visibility are part of the way the state demonstrates its magnificence.

While prom-goers are mindful of the contemporary forms of Junkanoo, their ambivalence toward the material photographic image intriguingly recalls the tradition's forms in the early twentieth century.[105] Even though the spectacle of image-making at the proms is very different from the century-old forms of Junkanoo, it suggests a similarly unconventional approach to photography. In a sense, while the proms draw so heavily on the contemporary aesthetics of hip-hop, with its shiny language of the modern and the global, they embody—again recalling Diawara—a rearticulation of forms of working-class visibility, of masking and eschewing photographic inscription, as expressed in early circum-Caribbean forms of Junkanoo. While it is tempting to see the proms as part of a genealogy of African diasporic practices of contestation, of opposition, to the governing classes—and this is certainly a part of the story—what the proms ultimately provide is a way of seeing or visualizing power in the twenty-first century, whether through particular commodities, the camera, or shining light; or through spaces of visibility, whether the hotel entrance, the red carpet, or Rawson Square. In other words, hip-hop's language of shine, shimmer, and splendor has thrown light on postcolonial structures of visibility, highlighting the spectacular performance of power, whether in everyday forms of visibility or the spectacles of national culture. The ways of seeing that hip-hop inspires call to mind the lucidity of the little boy who blurts out the truth in "The Emperor's New Clothes," the well-known fable about the spectacles of power. Hip-hop offers a way of seeing and seeing through performances of prestige, a way of understanding their visual production, and a way of reenvisioning self and social status through their optics.

4

THE SOUND OF LIGHT

Reflections on Art History in the Visual Culture of Hip-Hop

Light confirms my reality, gives birth to my form.
—**Ralph Ellison**, *Invisible Man* (1947)

The power of the surface is inescapable, as is its efficiency as
a depository of complex histories.
—**Malik Gaines**, "Kehinde Wiley: Pieces of a Man" (2002)

In May 2008, the *Detroit News* reported on a spectacular local high
school prom entrance. A young African American woman hired pho-
tographers, at the cost of approximately $6,000, to enact the part of
paparazzi to make her feel, as she put it, "like a star" amid the flashes
of their cameras.[1] This prom entrance recalls the one staged in the Ba-
hamas in 2004 in which a young woman hired professional photogra-
phers to line the red carpet, not so as to have pictures taken but so as
to create the effect of being photographed. She explicitly enlisted the
photographers to simulate the blinding flashes of visibility, the sound of
being bathed in light, the moment of being seen yet with the invisibility
that comes at the point of visual saturation. Such entrances very much
attempt to participate in the structures of visibility that frame celebrity
in American mainstream media, to bask literally in the limelight shined
on "stars." But these entrances may also shed light more specifically on
visual expressions in contemporary hip-hop, which provide some of the
most prevalent representations of celebrity among black urban com-
munities throughout the African diaspora, from Detroit to Nassau. The
notion of the entrance not simply as a space in which to be seen but as a
place in which to perform one's appearance theatrically has been popu-
larized in part by rap stars, like Diddy (Sean John Combs), who grab
the media spotlight by descending from helicopters or ascending from
luxury yachts for event entrances.[2] Such displays from the image world
of hip-hop inform the ways that black urban populations, like the papa-

razzi prom entrance organizers, approach and insert themselves into mainstream structures of visibility and how they use these modalities of performance and display to represent and reflect on black subjectivity.

Contemporary visual expressions of hip-hop and its African diasporic counterparts—as I have argued throughout the book—whether in music videos, street photography backdrops, or cover art, give expression to and generate distinct approaches to representation and visibility. Black urban populations conversant with the visual language of contemporary hip-hop have more in mind than garnering attention; they perform the effect of being seen and represented more generally.[3] As noted already, many prom-goers who cite hip-hop as their most prevalent visual influence are not interested in securing material reproductions of their entrances, despite their investment in performing themselves being represented, in being seen to be seen.[4] Influenced by expressions of visuality in hip-hop, they often place a premium on being bathed in light from flashing cameras, the moment of being seen, and occupying the generative spaces of image creation. The optical effect of being seen and pictured has become its own form of image.

Despite the prominence of visual expression in contemporary hip-hop, many art historians, curators, and critics often frame hip-hop primarily as a musical genre or employ analytical approaches derived from the study of hip-hop's sonic iterations. This is evident in two early exhibitions that took up a hip-hop theme: *One Planet under a Groove: Hip Hop and Contemporary Art*, organized by Franklin Sirmans and Lydia Yee for the Bronx Museum of the Arts in 2001, and *Mass Appeal: The Art Object and Hip Hop Culture*, curated by Sirmans at Gallery 101 in Ottawa in 2002.[5] The curators of these shows and many other scholars frequently use analogies derived from techniques of hip-hop DJing, specifically "sampling, mixing, and remixing" or "cutting and scratching," in their formulation of hip-hop's visual aesthetics.[6] These commentators propose that studio artists whose work is informed by the "conceptual strategies of hip hop" engage in a sort of remixing that is much like that of hip-hop DJs, who reutilize break beats from existing sound recordings in their musical arrangements.[7] Studio artists, curators argue, engage in a comparable sort of remixing by sampling from existing works of art, reconfiguring art history in the process. Such explorations of the intersections of hip-hop's musical production with studio practice have been instructive, in that they suggest how hip-hop culture and popular expressions in the African diaspora more generally

might yield new perspectives on art history and art-making. However, by privileging theoretical approaches to hip-hop music in their examination of contemporary art, these curators and scholars might be forestalling a more thoroughgoing interrogation of visuality in hip-hop and its relation to art and its histories. Such interpretations recall Michele Wallace's lament that in African American studies "drawing parallels or alignments between Afro-American music and everything else cultural among Afro-Americans, stifles and represses most of the potential for understanding the visual in Afro-American culture."[8] An examination of hip-hop's vernacular forms of visual culture not only offers the opportunity to understand the visual in African American culture and its complex relationship to the sonic but also provides critical reflection on visual representation in the history of Western art.

This argument can be demonstrated by a consideration of artwork by two artists whom curators and scholars have often identified with hip-hop in contemporary art: Kehinde Wiley (b. 1977) and Luis Gispert (b. 1973). Wiley, an artist originally from Los Angeles now residing in New York, has in many respects become the poster child of hip-hop in contemporary art. His massive paintings have commanded attention in numerous group shows, including *Mass Appeal* (2002) and *Recognize! Hip Hop and Contemporary Portraiture* (2008), as well as in solo exhibitions such as *Faux/Real* (2003), *Passing/Posing* (2004–2005), and *Kehinde Wiley: Columbus* (2006).[9] After obtaining his MFA from Yale University's School of Art in 2001, Wiley, as an artist-in-residence at the Studio Museum in Harlem in 2001–2002, created his earliest series of paintings that figuratively addressed hip-hop. These canvases, which remain his most iconic body of work, portray young black men dressed in the street stylings of hip-hop—bubble jackets, hoodies, and baggy jeans—assuming poses derived from existing works of European art.[10] Wiley typically meets the subjects of his paintings by chance, taking to the streets of black urban communities, such as those found in New York's Harlem, Columbus, Ohio, or, more recently, those in Rio de Janeiro, where he asks young black men to pose for him who command, as he describes it, "a certain type of power" as they stride through urban space.[11] Each model chooses his own pose from Wiley's collection of art books.[12] Once his model settles on and into a pose, Wiley takes photographs of him that serve as the basis for his monumental oil paintings. He depicts his contemporary subjects floating in a nondescript, luminous, and ornamental background that is surrounded by—not insignificantly—a halo of light and is set in heavy ornate frames. In 2009 Wiley's

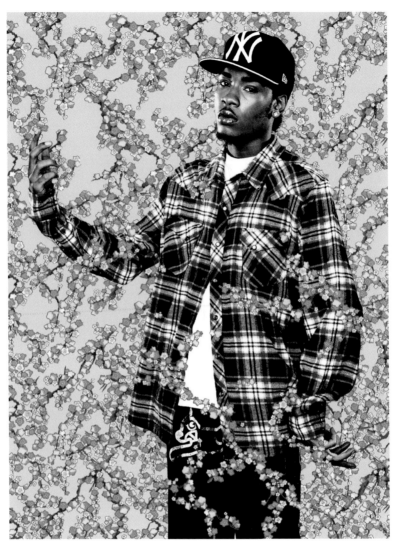

4.1. Kehinde Wiley, *Portrait of Simon George*, from the *Black Light* series, 2009. Archival inkjet print on Hahnemühle fine art paper, 30 × 24.53 in., edition of six. Courtesy of the artist and Roberts & Tilton, Culver City, California.

4.2. Detail from Kehinde Wiley, *Portrait of Simon George*, from the *Black Light* series, 2009. Archival inkjet print on Hahnemühle fine art paper, 30 × 24.53 in., edition of six. Courtesy of the artist and Roberts & Tilton, Culver City, California.

photographs of his male subjects became the central focus of his work, as he produced his first photographic series, *Black Light* (fig. 4.1). In preparing these photo shoots, Wiley had his studio especially equipped with visual technologies that "blasted out" light, which he wanted to be reminiscent of the dazzling shine of Hype Williams's hip-hop music videos.[13] The resulting photographic prints — as is evident in a detail of Wiley's *Portrait of Simon George* (2009) — present viewers with images of young black men bathed in a brilliant light that highlights their facial features, literally making their skin shine, an aspect of Wiley's work that I will return to later (fig. 4.2).

Another artist at the top of curators' hip-hop art roll call is New Jersey–born, Miami-reared photographer, sculptor, and filmmaker Luis Gispert. Gispert also earned his MFA from Yale University in 2001, studying there at the same time as Wiley. Gispert's photographs, par-

ticularly his series *Cheerleader*, figured prominently in the group shows *One Planet* and *Mass Appeal* and in solo shows, such as *Urban Myths Part I and II* at the University of California, Berkeley, and *Luis Gispert: Loud Image* at the Hood Museum of Art at Dartmouth College (2004).[14] In a striking parallel to Wiley's paintings, *Cheerleader* features subjects who enact roles from art history's representational past. Poses, compositions, and techniques from Italian Baroque paintings in particular often serve as Gispert's pictorial inspiration. Unlike Wiley, though, who chose to depict young men, Gispert has portrayed young women of numerous ethnicities dressed as cheerleaders. They often wear audacious gold jewelry and gold grills on their teeth, acrylic nails, or forms of bodily adornment associated with hip-hop culture. In *Cheerleader*, female figures hover in midair like celestial "hoochy goddesses," to cite the title of one photograph, against a brilliant green monochrome background. Gispert's *Cheerleader* and Wiley's *Passing/Posing* exhibitions, occurring contemporaneously, were formative in narratives of hip-hop and contemporary art as they developed at the beginning of the twenty-first century.

Curators and critics have attributed Wiley's and Gispert's appropriation of canonical works in art history, which accords with many trends of postmodernism, to strategies of remixing in hip-hop and have lauded the artists for revising and "racing" art history.[15] The artists indeed use European Renaissance and Baroque pictorial traditions to visualize another history of art, one that brings the black body (and other ethnicities, in Gispert's case) literally and figuratively to the surface. Both artists, though, engage in a much more radical interrogation of art history and contemporary popular culture than scholars have acknowledged, and they do this precisely by drawing on strategies and approaches to representation, or the vernacular visual modernities, that are evident in black urban visual cultures. Rather than remixing art history, the artists refract it through the lens of hip-hop in such a way as to reflect on techniques of light and surface effect in the history of oil paintings, while highlighting alternative ontologies of representation that black urban populations engage in.

The Hip-Hop Revolution Will Be Televised

Contemporary hip-hop, which informs these artists' works, must be distinguished from earlier permutations of the genre. Hip-hop started as a subcultural movement among Afro-Caribbean, African Ameri-

can, and Latino/a youth in the Bronx in the late 1970s. It comprised four different yet related types of expression: DJing, emceeing, break-dancing, and writing (the production of graffiti). By the mid-1980s, when mainstream interest in graffiti and break-dancing was waning, hip-hop music was enjoying new life on the American pop charts. Scholars and many fans often view these early days of hip-hop as a golden era.[16] It was the time when, so the typical narrative of hip-hop goes, many musicians used hip-hop to critically and creatively respond to the poor conditions that the social and economic changes of the Reagan era had wrought in black and Latino communities in postindustrial urban America. It is this early period that curators of recent exhibitions on hip-hop and contemporary art hark back to in their characterizations of the genre.[17] Wiley, Gispert, and many other artists associated with the hip-hop generation came of age during what critics regard as the "post-soul era," when the message in hip-hop, and the medium that delivered that message, started to change.[18] In the 1980s, as hip-hop gained visibility and commercial success nationally and globally, rappers increasingly turned their attention from politics to pleasure and focused on earthly and bodily gratification, hedonism, and even nihilism.[19] While some rappers in the past had shined a critical light on capitalism,[20] hip-hop artists in the postsoul period unabashedly celebrated materialism or a "radical consumerism," draping themselves in symbols of wealth from gold chains and medallions to all manner of brand-name goods. Numerous scholars, psychologizing, attribute these manifestations of hypercapitalism in later forms of hip-hop to black youths' marginalization and ghettoization in postindustrial American society.[21]

What is of interest here is not so much why materialism entered hip-hop's lexicon but that this later phase of hip-hop was produced, promoted, and propagated in forms of visual culture. For the rise of these later "materialistic" manifestations of hip-hop coincided, not inconsequentially, with the popularity of new forms of visual expression. Hip-hop came of age, significantly, as music television reached maturity.[22] In the late 1980s, the music video radically transformed the way music was distributed and even produced.[23] New magazines, such as *The Source* and *Vibe*, founded in 1988 and 1993, respectively, also played a role in hip-hop's visualization and popularization.[24] Through corporate America's visual cultural networks, types of hip-hop that celebrated capitalism gained global currency.

This preoccupation with material consumption was perhaps most explicit in the visual cultural expressions of hip-hop that emanated

mainly—although not exclusively—from the southern United States, in the work of musicians like the Hot Boys, Ludacris, Lil Jon, and Soulja Boy. Beginning in the late 1990s, expressions of hip-hop from New Orleans, Florida, and Georgia, in particular, gained recognition, if not respect, as southern rappers topped the hip-hop charts.[25] Southern rappers produced a type of hip-hop music known as bounce or bass music, labeled as such for its throbbing bass, which could be felt as much as heard. But southern hip-hop did more than promote music designed to create sonic effect in car sound systems as young people moved through urban space. Visual manifestations of the genre—in videos, album covers, and print media—depicted an equally loud style and lifestyle, one that can be summed up in one word: "bling!"

The cover of B.G.'s CD *Chopper City in the Ghetto*, designed by the firm Pen and Pixel Graphics Inc., appears to epitomize the concept of bling. Recalling the 2003 *Oxford English Dictionary*'s definition of "bling" as a "piece of ostentatious jewellery" and any "flashy" accoutrement that "glorifies conspicuous consumption," this cover portrays B.G. surrounded by a visual pastiche of prized commodities (fig. 4.3). The rapper—he is credited with coining the word "bling"—is wearing a gold chain with a diamond pendant set off by his diamond-encrusted name and sits in a phantasmagoric lair of luxury goods. Photographed from below, he appears larger than life and is surrounded by a sparkling automobile, a bottle of champagne, a chandelier, and a chalice, or "pimp cup," all of which sparkle. A heavy, ornate gold frame containing a second image of B.G. occupies a prominent place among the other signs of wealth. The inclusion of this double depiction of the rapper suggests that the framed image is not merely about capturing his likeness. Rather, his portrait foregrounds how being seen being represented offers value in the visual economy of late twentieth-century hip-hop.

"Bling," however, refers to more than flashy objects or one's self-aggrandizing portrayal as a work of art; it, to reiterate, describes a specific visual effect. As the *Oxford English Dictionary* describes it, the expression appears to "represent the visual effect of light being reflected on precious stones and metals." In coining the term, B.G. has said, he sought to characterize "the imaginary sound produced when light reflects off a diamond."[26] Bling captures the moment, so central in contemporary hip-hop, when consumption becomes conspicuous. Even as "bling" denotes an investment in the light of visibility, the concept may also be seen to pinpoint the limits of the visible world: the instant that

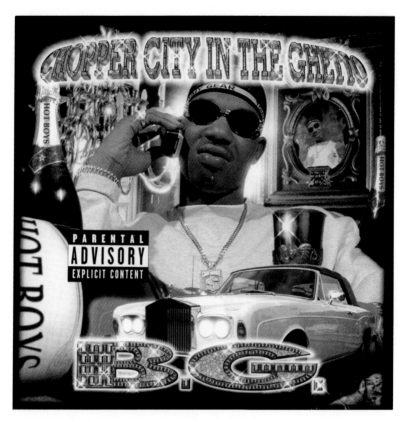

4.3. Pen and Pixel Graphics Inc., cover art, B.G., *Chopper City in the Ghetto*, 1999. Cash Money Records, New Orleans.

reflected light bounces off of a shiny object, it denies and obliterates vision. It saturates the visual plane, ultimately blinding the viewer. Indeed, in the track "Bling, Bling," B.G. boasts of bling's blinding power: "Girls wear shades just to stand on [the] side of me. They say 'Take that chain off, boy, you blindin' me.'"[27] Bling, then, describes a state between hypervisibility and blinding invisibility, between visual surplus and disappearance. Bling signals the physiological—even painful—limits of vision. Bling also illuminates an approach to visibility in which optical and blinding effect has its own representational value.

In keeping with this fascination with the ocular effect of light, hip-hop image-makers often fix attention on the reflective boundaries of the object or, put more simply, on shiny surfaces. Starting in the late 1990s, influential music video and film director Hype Williams (Harold Williams) developed a style of cinematography that focused on light and

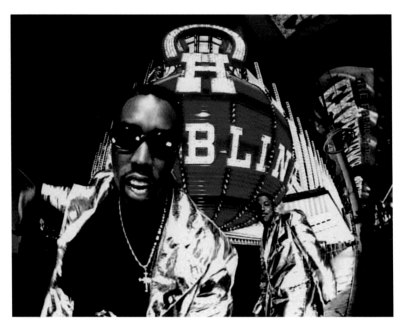

4.4 Hype Williams, video still from *Feel So Good* by Mase, 1997. Bad Boy Entertainment, New York. © Harold [Hype] Williams.

its reflection in surfaces as both subject and form. This aesthetic would visually define hip-hop for the next decade, spotlighting hip-hop stars like Diddy, Jay-Z, Missy Elliot, and Busta Rhymes. Williams produced and popularized a distinctive look for hip-hop music videos using lights and shiny surfaces, highlighting "luminous objects in the frame (neon, incandescent, and fluorescent bulbs)" and "highly reflective (metallic or wet) surfaces," as film theorist Roger Beebe describes it (fig. 4.4).[28] Williams's inventory of reflective objects included the ubiquitous shine of luxury automobiles and the sparkle of jewelry, as well as the shimmering surface of black female skin. More specifically, Williams often depicted sexualized parts of black women's bodies in ways that heightened their shine.[29] The videographer, who tellingly cites seventeenth-century Dutch artist Rembrandt van Rijn (renowned for his use of light in the painting technique of chiaroscuro) as one of his influences, would further electrify his shiny surfaces by saturating the entire scene in bright white light.[30] He also became well known for his distinctive use of an extremely wide-angle lens, which created the impression that viewers were observing the world presented in the video, hip-hop's fun house, through a peephole. Actually, Williams's signature fish-eye-lens look

made the entire video at times resemble a reflection on a shiny surface.[31] Through his cinematographic techniques, he set out to enlarge the aura of rappers and the power of their celebrity.[32] Not only did he succeed in giving rappers a larger-than-life presence but also his visual brand gave their phantasmagoric lifestyle of hyperconsumerism visual substance, precisely by using light and its optical effect on shiny surfaces.

Notes on Surface and Shine in the History of Art

In order to understand why shine and surfacism have surfaced in contemporary forms of hip-hop, it is useful to look at these visual expressions within a broader historical perspective. Elucidating the historical conditions under which these aesthetic forms figured in the past may offer insight into their production in the visual economy of contemporary hip-hop. "Surfacism" refers here to an emphasis on the materiality or visual texture of objects within or of the picture plane, "the elaborately wrought and highly finished representations of objects that are themselves elaborately wrought and highly finished."[33] Shine, or what Roland Barthes calls "sheen," is a related concept.[34] Artists have used shine, the visual production of light reflecting off polished surfaces or passing through translucent glass, to emphasize the materiality and haptic quality of objects.[35]

Shine and surfacist practices have a long and varied history in different cultural contexts. One scholar, John Berger, attributes the development of surface aesthetics in the visual economy of European art to two historical developments: the invention of oil painting as an art form in the sixteenth century and the formation of new wealth and new moral economies surrounding capital.[36] He maintains that oil painting allowed artists like the German-born Hans Holbein the Younger, whom the art historian locates at the beginning of this tradition, to represent a hitherto unachievable sense of "the tangibility, the texture, the luster, and the solidarity" of the world they depicted.[37] Holbein used the medium of oil paint to populate his entire picture plane with objects, whose surfaces he depicted in meticulous detail. In a painting like *The Ambassadors* (1533), for example, two impeccably dressed statesmen, Jean de Dinteville (a French ambassador in the court of Britain's King Henry VIII) and Georges de Selve, stand magisterially next to a collection of their possessions, which include objects symbolic of the sciences and arts (fig. 4.5). With the exception of the merchants' skin (a point I will return to soon), "there is not a surface in this picture which does not

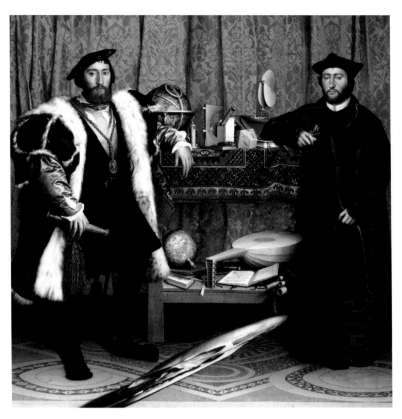

4.5. Hans Holbein, *The Ambassadors*, 1533. Oil on wood, 81.5 × 82.48 in. National Gallery, London.

make one aware of how it has been elaborately worked over," from the ambassadors' sumptuous fur-lined clothes to the well-crafted instruments and the patterned textile that creates a background surface in the painting.[38] Berger relates this new tactile rendering of the material world in oil paint to the "new power of capital" and "new attitudes to property and exchange."[39] The painting may be seen as an early art-historical precedent for the fashioning of power and prestige through material possessions, including works of art. Holbein's anamorphic depiction of a skull in the foreground of the painting, however, also draws attention to what the world of appearances hides from view: the inevitably of death, the fragility of things. Surfacism, then, Berger argues, from its earliest inception in European art, gave visual form to a way of seeing that was bound to the market economy, new forms of self-fashioning, and the optical effects achievable specifically through oil painting.

While Berger's genealogy of surfacism dates to the sixteenth cen-
tury, many art historians associate surfacist practices with aesthetic ap-
proaches that spread across Europe in the seventeenth and eighteenth
centuries. Art historian Svetlana Alpers details how an attention to the
surface appearance of things, what she calls the art of describing, was
a dominant aesthetic among Dutch artists of the seventeenth century.
These artists (from Frans Hals or Jan Vermeer to Johannes Cornelisz
Verspronck), in their commitment to rendering the visible world, ap-
proached "the picture as a surface (like a mirror or a map, but not a win-
dow) on which words along with objects can be replicated or inscribed."[40]
Of particular interest here is that these Dutch artists reproduced light
in new ways so as to give the world around them its descriptive texture.
Alpers maintains that these Dutch painters, for the first time in the his-
tory of art, attempted to reproduce the optical effect of rays of light hit-
ting the surfaces of the objects in their paintings.[41] By arresting the flux
of the optical experience of light reflecting on and through the surfaces
depicted on their canvases, these artists depicted what visual theorist
Norman Bryson refers to as the gaze, a way of capturing and prerecord-
ing a scene so as to make it seem fixed in its own world—impervious
and removed, hence independent of, and indifferent to, the viewers of
the work.[42] In contrast to bling's bodily centered (and indeed physiologi-
cally blinding) use of the momentary effect of light, the Dutch still lifes
presented corporeally and temporally removed representations of the
gaze in their "shellacked" canvases.[43]

Significantly, deepening the sense of a historical relationship between
materialism and surfacism, Hal Foster relates the production of shine
in Dutch paintings to commodity production and the increased cen-
trality of the market in Dutch life in the seventeenth century.[44] Building
on a study by Barthes, he posits a connection between the Dutch still
life paintings and the diverse class of objects that were newly circulat-
ing as commodities in Dutch domestic and imperial economies.[45] Foster
makes the prescient point that shiny surfaces in Dutch paintings did
not simply give commodities a material and almost tactile form but also
constituted a representational system in which the objects came to be
produced and perfected as commodities, in the face of ethical debates
about consumption.[46] The "special shellac" of Dutch still life paintings
"endow[ed] them with a pictorial value to match the commercial value
they had already acquired on the market."[47] The shiny effect also made
this commercial value appear to be innate, intrinsic to the value of the
commodity.[48]

Barthes points out that in other contemporaneous seventeenth-century paintings Dutch artists also made their male patrons, often guild members, look "ultra human."[49] Painters endowed their subjects with "extreme signs of humanity": large heads, brown or plum-colored eyes, pinkish skin, and salient facial features highlighted through the delicate use of shadow.[50] These guild portraits, moreover, made their male subjects appear almost divine, otherworldly, and omnipotent, in part through the use of arrested gesture and striking lighting.[51] In this respect, these Dutch artists produced portraits in which men were superhuman and in which objects had a visual life.

The surfacism and shine of Dutch painting had a very different appearance, aim, and specular address than did paintings composed according to Cartesian perspectivalism, a mathematically based and disembodied mode of perception organized around the concept of single-point perspective as delineated by Leon Battista Alberti in 1435–1436. Starting in the Italian Renaissance many European painters ordered their canvases from this monocular perspective: "in the manner of a lone eye looking through a peephole at the scene in front of it," as Martin Jay describes it.[52] Painters who were structuring their canvases by these means often created a sense of visual entry into the picture plane and the illusion of recession through three-dimensional space by de-emphasizing, if not effacing, the painting's flat surface. In contrast, Dutch artists, who were interested in descriptive surface details, often crowded the picture plane, used multiple viewpoints, and framed their objects more haphazardly in space, hindering a visual recession into the painting. Numerous scholars have reiterated the differences between Cartesian perspectivalism and surfacism, and I do not aim to retrace the substance of these discussions here. Rather, I want to stress a point made by Alpers, Jay, Clement Greenberg, Christopher Pinney, and others: that surfacism historically articulates a way of seeing and describing that constitutes an alternative to, and perhaps a repudiation of, Cartesian perspectivalism, the most dominant and normalized scopic regime in modern history.[53]

Moreover, surfacist aesthetics often held up a lens through which this naturalized mode of representation could be refracted and fractured. Christine Buci-Glucksmann makes this argument in regard to another stylistically complex style of artistic production, the Baroque, in which artists often overembellished the surfaces within and beyond their paintings with proliferating, ornamental detail.[54] She asserts that surfacist aesthetics furnished an "anamorphosistic mirror, either con-

cave or convex, that distorts the visual image—or, more precisely, reveals the conventional rather than natural quality of 'normal' specularity by showing its dependence on the materiality of the medium of reflection."[55] Buci-Glucksmann's characterization of surfacist aesthetics as a type of mirror is an idea to which I will return. She posits that Baroque surface aesthetics, by offering this counter-approach to vision and representation, reflected on normalized models of visuality in such a way that the means of construction in conventional modes of representation, particularly through the medium of reflection, were made visible.

Holbein's painting *The Ambassadors*, although removed from the period Buci-Glucksmann has analyzed, might elucidate how surfacist aesthetics, through anamorphosis and otherwise, can render conventions of representation legible to viewers. Holbein's anamorphic depiction of the skull, which looks like a distorted disk on the surface of the painting, served as more than a memento mori.[56] Even more pertinent, the skull, which can be seen only when viewers shift how they perceive the work, requires that viewers not only acknowledge another way of seeing but also recognize the perceptual boundaries of "normal" vision. "To see the large death's-head," as historian Stephen Greenblatt puts it, "requires a still more radical abandonment of what we take to be 'normal' vision; we must throw the entire painting out of perspective in order to bring into perspective what our usual mode of perception cannot comprehend."[57] It is this potential of surfacist aesthetics to foreground other ways of seeing, to bring naturalized structures of vision to the surface (as described by Buci-Glucksmann), and to reveal the structural limits of vision that I want to highlight as intrinsic to the visual history of surfacism.

While scholars have written about many historically specific occurrences of surfacism and shine in the history of art, I have concentrated here on the periods that Gispert and Wiley engage most explicitly in their early work—that is, late Renaissance, Dutch, and Baroque painting practices in the late sixteenth through eighteenth centuries.[58] The contemporary reappearance of surface aesthetics in hip-hop should be situated against this historical backdrop. What are the prevailing norms of visuality that hip-hop highlights, both historically and in contemporary society? What might bling, especially as Wiley and Gispert interpret it, uniquely reveal about these ways of seeing and about the visual production of the commodity in contemporary society? What might the visual cultures of late twentieth-century hip-hop, in ways that are dis-

tinct from previous articulations of surface aesthetics, render visible in their blinding aesthetics?

Shine and the Fact of Blackness

A look at popular depictions of canonized works of European art in hip-hop begins to reveal what hip-hop's surface aesthetics may have to say about naturalized ways of seeing and canonized ways of representing. Consider an advertisement for a website on hip-hop that was published in the popular hip-hop magazine *Vibe* in 2000, at the height of bling's popular enshrinement (fig. 4.6). Under the words "What is hip-hop?" a version of the painting *Portrait of Henry VIII of England* (fig. 4.7) by Hans Holbein, created in 1536, appears in visual call-and-response with the bejeweled question. The ad pictures the king wearing a rapper's signature gold chains and diamond jewelry, all star-studded enlargements of the jewels he wears in the Holbein painting. Hip-hop is, the ad provocatively suggests, an extension of a much longer history of refashioning status and prestige through shiny jewels, tactile surfaces, and sumptuous goods. Indeed, the ad's designer plots a direct representational genealogy between Henry VIII and B.G., who is denoted in absentia by the quote "I be that player with the ice [jewelry] on me." The advertisement crowns the defiant King Henry, infamous for marrying six wives, divorcing the Anglican Church from the Church of Rome, and lavish displays of wealth—the originator of "Bling, Bling."[59] Hip-hop is, the ad implies, not only a contemporary manifestation of a longer history of conspicuous consumption but also a mode of critical and comical reflection on the visual effect of the commodity. More than simply reproducing Holbein's original painting, the advertisement could literally be seen as its distorted mirror image, reflected by means of the logic of the visual in hip-hop. In the spirit of Oscar Wilde's *The Picture of Dorian Gray*, the embellished and reversed version of the painting draws attention to the king's bling, making his excesses more visible on the surface of the image.

In addition—to recall Buci-Glucksmann's argument that surfacist aesthetics historically renders legible conventions of representation—hip-hop, as presented in the ad, showcases the optical effect of the work of art. Significantly, Berger places Holbein at the beginning of a genealogy of artists who used the visual effect of oil painting to fashion a visual language of property and prestige. The print ad could be seen as an effort to render the sensorial experience or effect of this form of

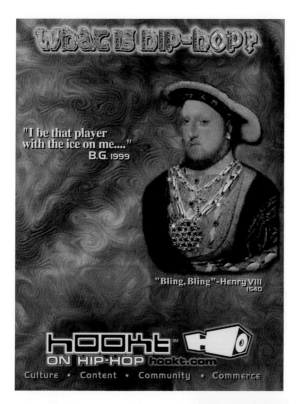

4.6. Hookt.com, "What Is Hip-Hop?" Advertisement. *Vibe*, March 2000, p. 101.

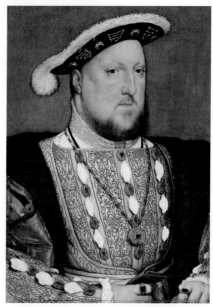

4.7. Hans Holbein, *Portrait of Henry VIII of England*, c. 1536. Oil on wood, 10.83 × 6.88 in. © Museo Thyssen-Bornemisza Collection, Madrid. Photo: Museo Thyssen-Bornemisza / Scala / Art Resource, New York.

painting, to bring out the optical impact of shine. The ad uses popular understandings of bling to bring to the surface the techniques that painters like Holbein used to convey the value of the object and the status of their subjects. This interest in the effect of light is hinted at in the ad, which pictures the king's jewels literally highlighted by starburst reflections, against a liquefied backdrop of light. The popular image indicates anecdotally what became more explicit in Wiley's and Gispert's work: vernacular approaches to visuality in later popular cultural forms of hip-hop offer a lens to reveal and magnify the techniques used in the visual production of power and prestige in European portraiture that followed conventions used in Holbein's artwork. If surfacist artistic practices in the past reflected on normalized conventions of representation, this ad and other artworks in the same hip-hop vein are one step removed. They use bling to reflect on surfacism and the visual production of shine.

But bling and contemporary surface aesthetics in hip-hop also accentuate, more broadly, other frequently unrecognized aspects of normalized modes of seeing and describing. In particular, contemporary representations in hip-hop—from music videos to studio art—that focus on the shiny surfaces of black skin call attention to an often unacknowledged and instructive history in early painterly manifestations of surfacism. In the early oil paintings, according to Berger and Barthes, skin was the only surface that was *not* rendered in a tactile way commensurate with the visual production of surface effect everywhere else in the painting.[60] For example, Berger notes that in *The Ambassadors* the only surface Holbein did not portray using the visual language of the commodity was these men's white skin. This observation is especially striking given that at the time Holbein produced this work, black skin was intrinsically connected with global capitalism, slavery, and the new ways of seeing that Berger describes. Indeed, Berger ponders whether the men pictured in Holbein's work amassed their possessions through the profits of the first transatlantic colonizing ventures.[61] In marked contrast to the way the ambassadors' skins escaped representational inscription as "object[s] in the midst of other objects," as expressed by Frantz Fanon, the bodies of persons defined as black not only literally circulated in a global economy as commodities but also were visually defined as such through the visual logic of surfacism and the aesthetics of shine.[62]

That slaves came to be visually produced as property in part through the depiction of their skin as shining is evident both in and beyond the

realm of painting. Dutch artist Dirk Valkenburg, for instance, at the beginning of the eighteenth century depicted the enslaved in ways that emphasized their glossy appearance. Works such as Valkenburg's *Slave "Play" on a Sugar Plantation in Surinam* (1706–1708) present partially dressed black subjects with their musculature or curves of their breasts emphasized through the depiction of reflecting bright white light. The slaves' glistening, shellacked, and hardened bodies represented, as art historian Charles Ford recognizes, a "grotesque *pronk stilleven*, advertising their master's ownership of themselves" (fig. 4.8).[63]

In fact, slave traders actually greased the bodies of enslaved Africans, using sweet oil or greasy water "to make them shine," as freedman Moses Roper described it, "before they [were] put up to sell."[64] Many buyers' assessments of slaves came through visual inspection in the pens. Slave traders therefore had a vested interest in glossing over the scars of the enslaved through shine, in rendering illegible "the hieroglyphics of the flesh," in creating the veneer of discipline and health.[65] Bodily shine helped to increase slaves' worth, to heighten their assimilation and visual verisimilitude to the world of objects.[66] In this way, the reflective surface of the black body—what might be characterized as the visual production of the slave sublime—served to blind buyers, if you will, to the slave's humanity. This treatment of their skin sealed them, as Fanon so succinctly described, "in crushing objecthood."[67] Contemporary attention to surface aesthetics and to the representation of black skin and black people as part of the visual economy of surfacism brings to the fore this other genealogy of surfacism, one that paintings like Holbein's *The Ambassadors*, *Portrait of Henry VIII*, and much of the art-historical literature on surface aesthetics occludes from view.[68] The visual modes of commodity production extended to enslaved Africans. I am not suggesting that many rappers and people influenced by hip-hop make explicit the connection between the shine of bling and degradations of slavery—although some rappers do, such as Kanye West.[69] What I wish to suggest is that the artists who draw on surfacism and its connection to black bodies implicitly call up the connection between surface aesthetics, capitalism, and the historical denial of subjectivity to enslaved persons of African descent.

More specifically, bringing the surface of the black body and blinding visibility in hip-hop into focus sheds light historically on how prevailing scopic regimes configured notions of race, both the supposed transparency of whiteness and the glare of blackness. Continuing the history of surface practices that allow critical reflection on normalized

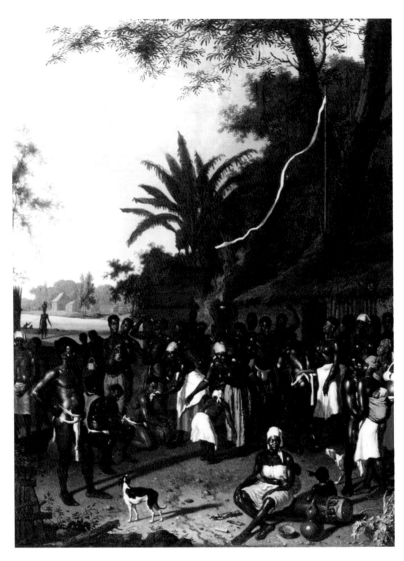

4.8. Dirk Valkenburg, *Slave "Play" on a Sugar Plantation in Surinam*, 1706–1708. Oil on canvas, 58 × 46.5 cm. National Gallery of Denmark, Copenhagen. © SMK Photo.

modes of specularity, the surface aesthetics of hip-hop reveal how both ways of seeing and ways of describing contributed to what literary critic Robyn Wiegman characterizes as the anchoring of "whiteness in the visible epistemology of black skin."[70] Wiegman traces the racial logic of corporeal inscription to Cartesian perspectivalism to beliefs connected to this mode of perception that observation yielded scientific and objective truth. Notably, ideals of race as inscribed on the surface of skin gained currency in the seventeenth and eighteenth centuries, a period contemporaneous with the development of the art of describing, when natural scientists, philosophers, and artists expressed faith in surface appearance. In other words, the very notion of blackness as locatable on the surface of black skin is an extension, the (il)logical end, of a blinding faith in the deeper epistemological meaning of epidermal shiny surfaces. Hip-hop's corporeal surface aesthetics bring to the fore the historical role earlier ways of seeing played in magnifying the idea of race and in the commodification of blackness.

Bling also illuminates the limits of these "economies of vision," to use Wiegman's characterization. Bling refracts such logic, using precisely the site of racial inscription and commoditization, the black body, to disaggregate the equation between seeing and knowing. Arguably, this incommensurability between vision and the surface of black bodies is evoked in Hype Williams's provocative use of the fish-eye lens. This photographic device seems to visualize a monocular perspective, a disembodied way of looking, that is associated with Cartesian perspectivalism and with the optical devices that contributed to the belief in surfacism in the seventeenth and eighteenth centuries. While Williams's wide-angle lens appears to function like a magnifying glass, promising a voyeur-like, intimate inspection of the pictured object, it also notably warps and distorts anything fixed in his viewfinder. Indeed, in many instances, Williams's camera seems to bring the object so close that it can no longer be seen. In this regard, Williams's hip-hop aesthetic pinpoints an aspect of bling and the surface effect of late hip-hop more broadly: it calls attention to the failure of vision, to how vision obscures from view that which it purports to reveal. Bling's emblazoned invisibility recalls much of the literature on what Fanon referred to as the "fact of blackness," the way the overdetermined surface of the black skin prevented many from seeing the humanity and subjectivity of persons of African descent.[71] In other words, inherent in hip-hop's surface visual economy is a critical reflection on how observing the surface appearance of things has been an obstacle to certain ways of seeing, a fact of visibility's limits

that, historically, people of African descent have long experienced. In this respect, hip-hop's surface aesthetics may be seen as a manifestation of Buci-Glucksmann's reflective mirror that renders visible the relation of past modes of scopic regimes to race, the commodification of blackness, and the blindness to black subjectivity, while highlighting the limits of vision more generally.

Moreover, bling's highlighting of the intersection between hypervisibility and disappearance not only brings into view the boundaries of normalized ways of seeing but may articulate alternate modes of visuality. The characterization of "bling" in the *Oxford English Dictionary* or by B.G. as sound produced by reflecting light may be read as an effort to describe what is in excess of visibility, a type of representation that transcends the realm of the visible world, so much so that it becomes sound. This notion of the sound of light may be considered with respect to literary scholar Alexander Weheliye's provocative suggestion that persons rendered invisible within the visual economies of race in the United States and other locales of the African diaspora often sought solace and subjectivity through sonic means.[72] Faced with the glare of mechanisms of vision that fixed racial signification, black subjects often strove to constitute subjecthood outside the optical realm through sound. Weheliye cautions that sonic technologies should not be interpreted as the sole site of black identity formation; rather, black subjectivity "inhabits the spatiotemporal terrain between sonic modernity and visual modernity: the crossroads of subjection and subjectivation."[73] Black subjectivity was constituted somewhere between the glare of invisibility and the blackness of sound. Does the use of sound to describe bling's light similarly aim to characterize a sonic visibility, a mode of visuality that reflects and deflects historically dominant modes of seeing blackness and seeks to represent subjectivity within, yet beyond, what is defined as the visual realm? Is light's sonic casting a reimaging of the boundaries of vision so that it is capable of registering—hearing—black subjectivity? In other words, the sound of bling may be not only a repudiation of dominant scopic regimes but also an enunciation of alternate modes of fashioning black visibility and personhood.

The Power of Surface and Light in Kehinde Wiley's Artistic Practice

Given that contemporary forms of hip-hop are expressed through a distinct visual language that sometimes reflects on art history and visuality

more generally, it is surprising that scholars and curators have turned a blind eye to these popular visual cultural genres in their appraisals of hip-hop in contemporary art.[74] Understanding the visual cultural manifestations of later forms of hip-hop—bling and its surface aesthetics—may bring into focus why artists like Wiley and Gispert use the visual language of those expressions as both form and content in their artistic practice—and why that language provides a pertinent framework for their critical reflection on art and art history.[75]

Wiley, for one, has made his direct engagement with the concept of bling explicit in his artistic practice. In a 2004 interview with curator Christine Kim regarding his earliest series of portraits of young black men based on old European oil paintings, he emphatically stated: "With the work I'm doing now, I'm interested in history as it relates to bling-bling."[76] Wiley invoked bling in part to characterize the parallels he first detected, as artist-in-residence at the Studio Museum in Harlem in 2001, between the flash of bling as manifest among black youth in the streets of Harlem and the opulence of male subjects depicted in early European oil paintings. Echoing the genealogy of conspicuous consumption plotted in the "What is hip-hop?" ad, Wiley recognized in the "flossing" and carriage of young black men in Harlem a sense of "power" and "pomp" that recalled the stances of omnipotence and pageantry in European portraits.[77] Wiley first encountered these paintings in museums as a child. He recalls his visits to the Huntington Library, Art Collections, and Botanical Gardens in San Marino, California, for instance, when he saw portraits of royalty and gentry and was fascinated by the "artificiality" and "opulence" of these works. "There was this strange otherworldliness that, as a black kid from Los Angeles, I had no manageable way of digesting. But at the same time, there was this desire to somehow possess that or belong to that."[78] Wiley's monumentalized portraits of black men in hip-hop gear assuming poses from European paintings may betoken his desire to possess these traditions. Yet Wiley was less invested in positing hip-hop as a neo-Baroque aesthetic, as some critics have argued, or in conscripting "old master" paintings as part of bling's early history, than in using bling as a conceptual framework to interrogate the performance and visual propagation of power.[79] Bling, he explains, for him came to "stand in for a much broader and complicated field of interest . . . when thinking about picturing power, which is one of the dominant themes in my work."[80]

By superimposing the opulent worlds of rulers and rappers, Wiley sought to visualize conventions for representing power in European

portraiture on the surface of his paintings. Wiley recognized that "the history of painting has been the history of those men trying to position themselves in fields of power that are very defined and codified as a type of vocabulary that's evolved over time."[81] Wiley scripted black urban youth into this history in order to ripple its codified visual field. In so doing, he took care to represent his black male subjects in such a way that they appear both within yet outside these defined vocabularies. In his early paintings he shows his male subjects in the process of being enclosed in the surface of his canvases, "shellacked" within the image world they inhabit. This is suggested by the male figure in the painting *Passing/Posing (Female Prophet Anne, Who Observes the Presentation of Jesus on the Temple)* (2003), whose hand seems to reach out toward the golden swirls of light that undulate across the surface of the work, as if marveling at them (fig. 4.9). Wiley renders his black male subjects, with their grand gestures, in ways that are in keeping with the subject matter and form of early painterly manifestations of surfacism. However, he emphasizes tactility and shine only on some parts of his paintings. While his male figures assume powerful and theatrical poses in the center of his canvases illuminated by a halo of light, their lower extremities dissolve in the picture plane. In *Passing/Posing (Female Prophet Anne, Who Observes the Presentation of Jesus on the Temple)*, for instance, the young man's jersey is displayed in surfacist detail, standing out in the foreground of the image, but his limbs disappear in the orange light and background of the bright canvas. Wiley, by portraying his subjects within the conventions of portraiture but not carrying this through for the entire painting, allows the illusions of portraiture to arise and then dissipate on the surface of the work. His figures inhabit the surface of the canvases, between visibility and invisibility. They appear both luminescent and transparent, statuesque and ephemeral, photorealist and abstract, present and absent: accidental inhabitants of history on the verge of disappearance.

Wiley, in part informed by bling, was especially attentive to how producers of European portraits used the optical illusion of what he describes as "super-rapturous light" and surface reflection to convey the power and seemingly otherworldly status of their sitters.[82] Not coincidentally, for his early figurative hip-hop paintings he chose many artworks by the late Renaissance and seventeenth-century Dutch painters, when they were employing oil paint for the first time and using it to create the appearance of a tactile, haptic surface and to reproduce the optical effect of light hitting the surface of objects. It is as if Wiley, in

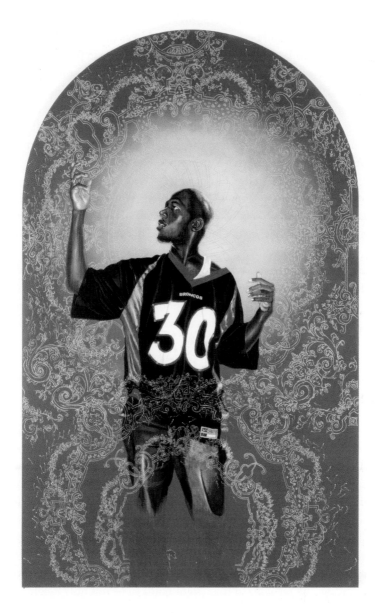

4.9. Kehinde Wiley, *Passing/Posing (Female Prophet Anne, Who Observes the Presentation of Jesus on the Temple)*, 2003. Oil on canvas mounted on panel, 96 × 60 × 1.5 in. Courtesy of the artist.

his reappraisal of art history, in order to understand how the refashioning of prestige and personhood "evolved over time," had to go back, way back, to the beginning of this visual vocabulary. In preparation for his work the artist studied the earliest techniques of oil painting, focusing in particular on the use of light to model three-dimensional form.[83] Wiley, influenced by Richard Dyer's work on the technologies of light and its relation to whiteness, sought to capture the sense of bodily transcendence conveyed by light in these earlier paintings. Dyer demonstrates how light often gave European subjects a spiritual quality, "a sense of being in the body but not of it."[84] Within his canvases, as evident in *Passing/Posing (Female Prophet Anne, Who Observes the Presentation of Jesus on the Temple)*, Wiley saturated his black male figures in this ethereal light, giving it a luminous and decorative presence on the surface of his canvases.[85]

Light and reflective surfaces also became an important source in various stages in the production of his paintings. For instance, he would flood his studio with light as he took photographs of his models. He also subsequently used computer digital imaging software to further saturate the image with, as he put it, "more light than can exist in the photographic setting."[86] He would then project these light-enhanced photographs via projector onto his monumental canvases, literally using light as a mode of translation. The resulting canvases, however, instead of displaying the subtle modeling of light to convey the materiality of objects or the etherealness of subjects, evince a flattening of light. While Wiley adds some amount of detail to his figures through overpainting, particularly to his subjects' faces, his relatively flat method of paint application does not allow the illusion of light to take effect. This is most dramatically the case when he uses metallic paint, which produces a flat, reflective plane of light in the painting. The metallic paint explicitly sets the illusion of light and its sometimes blinding effect (depending on the angle from which viewers approach the work) on the surface of the painting. In thinking about how to make paintings "about the system of painting," he recognized that "light ha[d] to be not only heightened but pointed to as a tool."[87]

Wiley's foregrounding of light as a tool is evident in a comparison of his *Portrait of Andries Stilte I* (2005) with its Dutch source painting, Johannes Cornelisz Verspronck's *Andries Stilte as a Standard Bearer* (1640) (figs. 4.10 and 4.11). Wiley did two versions of the painting (as did Verspronck), but one of the paintings clearly illuminates Wiley's engagement of art history in ways that emphasize light and surfacism in art. In

Wiley's painting, a young man dressed in hip-hop street garb assumes a self-possessed pose similar to the one that Stilte, a wealthy member of a prestigious civic militia, strikes in the seventeenth-century painting, even though Wiley's model does not quite capture the haughty repose of Verspronck's figure. Indeed, his model's "imperfect" performance of the gesture heightens what Barthes refers to as the externalization of the notion of power through embalmed gestures in Dutch painting.[88] What is most notable in Wiley's version of the image is the background and foreground, which he renders as material latticeworks of radiating light. The figure stands assertively in the middle of proliferating ornamentation in a narrow pictorial space, which seems to be disappearing, between the designs. Wiley's depiction of stylized light in the painting visualizes the effect of light in the seventeenth-century painting. He tunes viewers visually in to Verspronck's use of light in the early portrait, the way light shimmers off Stilte's pink sumptuous garments, visually defines the finery of his lace, suggests the texture of his feather, and highlights the ample folds of his standard, a testament to his newly elevated status in a civic militia. If many of the original Dutch paintings arrested the artist's perception of light on the object at the moment of the works' creation, Wiley's canvases attempt to capture the visual experience of viewing the oil paintings—the visual effect of the techniques of oil paintings. In this regard, his works offer a glance at the initial painter's gaze ("glance" referring here to Bryson's characterization of the momentary, embodied, and partially blinding experience of viewing: "vision in the durational temporality of the viewing subject").[89] This corporeal experience of vision recalls the physiological and even painful experience of light that is so intrinsic to bling. Inspired by ways of seeing in hip-hop, Wiley's work offers a glance at how the early portrait painters used light to convey the prestige of their subjects to the beholder. Thus, what is new in Wiley's bling-informed, neo-Baroque aesthetic is not another era of flamboyant fashions but a new way of foregrounding literally the way painters constructed opulence and power through surfacism and light.

Portrait of Andries Stilte I also shows how Wiley brings surfacist and decorative effect to the forefront of his canvases. The earliest producers of surfacist aesthetics rendered the surfaces of decorative objects with elaborate detail. Wiley's artistic reinterpretations make the ornamental—the surfacist—embellishment of objects the subject of his paintings. In *Portrait of Andries Stilte I*, for instance, the decorative surfaces and ornate objects that once formed the backgrounds of

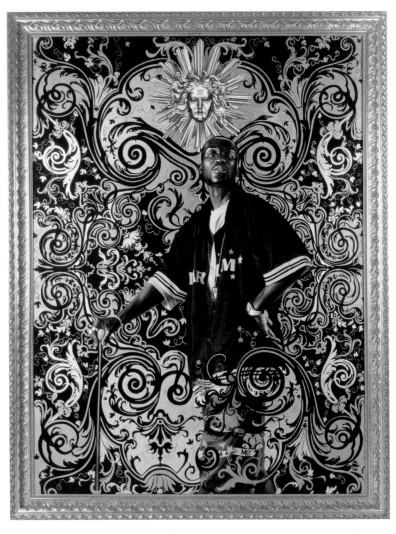

4.10. Kehinde Wiley, *Portrait of Andries Stilte I*, 2005. Oil on canvas, 96 × 72 in. Courtesy of the artist.

4.11. Johannes Cornelisz Verspronck, *Andries Stilte as a Standard Bearer*, 1640. Oil on canvas, 40 × 30 in. National Gallery of Art, Washington, DC. Patrons' Permanent Fund 1998.13.1.

seventeenth-century Dutch paintings, and of late Renaissance and Baroque paintings in Europe overall—like the textile backdrop of Holbein's painting *The Ambassadors* (fig. 4.5)—compete with the human subject of the work for representational supremacy. Wiley makes explicit reference to the decorative surfaces of objects in his inclusion of the gold mask, representing Louis XIV as Sun King, that appears just above the main figure in the work. André-Charles Boulle, an artisan in the court of Louis XIV, used such decorative insignias in his elaborate cabinets. Bolle became renowned for crafting his pieces with veneers, using polished strips of exotic woods and materials from across the French Empire and the globe on the surface of his furniture. *Portrait of Andries Stilte I*, then, places the black male figure within the shiny surface, the skin, of the luxury commodity, inhabiting the shallow depth of field in the canvas. This painting also assumes the appearance of a textile, like a Seydou Keïta photograph in which the backdrop patterns have come to life (fig. 3.17) or a Yinka Shonibare figurative sculpture in which the fabrics, wrought at the interstices of Dutch imperialism and global cultural exchange, have taken three-dimensional form (fig. 4.12). Wiley's work recalls too the Versace collections of the early 1990s, which were so

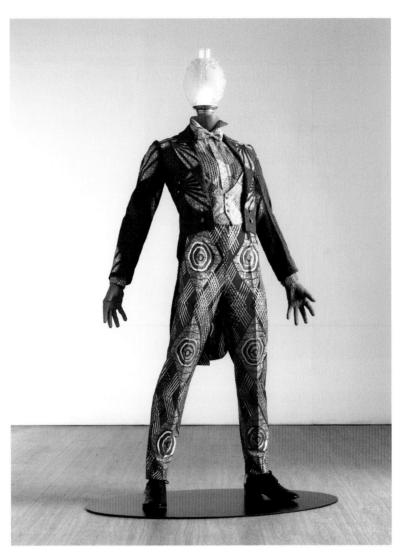

4.12. Yinka Shonibare, MBE, *Fire*, 2010. Mannequin, Dutch-wax-printed cotton textile, leather, wood, brass lamp stand, glass lamp shade, circuit board, and LED, 72½ × 43¼ × 27½ in. Copyright the artist. Image courtesy of the artist and Stephen Friedman Gallery, London.

popular in hip-hop culture, and the intertwined relationship between the selling of global brands and the fashioning of hip-hop celebrity.[90] The difference between figure and ground, between human and object, between the subject of portraiture and the surface of the decorative, and between the individual and the global become interpolated and flattened out on Wiley's canvases.

Wiley's emphasis on surface and light was made even more explicit in his series of photographs titled *Black Light*. As is evident in his *Portrait of Simon George* (2009) and *Le Roi à la Chasse* (2009), the *Black Light* photographs feature young men posed against backdrops that came from home décor magazines of the 1950s or from Martha Stewart's home collection of the 1990s (figs. 4.13 and 4.14). As in Wiley's paintings, the designs from the background wind into the foreground of the image, partially covering the male subjects and pressing them into a shallow pictorial space. Interestingly, Wiley hired a light design specialist, Steve Moyer, to create lighting reminiscent of the dazzling shine of Hype Williams's hip-hop music videos in his studio. Light, in particular, draws viewers to his model's faces and eyes, which emit a halo of white light and reflect the source of their illumination (fig. 4.15). The surfaces of their skins also reflect the crisp light source. The artist literally greased his subjects, heightening the effect of bodily shine.[91] Wiley's choice of the title *Black Light* for the photographs was based in part on his thinking about the black clubs that many urban black youth frequent and the use of black light, a device that allows for heightened visibility of whiteness and of other elements that would otherwise be rendered invisible in the dark. In the series, the artist does the work of black light, making visible and bringing historical uses of light and surface aesthetics to the fore.

The series *Black Light*, composed by means of photographing young men against a green screen and adding backdrops in the postproduction process, recalls the genre of club and street photography studios. Wiley first encountered this form of picture-making when growing up in Los Angeles. He acknowledges that these popular forms of photography offered a platform—through the drop and pose ("fabricated on the spot")—to "posit yourself in the world and yourself in such a way that you are communicating a grandiosity," whether or not you possessed material means.[92] While the street photographs are but one source Wiley draws on, they represent a popular, black urban source that was formative in his approach to the pose and performance of power in the history of art.

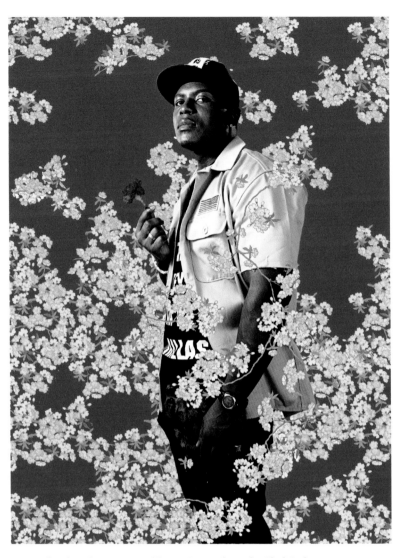

4.13. Kehinde Wiley, *Portrait of Simon George*, from the *Black Light* series, 2009. Archival inkjet print on Hahnemühle fine art paper, 30 × 24.53 in., edition of six. Courtesy of the artist and Roberts & Tilton, Culver City, California.

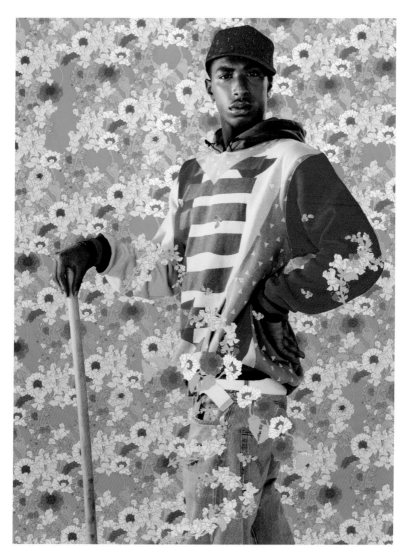

4.14. Kehinde Wiley, *Le Roi à la Chasse*, from the *Black Light* series, 2009. Archival inkjet print on Hahnemühle fine art paper, 30 × 24.53 in., edition of six. Courtesy of the artist and Roberts & Tilton, Culver City, California.

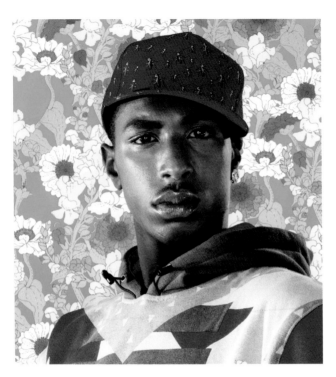

4.15. Detail from Kehinde Wiley, *Le Roi à la Chasse*, from the *Black Light* series, 2009. Archival inkjet print on Hahnemühle fine art paper, 30 × 24.53 in., edition of six. Courtesy of the artist and Roberts & Tilton, Culver City, California.

In an aspect of his work that is also related, in part, to black urban visual practices, Wiley also elucidates how the act of being represented, inhabiting the frame of art, literally and figuratively, affects status and affirms the subject's power. This preoccupation with the occupation of art and the broader framework of representation recalls popular images and approaches to visuality in contemporary forms of hip-hop, from the prom paparazzi scenes to numerous rappers' enshrinement in print ads framed as works of art.[93] Wiley interrogates the fact that being in the frame of representation was foundational to the prestige of oil painting. He underscores these issues by painting frames within the boundaries of the canvas or more typically by placing his paintings in heavy ornate and often gilded frames; for example, the ornamental gold frame on *Portrait of Andries Stilte I* and the elaborate black frame accompanying the portrait *St. Sebastian II*, an image that is based on a 1510 Flemish triptych of the saint by an unknown artist (fig. 4.16). While the frame

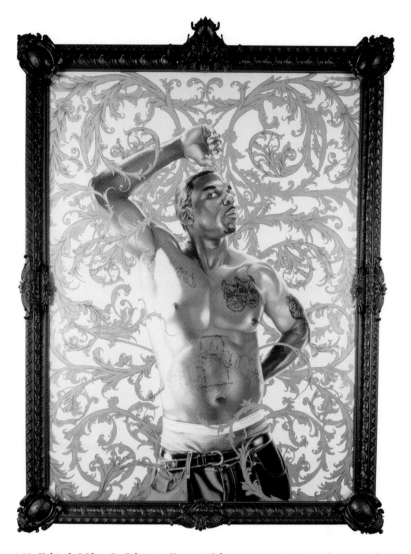

4.16. Kehinde Wiley, *St. Sebastian II*, 2006. Oil on canvas, 96 × 72 in. Courtesy of the artist.

provides contiguity with the designs within the painting, for the most part the heavy black frame imposes itself on the work. It insists that the image contained within it has been defined and enshrined as valuable through the frame of art. Wiley's paintings, as such, critique picturing practices, or what might be described in the art world as "enframing," the process by which certain subjects and practices are reified as art, forestalling other representational possibilities or forms of revealing.[94]

Wiley's interrogation of the frame, this exploration of the meaning of being represented, has a longer history in American art. African American artists in particular have used the frame as a pictorial device to circumscribe black vernacular performances of visibility in public. In her performance piece *Art Is* . . . (1983), for example, performance artist Lorraine O'Grady (in collaboration with George Mingo and Richard De-Gussi) created a float consisting entirely of a giant gilt frame mounted upright on gold fabric. The float appeared in the Afro-American Day Parade in Harlem (on the same streets from which Wiley eventually drew his first subjects). Costumed performers, clothed entirely in white and bearing ornate gold frames, ran up to onlookers, allowing them to pose, to inhabit, however momentarily, the frame of art (fig. 4.17). Similarly, the New York–based artist Hank Willis Thomas in his series *A Thousand Words* of 1997 and 1998 asked people he encountered on the streets and at private and public gatherings, such as the Million Woman March, to position themselves within small metallic frames; he then photographed his subjects as they did so. While these projects are in part about a representational inclusion, a claiming of the frame for the historically unrepresented, Wiley and, before him, O'Grady and Willis Thomas highlighted "the institutional work assigned to the frame as that which brings the world forward through its reification," as art historian Huey Copeland has noted about Thomas's *Thousand Words* series.[95]

Wiley's framed paintings, in keeping with the revelatory potential of surfacist aesthetics, also bring into focus alternate ways of seeing that dominant forms of representation conceal from view: they foreground specific forms of image-making that black urban youth engage in. Wiley's paintings highlight how African American youth often perform visibility and represent themselves through visual effects, practices that typically take place outside the traditional frames of painting. Wiley was in fact inspired to create his work after observing "a runway element" in the ways black men moved through urban pedestrian neighborhoods like Harlem.[96] Wiley recognized that many young men in metropolitan cities were keenly aware of the importance of being

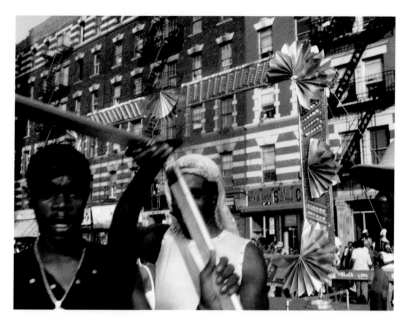

4.17. Lorraine O'Grady, *Art Is . . . (Caught in the Art)*, [Afro-American Day Parade, Harlem], 1983/2009. C-print, 16 × 20 in. Photograph of a performance by O'Grady. Courtesy of Alexander Gray Associates, New York.

seen being seen, an insight that recalls the prom paparazzi scenes. He put a spotlight on the runway feel of these everyday performances by approaching his potential subjects with a small video crew in tow.[97] He enacted a spectacle of being seen in order to invite young men with a sense of their runway presence to pose for him. The painter's process of looking for models, his staging of his own paparazzi scenes, incorporated the modes of visibility in hip-hop and in "celeb-reality" culture more generally into his artistic practice. When Wiley paints his models bathed in light, it reflects these everyday practices of visibility among black urban communities and the processes of being bathed in the light of the artist's video camera, illuminated by his camera's flashes, or circumscribed by his gold frames. In some respects, Wiley's paintings, through form and content, call attention to an aspect of black urban culture that may be seen as both a refinement and a repudiation of European portrait-making practices, a culmination of the effect of visual effect. In vernacular expressions of hip-hop culture, the optical effect of light has its own representational value, often independent of the frame of representation.

While Wiley uses the vocabulary of hip-hop to reflect on European

portraiture and the frame of Western art more generally, he is equally interested in pulling back the curtain on another image world projected through light: representations of male power and prestige in popular displays of contemporary hip-hop. Although some appraisals of Wiley's paintings assume that he sets out to aggrandize the status of his black subjects, he casts images of hip-hop culture and its visual production, as with his approach to European portraiture, in a critical light.[98] He points out precisely how the illusion of light and surface reflection gave male rappers global presence, as Hype Williams himself recognized.[99] Many scholars have commented on and critiqued the way hip-hop's visualization and popularization coincided with its hypermasculinization and hypersexualization.[100] The world of music videos imaged male prestige not only through material possessions but also through the shiny economy of black female skin, a projection of male power that, at its worst, was sexist, misogynistic, and homophobic. Wiley, as a gay male, experienced these representations of black masculinity in hip-hop, as he did the European portraits he encountered in his childhood, as something otherworldly that he did not belong to but that intrigued him nonetheless. His almost homoerotic encounters with his potential models on the streets are the artist's flirtation with these representations of black masculinity, his attempt to possess and depose hip-hop's visual construction of masculinity. That his subjects often assume the poses of female figures or take female names—that they, in effect, cross-dress by taking on personas in art history—further destabilizes the cool pose of hip-hop's masculinity.

Wiley's equation of light and surface effect in hip-hop with rappers' performances of masculinity is made explicit in some of his paintings, in which the swirls of light in the canvases, on closer inspection, take on the appearance of sperm. In the work *Alexander the Great, Variation* (2005), Wiley shows a figure sporting a puffy jacket surrounded by spirals or currents of light (fig. 4.18). Light in the work, though, morphs into what Sirmans has aptly identified as "spermatozoa."[101] The spermatozoa in Wiley's canvases, often rendered with metallic paint, first took the form of patterns derived from aerial views of specific military battle plans. They literally follow a historical visual script of masculine power.[102] In this and other paintings, Wiley's use of light is doubly inflected. Light offers an alternative mode of representation that black urban men and women use to make their subjectivities stand out. However, in the context of hip-hop culture, light also eclipses some black subjectivities that must not come into view, precisely within the self-

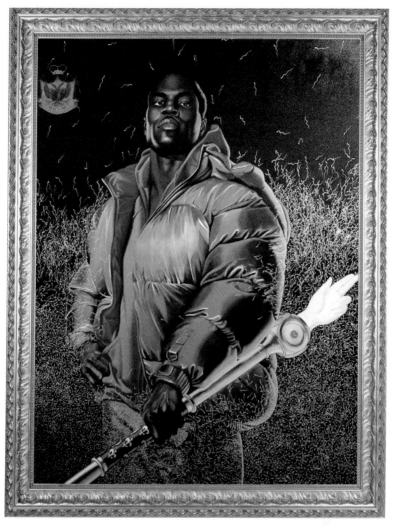

4.18. Kehinde Wiley, *Alexander the Great, Variation*, 2005. Oil and enamel on canvas, 72 × 60 in. Courtesy of the artist.

conscious performances of masculinity that must always be seen being seen. Greg Tate's observations have come closest to capturing the complex casting of light in Wiley's work. He recognizes that in these paintings "there is a surface quality of being caught and exposed to the light, Technicolor light, pageant light, spectacle light, line-up light to the men apprehended in Wiley's paintings."[103] Wiley portrays his figures as "caught" in the lineup light as well as the limelight. The figure in *St. Sebastian II* literally looks constrained by the painting's decorative surfaces, as the ornamental patterns, which echo the designs of the tattoos on his skin, coil around him. His pose could also be read equally as a gesture protecting himself from the glare of lights and as a basking in the visibility they give him. This dual casting of light seems evident in *Portrait of Andries Stilte I* (fig. 4.10), in which the figure stands triumphantly in a decorative rendering of light within the shiny surface of an object that forms a barricade around him. Wiley uses blinding light to reveal modes of black subjectivity that are concealed and rendered invisible in bling's shine.

Wiley's light and surface aesthetics also reflect more broadly on the relationship between the commodity and blackness in contemporary society. Given that historically surfacist ways of seeing have been related to the market economy and the visual production of commodities, what might hip-hop's surface aesthetics, as represented by Wiley, reveal about the commodity status of blackness historically and in late capitalism? Is bling a contemporary reappearance of the shine of blackness as commodity in the global marketplace? Wiley's meditation on the visual effect of the commodity and its relation to the global marketing of blackness through hip-hop culture is foregrounded in his *Diamond* series, which accompanied his first set of paintings of young black men and prefigured some of the wider concerns of his work since then. He exhibited these paintings at the Studio Museum in Harlem's exhibition *Ironic/Iconic* in 2002. In this series of small paintings, jewels take the place of human subjects. The artist conceived the paintings as "a type of metaphorical stand-in for bling" but also used these works to explore the way portraiture is, to quote the artist, "the recognition of the person as a value."[104] The *Diamond* paintings signified the reduction of "value down to its most essential component," that is, jewels.[105] One painting in the series, *Labyrinth (Blue Diamond)* (2002), consists of a single blue diamond that—like his male figures—hovers in a brilliant blue nondescript background (fig. 4.19). Impressionistic swirling ornamental designs frame the diamond against a liquid sky, like sperm attracted to an

4.19. Kehinde Wiley, *Labyrinth (Blue Diamond)*, 2002. Oil on wood panel, 25 × 24 in. Courtesy of the artist.

egg. The painting's visual focus, however, is the center of the diamond, which the artist takes care to depict as a kaleidoscope of refracting blue light. The series of paintings suggest that from the earliest inception of his hip-hop-inspired work, Wiley was coming to representational terms with how light and its visual effect have informed notions of value, of social worth, and of power and prestige in and outside of portraiture.

When Wiley exhibited the *Diamond* paintings at Deitch Projects in New York in 2001–2002, he commissioned musicians to play West Coast gangster rap recomposed as chamber music and showed the work with an eight-foot-tall, diamond-shaped ice sculpture at the opening. The giant sculpture was a supersized reference to bling, which in hip-hop

parlance is also referred to as "ice," as manifest in contemporary black popular culture and in the opulent European portraits. The ice sculpture melted down and "decayed," as the artist put it, during the course of the exhibition, serving as a memento mori, a rapidly disappearing reminder of the ephemerality of all that shines.[106]

Wiley's *Diamond* series and figurative paintings may offer a visual counterpart to the work of theorists like Fred Moten, who reevaluate notions of value and the commodity through a consideration of black culture, black subjects, and slavery. Moten, for one, takes issue with Karl Marx's theory of value. Specifically, Moten quarrels with Marx's premise that commodities cannot speak, a point that is intrinsic to Marx's argument that objects such as diamonds and pearls have no innate value, none that exists before their valuation through market exchange.[107] Moten is quick to point out that Marx neglected to recognize slavery and the fact that the enslaved were indeed commodities who spoke, who indeed screamed as they were violently reminded of their status as objects. Beyond the argument that blacks who were defined as objects sounded their subjectivity, Moten makes the broader point that an acknowledgment of slavery and blackness requires a radical rethinking of the notion of value. He reiterates that some commodities had "value" before their exchange value (contrary to Marx's view) and conceives of speech, the "materiality" of "breath and sound," as possessing value for slaves and their descendants.[108] Moten's consideration of the sound of the commodity may be insightful here for developing an understanding of the sound of light and rethinking the notion of value as defined through the optical realm. Do conceptualizations of the sound of light, building on Moten, highlight alternative formulations of black subjectivity and redefinitions of value? Might Wiley's portrait of light-reflecting diamonds and the visual world of bling point to what might be considered the *material value of light* in black urban practices? By this I mean: Is it possible that black bodily shine, once the most explicit visual manifestation of the commodity, now has its own material value? This might explain why black urban subjects often "fake that floss" (wear shine-producing but fake jewelry) or stage paparazzi entrances directed at producing light. In contemporary black urban cultures, the simulation of shine seems to have its own value, which can be produced without commodities through the effect of light and outside the market economies of mainstream America. This state of affairs would seem simultaneously the culmination of practices of commodification and their dematerialization, a metatroping and refraction of a

long history in the visual production of the commodity and systems of value in capitalism.

Wiley's paintings, moreover, which he describes as being about "the consumption and production of blackness [a]nd how blackness is marketed to the world," appear to shine a light on a shift in the representational politics of blackness in the last two decades, brought about by the unprecedented global commodification of black culture.[109] As art and cultural theorist Kobena Mercer observes, throughout the twentieth century African Americans struggled for representation within mainstream American popular culture and as subjects of art—and indeed viewed visibility within these structures of representation as a blueprint for racial uplift.[110] In contrast, since the turn of the twenty-first century black culture has been hypervisualized. Mercer, following sociologist Herman Gray, uses the term "hyperblackness" to characterize how contemporary forms of black culture saturate the public sphere, both nationally and as a global brand. Hip-hop has played a central role in this unprecedented spectacularization of black culture. I would take it one step further to point out that hip-hop's bling-bling culture, its blinding visual expressions, are products, producers, and personifications of this notion of hypervisible black culture. Wiley's portraits of diamonds and his monumentalized representations of black men caught in light similarly reflect on and are reflections of this unprecedented moment of emblazoned black visibility.

Wiley's attentiveness to blackness and light may instructively be compared with an early historic moment in the 1960s and 1970s when poets, photographers, and painters associated with the Black Arts Movement sought to conceptualize and represent black light and in doing so to reorient philosophies of aesthetics and beauty more generally.[111] Writers like Larry Neal and Gwendolyn Brooks in the Black Arts Movement were cognizant of the ways that socially inscribed meanings of whiteness colonized light, and all the virtues associated with it, from knowledge to godliness. Some visual artists at this time gave black light painterly form by attempting to extract whiteness from the idea of and representation of light. This is evident in artist and activist Faith Ringgold's series *Black Light*, exhibited in 1970. In the canvases, in an effort to reflect on the use of light in the history of painting and its implicit role in manifesting whiteness and denigrating blackness, Ringgold removed the tone white from her palette. Wiley's series *Black Light* cuts back to a historic moment when the aesthetics, metaphysics, and politics of blackness and light were central in discourses concerning

black nationalism, rights, and anticultural imperialism. In doing so, he highlights the shifting contemporary terrain where debates about politics, culture, and aesthetics are taking place, a terrain that is informed by hip-hop and the heightened visibility of blackness in contemporary global consumer culture.

The Visual Illusion and Volume of Light in Luis Gispert's *Cheerleaders*

Luis Gispert, similarly, creates artwork that speaks of and through the hypervisible language of hip-hop culture in such a way as to reflect on the history of art and contemporary popular cultural representations of blackness. Gispert identifies forms of hip-hop practiced in the US South as formative in his artistic practice.[112] He spent much of his youth in Miami in the mid-1980s, when the city boomed with the sounds of the city's African American, Latino, and Caribbean-infused bass music culture. In 2001 Gispert exhibited a series of photographs that aimed to capture the visual practices that surrounded Miami's hip-hop scene, his series *Cheerleader*. Composed of eleven large-format Fujiflex photographic prints and two accompanying videos, the series portrays cheerleaders of various ethnic backgrounds sporting the accoutrements of bling.

Gispert conceived the series on the heels of a trip to Italy and France, where he first started to perceive parallels between the audacious ornamentation of Italian Baroque paintings and the visual expressions of hip-hop. "Bling, bling" constituted, he concluded, an urban Baroque aesthetic: "The jewelry, the shiny clothing, the elaborately painted fingernails, all of the gold and platinum—it is fundamentally about excess and about an appetite for Baroqueness."[113] In the series *Cheerleader* Gispert combines these urban bodily practices in hip-hop with seventeenth-century Baroque pictorial traditions. In the photographs, female figures adorned with the visual weaponry of bling inhabit spaces where Virgin Marys and saints take up heavenly residence in Baroque paintings. In *Untitled (Single Floating Cheerleader, a.k.a. Hoochy Goddess)* (2001), for instance, the artist presents a cheerleader suspended in space against a luminous green background, weighed down only by her heavy gold jewelry, gun-shaped diamond-studded pendant, and gold teeth (figs. 4.20 and 4.21). The image recalls the many scenes of heavenly ascension, typically toward or within light, that animate Renaissance and Baroque paintings. The cheerleader's pose is also remi-

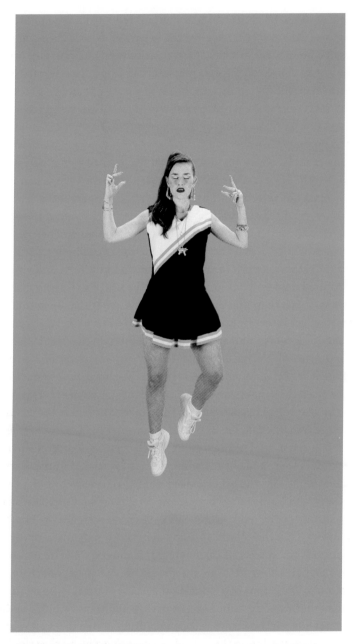

4.20. Luis Gispert, *Untitled (Single Floating Cheerleader, a.k.a. Hoochy Goddess)*, 2001, Fujiflex print, 40 × 72 in. The West Collection, Oaks, Pennsylvania.

niscent of other religious and pop-cultural representations of levitating figures. One could characterize the bejeweled female cheerleader as a sacred embodiment of hip-hop's secular culture, one who also brings the heavenly figures of Baroque religious paintings down to earth. But Gispert's Baroque juxtapositions, like Wiley's, are not simply a contemporary restaging of an art-historical representational script; they are, rather, a Brechtian unveiling of the visual effect of canonized modes of artistic production.

Gispert looks at art history through the lens of bling, perceiving through it the optical effects of works of art. Whereas Wiley's paintings have scoped out the effect of light and surface, Gispert focuses on the illusion of gravity. Specifically, he became fascinated with the way Renaissance and Baroque artists used painterly techniques of perspective, scale, and light to create the illusion of figures floating in space. This optical effect was central to the representation of otherworldly power and inspired deference, devotion, and, in the use of the Baroque in the Americas, subjection. That bling for Gispert is about the representation of visual effect is foregrounded in his *Untitled (Girls with Ball)*, a photograph that captures, from a high vantage point, two cheerleaders jumping in the air, with arms eagerly outstretched, in pursuit of a bowling ball (figs. 4.22 and 4.23). All the elements in the photograph seem to defy gravity, from the women, who hang in a nondescript green background, to the bright, seemingly weightless, red ball that hovers in the center of the image. What is notable in this first image of the series *Cheerleader* is that the artist does not represent bling as bodily accoutrement. The cheerleaders wear none of the commodities associated in popular culture with bling. Yet the artist makes explicit reference to bling in another way: the word "bling" appears with unblinglike simplicity on the shiny surface of the red bowling ball. Gispert's placement of "bling" on the bowling ball, the central focus of the gravity-defying composition, foregrounds the subject of the photograph and the *Cheerleader* images more generally: bling is about the production of visual effect. It calls attention to the means of producing the visual illusion—the mirage, to use the other word described on the ball. In addition, Gispert's specific engagement with the tradition of oil painting is signaled by the three quadrangular squares on the red ball, a trope that appeared in the earliest forms of oil painting in the Renaissance. Michel de Certeau notes that quadrangular reflections of light in paintings quite literally reflect what is not depicted in the canvas (but exist within the physical space that the subject of the work occupies).[114] Gispert's inclusion of a device

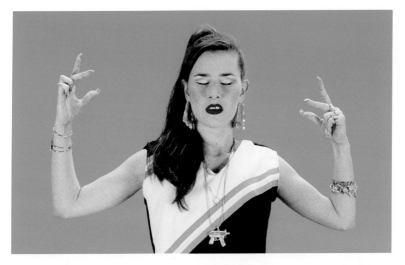

4.21. Detail from Luis Gispert, *Untitled (Single Floating Cheerleader, a.k.a. Hoochy Goddess)*, 2001. Fujiflex print, 40 × 72 in. The West Collection, Oaks, Pennsylvania.

associated with the beginnings of oil painting calls attention to his engagement with the history of the medium and his interest in making visible what the art form of painting itself does not bring into view: the way the painting constructs its subject through visual illusion.

Although Gispert's cheerleaders may resemble paper-doll cutouts from art history, the artist is employing them in such a way as to peel away the compositional devices that support gravity-defying illusion in sixteenth- and seventeenth-century paintings. *Untitled (Girls with Ball)*, for instance, presents the cheerleader figures suspended in a visual ballet, but all other organizing principles of Cartesian perspectivalism or the surface arts of describing are stripped away. Norman Bryson has argued that historically, oil painting functioned as an erasive medium: "What it must first erase is the surface of the picture-plane: visibility of the surface would threaten the coherence of the fundamental technique through which the Western representational image classically *works* the trace, of ground-to-figure relations."[115] Gispert, by placing figures against a monochrome bright green backdrop, literally pulls the ground from the representation, thus highlighting the organizing structure, the erasive illusion, of oil painting. Specifically, the artist, who was originally trained as a filmmaker, uses the chromo-key green backdrop, the device used in film to superimpose figures against any ground. Through his erasure of the illusion of perspective and foregrounding surface, the

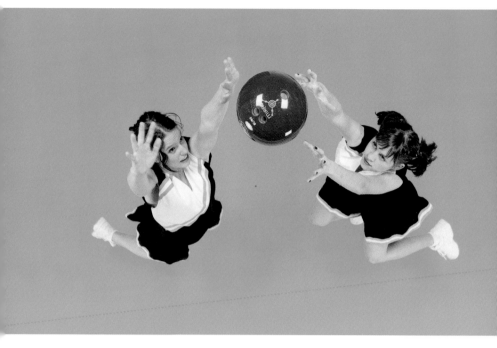

4.22. Luis Gispert, *Untitled (Girls with Ball)*, 2000. Fujiflex print, 40 × 70 in. Collection of Lee Stoetzel, New York.

series of photographs visualizes "ground-to-figure relations," the creation of spatial depth and figural ascent.

Gispert's reflection on representation is not confined to historical paintings; he also interrogates the marketing of black youth culture through the language of contemporary advertising. The figure of the cheerleader in the series stands as an example of a mutable and pliable American pop icon that is used to sell everything from ideals of nation, gender, race, and sexuality to consumer products, from television shows to toothpaste. The cheerleaders who don the flashy accoutrements of hip-hop culture in Gispert's series call attention to a contemporary moment when black urban culture circulates across cultures, ethnicities, and nations as a fungible commodity—indeed, as Gray might argue, as the most visible consumer product nationally and globally.[116] The fungibility of black culture is made most explicit in the series *Cheerleader* in Gispert's music video *Foxy Xerox* (2003), which is centered on a white woman in blackface wearing gold chains who is levitating, lip-synching, and assuming the bodily postures of male rappers.

Intriguingly, Gispert has recognized that some of the same visual

4.23. Detail from Luis Gispert, *Untitled (Girls with Ball)*, 2000.
Fujiflex print, 40 × 70 in. Collection of Lee Stoetzel, New York.

effects that were central to the impression of supernatural power in
Renaissance and Baroque paintings have informed the production of
blackness in the world of advertising. Most notably, the illusion of the
gravity-defying heroic bodies suspended in space laid the ground for
the representation of black subjects in advertising and the portrayal
of their seemingly superhuman power.[117] Gispert's *Untitled (Girls with
Ball)* recalls the divine ascent in Baroque painting, but the image also
refers to more secular pursuits. The photograph draws thematically and
compositionally on ads for the National Basketball Association (NBA)
that feature black men, photographed from a high vantage point, sus-
pended in air and strenuously reaching for a basketball. Gispert sub-
stituted a bowling ball for the basketball, and he replaced the NBA's
logo with the word "bling." The work also brings to mind photographs
or glossy posters of Michael Jordan taped to the walls of little boys'
rooms that immortalize the black basketball star "hanging" in mid-
air, and even of the Nike brand he endorsed, consisting of a leaping
figure. The artist's suspended (in)animation recalls the artwork of Paul
Pfeiffer, who digitally lifts NBA players from photographs and video

footage, leaving a lone twisting and contorted figure floating in space, suspended in light. In the resulting images, however, as manifest in Pfeiffer's *Four Horsemen of the Apocalypse (17)*, black men, despite being bathed in superrapturous light, seem weighed to the ground, unable to escape their earthly and bodily confines (fig. 4.24). Gispert's photographs similarly bring the visual production of heralded black sports figures, caught hanging in time, into view. The use of the green backdrop, for one, a visual device that advertisers use in the manufacture of their images, calls attention to such images' fabrication. Gispert's *Untitled (Girls with Ball)* foregrounds how certain techniques of photography (still and moving)—the freeze-frame, the replay, slow motion, high camera angles (basket cams), lighting—all reconfigure ground-to-figure relations to generate the effect of superblackness.

Bling in Gispert's photographs is ultimately not simply about the visual figuration of black athletes or about how NBA players participate in popular manifestations of bling (in 2003, tellingly, NBA players' championship rings were inscribed with the word "bling"); his photography and video work also casts a spotlight on the marketing of the black body as commodity. This is evident in the work of another artist, Hank Willis Thomas, who uses the language of advertising to reflect on the branding of blackness. In the photograph *Branded Head* (2003), Thomas presents, against a nondescript background, a porous close-up of a black male head in profile (fig. 4.25). The figure's scalp bears a Nike brand in upraised shiny flesh. The photograph literally focuses on the shiny surface of the black body, glowing with the shine of sweat, depicted in the heat of harsh light, as the site of objecthood. The source of light in the photograph is notably ambiguous and seems simultaneously evocative of a camera's light, lineup light, limelight, the ESPN highlight, and the slave buyers' sight.[118] *Branded Head* brings to mind Anthony Pinn's provocative argument that the sweating black body signifies spiritual transcendence in the black Pentecostal church.[119] In Thomas's photograph, however, the sweating black body appears unable to transcend its status as object, much like Pfeiffer's and Gispert's figures, which, despite being based on poses and pictures of transfiguration, remain confined to the material world. The black figure's objectification, its inability to imprint subjectivity, is suggested in Thomas's cropping of the figure's face, the incisive cut that excises the visage from view. Thomas's and Gispert's surface aesthetics bring the histories of the slave sublime head-to-head with the sublime blindness of black hyper-

4.24. Paul Pfeiffer, *Four Horsemen of the Apocalypse (17)*, 2004. Fujiflex digital C-print, 60 × 48 in., edition of six. Courtesy of the artist and The Project, New York.

4.25. Hank Willis Thomas, *Branded Head*, 2003. Lambda photograph, 30 × 20 in. Courtesy of the artist and Jack Shainman Gallery, New York.

4.26. Luis Gispert, *Untitled (Car Toes)*, 2002. Fujiflex print, 40 × 60 in. Collection of Rosa and Carlos de la Cruz, Key Biscayne, Florida.

visibility, highlighting how in both instances, despite the glare of visibility, the subjectivity of the figure disappears from view.

While Gispert's *Cheerleader* photographs intimately engage popular cultural and art-historical visual economies, images in the series also highlight black and Latino youths' conceptions of visuality—ideas informed by southern US manifestations of hip-hop. The photograph *Untitled (Car Toes)*, for instance, provides a snapshot of popular visual practices, particularly the pastime of cruising: driving slowly through urban space to be heard and to see and be seen being seen (fig. 4.26). The image depicts a bejeweled foot and a hand adorned with gold rings and with elaborately painted and sculpted nails dangling out of a car window. A male hand, similarly displaying bling's accoutrements, grasps the steering wheel. The occupants themselves, however, are secondary subjects in the image. Despite their shine, they are notably invisible in the photograph. The image points up the effect they aim to produce sensorially. Light shines off the glossy red surface of the car, light adds to the sculptural qualities of the toes, and the jewelry reflects bling's signature star. Gispert added to the shiny subject matter with his choice of medium, a high-gloss Fujiflex photographic paper that aptly portrays and projects light.

Another installation, *Low Profile* (1999), further develops the theme of the car as a site of production of visual effect (fig. 4.27). For this in-

4.27. Luis Gispert, *Low Profile*, 1999. Fiberglass and factory Dodge Viper paint, 90 × 175 in. MDCC Centre Gallery, Miami.

stallation Gispert took the measurements of a red Dodge Viper, a car he identified as representative of hypermasculinity in Miami's hip-hop culture, and applied high-gloss car paint to a piece of fiberglass on a gallery wall that measured 90 inches by 175 inches, the vehicle's exact surface area. He also suspended imitation hubcap rims at the same height as their exact height on the Viper. This work highlights many of the popular representational practices of later forms of hip-hop that I have outlined throughout this chapter, a logical and literal unfolding of the formal and theoretical concerns of Gispert's work. The installation consisted solely of the reflective surface—the site of the performance of masculinity, the sight of popular representational practices in hip-hop, and the sight of the visual production of light's effects. The installation also presents the sparkling shell of the commodity, which has become central to the value of things, *independent of the things themselves* (in this instance, the car). The installation is the representation of the effect of light and the shiny surface as its own image, as the work of art in the age of contemporary hip-hop.

Gispert's covering of the gallery wall with a glossy surface extends and subtends his broader engagement with the history of painting to

reflect on the boundaries of visuality and specularity more generally. He used bling to underscore the limits, the pictorial impossibilities, of Cartesian perspectivalism and surface aesthetics. Gispert provocatively labels his larger body of work, which includes the series *Cheerleader*, "loud images," invoking the sonic to describe his visual production.[120] Might this invocation of sonic visuality aim to characterize what Weheliye calls the "crossroads of sonic and visual modernity," or the visual scream of the commodity? Do Gispert's loud images give form to a type of visual expression that, like bling, exceeds the optical realm? Gispert describes the powerful sonic effect of Miami's bass music as occurring "toward the end of the audible spectrum."[121] Gispert's photographs may similarly be characterized as images that aim to reproduce the blinding effect of vision, the "sound of light," pointing out the end of the visual spectrum. His loud images speak to alternate modes of visuality, of subjectivity, that sound at vision's end.

The Work of Art in the Age of Hip-Hop

All the artists discussed here have used visual expressions of hip-hop in the late twentieth century and situated the notion of bling to accentuate the commodity status of blackness, both historically and in contemporary society. As Moten foregrounds and bling illuminates, enslaved Africans and people of African descent whose subjectivities were (and continue to be) eclipsed in the shine of surface aesthetics have long been aware of the construction and limitations of European modes of visuality. In other words, that people of African descent were defined as black through the visual logic of Cartesian perspectivalism and subsequently through surface aesthetics were defined as commodities immediately casts light on the blind spots of the European ways of seeing and describing. Bling, unlike normalized disembodied and monocular modes of specularity, highlights other bodily forms of perception and the blinding limits of visibility. Many visual practices of black youth simulate a bodily, physiological experience of seeing, and they have made the physical sensation of viewing intrinsic to their performance practices. They have taken the moment when the limit of the visual realm has been reached and have made the effect of this visual breach the substance of their representations, the source of their self-fashioning. Characterizations of the sound of light, the sound of the commodity, and the sound of loud images have all been exploited to convey alternative approaches to representation, to find ways to ar-

ticulate black subjectivity outside dominant or conventional Western economies of vision. Returning to Wallace's concerns about the problem of the musical in visual cultural studies of African American culture, the exploration of the visual cultural manifestations of hip-hop and contemporary hip-hop art that I have presented here evinces how the visual and sonic extend and subtend each other to form new expressions of sonic visuality, expressions that come to light at the juncture of sonic and visual modernities.

Bling, while foregrounding the historic relationship between blackness and the commodity, also ultimately speaks to the representational politics of blackness in the contemporary moment, in the age of black hypervisibility. Gispert's and Wiley's works and the popular cultural focus on blinding visibility reflect on how the hypervisualization of black culture—to return to Mercer—has radically transformed the conditions of imaging black subjectivity. What possibilities of black subjectivity lie at the interstices of hypervisibility and disappearance? Might the hypervisibility of bling be another instance of the disappearance of the black subject, a new form of emblazoned invisibility? Wiley, Gispert, and the producers of popular images of hip-hop capture the complexities of this contemporary moment of hyperblackness and the new politics of representation and aesthetic practices that it brings to light.

NOTES

Introduction

1. Google, for instance, describes African Americans in the United States as in "the vanguard of digital consumption." Google's report notes that "lower income African Americans are willing to cut back on other things in order to afford the latest technology." See Google, "5 Truths of the Digital African American Consumer," 12. See also Rideout et al., *Children, Media, and Race*, 1–20, and Forbes, *Music, Media and Adolescent Sexuality in Jamaica.*

2. I use the characterization of "black public sphere" offered by the editors of *Public Culture*. "The Black public sphere is primarily concerned with modernity and its relation to Black people through culture, politics, law and economics. Modernists, from W. E. B. Du Bois to the present, have been concerned with how to adopt modernism and modernization to Black ways of life. They have sought to make Blackness *new* and remove it from the pathological spaces reserved for it in Western culture, to define their own version of modernity so as to provide a quality of life for Black people and to legitimize Black ways of life as modernist expressions." Moreover, commodities and their circulation and their relationship to markets, freedom, identity, property, and pleasure are key in the articulation of the black public sphere. I am using "black public spheres" here to denote public spheres across different black urban communities. Appadurai et al., "Editorial Comment," xii–xiii.

3. Silverman describes photography as a representational system and a network of material practices, *Threshold of the Visible World*, 136.

4. Studies on the circum-Caribbean analyze the movement of people (from loyalists to laborers), material goods, performance practices, and political ideologies across the transnational circuit in the United States (particularly the southern United States) and Caribbean. Such intraregional travel often rendered local, colonial, and national configurations of race (or racelessness) legible. Examples of this scholarship include Patterson, "Emerging West Atlantic System"; Adams et al., *Just below South*; Cartwright, *Sacral Grooves, Limbo Gateways*; and Regis, *Caribbean and Southern.*

5. *Un*-visible describes a state of being unrecognized and unseen by mainstream society and comes from Ellison, "Introduction," xv. A more detailed explanation of the term comes later in the chapter.

6. Both *The World Stage: Jamaica* and *Illuminated Presence* took place as this book went to press and therefore will not be described at length here.

7. I examine this in chapter 2. On skin bleaching as a form of preparation for the video light, see McDonald, "Skin Bleaching and the Dancehall"; Athaliah Reynolds, "'Proud a Mi Bleaching': 'Skin-Bleachers' Defend Their Action Despite Health and Cultural Warnings," *Sunday Gleaner*, November 15, 2009, A6; Claude Mills, "Heat in the City: The Layers of the Dancehall Queen," *Gleaner Flair Magazine*, April 22, 2002, 8–9; and Stanley Niahh, interview with author, Kingston, Jamaica, August 15, 2011.

8. MOB dancers, interview with author, Kingston, Jamaica, June 6, 2009; Ian Dice Charger, interview with author, Kingston, Jamaica, August 19, 2011; and Hodges, interview with author, Kingston, Jamaica, August 19, 2011.

9. Michael Graham, "Crazy Hype," interview with author. Kingston, Jamaica, June 6, 2009.

10. Jack Sowah, interview with author, Kingston, Jamaica, August 21, 2011.

11. People have been gathering in the outdoor arenas to dance since the 1950s. Hope, *Inna di Dancehall*, 10.

12. Sonny (whose last name is unknown to me) is the owner of Sonny's Video and Photography. The sign he uses at his photography studios displays the name "Photo Sonny."

13. The modern African diaspora characterizes people of African descent brought to the Americas in transatlantic slavery, the generations that came after them, and the secondary diasporas produced through contemporary migration. A sampling of the scholarship on the centrality of music or sound within African diasporic formation includes Baucom, "Frantz Fanon's Radio"; Best, *Culture @ the Cutting Edge*; Von Eschen, *Satchmo Blows Up the World*; Gilroy, *Black Atlantic*; Iton, *In Search of the Black Fantastic*; and Weheliye, *Phonographies*. On the centrality of print media, see Edwards, *Practice of Diaspora*. On the circulation of black intellectuals, see James, *Holding Aloft the Banner of Ethiopia*, as well as the Gilroy and Edwards citations earlier. On visual cultural expressions like fashion, minstrelsy, or "black ephemera," see Chude-Sokei, *Last "Darky"*; Gilroy, "Wearing Your Art on Your Sleeve"; Neptune, *Caliban and the Yankees*; and Thompson, *Developing Blackness*. For Wallace's incisive critique of the privileging of the study of music in African American studies, see Wallace, "Modernism, Postmodernism, and the Problem of the Visual in Afro-American Culture," 40–41.

14. Gilroy, *Black Atlantic*, and Edwards, *Practice of Diaspora*, 66.

15. Hall, "Cultural Identity and Diaspora."

16. This study is indebted to the "encoding and decoding" methodology that British cultural theorist Stuart Hall espoused for analyzing the influence of mass media. His work offers a prescient model, given the book's focus on how black populations interpret and often reconfigure visual media and photographic and videographic technologies. I am especially interested in how the visual intercedes and intervenes into the linked but distinctive mo-

ments of production, circulation, distribution, and consumption, impacting the production of popular cultural forms and studio art practices, as well as encoding broader approaches to representation and visibility among black urban populations. Hall, "Encoding, Decoding," and "Reflections upon the Encoding/Decoding Model."

17. On the unfinished qualities of music, see Gilroy, *Black Atlantic*, 104–105. Elaborating on the "black fantastic," Iton explains, "Popular culture thrives on, and indeed demands, nuance, dadaesque ambiguity, and contrapuntality as it resists fixedness in its moves between the grounded and the fantastic." He continues, "My suggestive reference to a black fantastic, then, is meant to refer to the minor-key sensibilities generated from the experiences of the underground, the vagabond, and those constituencies marked as deviant — notions of being that are inevitably aligned within, in conversation with, against, and articulated beyond the boundaries of the modern." Iton, *In Search of the Black Fantastic*, 11, 16.

18. On the joints and gaps as intrinsic to African diasporic formation, see Edwards, *Practice of Diaspora*, 13–15.

19. Meyer, *Aesthetic Formations*.

20. Gilroy, "Get Free or Die Tryin'," 34.

21. The "practice of diaspora" comes from Edwards, *Practice of Diaspora*. On the use of photography to create broader communities, geographies, and cultures in the African diaspora, see Campt, *Image Matters*; Diawara, "1960s in Bamako"; Raiford, "Photography and the Practices of Critical Black Memory."

22. The hand-painted photographic ground was also the product of geographic distance, rendered pictorially even as from afar. Featuring a reversed American flag in its corner, the artist created the image with a sense that proximity, attainment of an imagined and allusive site of diasporic belonging, came through the photographic technology. Conversely, in the United States, patrons pose before photographic backgrounds depicting "tropical" Caribbean landscapes. On the iconography of the picturesque tropical Caribbean landscape, see Thompson, *Eye for the Tropics*.

23. Metz, "Photography and Fetish," 84.

24. As Saidiya V. Hartman describes it, African diasporic communities are formed in part through "a sentient recollection of connectedness experienced at the site of rupture, where the very consciousness of disconnectedness acts as mode of testimony and memory." Hartman, *Scenes of Subjection*, 73–74.

25. In the 1980s, music videos would circulate through VHS tapes, which were physically carried between the United States, Jamaica, and the Bahamas. Hip-hop and R&B music videos from the United States later had widespread visibility in the Caribbean, through stations like Black Entertainment Television, the most popular station among youth in Jamaica. The performers in Jamaica, like the MOB dancers, and some of the prom participants who play music videos during their entrances all describe the influence of music videos on their performances. MOB dancers, interview. On the early circula-

tion of the music video in Jamaica, see Batson-Savage, "Here Come the 'Hot-steppers,'" *Gleaner*, January 16, 2005, E1.

26. Jack Sowah, interview with author, Kingston, Jamaica, August 21, 2011.

27. On how the process of compression to facilitate the speedy circulation of information leads to loss of digital data and its parallels in contemporary art, see Griffin, "Compression," 3–20.

28. Hope, "*Passa Passa*," 134.

29. While the circulation of media has the potential to disrupt conventional strictures of gender and sexuality, more often than not the visualization of nonheteronormative displays of gender and sexuality has provoked debate, censure, and calls for censorship.

30. See Roach's concept of "surrogation" and Stanley Niaah and her analysis of how groups across Africa and the African diaspora to create a transnational sense of community through performance geographies: Roach, *Cities of the Dead*, 2, and Stanley Niaah, *Dancehall*, 32–33.

31. Roach, *Cities of the Dead*.

32. The camera revealed much about participants' investment in photographic and videographic technologies as well as what was unphotographable in each setting. But perhaps most important, my use of these devices allowed me to develop a clearer sense of the presumed gender of the camera in these contexts and about the heteronormativity of relations between cameramen (male in every instance) and their subjects. Many of the illustrations in the book are the product of my research; the video stills capture the in-between state of representation that I see as characteristic of many of these forms.

33. *Oxford English Dictionary* (British ed.; Oxford University Press, 2003) defines "after-image" as "an impression of a vivid image retained by the eye after the stimulus has ceased."

34. See Cadava's study of Walter Benjamin, *Words of Light*, 43.

35. Lorde, "Afterimages," 102–105. Afterimages, as Lorde describes them, are close to what German cultural critic Siegfried Kracauer termed "memory-images." Kracauer distinguishes photographic images from memory-images. He argues that while the latter can mechanically record across space and time, memory-images are formed in the subjective consciousness according to their significance. They represent a truth that the camera cannot capture. Afterimages, to extrapolate from Lorde, are forms of memory-images and knowledge produced through the photograph, the process of its production and its phenomenological effects that are created in the body. Kracauer, "Photography," 425.

36. Since Frenchman Louis-Jacques-Mandé Daguerre announced the development of a photographic process he called the daguerreotype in 1838, Englishman Henry Fox Talbot patented a form of image-making called the calotype in 1841, and other inventers developed photographic processes globally in the early nineteenth century, photography has been associated with the fixing of the impressions of light, directed through a camera obscura, on a metal plate or on chemically treated paper. Talbot's calotype photo-

graphic process also helped to popularize the production of multiple prints from a negative. For an examination of these early forms of photography, see Batchen, *Burning with Desire*, 24–53.

37. These characteristics reflect what Hall identifies as a quintessential trait of diasporic formation: the process of becoming, the always unfinished work of cultural formation and identity in the African diaspora. Hall, "Cultural Identity and Diaspora."

38. Barthes, *Camera Lucida*, 5.

39. This is evident in the daguerreotypes taken by Joseph T. Zealy of enslaved Africans in North Carolina in 1850 and in Brazil, which polygenists, like Louis Agassiz, likely used to forward theories of the distinct origins of the races and inferiority of black people. The postcards of picturesque black Caribbean inhabitants in Jamaica and the Bahamas from the late nineteenth and early twentieth century taken by a host of photographers in the employ of the colonial governments offered testaments, by the very appearance of black inhabitants as picturesque photographable subjects, to the primitive yet disciplined character of blacks in the islands. The daguerreotypes, which revealed too much particular detail to denote racial types, and the staged Caribbean postcards, which were often painted over to hide unwanted details, highlight some of the historically changing, and always contested and unstable, ways that different constituencies sought to use photography to fix notions of blackness and black people, to render blackness seemingly legible through the photographic medium, and in doing so to deny blacks rights. On the Agassiz images, see Wallis, "Black Bodies, White Science"; Young, "Still Standing"; and Smith, "Art of Scientific Propaganda." On colonial photography in the Caribbean, see Thompson, *Eye for the Tropics*.

40. Willis, *Posing Beauty*.

41. Thaggert makes the apt point that photography and understandings of the black racial stereotypes often functioned in similar ways. Both the surface of the photograph and the skin of black individuals were "deictic," pointing to something else, the former pointing to the subject of the photograph, the latter to the surface of black bodies, signifying a host of "inherent" racial traits. Thaggert, *Images of Black Modernism*, 146. For other compelling analyses of black skin and photographic surfaces, see Grigsby, "Negative-Positive Truths"; Cheng, *Second Skin*; and Raengo, *On the Sleeve of the Visual*.

42. Sekula, "Body and the Archive," 3–64.

43. Mirzoeff, *Right to Look*.

44. Kehinde Wiley, telephone interview with author, January 7, 2009.

45. Campt, *Image Matters*, 33.

46. I am using opacity here as Édouard Glissant does. See Glissant, "For Opacity," 252–257.

47. Boorstin, *Image*, 63.

48. Braudy, *Frenzy of Renown*, 553.

49. Braudy, *Frenzy of Renown*, 553.

50. Some of the central scholarly critiques of celebrity culture include

Boone and Vickers, "Special Topic: Celebrity"; Boorstin, *Image*; Braudy, *Frenzy of Renown*; Debord, *Society of the Spectacle*; Dyer, *Stars*; Gamson, *Claims to Fame*; Lowenthal, "Triumph of Mass Idols"; Marshall, *Celebrity and Power*. On celebrity in the Caribbean, see Stanley Niaah, "'I'm Bigger Than Broadway.'" On simulated reality or simulacra, the substitution of symbols or signs of the real for the real, see Baudrillard, "Simulacra and Simulations."

51. Quotation from Best and Kellner, "Debord and the Postmodern Turn," n.p.

52. As Braudy stresses, "The urge to fame is not so much a cause as a causal nexus through which more generalized forces—political, theological, artistic, economic, sociological—flow to mediate the shape of individual lives." *Frenzy of Renown*, 585.

53. Dyer, *White*, 109.

54. Dyer, *White*, 84–144.

55. Dyer, *White*, 83, and Grigsby, "Negative-Positive Truths," 16–38.

56. See Roth, "Looking at Shirley, the Ultimate Norm," and Winston, "Whole Technology of Dyeing." For an assessment of how recent digital technologies are transforming the filmic representation of black skin, see Ann Hornaday, "Filmmaking Takes New Tone," *Washington Post*, October 18, 2013, C01.

57. Silverman, *Threshold of the Visible World*, 29.

58. See the full discussion of this in chapter 2.

59. Products ranged from manufactured ones, like Ambi, Nadinola, and Neoprosone, to homemade recipes, composed of toothpaste, bleach, corn meal, curry powder, or milk powder. Hope, "From *Browning* to *Cake Soap*," 41, and Reynolds, "'Proud a Mi Bleaching,'" A6.

60. Thanks to Hannah Feldman for her insightful suggestion of this term.

61. Pinney and Peterson, "Introduction."

62. Edwards and Hart, *Photographies, Objects, Histories*, 1–15.

63. Roland Barthes describes the process of posing as "instantaneously mak[ing] another body for myself, I transform myself in advance into an image." Barthes is attentive to posing but lays emphasis on the material production of the image as central to defining what photography is. I want to embrace the shift in the temporality and physical makeup of photography exhibited in some of the forms of photography examined here, seeing the pose and process of being seen being photographed as an intrinsic part of photography. *Camera Lucida*, 10.

64. Mercer, "Hew Locke's Post-colonial Baroque," 4.

65. Deborah Poole used the term "visual economy" to describe how the field of vision is organized in some systematic ways, that have "as much to do with social relationships, inequality, and power as with shared meanings and community." The term also captures a sense of the global channels through which images flow. Poole, *Vision, Race, Modernity*, 8.

66. Marx, "Fetishism of the Commodity and Its Secret," 165.

67. Such investments in the visual economy of light abound in the world

of hip-hop, where rappers often boast of the blinding effects of their bling or the status they accrue through the effect of light. For a broader history of the wearing of flashy jewelry in black performance, see chapter 3. But it was in the late 1990s, I would suggest, when rappers highlighted their jewelry not just as accessories but as products that affected vision. See, for instance, Lil Wayne's "Shine," *Lights Out* album, Cash Money Records, 2000; Big Pun's "Sex, Money, & Drugs," *Mr Peter Parker — Happy Birthday Big Pun* album, 2009; and Jay-Z's "Allure," *The Black Album*, Roc-A-Fella Records, 2003. In Lupe Fiasco's lyrics for the single "The Cool," a man digs himself out of his grave with his gold chains, like a "reverse archaeologist." "Except . . . his buried treasure was sunshine. So when some [sunshine] shined through a hole that he drove, it reflected off the gold and almost made his son blind." *Food & Liquor*, Record Plant Studios, 2006. On the way that "black shine" counters the fact that "the sun never shines in the ghetto," see State Property's "Sun Don't Shine," *State Property* album, Roc-A-Fella and Def Jam records, 2002.

68. B.G. as quoted in Bok, *Little Book of Bling*, 5. Or, as *New York Times* critic Kelefa Sanneh put it, B.G.'s saying mimicked "the imaginary sound of light hitting diamonds." "Loving, Rapping, Snuggling And . . . ," *New York Times*, January 3, 2005, E1. See also the definition of "bling bling" by Nicole Hodges Persley in "Bling, Bling," 468: "When pronounced, the phrase is supposed to imitate the sound of the gleam coming from high-quality diamonds when the light hits them."

69. *Oxford English Dictionary*.

70. In this way bling can be distinguished from other forms of "conspicuous consumption" as defined by Thorstein Veblen, who first used the term (1931). Public displays of wealth evident in hip-hop do evince "pecuniary emulation," to use Veblen's characterization, when persons who are members of the working classes consume conspicuously so that they appear of higher social standing. However, the expense or accumulation of luxurious goods in hip-hop culture is directly related to the specific visual qualities of these possessions, which must shine, floss, or bling in order to convey prestige. In this instance commodities accrue worth not only for their exchange-value, as Karl Marx recognized and critiqued, but for their visual production (1990). Veblen, *Theory of the Leisure Class*, 68–101; Marx, "Fetishism of the Commodity and Its Secret."

71. On pecuniary emulation in African American culture, see Rucker et al., "Power and Consumer Behavior," 352–68.

72. In this vast literature several scholars have been pivotal. See Gell, *Art and Agency*; Latour, *We Have Never Been Modern*; Bourdieu, *Outline of a Theory of Practice*; Miller, *Materiality*; and Appadurai, *Social Life of Things*. For more recent engagements with this literature, see Bennett, *Vibrant Matter*, and Coole and Frost, *New Materialisms*.

73. See, for instance, Robinson, *Black Marxism*; Moten, *In the Break*; Judy, "On the Question of Nigga Authenticity"; Williams, *Capitalism and Slavery*; Kelley, *Race Rebels*; Copeland, *Bound to Appear*.

74. Richard Majors and Janet Mancini Billson argue that many contemporary black males model themselves after "badmen" like John Henry, Stagalee [Railroad Bill], Shine, or boxer Jack Johnson. *Cool Pose*, 33.

75. Levine, *Black Culture and Black Consciousness*, 427.

76. Levine, *Black Culture and Black Consciousness*, 427.

77. See, for instance, West, "Nihilism in Black America," and Gilroy, "Diaspora, Utopia and the Critique of Capitalism," 153–222. On the anxieties over the "popular" in postcolonial Jamaica, consult Scott, *Refashioning Futures*. The geographically specific configurations of critics and defenders of these displays of conspicuous consumption in each context are laid out across the chapters.

78. Curtailments of urban popular culture extend to the radio airwaves and television bandwidths. The Jamaica Broadcasting Commission in Jamaica banned some forms of dancehall music from the radio airwaves and public broadcasting that animated public space on the island in 2009. Music related to daggering, a sexually explicit lyrical and performance genre, was banned. See discussion in chapter 2. In the Bahamas, the cable company removed Black Entertainment Television from local basic cable offerings, seeking to prevent the perceived corrupting influence of music video programming (targeting a station that played hip-hop and R&B specifically and not rock music). The Bahamian government has also hindered the staging of live concerts by Jamaican and African American musicians, as well as the movement of the street photographers who travel with them. Photographer John Jones explained that he was denied a visa to work in the Bahamas when he sought to bring his street photography studio to the islands. Jones, interview with author, Kingston, Jamaica, July 6, 2008. In 2004 and 2009, the ministries of education in the Bahamas and Jamaica, respectively, even sought to curtail the spectacles surrounding prom and graduation ceremonies. Raymond Kongwa, "Sears to Parents: 'Be Temperate in Prom Spending,'" *Nassau Guardian*, August 9, 2004, A1. In the past, Jamaica's Constabulary Force have shot and injured dancehall participants as they attempted "to lock down the dance." Stanley Niaah, *Dancehall*, 9, 63.

79. Scott, *Refashioning Futures*.

80. The chapters explore these discourses through an analysis of criticisms published in local newspapers.

81. Rose, *Black Noise*, and Neal, *What the Music Said*.

82. Patterson, "Condition of the Low Income Population in the Kingston Metropolitan Area," and Horace, *They Cry Respect*.

83. Natasha Barnes succinctly characterizes "Jamaica's 'brown' caste" as follows: "Although no anthropological description of the group exists . . . to be a Jamaican 'brown' is to have membership in a small, privileged mulatto oligarchy that was the result of generations of careful mulatto breeding, which was socially distinct from other mixed-race communities. Phenotypically light-skinned and curly-haired, 'browns' symbolized an ideally creolized configuration of Afro-Anglo moral, social, and aesthetic registers. 'Brown'

men, like those of the famous Manley dynasty, were the inheritors of the emergent nation's political and mercantile institutions, while 'brown' women the staple choices for the island beauty queens." Barnes, *Cultural Conundrums*, 110–111.

84. Thompson, *Economic History of the Bahamas*, and Craton, "Bay Street, Black Power and the Conchy Joes."

85. In hip-hop culture, a grill is a removable piece of jewelry worn over the teeth.

86. Ebony G. Patterson's photography-based textiles also cut back to representations associated with the 1960s and 1970s. In her series *Gangstas for Life* (2010) she used paintings from the era of black nationalism or independence by Jamaican artists like Albert Huie and Barrington Watson and posed men dressed in the flashy stylings of dancehall, like the figures that inhabit these artists' iconic works. Charles H. Nelson also makes explicit the ways contemporary black urban expressions stood in contrast to the political ambitions of the 1970s. He painted backdrops based on photographs of fallen black political leaders, like Martin Luther King Jr. (see fig. 1.38). He used these canvases in his own version of the street photography studios.

87. Canclini, *Consumers and Citizens*, 5.

88. Further, Manthia Diawara argues that in African nations where International Monetary Fund policies have greatly controlled and constrained the possibility of some forms of consumption, access to goods and their control in traditional markets have become a means of exercising forms of sovereignty from the IMF and nation-state. Diawara, "Toward a Regional Imaginary in Africa," 103–124.

89. Holt, *Problem of Freedom*, 76–78. On an early form of conspicuous consumption among slaves, see Tobin, "Taxonomy and Agency in Brunias's West Indian Paintings."

90. Kwass, "Ordering the World of Goods."

91. Gilroy, "Get Free or Die Tryin'," 8–9.

92. Gilroy, "Get Free or Die Tryin'," 34.

93. Gilroy, "Get Free or Die Tryin'," 9. See also Miller, *Slaves to Fashion*, 1–25.

94. Gilroy, "Get Free or Die Tryin'," 8.

95. Hartman, *Scenes of Subjection*, 25.

96. Rucker et al., "Power and Consumer Behavior," 352–368.

97. *Oxford English Dictionary* (British ed.; Oxford University Press, 2003).

98. Lacan, *Four Fundamental Concepts of Psychoanalysis*, 91–122, and Silverman, *Threshold of the Visible World*.

99. Kaja Silverman cites the example of Fanon as a black moviegoer in France waiting hesitantly for menial black characters to appear on the cinematic screen as a literal example of the way black subjects see themselves in discordant and deidealized ways through the screen, which normalizes and privileges whiteness. Silverman elaborates: "But at least within French culture of the 1950s, the ego-ideal can only entertain a highly disjunctive relation to the proprioceptive body, since, in order for the black subject to misrecog-

nize himself within the image of a dazzling 'whiteness,' he must also be 'seen' through it, and that is impossible." Silverman uses "screen" in this context to refer to the screen where the projected image swims in a darkened cinema and in the sense of the term as employed in psychoanalysis to describe a broader societal ideal of whiteness, "the repertoire of representations by means of which our culture figures all of those many varieties of 'difference' through which social identity is inscribed." Silverman, *Threshold of the Visible World*, 19, 29.

100. Thanks to Huey Copeland for this insightful reading.

101. Ras Kassa, interview with author, Kingston, Jamaica, June 11, 2009; Kehinde Wiley, telephone interview with author, January 8, 2009, and Rashaad Newsome, interview with author, New York, February 3, 2012.

102. Newkirk explains, "In my previous and earlier works [before *Bixel*], in all of the self-portraits . . . I wasn't so interested in painting myself as an individual. . . . I was really interested in the idea of what this specific black body represented, what my body could represent; it wasn't about the individual." Kori Newkirk, telephone interview with author, September 13, 2013.

103. Newkirk, interview.

104. Cheng, *Second Skin*, 101–131.

105. Cheng, *Second Skin*, 119.

106. Alpers, *Art of Describing*; Barthes, "World as Object"; Best and Marcus, "Surface Reading"; Carpentier, "Baroque and the Marvelous Real"; Clark, *Painting of Modern Life*; Ford, "People as Property"; Foster, "Art of Fetishism"; Greenberg, "Avant-Garde and Kitsch"; Hochstrasser, "Slaves"; Jay, "Scopic Regimes of Modernity"; Jameson, "Cultural Logic of Late Capitalism"; Joselit, "Notes on Surface"; MacGaffey, "Complexity, Astonishment and Power"; Pietz, "Problem of the Fetish, Part 1"; Pinney, "Notes from the Surface of the Image"; and Schama, "Perishable Commodities."

107. "Surfacism" derives here from Pinney, "Notes from the Surface of the Image," 204. This concept is discussed more fully in chapter 4.

108. None other than Clement Greenberg in his often-cited account of modernism, "Avant-Garde and Kitsch," in calling for the maintenance of aristocratic values in the evaluation of modern art, would observe in a footnote "that the culture of slave-owning tribes is generally much superior to that of the tribes that possess no slaves," linking systems of slavery to modern art. Greenberg, "Avant-Garde and Kitsch," 19.

109. Phelan makes her argument in regard to the era of multiculturalism in the 1980s. Phelan, *Unmarked*.

110. Du Bois, "Opinion—In Black"; Du Bois, "Criteria of Negro Art." On Manley, see Thompson, "'Black Skin, Blue Eyes.'"

111. Similarly, the novel *The Dragon Can't Dance* (1979), by Trinidadian author Earl Lovelace, set in the immediate postcolonial era in Trinidad and focused on local carnival traditions, centered on the politics of visibility, highlighting its centrality within the changing political landscape in the Anglophone Caribbean of the 1960s and 1970s. Lovelace, *Dragon Can't Dance*.

112. Ellison, "Introduction," xv. Ellison writes, "Thus, despite the bland assertions of sociologists, 'high visibility' actually rendered one *un*-visible— whether at high noon in Macy's window or illuminated by flaming torches and flashbulbs while undergoing the ritual sacrifice that was dedicated to the ideal of white supremacy." For a discussion of African American writer Ralph Ellison's use of the term "un-visible," see Gordon, *Ghostly Matters*. Thanks to Tina Campt for this reference.

113. I am influenced here by Azoulay, *Civil Contract of Photography*; Rancière, *Emancipated Spectator*; and Feldman, *From a Nation Torn*.

114. This recalls Rancière's description of the "emancipated spectator," who blurs "the boundary between those who act and those who look; between individuals and members of a collective body." Rancière, *Emancipated Spectator*, 19.

115. Many people, as Gerard Aching points out, have "diminish[ed] democratic access to visible sites and means of celebration and social critique." Aching, *Masking and Power*, 8.

116. Junkanoo is a centuries-old costuming tradition of the black populations of the circum-Caribbean. "Junkanoo" is the spelling for the masquerade most commonly used in the Bahamas. "Jonkonnu" is used in Jamaica. Historically it was referred to as "John Canoe." For more information on this celebration, see Judith Bettelheim's formative research on the subject, "Afro-Jamaican Jonkonnu Festival."

117. Thompson, "On Masking and Performance Art in the Postcolonial Caribbean," 284–303.

118. Phelan, *Unmarked*, 19.

119. Iton, *In Search of the Black Fantastic*, 11.

120. Clark said:

> Pictures—being at a picture booth is definitely—it's definitely like a status thing. I have been in situations where . . . guys may have come up to take one or two pictures, but then they will see some other guys come up and be waiting to take their picture, and it's almost like a status thing for them to say that, well, we are going to be here for a while. Here, give me ten more pictures. And they will actually come out their pocket and pay for ten more pictures and have it—I mean, it's—I don't know how I can explain it . . . to be at the picture booth you definitely will be recognized and be seen.

Darrin Clark, interview with author, New Orleans, July 4, 2008.

121. Artist Gary Simmons also did a series on these photographic backdrops in 1993.

122. These chapters are based in part on an analysis of interviews with creators and consumers of black urban visual culture, including music video producers, owners of media outlets aimed at black urban audiences, photographers and photography-studio backdrop artists, cinematographers, lighting designers, and studio artists, as well as the participants who engage in and view these forms. I was especially attentive to how creators and users de-

scribed what they aimed to visually affect and what they thought their clients desired to see. Interviewees spoke at length about strategies of being visible and of the crucial role of light in their work. They sometimes spotlighted particular sources that became models for thinking about and reproducing light in popular cultural expressions and contemporary art. In addition, my analysis is based on formal and phenomenological theories of what objects and photographic technologies do within specific cultural and spatial contexts. Given my interest in the broader post–civil rights and postcolonial contexts in which these practices take place, the book also examines local media discourses, whether in print media or on local radio stations, that surround urban cultures and their photographic practices.

123. The practices are undocumented for many reasons. Some of the practices studied here circulate in underground economies, and those that participate in these markets sometimes have an interest in not being tracked, and some of these practices involve performances that resist visual documentation and recovery. Photographers, for instance, often were concerned also about having their cash economy businesses written about, and many media and cable outlets are secretive about information regarding viewership.

Some of these cultural practices are so widely disregarded that local institutions do not collect information on these forms. The National Library of Jamaica, an institution with research files on newspaper articles on numerous subject areas, for instance, as of 2008, collected no information on dancehall.

1. "Keep It Real"

1. A photographer known as Sonny or Photo Sonny, who had seen street photographs in the United States, brought the practice to Jamaica by the early 1990s.

2. V. Thacker, interview with author, Atlanta, July 4, 2008; Sthaddeus Terrell, interview with author, February 25, 2009.

3. Hanchard, "Afro-Modernity," 247.

4. Hanchard, "Afro-Modernity," 247.

5. Hanchard, "Afro-Modernity," 253.

6. As in *Field of Dreams*, photographer John Davis notes: "Once they [people who are familiar with street photography] notice what you do, they will come. It's like what the big man said, if you build it they will come once they know." He said that if he set up the studios outside black communities, Caucasian passersby would ask, "What is that? Are you selling those backdrops?" John Davis, interview with author, May 10, 2008.

7. Alan Feuer, "Polaroids, Bedsheets and Backdrops," *Lens* (blog), *New York Times*, August 27, 2011, http://lens.blogs.nytimes.com/2011/08/27/a-singular-moment-in-new-york-street-portraiture/, accessed August 27, 2011.

8. My use of the term "social lives" here is inspired by Appadurai, *Social Life of Things*.

9. V. Thacker, interview.

10. From early on, advertisements for the SX 70 touted: "Color Photos Develop While You Watch." *Chicago Metro News*, August 24, 1974, 17.

11. As was the case at the Sweet Auburn Festival, photographers often present photographs in simple, white cardboard frames that fold like greeting cards. Davis's assistant would hurriedly place the photograph into its holder and close it before handing it to clients, making its contents not immediately visible. Unlike the very public viewership of the process of being photographed, viewing the photograph is a more intimate and private experience in which the client opens the closed frame and inspects the photograph, greeting the image with satisfaction, laughter, or seriousness.

12. Eddie Robinson, interview with author, New Orleans, February 25, 2009.

13. Jerome Lee, interview with author, New Orleans, July 4, 2008.

14. Sandra Lewis, interview with author, New Orleans, July 4, 2008.

15. Robinson, interview.

16. I conducted interviews with photographers and backdrop artists in New York City, Atlanta, Washington, DC, New Orleans, Virginia, and Maryland. These photographers were headquartered in Atlanta, New Orleans, New York, Houston, Chicago, Miami, and North Carolina. I focused on many photographers who had long professional histories in the genre within their particular cities. Many more regional histories of street photography remain to be written.

17. The backdrops vary in style and subject. Within a single photographer's offerings in New Orleans in 2008, for instance, an unlicensed image of rapper Lil Wayne, thrown up hurriedly with a can of spray paint on a sheet, appeared next to a representation of Barack Obama. The fact that Obama, pictured when he was still running for president, was depicted as the face on a hundred-dollar bill, with his catchphrase "Change We Can Believe In," speaks to the often-topical nature of backdrops, as well as the prevalence of themes related to wealth, money, and status.

18. James Green, interview with author, Fairbanks, Virginia, November 19, 2008.

19. The three-quarter pose ironically reproduces a pose associated with subjectivity in nineteenth-century studio portraiture. Tagg, *Burden of Representation*, 34–37.

20. Fig 1.12 makes reference to *American Gangsta*, a popular television show. It was unusual to see specific television shows inform the image world of the backdrops.

21. John Davis, interview with author, May 10, 2008. Davis elaborates: "They would act like they messing with the door handle, like they sitting on the hood, like they—and actually, the way the picture comes out, it seems like they was rubbing the car, pointing at the car. It's just something that they could say, hey, that's my car."

22. Artists include Hawk from Maryland, Lenny from New York, and Peter from North Carolina.

23. Green, interview.

24. Terell Hawkins, interview with author, Prince George's County, Maryland, February 5, 2009.

25. See the backdrop showing the Brooklyn Bridge in Kingston (fig. I.5). Other Kingston backdrops focused on the names of local dancehalls and sound system promoters. Although focusing on local venues, these backdrops depict dancehalls and consumer goods that circulate and connect urban communities across geographic boundaries in the African diaspora. The emphasis on light is evident on some of these latter dancehall backdrops. In photographs taken against the backdrop pictured in fig. 2.16, the subjects of the image look as if they are in a bright yellow spotlight surrounded by a flood of white lights.

26. Edwards, *Practice of Diaspora*.

27. Green, interview.

28. Sekula, "Body and the Archive," 11.

29. Larry Reid, interview with author, Brooklyn, October 3, 2008.

30. Majors and Billson, *Cool Pose*, 8 and 28–29; longer quotation from p. 8.

31. Reid, interview.

32. Terrell, interview.

33. For an example, see figure 1.36.

34. Reid, interview.

35. Stacy Willis, interview with author, May 10, 2009.

36. For one description of such encounters, see introduction note 120. Darrin Clark, interview with author, New Orleans, July 4, 2008.

37. Terrell elaborated: "She [his client] wouldn't even take the Polaroids from me. 'Man, take my picture.' I have a whole collection of pictures of her. . . . She wouldn't even take the pictures, Polaroids, she would just—'take my picture.'" He had pictures for which clients had never paid. Terrell, interview.

38. Clark, interview.

39. He opened on Seventh Street and T Street in Washington, DC. Richard Simms, interview with author, February 6, 2009.

40. Clark, interview.

41. This is based on interviews with clients at the Sweet Auburn Music Fest in Atlanta in 2008; and The Essence Festival in 2008 and Mardi Gras in 2009, both in New Orleans. One photographer noted specifically that the 689 series of Polaroid film had the "sharpest color," as did the "vibrant" Fuji FP 100C film. These films appeared "more true in life." Davis, interview.

42. See advertisement in *Milwaukee Star*, May 16, 1970, 15.

43. Nelson elaborated: "So this is a true photograph. . . . Color is not tweaked, you know, it's not airbrushed out. It's not made to look—make people look better. Whatever you capture in that shot is the shot." Charles H. Nelson, interview with author, Atlanta, May 12, 2008.

44. See the Walgreen advertisement "Prints from Prints: No Negatives Needed," *Chicago Metro News*, July 7, 1979, 2; or the advertisement of Levon Studios of Chicago stating they could repair or enlarge old photographs and

mentioning "Polaroid Snap Shots" specifically, *Chicago Metro News*, December 6, 1980, 7.

45. Thanks to Huey Copeland for this reference.

46. Simms, based in Washington, DC, kept what he calls his "waste" photographs. Robinson, based in Texas, retained some photographs, and Terrell kept and carefully dated all of his. Simms, interview; Robinson, interview; Terrell, interview.

47. Charles H. Nelson, interview. For one of the few art-historical accounts of Nelson's work, see Okeke, "Studio Call."

48. Nelson, interview.

49. Nelson, interview.

50. When Nelson subsequently documented the project in a gallery context, he created a wall mural of the Polaroids.

51. Although some occupants of Nelson's makeshift photograph studio reveled in being within the video camera's scope, others questioned and in a few instances yelled at the artist's Caucasian videographer, whom many people assumed was not with Nelson at all.

52. The central presence of and response to the video camera inspired Nelson in all subsequent manifestations of the *Backdrop Project* to use the video camera to record the public performative engagement with the backdrops as part of the work. When he reinstalled the *Backdrop Project* in March 2000 in front of the Studio Museum in Harlem on 125th Street, he was sure to have the video camera present for more than documentary purposes. In 1999, for an exhibition at the art space Eyedrum in Atlanta, he installed an unstaffed video camera in the gallery in front of his backdrop, as well as a monitor that allowed people to see themselves being seen posing for the photograph. The monitor, which captivated visitors entering the gallery, seemed simultaneously to extend the narcissistic condition of the street photograph and refract it, making it regard itself. Participants, as they stood at the intersection of Nelson's still camera, video camera, and monitor, saw themselves being seen photographed by the artist, other gallery-goers, and eventual video watchers, and they also became spectators of their own performances of visibility.

53. If we compare the artist's backdrop to the crime scene photograph taken in the aftermath of Shakur's death, we might discern how Nelson recreates the scene from a higher vantage point reminiscent of Weegee's scopic perspective above a crime victim. In Nelson's backdrop the body in question, however, is not visible: the young rapper is not there. The artist returns time and again to the theme of death in his backdrops. In addition to taking the photographs associated with the death of African American leaders as the painted subjects of his backgrounds, he created a background of a young male subject pouring libations in honor of the dead.

54. Copeland, *Bound to Appear*.

55. West, "Nihilism in Black America."

56. I am paraphrasing Frederick Douglass's speech "What to the Slave Is the Fourth of July? Extract from an Oration. At Rochester, July 5, 1852."

57. For a discussion of the idea and desire for photography as well as a careful and nuanced examination of different developers of early protophotographic and photographic practices, see Batchen, *Burning with Desire*, 24–102. For a discussion of Antoine Florence's part in the invention of photography, less frequently included in accounts of photography, see Watriss, *Image and Memory*.

58. Before that time it was typical to paint the studio wall in the posing area a dull blue, buff, or light gray or to cover it with plain-colored paper or fabric. Darrah, *Cartes de Visite in Nineteenth Century Photography*, 33. For more on the history of the backgrounds, see an address by one Paul Brown transcribed in *Philadelphia Photographer* 16 (1879): 219–221; Taft, *Photography and the American Scene*; and Wyman, "From the Background to the Foreground."

59. According to Wyman, photographers Napoleon Sarony and J. M. Mora also made extensive uses of the backdrop. "From the Background to the Foreground," 2. In Europe, the principal manufacturer of painted backdrops was A. Marion & Co., based in London and Paris. In the United States suppliers in the 1860s and 1870s included John H. Simmons and Wilson, Hood & Co. in Philadelphia, which advertised custom-made painted "fancy" backdrops. Darrah, *Cartes de Visite in Nineteenth Century Photography*, 31.

60. Darrah, *Cartes de Visite in Nineteenth Century Photography*, 31. L. W. Seavey, Supporting Frame for Photographic Backgrounds, Patent 375,006, December 20, 1887.

61. L. W. Seavey, Theatrical Scenery, Patent 349, 526, September 21, 1886.

62. Seavey designed his backdrop device so that the displayed studio background could be pulled out into three-dimensional space.

63. Wyman, "From the Background to the Foreground," 2.

64. Wyman, "From the Background to the Foreground," 2.

65. Wyman, "From the Background to the Foreground," 2; Friedberg, *Window Shopping*, 15.

66. I am not certain if this statement is based on a survey of photographs in the collection of the International Center of Photography (ICP). When I contacted the ICP, this information could not be verified. Cowin, *African American Vernacular Photography*, 126.

67. Cowin, *African American Vernacular Photography*, 126.

68. Peterson, "Eddie Elcha's Harlem Stage." Thanks to Emilie Boone for this information.

69. See, for example, an advertisement in the Jamaican newspaper *Daily Gleaner* for the photographer J. W. Cleary. He informed patrons of his "New Gallery, New Backgrounds, Improvements etc. prices Moderate. 18 Church Street." *Daily Gleaner*, January 3, 1885. An artist by the name of Rudolph D. C. Henriques advertised that he "paint[ed] scenes for theatrical and photographic purposes." Henriques also created death masks from photographs. *Daily Gleaner*, August 30, 1904, 2.

70. Pinney, *Camera Indica*; Pinney, *Coming of Photography in India*; and Wendl, "Observers Are Worried."

71. Tobias Wendl notes that photographers from across Sierra Leone, Liberia, the Ivory Coast, and Upper Volta (Burkina Faso) traveled to Sekondi to purchase them directly from Thomas's business, Tommy's Paramount Studio. Wendl describes what might be viewed as another aesthetic focused on light in the backgrounds: "Among the earliest subjects were painted references to Ghana's newly-electrified cities. The emergence of light from immemorial darkness—previously unimaginable for villagers who perceived it as a miracle of modern civilization—was symbolized by the image of one or more street lights. As photography itself increasingly reflected the modernization of Ghana, street-lights were replaced by high tension lines and pylons." Wendl, "Portraits and Scenery in Ghana," 146, 153.

72. Wendl, "Portraits and Scenery in Ghana," 146, 153.

73. While none of the photographers I worked with in the United States said they knew about the use of the painted backdrops in contemporary African photographic practices, they appear to share an emphasis on and interest in the latest consumer products, in objects and spaces that signify wealth, status, the modern, the new. Tobias Wendl's observation in Ghana that in the studios in Accra "the backgrounds presented these items like so many trophies, in the middle of which the person being photographed appeared like the king of an idealized society of mass consumption" could easily be applied to street photographs (Wendl, "Portraits and Scenery in Ghana," 154).

74. Appadurai, "Colonial Backdrop," 7.

75. Appadurai, "Colonial Backdrop," 7.

76. See Cowin, *African American Vernacular Photography*; Appadurai, "Colonial Backdrop"; Wyman, "From the Background to the Foreground"; Lippard, "Frames of Mind"; Neale, *Los Ambulantes*; Wendl, "Portraits and Scenery in Ghana"; and Strassler, *Refracted Visions*.

77. See Pinney, "Notes from the Surface of the Image," and Strassler, *Refracted Visions*, 93–109. Pinney argues that the subjects of photographs in India and Africa appear mobile in their depiction in the photographs, appearing even to burst forth from the surface of the image. He contrasts them with ethnographic and colonial uses of the ethnographic grid as a studio drop, which often sought to fix notions of location, place, type, race, and ethnicity.

78. Lippard, "Frames of Mind," 8.

79. Green, interview with author.

80. Hanchard, "Afro-Modernity," 248.

81. Hanchard, "Afro-Modernity," 247.

82. Elcha is one such photographer who photographed in clubs in Harlem. Peterson, "Eddie Elcha's Harlem Stage," 44. On black female photographers in black clubs in Los Angeles in the 1940s, see Moutoussamy-Ashe, *Viewfinders*. Robinson, interview.

83. Little has been written on the backdrops in the United States, despite their prevalence. Two short descriptions have appeared, in a newspaper

blog and newspaper: Feuer, "Polaroids, Bedsheets and Backdrops," and Paul Schwartzman, "D.C. Street Photos Tell Stories All Their Own," *Washington Post*, October 2, 2004, C01. Thanks to Richard Powell for alerting me to the latter article. The influential *Afterimage* issue on backdrops published several photographs of street photographs from the United States but offered no analysis or description of the genre. Wyman, "From the Background to the Foreground." My sketch of this history comes primarily from interviews with the artists and photographers Clark, Davis, James, Hawkins, Reid, Robinson, Simms, and Terrell.

84. Green, interview, and Simms, interview.

85. Schwartzman, "D.C. Street Photos Tell Stories All Their Own."

86. Phu, "Shooting the Movement," 170.

87. Seale, *Seize the Time*, 182.

88. Simms, interview. The Newton photograph appeared (often reversed) in poster form, on pins, in newspapers, and on picket signs, especially after Newton's arrest in 1968. Intriguingly, too, the Panthers, as they did on Newton's birthday in 1968, would restage the props of the photograph—the empty wicker chair, the zebra skins, the shields, center stage—both invoking the absent leader and making the signifiers associated with him and black power available to viewers. See the photograph published in the *San Francisco Express Times*, February 22, 1968. Thanks to Erin Reitz for bringing this photograph to my attention. For further discussion of Newton's photograph, see Seale, *Seize the Time*, 182; Phu, "Shooting the Movement"; and Raiford, *Imprisoned in a Luminous Glare*, 129–208.

89. Thompson, *Developing Blackness*, 9–19. At this time, photographers began drawing on imagery from the diaspora. One photographer notes that his second backdrop pictured Jamaican reggae musician (and soon-to-be legend) Bob Marley, and later the representation of the Caribbean as tropical landscape became an important part of this diasporic iconography. Robinson, interview.

90. Simms, interview.

91. Singh, *Black Is a Country*, 203.

92. Political activity shifted from the epicenter of university campuses to the targeting of companies and their products at this time. Olshaker, *Instant Image*, 155.

93. Olshaker, *Instant Image*, 147.

94. Olshaker, *Instant Image*, 147–152.

95. The *Boston Globe* broke this story in November 1977. A series of articles ran in the *Boston Globe*: "Polaroid's S. Africa Ban Defied?," November 21, 1977, 1; "Polaroid Halts Its S. Africa Shipments," November 22, 1977, 1; and "Polaroid, Ex-agent Differ on Company Ban," November 23, 1977, 1.

96. Olshaker, *Instant Image*, 163.

97. "Journal Gets Polaroid Grant," *Milwaukee Star*, December 21, 1968, 4.

98. Olshaker, *Instant Image*, 167.

99. Williams quoted in Olshaker, *Instant Image*, 148; Williams quoted in David Taylor, "Polaroid Boycott Tactics Set," *Boston Globe*, January 26, 1971,

37, quoted in Olshaker, *Instant Image*, 158. Given proposals in Massachusetts that welfare recipients should carry identification cards, perhaps Williams suspected such proposed identification card programs could become more widespread. Olshaker, *Instant Image*, 167. See also the PRWM's 1971 pamphlet "No Bullshit, Boycott Polaroid," especially pp. 6–12.

100. In other words, a part of the current popularity of the form is not only that it gained popularity in the 1970s as a mode of picture-taking but also that political action surrounding black rights may have remained associated with it.

101. Simms, Hawkins, Clark, and Robinson interviews, and Schwartzman, "D.C. Street Photos Tell Stories All Their Own," C01. An artist known as De-Vaugh was one of the early backdrop artists. His backdrops traveled nationally.

102. Schwartzman, "D.C. Street Photos Tell Stories All Their Own," C01.

103. Photographers created the makeshift, often well-lit nocturnal studios at busy intersections with high pedestrian traffic. Ivory McKnight was one of the earliest photographers to hang a line of backgrounds in Washington, DC, at Benning Road and East Capital Street, in the mid-1980s. Clark, interview.

104. Photographers typically either bought exclusive rights to produce photographs at the concerts and/or agreed to pay the entertainer a percentage of their earnings. They often acquired the licensing rights to use the musicians' image on the backdrops at and outside of the concert.

105. Clark, interview.

106. Otis Spears, telephone interview with author, February 30, 2008.

107. Neal, *What the Music Said*, 124.

108. Neal, *What the Music Said*, 125–126. "Living space of poverty" comes from David Theo Goldberg, "'Polluting the Body Politic,'" 196.

109. Neal, *What the Music Said*, 132.

110. Robinson, Clark, Terrell, and Reid interviews. The backdrops would become popular beyond the genre of hip-hop, with R&B and pop musicians, like Chris Brown, Patty LaBelle, and Trey Songz, also touring with street photographer Larry Reid.

111. Gilroy, "One Nation under a Groove," 39–40.

112. Fleetwood, *Troubling Vision*, 149.

113. Neal, *What the Music Said*, 134.

114. Thomas, *Modern Blackness*, 251.

115. Sonny, interview.

116. Scott, *Refashioning Futures*, 192.

117. Esther Figueroa, interview with author, Kingston, Jamaica, August 15, 2011.

118. *Oxford English Dictionary* (British ed.; Oxford University Press, 2003).

119. "When my father and my parents them was going out, it was mostly like you will go in a club, a guy have a wicker or they just go around and take they pictures. They sitting down, doing they thing, sitting, drinking, eating, be no posing, nothing like that." Terrell, interview.

120. B.G. as quoted in Bok, *Little Book of Bling*, 5.

121. B.G., "Bling, Bling," *Chopper City in the Ghetto*, CD, © 1999, Universal Records; Big Tymers, *Big Tymers*, CD, © 1998, Universal Records.

122. Hawkins, interview.

123. Green explained that he emphasized light "to define the 3D object. That's what they want to see. I mean, I want it looking as real as possible. I think that's what attracts people first to the drop, is that it looks real." Green, interview. Photographer John Davis complimented Green's backdrops, noting they "look like—the glaze that he put on it look like they waxed the car or something." Davis, interview.

124. Jackson, *Real Black*, 177.

125. Davis, interview.

126. Debord, *Society of the Spectacle*.

127. Gilroy, "Get Free or Die Tryin'," 8, 19.

128. West, "Nihilism in Black America," 25.

129. West, "Nihilism in Black America," 24–25.

130. West maintains that "the major enemy of black survival in America [is] the nihilistic threat—that is, loss of hope and absence of meaning." "Nihilism in Black America," 23.

131. Emdur, "*Prison Landscapes*," 18–22.

132. As photographer Darrin Clark detailed, "I know in some cases when I'm taking pictures they make reference to jail poses. They make reference to how people used to pose in jail. Or if you are taking a jail picture, how you would stoop down and do certain gestures with your hands and things with— so as far as the guys is concerned, I know some of it comes from the culture in jail. . . . What happens if it's more than one guy, one guy will stand straight up, the other guy will stoop down, stoop. And it was kind of popular culture back at the eighties not to look at the camera, and that's kind of how—I mean, I mean, they make reference to it being a jail pose by stooping down and them looking away from the camera." Clark, interview.

133. Emdur, "*Prison Landscapes*," 19.

134. Taussig, *Mimesis and Alterity*, 1.

135. Rancière, *Emancipated Spectator*, 2.

136. Rancière, *Emancipated Spectator*, 22, 19.

137. Appadurai, "Colonial Backdrop," 4.

138. Hawkins, interview.

139. Mendlesohn, "Introduction," 5–6.

140. Keeling, "Passing for Human," 237.

141. Keeling, "Passing for Human," 244.

142. Nelson explains, "I was thinking about . . . these notions realism in reality, basically. So it's, like—it's, you know, Courbet's interested in depicting reality, but then you have—it's a painting, which is a staged representation of reality." Nelson, interview.

143. Jackson, *Real Black*, 176.

144. Hanchard, "Afro-Modernity," 255.

145. Dery, "Black to the Future," 180.

146. See interview with Tate in Dery, "Black to the Future," 212.

147. See, for example, "Get Yourself Together," advertisement, *Milwaukee Star*, May 16, 1970, 15.

148. Hawkins, interview.

2. Video Light

1. Jack Sowah, interview with author, Kingston, Jamaica, August 21, 2011. See also Stanley Niaah, *Dancehall*, 168.

2. On the predominance of male dancers in the dancehalls, see Hope, "*Passa Passa*" and *Man Vibes*, and Ellis, "Out and Bad."

3. On the legibility of black subjects in moving camera technologies, consult Winston, "Whole Technology of Dyeing," 105–123.

4. Skin bleaching temporarily changes the surface of the skin. Products must be reapplied to maintain changes in pigmentation.

5. As Winnifred Brown-Glaude persuasively argues, "Bleachers betray or at least destabilize popular conceptions of blackness that rely on an understanding of the body as given, fixed, permanently and *naturally* marked by race." "Fact of Blackness," 35.

6. I am using "flesh" of video here as Laura U. Marks does in *Skin of the Film*, xi–xvii. I discuss this concept later in the chapter.

7. Franklyn "Chappie" St. Juste, interview with author, Kingston, Jamaica, August 18, 2011.

8. For a more detailed characterization of "Jamaica's 'brown' caste," see introduction note 83.

9. Gilroy, *Darker Than Blue*, 34.

10. Scott, *Refashioning Futures*, 191–192.

11. A garrison, as defined in Jamaica in the Report of the National Committee on Political Tribalism, July 23, 1997, refers to a community "in which anyone who seeks to oppose, raise opposition to or organize against the dominant party would definitely be in danger of suffering serious damage to their possessions or person, thus making continued residence in the area extremely difficult if not impossible. A garrison, as the name suggests, is a political stronghold, a veritable fortress completely controlled by a party." The report is quoted in Henley Morgan, "Tivoli Enquiry versus Garrison Enquiry," *Jamaica Observer*, July 3, 2013, http://www.jamaicaobserver.com/columns /Tivoli-enquiry-versus-garrison-enquiry_14613041, accessed June 14, 2014.

12. The Sound System Association of Jamaica currently has some 150 registered sound systems, and countless others are operating informally. On the economies surrounding dancehall, see Stanley Niaah, *Dancehall*, 1–2, 48; Stanbury, "Mapping the Creative Industries and Intellectual Property"; Hope, *Inna di Dancehall*, 17; Stolzoff, *Wake the Town and Tell the People*.

13. DJs and promoters set up sound systems, consisting of turntables and large speakers, which became central sites for the playing of the latest local and international music. Hope, *Inna di Dancehall*, 10.

14. Hope, *Inna di Dancehall*, 14.

15. Carnegie, "Dundas and the Nation," 470–509.

16. Cooper, "'Lyrical Gun,'" 429–447.

17. We might see parallels with Giorgio Agamben's concept of the bare life, which generally refers to people living outside the protection of the state who do not possess "the good life." See Agamben, *Homo Sacer*. On how Giorgio Agamben's concept of the bare life is conceptualized in Jamaica, see Edwards, "Notes on the Age of Dis," 589–611.

18. On "modern blackness," see Thomas, *Modern Blackness*, 230–262. On the notion of slackness, consult Cooper, *Noises in the Blood*, 136–173. Cooper writes: "Slackness is a metaphorical revolt against law and order; an undermining of consensual standards of decency. It is the antithesis of Culture" (141).

19. Gilroy, *"There Ain't No Black in the Union Jack,"* 188–189. See also Chude-Sokei, "Postnationalist Geographies."

20. In the 1990s, women in particular wore a variety of sartorial styles: "Gold braids, colored wigs, gold cargo necklaces and earrings, mesh tops with one-inch holes, transparent low-cut blouses, transparent leggings and stockings, g-string panties, gloves, nail extensions and spectacles were common." Stanley Niaah, *Dancehall*, 96.

21. Bakare-Yusuf, "In the Sea of Memory," 232.

22. Hope, "*Passa Passa*," 133; Stolzoff, *Wake the Town and Tell the People*, 206; and Bakare-Yusuf, "Fabricating Identities," 465.

23. A character who is a photographer plays a small but significant role in the film.

24. Marlon "Biggy Bigz" Reid, interview with author, Kingston, Jamaica, June 7, 2009, and Jay Will, interview with author, Kingston, Jamaica, June 10, 2009.

25. Sowah, interview, 2011.

26. Will, interview.

27. Some images also circulated within the pages of local magazines *Hard-Copy* and *Banned from HardCopy*, and in *XNews* newspaper. Hope, *Inna di Dancehall*, 69 and 140n37.

28. One reporter, Allan Chambers, lamented, "The dances can be now classified as fashion shows, because that's all these patrons do at [*sic*] dance is 'model' on each other. Men no longer dance with women anymore. Instead, the women stand on one side of the dancehall while the men congregate on the other." "Dancehalls Then, 'Standhalls' Today," *Gleaner*, September 28, 1998, 2C.

29. Sowah, interview, 2011.

30. Sowah, interview, 2011.

31. Wright, "Emancipative Bodies," 213.

32. Sowah, interview, 2011.

33. MOB dancers, interview with author, Kingston, Jamaica, June 6, 2009.

34. Sowah, interview, 2011.

35. The full quotation reads: "If you are fully clothed they [videographers] tend to think you are boring, hence feeding the hype of the naked girls. Before, it was just associated with the innocence of dancing, or if the videoman liked your outfit he would feature you several times for the night from head to toe, it has never been about X-rated lewdness." Tanya Ellis, "Video 'Red' Light Girls," *Jamaican Online Star*, February 22, 2008, http://jamaica-star.com/thestar/20080222/ent/ent16.html, accessed December 15, 2012.

36. Wright, "Emancipative Bodies," 214, and Stanley Niaah, *Dancehall*, 171.

37. As a Portmore resident, Simone Ainsworth, explained,

> When they see the video man, they just go crazy, trying to outdo each other. They "jam off" together, dancing and talking, but once the video lights fall on them, they transform. They rival each other for the attention of the cameraman. . . . And the cameraman makes the rounds, ignoring the men and dismissing the girls who are fully clad. He goes in pursuit of exposed skin. And he goes in close with the lens. The men at a dance stand aside and look.
>
> They profile in the latest designer wear and don't sweat. When they get on the video, they pose in one position, nursing a Heineken or a Guinness bottle. They hardly breathe, so frozen is the pose.

Quoted in Claude Mills, "Girls and 'Dem Crew," *Gleaner*, April 6, 1998, 11A.

38. Wright, "Emancipative Bodies," 215.

39. Night Rider, videographer, quoted in Wright, "Emancipative Bodies," 233.

40. Cooper, *Noises in the Blood*, 141, and Bakare-Yusuf, "Fabricating Identities," 462.

41. Bakare-Yusuf, "Fabricating Identities," 468.

42. Wright, "Emancipative Bodies," 233, and Hope, *Inna di Dancehall*, 20.

43. See Hope, *Inna di Dancehall*, 19, 65, and Saunders, "Is Not Everything Good to Eat, Good to Talk," 95–115.

44. On the complexities of black urban women's performances for the camera, see Thompson, "Performing Visibility," 26–46.

45. Sowah, interview, 2011.

46. Sowah, interview, 2011.

47. Sowah, interview with author, Kingston, Jamaica, August 9, 2013.

48. Wright, "Emancipative Bodies," 217.

49. Ras Tingle notes that on a trip to Nassau he became aware of the widespread viewership of dancehall footage from Jamaica, when local people in Nassau (having viewed videos from Kingston) used the name of a police officer in Jamaica to refer to the presence of law enforcers in Nassau. Ras Tingle, interview with author, Kingston, Jamaica, June 11, 2009.

50. Sowah, interview with author, 2013.

51. Gina A. Ulysse writes: "During my fieldwork in the mid 1990s, bootleg copies of Biggie's fashion shows (he was one of dancehall's top clothing designers at that time) made their way to Brooklyn in one day, or the latest Video Soul or MTV buzz clips could be seen before record companies formally released these albums on the island." *Downtown Ladies*, 106.

52. Sowah, interview, 2013. In 1995, the Jamaican dollar was worth about US$0.0308, and in 2011 about US$0.0116.

53. Pamella Fae Jackson, "Dancehall Site: A Hit in Cyberspace," *Gleaner*, July 10, 1999, B7.

54. Felicia Greenlee, interview with author, Kingston, Jamaica, August 9, 2013.

55. Stanley Niaah, *Dancehall*, 168.

56. Every copy of a copy of VHS tape represents a generation and displays what is often referred to as "generation loss," the loss in quality.

57. Richard Delano Forbes, interview with author, Kingston, Jamaica, August 9, 2011.

58. Sowah, interview, 2011.

59. Leading, interview with author, Kingston, Jamaica, June 27, 2009.

60. Joshua Chamberlain, interview with author, Kingston, Jamaica, June 2, 2009.

61. The chorus of the song comments that "some gals not ready for the video light yet" because they lack an "upfront appearance." Frisco Kid, "Video Light" (single), Cell Block Studio Records, 1996.

62. The earliest reference I have found is Mills, "Heat in the City," 8.

63. On occasion, videographers have a detached, handheld light.

64. MOB dancers, interview with author, Kingston, Jamaica, June 27, 2009, and Color Squad, interview with author, Kingston, Jamaica, August 21, 2009.

65. Sowah, interview, 2011.

66. On dancehall in Japan, see Sterling, *Babylon East*.

67. "Women Fight for Video Light," *Jamaica Star Online*, August 12, 2008, http://jamaica-star.com/thestar/20080812/news/news1.html, accessed December 10, 2012.

68. Richards, interview with author, Kingston, Jamaica, June 6, 2009, and Sowah, interview, 2013.

69. This seems an interesting reversal of the dynamics surrounding paparazzi or news scoops in the United States, in which people with cameras actively seek out and compete for subjects. Sowah, interview, 2013.

70. Sowah, interview, 2011.

71. The diffuser or scrim is a "translucent material attached to the front of a lighting fixture to disperse and soften the light quality, or to reduce its intensity. Spun-glass sheet and frosted plastic sheeting are widely used." Millerson, *Lighting for Video*, 148.

72. Mills, "Heat in the City," 8.

73. Sowah, interview, 2011.

74. On my use of "the afterimage" throughout the book, see the section on afterimages in the introduction.

75. Marks focuses on how filmmakers working between cultures use cinema and video to translate a physical and multi-sensorial sense of place and culture. Marks, *Skin of the Film*, xi, 21–22.

76. Marks, *Skin of the Film*, xi.

77. Marks, *Skin of the Film*, xiii.

78. Marc Ogden, a video engineer at CBS, quoted in Roth, "Looking at Shirley, the Ultimate Norm," 129. See Roth too on the technological challenges of representing non-Caucasian skin because of racial bias.

79. Larkin, *Signal and Noise*, 237.

80. Sowah, interview, 2011.

81. Sowah, interview, 2013.

82. Sowah's sense that everyone deserved to be in the video light made the technology democratic in the sense that it was all-inclusive, available, and accessible to all. Sowah, interview, 2011.

83. Johann Dawes, interview with author, Kingston, Jamaica, June 19, 2009, and Radcliffe Roye, interview with author, Brooklyn, October 12, 2012. Sowah, interview, 2013.

84. Kenrick Brown ("Sick in Head"), interview with author, Kingston, Jamaica, June 8, 2009.

85. The dynamics of the dancehall recall Rancierè's description of emancipated spectatorship, which "challenges the opposition between viewing and acting." Rancierè, *Emancipated Spectator*, 13.

86. Rancierè, *Emancipated Spectator*, 19.

87. Correspondent, "Learning from Films." On the Central Film Organization in Nigeria, see Larkin, *Signal and Noise*, 73–122.

88. Correspondent, "Learning from Films."

89. In Jamaica the Central Film Organization showed films at first in Kingston "in schools, churches, colleges, the Poor House, the Verley Home, the Wortley Home, the Creche, Youth Clubs, to boy scouts and girl guides, Parent-Teachers Associations, Co-operative Societies and to numbers of other organisations." L. K. Sutherland, "Visual Education: Work of Central Film Organization," *Daily Gleaner*, April 27, 1949, 8.

90. Correspondent, "Learning from Films."

91. Correspondent, "Learning from Films."

92. Francis, "Sounding the Nation," 110.

93. Martin Rennalls cites the report in "A Career Making a Difference: Autobiography by Martin Rennalls," unpublished manuscript, 1991, quoted in Francis, "Sounding the Nation," 112.

94. "Thousands Enjoy TV in Park," *Daily Gleaner*, August 9, 1962, 1.

95. Philips Corporation in 1962 "heralded the dawn of television in Jamaica with those free public shows in the Victoria Park." "TV in Jamaica Began with Philips," *Daily Gleaner*, July 19, 1965, 9.

96. On the emergence of male dancers in the dancehall, see Stanley Niaah, *Dancehall*, 125; Hope, *"Passa Passa"* and *Man Vibes*; Ellis, "Out and Bad."

97. Dancers would indeed often look directly into the camera and offer a shout-out to Bogle, acknowledging him and other people who had been influential on them, as if the camera offered a portal to these figures. MOB dancers, interview; Ian Dice Charger, interview with author, Kingston, Jamaica, August 19, 2011; Davian A. Hodges, interview with author, Kingston, Jamaica, August 19, 2011.

98. As Donna Hope chronicles, fashions among men in dancehall went from "the 1980s/1990s dalliance with multiple and heavy gold necklaces, pendants and rings complemented by linen and lace costumes, to the platinum and 'ice' (diamond) craze of the late 1990s (a cross-fertilization with American hip-hop culture), to the current [2010] manifestation of dancehall male fashion [which] is the dancehall 'modeller' who complements his jewellery with expensive brand name clothing." *Man Vibes*, 95.

99. Krista Henry, "Dancehall Grows Away from Roots," *Sunday Gleaner*, September 24, 2007, F1.

100. Teino Evans, "Female Dancers Beg a 'Bly'—Say Men Bombarding the Video Light," *Jamaican Star Online*, March 31, 2006, http://jamaica-star.com /thestar/20060331/ent/ent1.html, accessed December 15, 2012.

101. Kisama McDeod, interview with author, Kingston, Jamaica, August 21, 2011.

102. Krista Henry, "Dancehall Grows Away from Roots," F1.

103. Hope, *Inna di Dancehall*, 63–64, and *Man Vibes*, 20–25.

104. Popular skin-bleaching ingredients include potent topical steroids, such as betamethasone and clobetasol. On skin-lightening products, see Hope, "From *Browning* to *Cake Soap*," 41; Wallace, "Lighten Up Yu Self!," 27–28; and Athaliah Reynolds, "'Proud a Mi Bleaching': 'Skin-bleachers' Defend Their Action Despite Health and Cultural Warnings," *Sunday Gleaner*, November 15, 2009, A6.

105. Reynolds, "'Proud a Mi Bleaching.'"

106. Serge F. Kovaleski, "In Jamaica, Shades of an Identity Crisis," *Washington Post*, August 5, 1999, A15.

107. See Austin-Broos, "Race/Class"; Barnes, *Cultural Conundrums*; and Ulysse, *Downtown Ladies*.

108. Barnes, *Cultural Conundrums*.

109. For a critique of contemporary color privilege in Jamaica, see Melville Cooke, "Blaming the Bleacher," *Daily Gleaner*, January 26, 2006, http:// jamaica-gleaner.com/gleaner/20060126/cleisure/cleisure4.html, accessed December 15, 2012.

110. Hope quotes participants in the panel discussion "Loving the Skin You're In," including final-year students at the Caribbean Institute of Media and Communication held at the basic school in the Mona Commons community, 1999. Hope, *Inna di Dancehall*, 42.

111. See interview in McDonald, "Skin Bleaching and the Dancehall."

112. Brown-Glaude, "Fact of Blackness?"

113. In the tune "Look Pon Me," Kartel reiterated a similar sentiment: "Di girl dem love off mi brown cute face, di girl dem love off mi bleach-out face." See discussion of Kartel and skin bleaching in Hope, "From *Browning* to *Cake Soap*," 180–182.

114. Reynolds, "'Proud a Mi Bleaching,'" A6.

115. Mills, "Heat in the City," 8–9.

116. Stanley Niaah has also noted: "One particular interviewee said, yeah, you bleach your skin on Thursday, there's a certain process, so that by the weekend you would be ready for the light." Stanley Niahh, interview with author, Kingston, Jamaica, August 15, 2011.

117. Greenlee, interview.

118. Winston, Dyer, and Roth note that film stocks, cameras, and lighting were not developed to focus on black skin. Winston, discussing technologies developed by Kodak, makes the important point that photographic technologies represented an "optimum" culturally determined ideal of white skin tones, preferring "a whiter shade of white." Winston, "Whole Technology of Dyeing," 121; Dyer, *White*, 90; Roth, "Looking at Shirley."

119. Sowah, interview, 2013.

120. "It brights them up and makes them look pretty," one interviewee states in McDonald, "Skin Bleaching and the Dancehall." See too Kovaleski, "In Jamaica, Shades of an Identity Crisis."

121. "Winston," interview, *Our Voices*, CVM TV, Kingston, Jamaica, April 7, 2003, quoted in Stanley Niaah, *Dancehall*, 135.

122. Reynolds, "'Proud a Mi Bleaching.'" In McDonald, "Skin Bleaching and the Dancehall," one interviewee describes how sun "activates" the skin, and the video includes footage of people protecting their skin from the sun's rays by various means.

123. Hope, "From *Browning* to *Cake Soap*," 183.

124. See Charles, "Skin Bleaching, Self-Hate and Black Identity in Jamaica"; Melville Cooke, "Blaming the Bleacher," *Daily Gleaner*, January 26, 2006, A6; Kovaleski, "In Jamaica, Shades of an Identity Crisis"; Ken Jones, "Bleaching Is More Than Skin-Deep," *Gleaner*, January 9, 2011, F1; Paul H. Williams, "Bleach Boys," *Gleaner*, February 26, 2012, H1.

125. On skin bleaching (in Ghana) as "an expression of a cultural memory anchored in colorism and its antecedent colonialism," see Y. A. Blay, *Yellow Fever*. On its manifestation in Jamaica, see Derron Wallace, "Lighten Up Yu Self!," and Cooke, "Blaming the Bleacher."

126. See elaborations of such arguments, in the order mentioned, in Charles, "Skin Bleaching, Self-Hate and Black Identity in Jamaica"; Wallace, "Lighten Up Yu Self!"; and Brown-Glaude, "Fact of Blackness," 35.

127. In 1910, the image drew the public ire of Garveyvite H. A. L. Simpson, who protested the libelous representation of the island's inhabitants in this image. For a description of the controversy surrounding this image, see Thompson, *Eye for the Tropics*, 71–74, 98.

128. On this score, see McClintock, *Imperial Leather*, 207–231.

129. Dyer, *White*, 122.

130. The use of a three-point (or more) system of lighting techniques—consisting of a primary light, a second softer light, and backlighting—created a glamorous haloed effect of light, one that he associates with Hollywood filmic iterations of whiteness. See Dyer, *White*, and Stacey, *Star Gazing*.

131. Esther Figueroa, interview with author, Kingston, Jamaica, August 15, 2011.

132. Dyer, *White*, 122.

133. On making one's skin cool, see Charles, "Skin Bleaching, Self-Hate and Black Identity in Jamaica," 711–728.

134. Kovaleski, "In Jamaica, Shades of an Identity Crisis," quotes Sheri Roth: "I know that they can do bad to your skin, but I have nothing to lose in wanting to be a brownin'."

135. Natasha Barnes, in considering the "skinless" practices of females in dancehalls, raises a question that bears re-posing here: "Is visibility enough of a liberatory strategy to convert the subversive act into an emancipatory politics?" *Cultural Conundrums*, 89.

136. Aching, *Masking and Power*, 5.

137. "The Best Jamaican Slang for the Year," in *The Best of Jamaica 2000*.

138. Hope, *Man Vibes*, 92.

139. Hope notes, for instance, that Jamaicans used "chi-ching" as the sound of the cash register. *Man Vibes*, 92.

140. Hip-hop's materialistic aesthetics also traveled through live concerts in which hip-hop musicians appeared with local musicians. The Fat Boys appeared with Jamaican DJ Tiger at the national stadium in December 1989. Newspaper reports also anticipated the appearance of the Cash Money Millionaires with DJ Well in July 1990. It is not clear if they appeared in concert. On the Fat Boys in Jamaica, see Howard McGowan, "Massive Turnout at Sting '89," *Daily Gleaner*, December 28, 1989, 8. On the Cash Money Millionaires, see Claude Mills, "Cash Money for Show in Ja," *Gleaner Youth Link Magazine*, May 13, 2003, 8.

141. The photographic studios became spaces where sartorial styles, some associated with hip-hop, could be donned. As anthropologist Gina A. Ulysse documents, the local availability of both counterfeit and brand-name goods in the 1990s did much to close a cultural gap between black urban spaces in the United States and Jamaica. Through street photographs dancehall attendees could pose with flashy accoutrements or the drink de jour in front of painted signifiers of wealth. Ulysse, *Downtown Ladies*, 51.

142. Approximately 81 percent of cable subscribers were, excluding hotels, in the low- and middle/low-income areas. "Subscriber (Cable) Television Policy—Part 1," *Gleaner*, June 21, 1995, 8A.

143. Report from Market Research Service Ltd, 2006, 200, quoted in Forbes, *Music, Media and Adolescent Sexuality in Jamaica*, 7.

144. MOB dancers and Cadillac dancers, interviews with author, Kingston, Jamaica, June 6, 2009.

145. Hope, "*Passa Passa*," 134.

146. Marshall, "Bling-Bling for Rastafari."

147. Krista Henry, "Dancehall Covers All," *Sunday Gleaner*, June 18, 2006, E6.

148. Elephant Man, "Signal de Plane" (single), Atlantic Records, 2003.

149. Cooke, "Blaming the Bleacher," and Hope, "From *Browning* to *Cake Soap*," 179.

150. Ian Dice Charger, interview with author, Kingston, Jamaica, August 19, 2011.

151. As one dancehall participant, Debbie Ouch, contended, "The clothes are not really expensive, people just feel they are." Quoted in Mills, "Girls and 'Dem Crew," 11A.

152. Paraphrased in *The Best of Jamaica 2000*. Bounty Killer states on his Myspace page: "They're singing about ice when poor people don't even have a fridge." www.myspace.com/therealbounty, accessed June 23, 2014.

153. Ian Boyne, "Decadent Dancehall Mirrors Society," *Gleaner*, January 5, 1997, A8.

154. Sowah, interview, 2011.

155. Hope, "From the Stage to the Grave," 256–266, and Paul, "'No Grave Cannot Hold My Body Down,'" 142–162.

156. Gilroy, *Darker Than Blue*, 25.

157. Cheng, *Second Skin*, 119.

158. Michael Graham, "Crazy Hype," interview with author, Kingston, Jamaica, June 6, 2009.

159. Pearnel Charles, quoted in *Jamaica Observer*, February 25–27, 1994, quoted in Stolzoff, *Wake the Town and Tell the People*, 5.

160. Brown, interview.

161. As Figueroa succinctly laid out the paradox, "In the beginning [the media] seems to make you special. . . . It picked you out; you are the one and chosen. But then everyone starts acting like you and, in a sense you are acting like whatever—whoever you thought the image was. . . . But then you just become a commodity like everything else." Figueroa, interview.

162. Roye, interview.

163. Roye, interview.

164. About the early broadcast of popular music, Stanley Niaah writes:

> The irony is that Jamaican popular music and culture, its purveyors and their lifestyles, did not feature in the media before programmes such as *Teen Age Dance Party*, produced by Sonny Bradshaw, were initiated at the former Jamaican Broadcasting Corporation in 1959 and became popular in the early 1960s. That single programme featuring Jamaican music and dance culture was broadcast on radio from Mondays to Fridays, and on television on Fridays, then moved out of the studios on

Saturdays. The first venue was the Broadcasting Corporation itself, but then it moved to the Rainbow Club (formerly Skateland in Halfway Tree), the Glass Bucket Club, and Johnson's Drive Inn.

Stanley Niaah, *Dancehall*, 11.

165. Hope, *Inna di Dancehall*, 16.

166. "Dancehall Rocking the Cable Waves," *Jamaica Gleaner*, January 11, 2004, E3.

167. "Dancehall Rocking the Cable Waves." *Jamaica Gleaner*, January 11, 2004.

168. I have chosen not to reveal the names of these sources.

169. See "Freddie McGregor Finds UWI Lecturer Off-Key on Crime," *Gleaner*, November 9, 2008, E2, and Denise Reid, "Dancehall Not Fuelling Violence," *Gleaner*, November 5, 2008, D12.

170. See Brown-Glaude's analysis of newspaper stories about skin bleaching in the *Gleaner*. Brown-Glaude, "Fact of Blackness." Mills too calls on psychologists to explain the "psycho-socio-biological" reasons behind video light. Mills, "Heat in the City."

171. Hope, *Inna di Dancehall*, 127. Hope defines the "video-light syndrome" as "the insatiable desire of many dancehall patrons to have their presence documented at the dances, stage shows and other dancehall events they attend." On the medicalization of dancehall discourse, see Brown-Glaude, "Fact of Blackness," 37.

172. On this score, see Scott, *Refashioning Futures*, 192.

173. Stanley Niaah, *Dancehall*, 63.

174. Banton quoted in Stanley Niahh, *Dancehall*, 63.

175. As dancehall historian Stanley Niaah describes, such incidences are so common that it is widely believed that a British film crew once orchestrated a raid because such frequent incursions had become associated with the experience of the dancehall. *Dancehall*, 9, 63.

176. The Act made it illegal to operate a loudspeaker between "(a) 2 o'clock and 6 o'clock in the morning on a Saturday or Sunday; and (b) midnight on a Sunday, Monday, Tuesday, Wednesday or Thursday and 6 o'clock in the following morning." Noise Abatement Act, March 26, 1997.

177. The police were also not granting permits. Teino Evans, "Night Noise Act Casts Shadow — Promoters Protest Regulation — Dutty Fridaze on Hold," *Jamaica Star*, April 18, 2008, http://jamaica-star.com/thestar/20080418/ent /ent1.html, accessed June 23, 2014.

178. The state reaction was also linked to the Noise Abatement Act, Bartley explained, and efforts to control noise in residential areas. Further, he stressed, "from the Ministry of Culture's perspective, it's a dialogue with proponents of dancehall to say, look, let's understand we are creating a society here and we have to be tolerant of each other. We cannot do what we feel like doing and say what we feel like. There has to be some control here." Sydney Bartley, interview with author, Kingston, Jamaica, August 19, 2011.

179. The language "good order or public safety" comes from the Noises (Night) Prevention Act (1944). For more information on these Acts, see Bettelheim, "Afro-Jamaican Jonkonnu Festival," 329.

180. The Commission specifically targeted any reference or suggestion of "daggering," a sexually explicit act referenced in song and enacted in dance. Watson, "'Daggering' and the Regulation of Questionable Broadcast Media Content in Jamaica," 292.

181. Ebony G. Patterson, interview with author, Chicago, February 10, 2011.

182. Kartel released an album titled *Colouring Book* in July 2001.

183. Dwayne Mcleod, "Shottas 'Bleach' to Hide," *Jamaica Star Online*, June 1, 2007, http://jamaica-star.com/thestar/20070601/news/news1.html, accessed December 9, 2012.

184. "Rude bwai" is a Jamaican expression for "rude boy." See a fuller explanation of the term later in this chapter.

185. Ebony G. Patterson, conversation with author, Studio Museum in Harlem, New York, June 15, 2012.

186. Thompson, "'Black Skin, Blue Eyes,'" 1–32.

187. When Huie began creating paintings, he recalled, many prospective subjects he approached to model for him had never experienced and could not imagine black subjects as works of art. They identified blacks with the touristic images, the postcards, photographs, and caricatures, that depicted black subjects as having what Huie described as asphalt black skin. "'Black Skin, Blue Eyes,'" 1–32.

188. C. S. Reid, "Our Passing Virtues," *Gleaner*, January 20, 1990, A6.

189. Marjorie Stair, "Those Male Suffers," *Gleaner*, January 20, 1990, A6.

190. Andre Fanon, "Is Dance Hall Music a Creative Force?," *Gleaner*, November 29, 1988, 14.

191. Scott, *Refashioning Futures*, 214.

192. Marvin Bartley, interview with author, Kingston, Jamaica, August 19, 2011.

193. Franklyn "Chappie" St. Juste recalls: "Right away . . . the public realized that they had an opportunity to voice their dissatisfaction with a variety of topics and every time they just head straight to the gate of the JBC." Franklyn "Chappie" St. Juste, interview with author, Kingston, Jamaica, August 18, 2011.

194. Johnson, "'Performing' Protest in Jamaica," 167, 171.

3. Shine, Shimmer, and Splendor

1. The costs of the proms vary. According to one local report the average cost is $1,500 (US and Bahamian dollars), with dresses typically amounting to between $350 and $900. Rental cars average approximately $500. Erica Wells, "Nowadays, Prom Means Big Bucks," *Tribune* (Nassau), June 28, 2004, 2C. Another account puts the cost of dresses alone between $700 and $1,000. Yolanda Deleveaux, "Dressed to Impress," *Tribune* (Nassau), June 24, 2008,

C3. Or, as a columnist inventories, "the cost for dresses, suits, limousines, hairstyles, can far exceed the tuition for one school term or even a year or two in some cases. The $300 hairdos, $300 limousines, $150 suit rentals, $800 bare-top formal gowns, $150 shoes, can add up to a down payment for a small home." Barrington Brennen, "Prom or Transcript," *Nassau Guardian*, June 25, 2007, L3. Finally, another writer lists the following: "Manicure: $45, Hair-Style: $225.80, Photographer: $300, Strech [sic] Hummer: $500, Dress: $1,500, Coat Suit: $800, Shoes: $250, Jewelry: $150, Walking Cane: $70." Arthia Nixon-Stack, "The High Price of Prom," *Nassau Guardian*, May 18, 2006, B1. For an account of the different entrances, see Butler, "The Prom," *Nassau Guardian*, Friday, July 1, 2005, A8: "Last year apparently a couple showed up in a helicopter, it would seem as though limousines no longer provide a touch of class. Others arrive in vehicles escorted by horses; have doves fly out of vehicles; step onto red carpets or rose petal strewn floors and some even come in our local horse drawn carriages which I am led to believe can cost in excess of two hundred & fifty dollars for this little jaunt. There are even those who now have junkanoo [sic] groups or other musicians awaiting their arrival so the same can be heralded."

2. Stack, "High Price of Prom," B1.

3. While some critics sound concern over the negative influence of American culture on Bahamian youth in general, they typically single out African American culture and hip-hop culture in particular. Vice president of the teachers' union Quentin Laroda, for one, attributed violence in schools to "American 'hip-hop' culture, in which it is 'cool' to be a thug." As he elaborated, "I think the violence in our society is based on a culture of imitation of the American cultures and some cultures of other countries as well. . . . [I] think the influence of the rap and hip-hop is greatly underestimated. . . . If you look at their [young people's] behaviour, it mimics a lot of the rap songs they listen to. The girls behave like they are in a rap video and the boys behave the same way." Vanessa Rolle, "'Thug Life' Plaguing Bahamian Schools," *Nassau Guardian*, November 27, 2008, A3. Professor at the College of the Bahamas Ian Strachan expressed a similar view. "Young girls in the society seem to see it as a badge of honor to have a bandit or gangsta man, or a child father who is either in jail or just getting out of jail. The music videos on BET and MTV often feature a lot of gangsta rap which further glamorizes and glorifies this lifestyle." Ian G. Strachan, "A Society That Glorifies Badness," *Nassau Guardian*, June 30, 2008, A7.

4. Kongwa, "Sears to Parents: 'Be Temperate in Prom Spending,'" *Nassau Guardian*, August 9, 2004, A1, A5.

5. For more about the word "Junkanoo" (or John Canoe, to use its earlier name) in the Bahamas, see introduction note 116.

6. See Pinney, "Notes from the Surface of the Image," and Oguibe, "Photography and the Substance of the Image."

7. Diawara, "1960s in Bamako," 254.

8. Diawara, "1960s in Bamako," 254.

9. "BET Slot Taken by Cartoon Network," *Nassau Guardian*, January 4, 2004, 1.

10. "BET Slot Taken by Cartoon Network."

11. A newspaper report explained: "Its [the members of the Radio Cabinet] 'rationale' for the suggestion was that 'the majority of the video portion accompanying the music is portrayed in a lewd and lascivious manner unsuitable to children and teenagers.'" "BET Slot Taken by Cartoon Network."

12. Gilroy, "'To Be Real,'" 29.

13. Gilroy, "'To Be Real,'" 29.

14. Eartha Hanna, interview with author, Nassau, June 24, 2006.

15. Indeed, in the age of digital reproduction, images of Nassau proms are conspicuously absent on the Internet, the favored visual domain of youth cultures in many parts of the world.

16. Cisco McKay, interview with author, Nassau, June 24, 2006.

17. Robin Leach, "Diddy to Make a Nightclub Entrance from a Helicopter 53 Stories above Vegas," *Vegas Pop*, February 2, 2007, www.vegaspopular.com /2007/02/16/, accessed June 16, 2008.

18. Gilroy, *Against Race*; Kelley, *Race Rebels*; West, "On Afro-American Popular Music."

19. Baldwin, "Black Empires, White Desires," 161. See also Kelley, "Playing for Keeps," and Rose, *Black Noise*.

20. Hayes quoted in Michael Dwyer, "There's a Riot Goin' On," *The Age* newspaper (Melbourne, Victoria), December 21, 2007, www.theage.com.au /news/film/theres-a-riot-goin-on/2007/12/20/1197740450217.html, accessed January 28, 2013.

21. The shape also resembles that of a diamond cutter.

22. Beebe, "Paradoxes of Pastiche," 303–327.

23. Another example of the use of the reflective surface in hip-hop is a video by Kanye West, *All Falls Down*, which he directed. The video, which is shot as seen through the rapper's eyes, only presents the artist as a reflection in shiny surfaces, in a limousine window, in a mirror, and in the glassy surface of his girlfriend's sunglasses.

24. Kanye West, "Diamonds from Sierra Leone," single, © 2005, Roc-A-Fella, Island Def Jam.

25. Kanye West, "Diamonds from Sierra Leone," single, © 2005, Roc-A-Fella, Island Def Jam.

26. These local tabloids print detailed descriptions of the various escapades of rappers, including reportage of their "bling," on a weekly basis.

27. Pedro Burrows, interview with author, Nassau, June 22, 2006; Sandra Ferguson, interview with author, Nassau, June 17, 2006; Tabatha Griffin, interview with author, Nassau, June 22, 2006; Nadia Miller, interview with author, Nassau, June 22, 2006; Godwin Sherwin, interview with author, Nassau, June 21, 2006; Jaime Taylor, interview with author, Nassau, June 21, 2006; Cisco McKay, interview with author, Nassau, June 21, 2006.

28. The mother of one of the preschool prom-goers highlighted the impor-

tance of bling's shimmering effects. The woman, who had been awaiting her son's prom debut since his birth, explained that her son wanted to look "like a pimp," likely influenced by the neo-pimp aesthetics of rappers like Snoop Dogg. To achieve this look she paid acute attention to his cream-colored suit with its jewel-like buttons, gold bow tie, cocked hat with a small feather, silver cane topped with carved wood, and shiny Jaguar with green and yellow ribbons and gold lamour. Her choices of commodities and colors were coordinated to shimmer and shine. Miriam Dean, interview with author, Nassau, June 24, 2006.

29. An ad for Home Fabrics read as follows: "Prom 2004 All Fabric for Prom 20% off Striking Special Occasion Fabrics, Beaded Silks and Chiffons, Iridesent [sic] Taffeta, Two tone Mandarin." "Prom 2004," *Tribune* (Nassau), May 20, 2004, A3.

30. Monique Forbes, "Prom Hairstyles: The Hottest Looks for 2005," *Nassau Guardian*, May 19, 2005, B12.

31. "Prom Night," editorial, *Nassau Guardian*, June 19, 2008, A6.

32. Lipsitz, "Diasporic Noise," 33.

33. Deleveaux, "Dressed to Impress," C3.

34. While there is not space to elaborate on this here, women often assume complex roles as agents and objects of male rescue at the proms. Women are cocreators of their entrance narratives, which often seem simultaneously respectable and reputable (two opposing value systems according to anthropologist Peter Wilson), conservative and nontraditional, romantic and antiromantic — agents of a staging of their nonagency. Wilson, *Crab Antics*.

35. Gilroy, "'After the Love Has Gone,'" 25–47.

36. Monique Forbes, "Prom Apparel: What's Hot and What's Not for 2005!," *Nassau Guardian*, May 26, 2005, 11.

37. Miller, interview.

38. Wells, "Nowadays, Prom Means Big Bucks," 2C.

39. Wells, "Nowadays, Prom Means Big Bucks," 1C.

40. Kongwa, "Sears to Parents: 'Be Temperate in Prom Spending,'" A1. See also descriptions of prom-goers "pretending to be rock stars," "Prom Night," A6. Or, as one writer maintains, "this has become the Bahamas' equivalent of the Oscars." Clement Johnson, "Paying the Price for Prom Night," *Tribune* (Nassau), June 17, 2004, A14.

41. Kongwa, "Sears to Parents: 'Be Temperate in Prom Spending,'" A5.

42. Jeff Cooper, "How I See It," *Tribune* (Nassau), June 22, 2004, A5.

43. Cooper, "How I See It."

44. Wells, "Nowadays, Prom Means Big Bucks," 2C.

45. "Exclusive Collections," *Nassau Guardian*, June 29, 2006, A22; "La Mode Classique," *Nassau Guardian*, May 27, 2004, A12.

46. Diawara, "1960s in Bamako," 244–261.

47. Diawara, "1960s in Bamako," 247.

48. Oguibe's observations are largely based on Stephen Sprague's research among the Yoruba in Nigeria in the 1970s (Sprague, "Yoruba Photography").

49. Pinney's definition is similar to that of Oguibe. It refers to an emphasis on the material qualities of photography—surface and light—or the tactile representation of objects within the picture plane. Pinney, "Notes from the Surface of the Image," 210.

50. Pinney, "Notes from the Surface of the Image," 210.

51. Pinney, "Notes from the Surface of the Image," 254.

52. Nicolette Bethel, interview with the author, Nassau, August 29, 2006.

53. Bethel, interview.

54. Columnist and contemporary prom critic Craig Butler recalls the following about his prom in the early 1980s. "The event itself was funded by us students. We held bake sales, car washes, uniform release days and walk-a-thons to raise the money. There was no charge to attend. Any personal expenses incurred were from the clothes bought for the event and whether or not we hired a limousine to take you there. The only costs involved were covered by hitting your parents up for enough money in your pockets so you could go to Pastiche and Waterloo. All these were modest costs when compared to the sums of today's events." Butler, "Prom."

55. Appiah, *In My Father's House*, 149. Nicolette Bethel, anthropologist and director at the Ministry of Culture, speculates that the recent shift in prom practices may relate to changes in the educational system brought about in 1993, when, in what could be considered a (belated) continuation of the project of decolonization, the Bahamian government overhauled and localized the educational curriculum, untethering the islands from the British educational system. These policies mandated an additional year before matriculation, making compulsory the completion of a twelfth grade. This meant, Bethel explains, that prom attendees were now sixteen to eighteen years old rather than fifteen to seventeen, and were closer to adulthood with a stronger sense of how they wanted to make their social debuts. While this explanation does not account for the precise change in the aesthetics and theatrics of the prom entrances since the late 1990s, it does suggest another provocative link between the political and institutional process of decolonialization and the aesthetics of prom, between leaving behind a British system and entering into an (African) American form.

56. Kongwa, "Sears to Parents: 'Be Temperate in Prom Spending,'" A5.

57. Kongwa, "Sears to Parents: 'Be Temperate in Prom Spending,'" A5.

58. Bethel, interview.

59. Brennen, "Prom or Transcript," 13.

60. Wells, "Nowadays, Prom Means Big Bucks," 1C.

61. "Prom Night," A6.

62. Although the more spectacular proms first gained prominence in a private Catholic school (St. Augustine's College) and occur to varying degrees across private and public school systems, critics tend to perceive them as the domain of public school students and their parents, who hail from the island's lower classes.

63. "Prom Night," A6.

64. Wilson, *Crab Antics.*

65. Diawara, "1960s in Bamako."

66. Thomas, *Modern Blackness,* 247.

67. Thomas, *Modern Blackness,* 233.

68. Neptune, "Manly Rivalries and Mopsies," 91.

69. David Rudder, "Bigger Pimpin'," © 2001, Lypsoland.

70. Neptune, "Manly Rivalries and Mopsies," 90.

71. Scott, *Refashioning Futures,* 192.

72. Thomas, *Modern Blackness,* 260.

73. Lipsitz, "Diasporic Noise," 36.

74. "Rather than concentrating too much on materialism, the focus should instead be on education and bringing up educational standard [*sic*], so that Bahamian youth can compete globally." "What Are Parents Thinking?," editorial, *Nassau Guardian,* June 21, 2004, A6.

75. "Prom Night," A6.

76. Wells, "Nowadays, Prom Means Big Bucks," 2C.

77. Wells, "Nowadays, Prom Means Big Bucks," 2C.

78. It is worth noting, too, that while luxury cars may be status symbols across many geographic contexts, in the Bahamas, where import duties double the price of luxury cars, to be seen in a Hummer, a Bentley, or a BMW is to display an added, even extreme, measure of wealth. In this regard, students, some of whom incorporate multiple cars into their entrances, enact the heightened value of being seen in luxury automobiles in the Bahamas.

79. Mbembe, "Provisional Notes on the Postcolony," 4.

80. Mbembe, "Provisional Notes on the Postcolony," 9, 4.

81. Mbembe, "Provisional Notes on the Postcolony," 9.

82. In this regard the touristic image of the Bahamas functions for tourists (who are often American) the way the ideal of America does among many working-class people in the Caribbean, as an imagined geography where they can transcend their social stations. In the Bahamian context, social transcendence applies to class and not necessarily race. In the islands until the late 1950s segregation policies in hotels, for instance, caused international controversy, because no matter the social position of black tourists, they could not enter the main hotels in Nassau. Thompson, *Eye for the Tropics,* 238.

83. All-inclusive hotels refer to hotels and resorts where guests pay one price for all meals, drinks, gratuities, and other activities. In the Bahamas these resorts do not allow entry of non-guests.

84. Haitians in the Bahamas started celebrating Flag Day, which commemorates Haitian independence, in 2006, an occasion some Bahamian critics saw as an affront to Bahamian society. Mark Desmangles, "The Intention of Haitian Flag Day Celebration in the Bahamas," letter to editor, *Tribune,* June 25, 2008, 4.

85. The term "freedom dreams" comes from Kelley, *Freedom Dreams.*

86. Nash Ferguson, *I Come to Get Me!,* vi.

87. Bethel and Bethel, *Junkanoo.*

88. "The face was always disguised sometimes blackened with charcoal,

whitened with flour or covered with a very frightening mask." Lelawattee Manoo-Rahming, "Recollections of Past Junkanoo Parades," *Nassau Guardian*, January 6, 1996.

89. In 1933, the editor of the *Nassau Guardian*, for instance, suspected that the use of Bay Street held some special significance for the performers: "Is it essential to the full enjoyment of those who take part in the aboriginal exhibition that its performance must take place in Bay Street? Almost we believe that this very fact gives spice to the occasion; almost we believe that if the mummers were asked to mum and posture and scream and jangle their cowbells and render the night hideous in another part of the town, the occasion would lose a great part of its importance in the eyes of participants." *Nassau Guardian*, December 27, 1933. Writers of letters to the *Nassau Guardian* complained that the presence of John Canoe in this main thoroughfare was antithetical to Nassau's orderly touristic image. One commentator asked plainly whether John Canoe could be allowed to persist in "a well-ordered town." *Nassau Guardian*, December 26, 1934. Another asserted that during the event "it was hardly safe for women and their children to be out upon the streets." *Nassau Guardian*, December 27, 1933. The presence of black masqueraders on Bay Street also offended the sensibilities of members of the colored middle classes. Etienne Dupuch, editor of the *Tribune* and a champion of black inclusion in hotels, also conceived of the parade as an event wherein "the customary noise of horns, bells and drums and the grotesque masqueraders disported themselves along Bay Street with an energy and vigour" and called for an end to the ritual. Bethel and Bethel, *Junkanoo*, 41.

90. Thompson, *Eye for the Tropics*, 150–153.

91. The woman emphatically explained: "Ma'ma—put your photograph thing away; dey doesn't want to be took. . . . Dere was a fellar takin dose last year—and a man got wild, and bit off his ear . . . dey don't want no one carrying away der faces dressed up dis way." Defries, *In a Forgotten Colony*, 78.

92. National Junkanoo Committee, "Bahamian Junkanoo," *Nassau Guardian*, December 23, 1994, 5.

93. As the National Junkanoo Committee put it, "If asked to name the quintessential element of his culture, any Bahamian will reply 'Junkanoo,' for it has become the central symbol [of] the nation." National Junkanoo Committee, "Bahamian Junkanoo," 5.

94. "Money Well Spent," editorial, *Nassau Guardian*, June 28, 1999.

95. A critique of the parade by Junkanoo participant Anthony Carroll makes explicit the primacy performers place on being on television. In a newspaper article Carroll lamented that the television crews and photojournalists of the major newspapers ignored persons participating in the parade as individuals and not part of the larger groups (with the exception of the photographer Derek Smith of the *Nassau Guardian*, who coincidentally participated in the paparazzi entrance at the 2006 C. R. Walker Senior High School prom). He protested that as individual entrants approached, "they [the television camera crews] turned the cameras off." "Surely," he concluded, "we have the

same passion, we spend the same long and tireless hours in our shacks . . . and therefore we expect all of the benefits and rewards that are dues [*sic*] us. And that most certainly includes the thrill of seeing our creations on our local television screens." Anthony Carroll, "Tony Carroll: My Overall Views on Junkanoo," *Nassau Guardian*, March 19, 1997.

96. Development Board, *Development Board Annual Report.*

97. Arlene Nash-Ferguson, "Coconut Nikes," *Nassau Guardian*, October 20, 2006.

98. As one reporter described it, "Mr Burnside said he envisioned the Junkanoo becoming so acclaimed globally that 'when a young Bahamian goes to Japan and says he is a Junkanoo, he will automatically be looked on with awe,' because he must be good in mathematics, art, music, dance and other disciplines to be a good Junkanoo." Raymond Kongwa, "The Junkanoo Industry?," *Nassau Guardian*, July 7, 2004, BR 1.

99. Originally, in 1995, the seats cost $15. By 2007, they cost $100. For an article about the fervor surrounding Rawson Square seats, see William Chea, "Spectators Angry over Bleachers Mix-Up," *Tribune* (Nassau), December 27, 1995, 1.

100. Nash Ferguson, *I Come to Get Me!*, 74.

101. Junkanoo participants refer to these decorations as "Junkanoo tricks," which include beads, imitation jewels, silk materials, etc. The increased use of these tricks, a costuming device informed by masquerade practices in Carnival and Mardi Gras, has met with criticism. Dale A. Charlow, for instance, in a letter to the *Nassau Guardian*, decried "the gross overuse" of tricks. "Some groups and individuals now go to the extreme of simply 'crafting' or laying the uncut, unfringed crepe paper on the cardboard and loading on as many jewels as they like. . . . Not only is the beauty lost, but the discipline is lost. . . . We are becoming so Bigheaded about this 'Globalization' of Junkanoo thing that we have forgotten from whence it came. . . . If we continue to 'Carnivalize' and make Junkanoo more like Mardi Gras and less like what we create, we will be the only ones to suffer." "The Preservation of Junkanoo," *Nassau Guardian*, February 13, 1997, 2A. Ardent Junkanoo supporter and leader Jackson Burnside has also expressed criticism of the emphasis on competition and believes that tricks may cloud the meaning of the parade. "Junkanoos strive to be 'The Best in the World,' which has been reduced to winning the parade, as if no other reward will do. The production of every major group will represent the enormous creative potential of the Bahamian people. Who is looking beyond the crepe paper, the glitter and glamour?" Quoted in Charles Carter, "Junkanoo Talks," *Nassau Guardian*, December 17, 2004, Lifestyles sec.

102. The preschool float that shimmered through the island's streets may also reflect approaches to visibility in Junkanoo. The motorcade moved through the main thoroughfares of Bay Street, a route publicized in a full-page ad in the local newspaper. Along the way it passed and ended at the British Colonial Hotel and traversed the very spaces that optimize visibility in the Junkanoo parade.

103. As a police superintendent, Douglas Hanna, explained, "Using one or two different strategies, we have tried, during this New Year's Junkanoo Parade, more than on Boxing Day, to contain groups of young men." Lindsay Thompson, "Police Kept the Peace at Junkanoo Parades," *Nassau Guardian*, January 2, 2001, 1. Other viewers could experience the parade but would have to do it from a parallel street, one that longtime Junkanooers would not perform on because it lacked the prestige of Bay Street.

104. For a report of the lawlessness of black male youth at the event, see Mark Symonette, "25 Arrested for Minor Offences," *Tribune*, December 27, 1997, 1. "Twenty-five young men were arrested for throwing missiles and disorderly behaviour at an otherwise 'quiet' Boxing Day parade, according to Assistant Commissioner of Police Paul Farquharson. The previous year, 'A number of young men, believed to be members of gangs, were arrested and detained at the Central Police Station until the parade was finished.'" Superintendent Douglas Hanna stated, as paraphrased in a local newspaper, that "in the past, persons, especially young men would go behind the bleachers and disturb spectators while 'having fun,' much to the annoyance of others." The new police measures had been "very effective." Thompson, "Police Kept the Peace at Junkanoo Parades," 3A.

105. Notably, some prom participants have started wearing masks, a practice that recalls the earliest forms of John Canoe. Whereas in 2006 only a small number of prom entrants wore masks, two years later the entire student body donned masks at the Bahamas Christian Academy prom.

4. The Sound of Light

1. Darren A. Nichols, "Look Like a Million Bucks," *Detroit News*, May 10, 2008, C3.

2. "Destiny's Child, Alicia Keys and Nelly Win at MTV Video Music Awards," *Jet* 98, no. 16, September 25, 2001, 14; and Robin Leach, "Diddy to Make a Nightclub Entrance from a Helicopter 53 Stories above Vegas," *Vegas Pop*, February 2, 2007, www.vegaspopular.com/2007/02/16/, accessed June 12, 2009.

3. This is explicitly evident in another paparazzi prom entrance, one staged in the Bahamas in 2004. Eartha Hanna, interview with author, Nassau, June 30, 2006. For a newspaper description of this entrance, see Erica Wells, "Nowadays, Prom Means Big Bucks," *Tribune* (Nassau), June 28, 2004, 2C. The observations here stem from my research and work on a documentary on the proms between 2005 and 2008.

4. Phelan, *Unmarked*, 148.

5. Yee and Sirmans, *One Planet under a Groove*, and Sirmans, *Mass Appeal*.

6. Many art historians and art critics make such musical analogies. See Yee, "Breaking and Entering," 19; Oguibe, *Culture Game*, 122; Sirmans, *Mass Appeal*, 1; Sirmans, "In the Cipher," 94; Murray, "Kehinde Wiley," 92. Here, I take issue not with these readings but with how such interpretations may be further expanded by looking at approaches to visuality in hip-hop.

7. Curiously, few appraisals of the contemporary art of hip-hop use graffiti as a model of visual aesthetics. As curator Sirmans puts it, "Although graffiti can be looked upon as a crucial element of expression in hip hop culture, the conceptual strategies of hip hop—sampling and appropriation, a cannibalist's penchant for mixing and remixing to make the new—have become the hallmark of a new generation of contemporary artists." *Mass Appeal*, 1.

8. Wallace, "Modernism, Postmodernism, and the Problem of the Visual in Afro-American Culture," 40.

9. A sample of Wiley's group and solo exhibitions includes: *Mass Appeal*, Bronx Museum of the Arts, exh. cat. by Sirmans; *One Planet under a Groove*, Bronx Museum of the Arts, 2001, exh. cat. by Yee and Sirmans; *Ironic/Iconic*, Studio Museum in Harlem, New York, 2002, exh. cat. by Christine Kim; *Black Romantic*, Studio Museum in Harlem, New York, 2002, exh. cat. by Thelma Golden; *Neo Baroque!*, Byblos Art Gallery, Verona, 2005–2006, exh. cat. by Micaela Giovannotti and Joyce B. Korotkin; *Kehinde Wiley: Columbus*, Columbus Museum of Art and Roberts and Tilton, Los Angeles, 2006, exh. cat. by Joe Houston et al.; and *Recognize! Hip Hop and Contemporary Portraiture*, National Portrait Gallery, Smithsonian Institution, Washington, DC, 2008, exh. cat. by Brandon Brame Fortune et al.

10. By iconic, I mean that the works are generally considered the most representative of and are most associated with Wiley's artistic practice overall.

11. Golden, "Kehinde Wiley (Interview)," 161.

12. More recently, Wiley uses posters and public sculptures as the basis of paintings created in China, West Africa (Dakar and Senegal), Brazil, and Jamaica. *The World Stage: China*; and Kim, *The World Stage: Africa, Lagos-Dakar; Kehinde Wiley.*

13. Kehinde Wiley, telephone interview with author, January 8, 2009.

14. Tejada, *Luis Gispert, Loud Image.*

15. This interpretation pervades much of the literature on Wiley, Gispert, and hip-hop in contemporary art more generally. A few examples are Lewis, "De(i)fying the Masters," 121; Yee, "Breaking and Entering"; and Fortune et al., *Recognize!*, 5.

16. George, *Death of Rhythm and Blues*; George, *Buppies, B-Boys, Baps and Bohos*; Dyson, *Between God and Gangsta Rap*; Boyd, *New H.N.I.C. (Head Niggas in Charge)*; Boyd, *Young, Black, Rich, and Famous*; George, *Post-soul Nation*; Shabazz et al., *A Time before Crack*, 2005; Dyson, *Know What I Mean?*

17. Several curators explicitly refer to hip-hop's earliest days, before the "postsoul" era, in their formulations of hip-hop studio aesthetics. Oguibe, *Culture Game*, 121–122; and Conrad, "Kehinde Wiley." See also Sirman's description of the exhibition *One Planet* in Mia Fineman, "The History of Art, in Baggy Jeans and Bomber Jackets," *New York Times*, December 19, 2004, 39.

18. George, *Post-soul Nation*, and Neal, *What the Music Said.*

19. Gilroy, *Against Race*; Kelley, *Race Rebels*; West, "On Afro-American Popular Music."

20. For accounts of the long and complex relationship of hip-hop artists to capitalism from hip-hop's beginnings, see Baldwin, "Black Empires, White Desires," 161. See also Kelley, "Playing for Keeps"; and Rose, *Black Noise*.

21. Rose, *Black Noise*; Baldwin, "Black Empires, White Desires"; Gilroy, *Black Atlantic*; Gilroy, *Against Race*; Watkins, *Representing*; Kelley, *Freedom Dreams*.

22. See Watkins, *Hip Hop Matters*, and Iton, *In Search of the Black Fantastic*, 101–130.

23. MTV, the major forum for the distribution of music videos, was founded in 1981.

24. Watkins, *Hip Hop Matters*, 55–58.

25. Sarig, *Third Coast*.

26. Bok, *Little Book of Bling*, 5. Or, as a reporter for the *New York Times* put it, B.G.'s onomatopoeia mimicked "the imaginary sound of light hitting diamonds"; Kelefa Sanneh, "Loving, Rapping, Snuggling And . . . ," *New York Times*, January 3, 2005, E1. See also the definition of "bling, bling" by Nicole Hodges Persley in *Icons of Hip Hop*, 468.

27. B.G., "Bling, Bling," *Chopper City in the Ghetto*, CD, © 1999, Universal Records; Big Tymers, *Big Tymers*, © 1998, Universal Records.

28. Beebe, "Paradoxes of Pastiche," 316.

29. Watkins, *Hip Hop Matters*, 215–216.

30. "Believe the Hype," *Guardian* (Manchester), June 29, 1999, 10.

31. In a video for the song "Drive Slow" (2006) by the Chicago rapper Kanye West, Williams actually used the luminous surface of a shiny car as the site on which much of the video was shot. See discussion in chapter 3 and fig. 3.3. West, "Drive Slow," single, New York: Roc-A-Fella Records, Asylum Records, and Atlantic, 2006.

32. Watkins, *Hip Hop Matters*, 214.

33. My use of "surfacism" derives here from Pinney, "Notes from the Surface of the Image," 204. The closing quotation comes from a description of these practices in Dutch seventeenth-century paintings from Schama, "Perishable Commodities," 478.

34. Roland Barthes describes "sheen" in Dutch painting as a "kind of glaze . . . [through which still-life painters] always render[ed] matter's most superficial quality"; Barthes, "World as Object," 107.

35. Schama, "Perishable Commodities," 478.

36. While oil painting was first used in the fifteenth century, John Berger maintains that "oil painting did not fully establish its own norms, its own way of seeing, until the sixteenth century"; Berger, *Ways of Seeing*, 84.

37. Berger, *Ways of Seeing*, 88.

38. Berger, *Ways of Seeing*, 90.

39. Berger, *Ways of Seeing*, 86–87.

40. Alpers, *Art of Describing*, xxv.

41. Alpers, *Art of Describing*, 34, cites the work of seventeenth-century astronomer and visual theorist Johannes Kepler here.

42. In this way these artists' paintings produce an asymmetry between the artist's original perception and the perception exercised by the viewing subject, whose physical presence and viewing experience are not accounted for in the work. For further discussion of the gaze as it relates to Dutch painting, see Bryson, *Vision and Painting*, 111–117.

43. Foster, "Art of Fetishism," 252.

44. Foster, "Art of Fetishism," 257.

45. Barthes, "World as Object."

46. Foster, "Art of Fetishism," 260–262.

47. Foster, "Art of Fetishism," 256.

48. In this regard, the use of shine in the Dutch still life paintings recalls Marx's arguments about conceptions of value in capitalism, which, incidentally, centered on the diamond and pearl. Marx argued against the idea that commodities possessed any material properties that endowed them with value. "No chemist," he charged, "has discovered exchange value either in a pearl or a diamond." Rather, "if commodities could speak they would say this: our use-value may interest men, but it does not belong to us objects." Shine, however, made value appear to belong to objects. Marx, "Fetishism of the Commodity and Its Secret," 176–177.

49. Barthes, "World as Object," 110.

50. Barthes, "World as Object," 110–111.

51. Barthes, "World as Object," 112–113.

52. Jay, "Scopic Regimes of Modernity," 7.

53. Alpers, *Art of Describing*; Jay, "Scopic Regimes of Modernity"; Greenberg, "Avant-Garde and Kitsch"; Pinney, "Notes from the Surface of the Image"; Carpentier, "Baroque and the Marvelous Real."

54. The designation "Baroque" derived etymologically from the Portuguese word for an oddly shaped pearl; it sought to characterize a style that, even more than the Dutch art of "describing," made irregularity the norm, embellished surfaces in proliferating ornamentation, composed work from multiple viewpoints, used light as a medium, and aimed not so much to describe the world faithfully as to represent its illegibility and excesses. Ornamentation sometimes extended to the frames of the artworks and broader architectural area where the work was displayed. Jay, "Scopic Regimes of Modernity," 17.

55. Christine Buci-Glucksmann, quoted in Jay, "Scopic Regimes of Modernity," 17.

56. Lacan, *Four Fundamental Concepts of Psychoanalysis*, 87.

57. Greenblatt, *Renaissance Self-Fashioning*, 19.

58. For a small sample of the art-historical literature on historically specific occurrences of surfacism and shine, see Clark, *Painting of Modern Life*; Greenberg, "Avant-Garde and Kitsch"; Jameson, "Cultural Logic of Late Capitalism"; Joselit, "Notes on Surface." There is also a notable history of shine in African American art and letters. A group of African American artists, AfriCOBRA (African Commune of Bad Relevant Artists, founded in 1968), for instance, defined "shine" as a "major quality" in their artistic philosophies. Africobra 1,

"Africobra 1," 85; and Africobra 1, *Africobra III*. A related concept of "black light" was also central to the Black Arts Movement more generally in Chicago. See Crawford, "Black Light on the *Wall of Respect*."

59. This is perhaps a fitting appellation for a ruler whose "vigorous and imposing bulk [was] fairly lost beneath the sheer mass of stuff—jewels, feathers, yards of rich cloths—with which he bedecked himself," and who wore, as a contemporary ambassador marveled, "one mass of jeweled rings" on his fingers while "around his neck he wore a gold collar from which hung a diamond as big as a walnut." Greenblatt, *Renaissance Self-Fashioning*, 28–29.

60. Barthes, "World as Object," 110, echoes this view when he notes that in Dutch paintings peasants had, in essence, no sheen and were portrayed in a manner that seemed "unfinished."

61. Berger, *Ways of Seeing*, 96.

62. Fanon, *Black Skin, White Masks*, 109.

63. Ford, "People as Property," 8.

64. Roper, *Narrative of His Adventures and Escape from American Slavery*, 119. For other slave narratives and oral histories about shine and the greasing of slaves, see Watson, *Narrative of Henry Watson, a Fugitive Slave*, 12; Rowe, "Interview," 368; Hutson, "Interview," 209; Bibb, "Narrative of the Life of Henry Bibb an American Slave," 115; Ashley, "Ex-slave Stories (Texas)," 75–77. For a scholarly consideration of this practice, see Johnson, *Soul by Soul*, 118–134.

65. Historian Walter Johnson, *Soul by Soul*, 145, explains that polished bodies hid rebellious pasts: "As the slaves removed their coats and frocks and shirts, buyers inspected their naked bodies minutely, looking for what they called 'clear' or 'smooth' skin, skin unmarked by signs of illness and injury. . . . More than anything, however, they were looking for scars from whipping. As Solomon Northup explained, 'scars upon a slave's back were considered evidence of a rebellious or unruly spirit, and hurt his sale.' . . . The buyers thought they could read slaves' backs as encodings of their history." Former slave William Hutson, "Interview," 209, viewed greasing as a practice aimed at disguising scars. "Some of them was well greased and that grease covered up many a scar they'd earned for some foolishness or other." The term "the hieroglyphics of the flesh" is from Spillers, "Mama's Baby, Papa's Maybe," 67.

66. As Johnson puts it, "In the pens the traders medicated and fed and shined and shaved and plucked and smoothed and dressed and sexualized and racialized and narrated people until even the appearance of singularity had been saturated with the representations of salability." *Soul by Soul*, 133–134. See also Oakes, *Slavery and Freedom*, 24.

67. Fanon, *Black Skin, White Masks*, 109.

68. A notable exception to this is Joselit, "Notes on Surface."

69. Kanye West, *All Falls Down*, Roc-A-Fella Records, 2004.

70. Wiegman, *American Anatomies*, 1.

71. Fanon, *Black Skin, White Masks*.

72. Weheliye, *Phonographies*, 50.

73. Weheliye, *Phonographies*, 50.

74. This curatorial position reflects more than benign neglect. At least one curator, Franklin Sirmans, whose insights have been very formative in considerations of hip-hop and contemporary art, insisted in an interview about the inaugural *One Planet* exhibition that hip-hop studio practice should not be seen in light of popular expressions of postsoul hip-hop, what he deemed "this bling, bling thing that has developed." Kerr, "Interview with Franklin Sirmans," 20–22.

75. One rare exhibition that did highlight surface aesthetics and reflection in black and Latino youth cultures was *The Superfly Effect*, curated by Rocio Aranda for the Jersey City Museum in 2005.

76. Kehinde Wiley, interview with Christine Kim, quoted in Fineman, "History of Art, in Baggy Jeans and Bomber Jackets," 39.

77. Golden, "Kehinde Wiley (Interview)."

78. Fineman, "History of Art, in Baggy Jeans and Bomber Jackets."

79. Positing hip-hop as a neo-Baroque aesthetic, see Giovannotti and Korotkin, *Neo Baroque!*, and Golden, "Kehinde Wiley (Interview)," 162. See also Cartwright, "Subwoofers, Subcultures, Subversions."

80. Kehinde Wiley, telephone interview with author, June 22, 2008.

81. Golden, "Kehinde Wiley (Interview)."

82. Wiley, interview, 2008.

83. One of the techniques Wiley studied was chiaroscuro. The method, first popular in the sixteenth century, involves first a detailed drawing, followed by layers of brown underpainting, and a full-color overpainting. In essence, the technique created the illusion of depth, through light and shadow, through the successive laying on of surfaces.

84. Dyer, *White*, 14.

85. Wiley, interview, 2008.

86. Wiley, interview, 2008.

87. Wiley, interview, 2008.

88. Barthes, "World as Object," 113.

89. Bryson, *Vision and Painting*, 111–117, notes how Jan Vermeer, for instance, in his paintings combined an interest in visually transcribing the adorned surface with notation, representing the "accidental history of the . . . physical surface striated by light."

90. Thanks to Randall Rhodes for this insightful observation.

91. Wiley, interview, 2009.

92. Wiley, interview, 2009.

93. See also an advertisement for rapper Snoop Dogg, "Snoop Dogg Top Dogg," *Vibe*, May 1999, or, for an example of the use of the frame in music videos, see the beginning of a 1996 Hype Williams video that he produced for Busta Rhymes. The video begins with a portrayal of Rhymes walking through the frame of a painting of himself. Williams, *Woo-Hah! Got You All in Check*, video, Elektra/Flipmode, New York, 1996.

94. Heidegger used the term "enframing" to characterize how historically

the natural world has been ordered within frames of understanding, like a landscape circumscribed in a frame. Enframing, the philosopher cautions, forestalls "every other possibility of revealing. Above all, Enframing conceals that revealing which, in the sense of *poiesis* [truth], sets what presences come forth into appearance." Heidegger makes the case that society often loses sight of enframing and how it closes off other forms of revealing, appearances, and truth. Wiley's frames, I want to suggest, call attention to how understandings of art result in a similar process of ordering and occlusion. Heidegger, *Question Concerning Technology, and Other Essays*, 27.

95. See Lippard, *Mixed Blessings*, 90–91; O'Grady et al., *Lorraine O'Grady, Photomontages*, 9; and Copeland, "Being in the Picture," 139. The series *A Thousand Words* was formerly titled *Frames*.

96. Golden, "Kehinde Wiley (Interview)," 161.

97. Houston et al., *Kehinde Wiley*, 6; and Wiley, interview, 2008.

98. Golden, "Kehinde Wiley (Interview)," 161; and Wiley, interview, 2008.

99. Williams has observed, "Rap artists were talented, but I made them look much more talented than they actually were. The mastering and manipulation of technical qualities like sound, camera angles and lighting have a way of creating presence, and that impacts the consumer." Quoted in Watkins, *Hip Hop Matters*, 214.

100. Watkins, *Hip Hop Matters*, 214; Gilroy, "'After the Love Has Gone'"; and Rose, *Black Noise*.

101. Sirmans, "Barkley Hendricks, Ordinary People," 87.

102. The spermatozoa first appeared in the *Diamond* series in 2001–2002. Wiley noted that at the time he produced the paintings he had been examining military portraits and was thinking specifically about the visual production of masculinity in this genre of painting. He explained that the swirls of light that look like sperm were patterned after specific aerial views of the American Revolutionary War. Wiley, interview, 2008.

103. Tate, "Kehinde Wiley's Cipher Syntax," 11–12.

104. Wiley, interview, 2008.

105. Wiley, interview, 2008.

106. Wiley, interview, 2008. Artists Amanda Williams and Krista Franklin similarly created an ice sculpture of rapper Lil' Kim, which melted during the course of their exhibition *Dreams in Jay-Z Minor* at Blanc Gallery in Chicago in 2012.

107. Moten, *In the Break*, 9–13, who begins his book with a description of Frederick Douglass's narrative about listening to the screams of his Aunt Hester, a slave, being whipped, is compelled to revisit volume 1 of Marx's *Capital*, where Marx makes the point that "if commodities could speak they would say this: our use-value may interest men, but it does not belong to us objects." Moten takes issue with Marx's underlying argument about the inability and impossibility of the commodity's speech, "the impossible material substance of the commodity's impossible speech." The idea that commodities can speak is placed in "an unachievable future." Marx, by discounting the commodity

that speaks, neglects, returning to Douglass's aunt's screams, the "trace of a subjectivity structure born in objection."

108. Moten, *In the Break*, 11.

109. Kehinde Wiley quoted in Paul Young, "The Re-Masters," *Daily Variety Magazine*, June 2, 2006, 33.

110. Mercer, "Diaspora Aesthetics and Visual Culture"; and Gray, *Watching Race*. Such efforts to render black subjectivity legible were epitomized in Ralph Ellison's *Invisible Man*, written in 1947.

111. On light in the Black Arts Movement, see Crawford, "Black Light on the *Wall of Respect*," 23–42. Crawford points out that explorations of blackness in the Black Arts Movement differentiated between types of black at the time, distinguishing types ranging from the shellacked shine they associated with minstrelsy (a form of black light) to velvet black.

112. Luis Gispert, interview with author, Brooklyn, April 25, 2007.

113. Cartwright, "Subwoofers, Subcultures, Subversions," 27.

114. De Certeau, "Gaze," 2–38.

115. Bryson, *Vision and Painting*, 92.

116. Gray, *Watching Race*.

117. Cartwright, "Subwoofers, Subcultures, Subversions," 25.

118. The sports channel ESPN features sports highlights.

119. Pinn, "Sweaty Bodies in a Circle."

120. *Loud Image* was the title of Gispert's solo show at the Hood Museum, in 2004.

121. Cartwright, "Subwoofers, Subcultures, Subversions," 24.

BIBLIOGRAPHY

Abel, Elizabeth. "Skin, Flesh, and Affective Wrinkles of Civil Rights." *Qui Parle: Critical Studies and Social Sciences* 20, no. 2 (2012): 35–69.

Aching, Gerard. *Masking and Power: Carnival and Popular Culture in the Caribbean*. Minneapolis: University of Minnesota Press, 2002.

Adams, Jessica, Michael P. Bibler, and Cécile Accilien, eds. *Just below South: Intercultural Performance in the Caribbean and the U.S. South*. Charlottesville: University of Virginia Press, 2007.

Africobra 1 [African Commune of Bad Relevant Artists]. "Africobra 1: 10 in Search of a Nation." *Black World* 19 (October 1970): 85.

Africobra 1 [African Commune of Bad Relevant Artists]. *Africobra III*. Amherst: University Art Gallery, University of Massachusetts, Amherst, 1973.

Agamben, Giorgio. *Homo Sacer: Sovereign Power and Bare Life*. Translated by Daniel Heller-Roazen. Stanford, CA: Stanford University Press, 1998.

Alpers, Svetlana. *The Art of Describing: Dutch Art in the Seventeenth Century*. Chicago: University of Chicago Press, 1983.

Appadurai, Arjun. "The Colonial Backdrop." *Afterimage* 24, no. 5 (1997): 4–7.

Appadurai, Arjun, ed. *The Social Life of Things*. Cambridge: Cambridge University Press, 1986.

Appadurai, Arjun, Lauren Berlant, Carol A. Breckenridge, and Manthia Diawara. "Editorial Comment: On Thinking the Black Public Sphere." *Public Culture* 7 (1994): xi–xiv.

Appiah, Anthony. *In My Father's House: Africa in the Philosophy of Culture*. New York: Oxford University Press, 1993.

Archer-Straw, Petrine. "Accessories/Accessaries; Or, What's in Your Closet?" *Small Axe* 14, no. 2 (2010): 97–110.

Ashley, Sarah. "Ex-slave Stories (Texas)." In *Born in Slavery: Slave Narratives from the Federal Writers' Project, 1936–1938*, vol. 16, pt. 1, of *Slave Narratives: A Folk History of Slavery in the United States from Interviews with Former Slaves*. Federal Writers' Project of the Works Projects Administration, 1–3. Washington, DC: Library of Congress, 1941.

Austin-Broos, Diane J. "Race/Class: Jamaica's Discourse of Heritable Identity." *New West Indian Guide* 68, nos. 3–4 (1994): 213–233.

Azoulay, Ariella. *The Civil Contract of Photography*. New York: Zone Books, 2008.

B.G. "Bling, Bling." *Chopper City in the Ghetto*. Universal Records, 1999.

Bakare-Yusuf, Bibi. "Fabricating Identities: Survival and the Imagination in Jamaican Dancehall Culture." *Fashion Theory* 10, no. 4 (2006): 461–484.

Bakare-Yusuf, Bibi. "In the Sea of Memory: Embodiment and Agency in the Black Diaspora." PhD diss., University of Warwick, 2000.

Baldwin, Davarian. "Black Empires, White Desires: The Spatial Politics of Identity in the Age of Hip Hop." In *That's the Joint! The Hip-Hop Studies Reader*, ed. Mark Anthony Neal and Murray Forman, 159–176. New York: Routledge, 2004.

Baldwin, James. *The Devil Finds Work*. New York: Random House, 1976.

Barnes, Natasha. *Cultural Conundrums: Gender, Race, Nation, and the Making of Caribbean Cultural Politics*. Ann Arbor: University of Michigan Press, 2006.

Barthes, Roland. *Camera Lucida*. Translated by Richard Howard. New York: Hill and Wang, [1980] 1981.

Barthes, Roland. "The World as Object." In *Calligram: Essays in New Art History from France*, ed. Norman Bryson, 106–115. Cambridge: Cambridge University Press, 1988.

Batchen, Geoffrey. *Burning with Desire: The Conception of Photography*. Cambridge, MA: MIT Press, 1997.

Batson-Savage, Tanya. "'Hol' Awn Mek a Answer Mi Cellular': Sex, Sexuality and the Cellular Phone in Urban Jamaica." *Continuum: Journal of Media and Cultural Studies* 21, no. 2 (2007): 239–251.

Baucom, Ian. "Frantz Fanon's Radio: Solidarity, Diaspora, and the Tactics of Listening." *Contemporary Literature* 42, no. 1 (2001): 15–49.

Baudrillard, Jean. "Simulacra and Simulations." In *Jean Baudrillard, Selected Writings*, ed. Mark Poster, 166–184. Stanford, CA: Stanford University Press, 1997.

Beebe, Roger. "Paradoxes of Pastiche: Spike Jonze, Hype Williams, and the Race of the Postmodern Auteur." In *Medium Cool: Music Videos from Soundies to Cellphones*, ed. Roger Beebe and Jason Middleton, 303–327. Durham, NC: Duke University Press, 2007.

Behrend, Heike. "'I Am Like a Movie Star in My Street': Photographic Self-Creation in Postcolonial Kenya." In *Postcolonial Subjectivities in Africa*, ed. Richard Werbner, 44–62. London: Zed Books, 2002.

Bennett, Jane. *Vibrant Matter: A Political Ecology of Things*. Durham, NC: Duke University Press, 2010.

Berger, John. *Ways of Seeing*. London: British Broadcasting Corporation, 1972.

Best, Curwen. *Culture @ The Cutting Edge: Tracking Caribbean Popular Music*. Kingston: University of the West Indies Press, 2004.

Best, Stephen, and Sharon Marcus. "Surface Reading: An Introduction." *Representations* 108 (2009): 1–21.

Best, Steven, and Douglas Kellner. "Debord and the Postmodern Turn: New Stages of the Spectacle." Illuminations: The Critical Theory Project, 1998. www.gseis.ucla.edu/faculty/kellner/Illumina%20Folder/kell17.htm, accessed June 23, 2014.

The Best of Jamaica 2000. Kingston: Gleaner Company, 2000.

Bethel, Clement E., and Nicolette Bethel. *Junkanoo: Festival of the Bahamas*. London: Macmillan Caribbean, 1991.

Bettelheim, Judith. "The Afro-Jamaican Jonkonnu Festival: Playing the Forces and Operating the Cloth." PhD diss., Yale University, 1979.

Bibb, Henry. "Narrative of the Life of Henry Bibb an American Slave." In *Puttin' on Old Massa: The Slave Narratives of Henry Bibb, William Welles Brown, and Solomon Northup*, ed. Gilbert Osofsky, 51–171. New York: Harper and Row, 1969.

Big Pun. "Sex, Money, & Drugs." *Mr Peter Parker — Happy Birthday Big Pun*, 2009. www.mixtapetorrent.com/mr-peter-parker-happy-birthday-big-pun-remixtape, accessed June 23, 2014.

Big Tymers. "Big Tymers." *How You Luv That*. Universal Records, 1998.

Blay, Yaba Amgborale. "Editorial: Struck by Lightening: The Transdiasporan Phenomenon of Skin Bleaching." *JENdA: A Journal of Culture and African Women Studies* 14 (2009): 1–10.

Blay, Yaba Amgborale. "Yellow Fever: Skin Bleaching and the Politics of Skin Color in Ghana." PhD diss., Temple University, 2007.

Bok, Lee. *The Little Book of Bling*. Bath, England: Crombie Jardine, 2006.

Boone, Joseph A., and Nancy J. Vickers, eds. "Special Topic: Celebrity, Fame, Notoriety." Special issue, *PMLA* 126, no. 4 (October 2011).

Boorstin, Daniel J. *The Image: A Guide to Pseudo-events in America*. New York: Vintage, [1962] 1992.

Bourdieu, Pierre. *Outline of a Theory of Practice*. Translated by Richard Nice. Cambridge: Cambridge University Press, 1977.

Boyd, Todd. *The New H.N.I.C. (Head Niggas in Charge): The Death of Civil Rights and the Reign of Hip Hop*. New York: New York University Press, 2002.

Boyd, Todd. *Young, Black, Rich, and Famous: The Rise of the NBA, the Hip Hop Invasion, and the Transformation of American Culture*. New York: Doubleday, 2003.

Braudy, Leo. *The Frenzy of Renown: Fame and Its History*. New York: Vintage, [1986] 1997.

Brown, Paul A. "Address." *Philadelphia Photographer* 16 (1879): 219–221.

Brown-Glaude, Winnifred. "The Fact of Blackness? The Bleached Body in Contemporary Jamaica." *Small Axe* 11, no. 3 (2007): 34–51.

Bryson, Norman. *Vision and Painting: The Logic of the Gaze*. New Haven, CT: Yale University Press, 1983.

Cadava, Eduardo. *Words of Light: Theses on the Photography of History*. Princeton, NJ: Princeton University Press, 1997.

Campt, Tina M. *Image Matters: Archive, Photography, and the African Diaspora in Europe*. Durham, NC: Duke University Press, 2012.

Canclini, Néstor García. *Consumers and Citizens: Globalization and Multicultural Conflicts*. Translated by George Yúdice. Minneapolis: University of Minnesota Press, 2001.

Carnegie, Charles V. "The Dundas and the Nation." *Cultural Anthropology* 11, no. 4 (1996): 470–509.

Carpentier, Alejo. "The Baroque and the Marvelous Real." In *Magical Realism: Theory, History, Community*, ed. Lois Parkinson Zamora and Wendy B. Faris, 89–108. Durham, NC: Duke University Press, 1995.

Cartwright, Derrick. "Subwoofers, Subcultures, Subversions: A Conversation with Luis Gispert." In *Luis Gispert, Loud Image*, ed. Roberto Tejada, 14–19. Hanover, NH: Hood Museum of Art, Dartmouth College, 2004.

Cartwright, Keith. *Sacral Grooves, Limbo Gateways: Travels in Deep Southern Time, Circum-Caribbean Space, Afro-Creole Authority*. Athens: University of Georgia Press, 2013.

Charles, Christopher A. D. "Skin Bleaching, Self-Hate and Black Identity in Jamaica." *Journal of Black Studies* 33, no. 6 (2003): 711–728.

Charles, Kerwin Kofi, Erik Hurst, and Nikolai Roussanov. "Conspicuous Consumption and Race." *Quarterly Journal of Economics* 124, no. 2 (2009): 425–467.

Cheng, Anne Anlin. *Second Skin: Josephine Baker and the Modern Surface*. Oxford: Oxford University Press, 2011.

Cheng, Anne Anlin. "Shine: On Race, Glamour, and the Modern." PMLA 126, no. 4 (2011): 1022–1041.

Chude-Sokei, Louis. *The Last "Darky": Bert Williams, Black-on-Black Minstrelsy, and the African Diaspora*. Durham, NC: Duke University Press, 2006.

Chude-Sokei, Louis. "Post-nationalist Geographies: Rasta, Ragga, and Reinventing Africa." *African Arts* 27, no. 4 (1994): 80–84, 96.

Clark, T. J. *The Painting of Modern Life: Paris in the Art of Manet and His Followers*. Princeton, NJ: Princeton University Press, 1986.

Columbus Museum of Art. *Kehinde Wiley: Columbus*. Columbus, OH: Columbus Museum of Art, 2006.

Coole, Diana, and Samantha Frost. *New Materialisms: Ontology, Agency, and Politics*. Durham, NC: Duke University Press, 2010.

Cooper, Carolyn. "'Lyrical Gun': Metaphor and Role of Play in Jamaican Dancehall Culture." *Massachusetts Review* 35, nos. 3 and 4 (Autumn 1994): 429–447.

Cooper, Carolyn. *Noises in the Blood: Orality, Gender, and the "Vulgar" Body of Jamaican Popular Culture*. Durham, NC: Duke University Press, 1995.

Cooper, Carolyn. *Sound Clash: Jamaican Dancehall Culture at Large*. New York: Palgrave Macmillan, 2004.

Cooper, Frank Rudy, and Ann C. McGinley, eds. *Masculinities and the Law: A Multidimensional Approach*. New York: New York University Press, 2012.

Copeland, Huey. "Being in the Picture: Hank Willis Thomas' *Frames* Series." *Qui Parle* 13, no. 2 (2003): 137–142.

Copeland, Huey. *Bound to Appear: Art, Slavery, and the Site of Blackness in Multicultural America*. Chicago: University of Chicago Press, 2013.

Correspondent. "Learning from Films: Keen Interest in Local 'Documentaries.'" *Times British Colonies Review* (Winter 1952): n.p.

Cowin, Daniel. *African American Vernacular Photography: Selections from the Daniel Cowin Collection*. New York: International Center for Photography, 2005.

Craton, Michael. "Bay Street, Black Power and the Conchy Joes: Race and Class in the Colony and Commonwealth of the Bahamas, 1850–2000." In *The White Minority in the Caribbean*, ed. Howard Johnson and Karl Watson, 71–94. Kingston: Ian Randle, 1998.

Crawford, Alexay D. "The Effects of Dancehall Genre on Adolescent Sexual and Violent Behavior in Jamaica: A Public Health Concern." *North American Journal of Medical Sciences* 2, no. 3 (2010): 143–145.

Crawford, Margo Natalie. "Black Light on the *Wall of Respect*: The Chicago Black Arts Movement." In *New Thoughts on the Black Arts Movement*, ed. Lisa Gail Collins and Margo Natalie Crawford, 23–42. New Brunswick, NJ: Rutgers University Press, 2006.

Darrah, William C. *Cartes de Visite in Nineteenth Century Photography*. Gettysburg, PA: W. C. Darrah, 1981.

Debord, Guy. *Society of the Spectacle*. Detroit: Red and Black, 1970.

de Certeau, Michel. "The Gaze: Nicholas of Cusa." *Diacritics* 17, no. 3 (1987): 2–38.

Defries, Amelia Dorothy. *In a Forgotten Colony; Being Some Studies in Nassau and at Grand Bahama during 1916*. Nassau: The Guardian Office, 1917.

Dery, Mark. "Black to the Future: Interviews with Samuel R. Delany, Greg Tate, and Tricia Rose." In *Flame Wars: The Discourse of Cyberculture*, ed. Mark Dery, 179–222. Durham, NC: Duke University Press, 1994.

"Destiny's Child, Alicia Keys and Nelly Win at MTV Video Music Awards." *Jet* 98, no. 16, September 25, 2001, 14.

Development Board. *Development Board Annual Report*. Nassau, Bahamas, 1934.

Diawara, Manthia. "The 1960s in Bamako: Malick Sidibé and James Brown." In *Black Cultural Traffic*, ed. Harry J. Elam Jr. and Kennell Jackson, 242–265. Ann Arbor: University of Michigan Press, 2005.

Diawara, Manthia. "Towards a Regional Imaginary in Africa." In *The Cultures of Globalization*, ed. Fredric Jameson and Masao Miyoshi, 103–124. Durham, NC: Duke University Press, 1998.

Douglass, Frederick. "What to the Slave Is the Fourth of July? Extract from an Oration. At Rochester, July 5, 1852." In *My Bondage and My Freedom*. New York: Haskell House, [1855] 1969.

Drewal, Henry, and John Mason. *Beads, Body, and Soul: Art and Light in the Yoruba Universe*. Los Angeles: Fowler Museum of Cultural History, 1998.

Du Bois, W. E. B. "Criteria of Negro Art." In *The Portable Harlem Renaissance Reader*, ed. David Levering Lewis, 100–105. New York: Penguin, [1926] 1994.

Du Bois, W. E. B. "Opinion—In Black." *Crisis: A Record of the Darker Races* 20 (October 1920): 265–266.

Dyer, Richard. *Stars*. London: British Film Institute, [1979] 1998.

Dyer, Richard. *White*. New York: Routledge, 1997.

Dyson, Michael Eric. *Between God and Gangsta Rap: Bearing Witness to Black Culture*. New York: Oxford University Press, 1996.

Dyson, Michael Eric. *Know What I Mean? Reflections on Hip Hop*. New York: Basic Civitas Books, 2007.

Edwards, Brent Hayes. *The Practice of Diaspora: Literature, Translation, and the Rise of Black Internationalism*. Cambridge, MA: Harvard University Press, 2003.

Edwards, Elizabeth, and Janice Hart, eds. *Photographies, Objects, Histories: On the Materiality of Images*. New York: Routledge, 2004.

Edwards, Nadi. "Notes on the Age of Dis: Reading Kingston through Agamben." *Small Axe* 12, no. 1 (2008): 1–15.

Elephant Man. "Signal de Plane." *Good 2 Go*. VP Records, 2003.

Ellis, Nadia. "Out and Bad: Toward a Queer Performance Hermeneutic in Jamaican Dancehall." *Small Axe* 15, no. 2 (2011): 7–23.

Ellison, Ralph. "Introduction." In *Invisible Man*, vii–xxiii. New York: Random House, [1952] 1981.

Ellison, Ralph. *Invisible Man*. New York: Random House, 1947.

Emdur, Alyse. "*Prison Landscapes*: The Archive Confronts a Cultural Taboo." *Art Papers* (Fall 2011): 18–22.

Fanon, Frantz. *Black Skin, White Masks*. New York: Grove Press, 1967.

Farquharson, Joseph T. "*Faiya-bon*: The Socio-Pragmatics of Homophobia in Jamaican (Dancehall) Culture." In *Politeness and Face in Caribbean Creoles*, ed. Susanne Muehleisen and Bettina Migge, 101–118. Philadelphia: John Benjamins, 2005.

Feldman, Hannah. *From a Nation Torn: Decolonizing Art and Representation in France, 1945–1962*. Durham, NC: Duke University Press, 2014.

Fiasco, Lupe. "The Cool." *Food & Liquor*. Record Plant Studios, 2006.

Fleetwood, Nicole. *Troubling Vision: Performances, Visuality, and Blackness*. Chicago: University of Chicago Press, 2011.

Forbes, Marcia. *Music, Media and Adolescent Sexuality in Jamaica*. Kingston: Arawak, 2010.

Ford, Charles. "People as Property." *Oxford Art Journal* 25, no. 1 (2002): 1–16.

Fortune, Brandon Brame, et al., eds. *Recognize! Hip Hop and Contemporary Portraiture*. Washington, DC: Smithsonian Institution, 2008.

Foster, Hal. "The Art of Fetishism: Notes on Dutch Still Life." In *Fetishism as Cultural Discourse*, ed. Emily S. Apter and William Pietz, 251–265. Ithaca, NY: Cornell University Press, 1993.

Francis, Terri. "Sounding the Nation: Martin Rennalls and the Jamaica Film Unit, 1951–1961." *Film History* 23, no. 2 (2011): 110–128.

Friedberg, Anne. *Window Shopping: Cinema and the Postmodern*. Berkeley: University of California Press, 1993.

Frisco Kid. "Video Light." *Video Light*. Cell Block Studio Records, 1996.

Fusco, Coco, and Brian Wallis, eds. *Only Skin Deep: Changing Visions of the American Self*. New York: Abrams, 2003.

Gaines, Malik. "Kehinde Wiley: Pieces of a Man." In *Ironic/Iconic, Artists in Residence*, exhibition catalogue, ed. Christine Kim, n.p. New York: Studio Museum in Harlem, 2002.

Gamson, Joshua. *Claims to Fame: Celebrity in Contemporary America*. Berkeley: University of California Press, 1994.

Gell, Alfred. *Art and Agency: An Anthropological Theory*. Oxford: Oxford University Press, 1998.

George, Nelson. *Buppies, B-Boys, Baps, and Bohos: Notes on Post-soul Black Culture*. New York: HarperCollins, 1992.

George, Nelson. *The Death of Rhythm and Blues*. New York: Pantheon, 1988.

George, Nelson. *Post-soul Nation: The Explosive, Contradictory, Triumphant, and Tragic 1980s as Experienced by African Americans (Previously Known as Blacks and before That Negroes)*. New York: Viking Press, 2004.

Gilroy, Paul. "'After the Love Has Gone': Bio-Politics and Etho-Poetics in the Black Public Sphere." *Third Text* 28–29 (Autumn–Winter 1994): 25–47.

Gilroy, Paul. *Against Race: Imagining Political Culture beyond the Color Line*. Cambridge, MA: Harvard University Press, 2000.

Gilroy, Paul. *The Black Atlantic: Modernity and Double Consciousness*. Cambridge, MA: Harvard University Press, 1993.

Gilroy, Paul. *Darker Than Blue: On the Moral Economies of Black Atlantic Culture*. Cambridge, MA: Harvard University Press, 2010.

Gilroy, Paul. "Diaspora, Utopia and the Critique of Capitalism." In *"There Ain't No Black in the Union Jack,"* 153–222. Chicago: University of Chicago Press, 1991.

Gilroy, Paul. "Get Free or Die Tryin'." In *Darker Than Blue: On the Moral Economies of Black Atlantic Culture*, 4–54. Cambridge, MA: Harvard University Press, 2010.

Gilroy, Paul. "One Nation under a Groove." In *Small Acts*, 19–48. London: Serpent's Tail, 1993.

Gilroy, Paul. "'To Be Real': The Dissident Forms of Black Expressive Culture." In *Let's Get It On: The Politics of Black Performance*, ed. Catherine Ugwu, 12–33. Seattle: Bay Press, 1995.

Gilroy, Paul. "Wearing Your Art on Your Sleeve: Notes toward a Diaspora History of Black Ephemera." In *Small Acts*, 237–257. London: Serpent's Tail, 1993.

Giovannotti, Micaela, and Joyce B. Korotkin. *Neo Baroque!* Maidstone, England: Charta, 2006.

Glissant, Édouard. "For Opacity." In *Over Here: International Perspectives on Art and Culture*, ed. Gerardo Mosquera and Jean Fisher, 252–257. New York: New Museum of Contemporary Art, 2004.

Goldberg, David Theo. "'Polluting the Body Politic': Racist Discourse and Urban Location." In *Racism, the City and the State*, ed. Malcolm Cross and Michael Keith, 45–60. New York: Routledge, 1993.

Golden, Thelma. *Black Romantic: The Figurative Impulse in Contemporary African-American Art*. New York: Studio Museum in Harlem, 2002.

Golden, Thelma. "Kehinde Wiley (Interview): The Painter Who Is Doing for Hip-Hop Culture What Artists Once Did for the Aristocracy." *Interview* 35, no. 9 (2005): 161–162.

Goldsby, Jacqueline. "Through a Different Lens: Lynching Photography at the Turn of the Nineteenth Century." In *A Spectacular Secret: Lynching*

in American Life and Literature, 214–307. Chicago: University of Chicago Press, 2006.

Google. "5 Truths of the Digital African American Consumer: A Digital Culture of Change." Research paper. Google / GlobalHue / Ipsos OTX MediaCT. June 2011. www.thinkwithgoogle.com/insights/library/studies/five-truths -of-the-digital-african-american-consumer/, accessed June 23, 2014.

Gordon, Avery. *Ghostly Matters: Haunting and the Sociological Imagination.* Minneapolis: University of Minnesota Press, 1997.

Gray, Herman. *Watching Race: Television and the Struggle for "Blackness."* Minneapolis: University of Minnesota Press, 1995.

Greenberg, Clement. "Avant-Garde and Kitsch." In *Clement Greenberg: The Collected Essays and Criticism*, vol. 1, *Perceptions and Judgments, 1939–1944*, ed. John O'Brian, 5–22. Chicago: University of Chicago Press, 1986.

Greenblatt, Stephen. *Renaissance Self-Fashioning: From More to Shakespeare.* Chicago: University of Chicago Press, 1980.

Griffin, Tim. "Compression." *October* 135 (Winter 2011): 3–20.

Grigsby, Darcy Grimaldo. "Negative-Positive Truths." *Representations* 113 (2011): 16–38.

Hall, Stuart. "Cultural Identity and Diaspora." In *Identity: Community, Culture, Difference*, ed. Jonathan Rutherford, 222–237. London: Lawrence and Wishart, 1990.

Hall, Stuart. "Encoding, Decoding." In *The Cultural Studies Reader*, ed. Simon During, 90–103. London: Routledge, 1993.

Hall, Stuart. "Reflections upon the Encoding/Decoding Model: An Interview with Stuart Hall." In *Viewing, Reading, Listening: Audiences and Critical Reception*, ed. Jon Cruz and Justin Lewis, 253–274. Boulder, CO: Westview Press, 1994.

Hanchard, Michael. "Afro-Modernity: Temporality, Politics, and the African Diaspora." *Public Culture* 11, no. 1 (1999): 245–268.

Hartman, Saidiya V. *Scenes of Subjection: Terror, Slavery, and Self-Making in Nineteenth-Century America.* New York: Oxford University Press, 1997.

Heidegger, Martin. *The Question Concerning Technology, and Other Essays.* Translated by William Lovitt. New York: Harper and Row, 1977.

Henriques, Julian. *Sonic Bodies: Reggae Sound Systems, Performance Techniques, and Ways of Knowing.* New York: Continuum, 2011.

Henriques, Julian. "Sonic Diaspora, Vibrations, and Rhythm: Thinking through the Sounding of the Jamaican Dancehall Session." *African and Black Diaspora: An International Journal* 1, no. 2 (2008): 215–236.

Henriques, Julian. "The Vibrations of Affect and Their Propagation on a Night Out on Kingston's Dancehall Scene." *Body & Society* 16, no. 1 (2010): 57–89.

Hernandez-Ramdwar, Camille. "Shottas and Cubatoneros: Badmanism, Bling, and Youth Crime in Trinidad and Tobago and Cuba." *Caribbean Journal of Criminology and Public Safety* 14, nos. 1–2 (2009): 285–305.

Ho, Christine, and Keith Nurse, eds. *Globalisation, Diaspora, and Caribbean Popular Culture.* Kingston: Ian Randle, 2005.

Hochstrasser, Julie Berger. "Slaves." In *Still Life and Trade in the Dutch Golden Age*, 204–227. New Haven, CT: Yale University Press, 2007.

Holger, Henke, and Karl-Heinz Magister, eds. *Constructing Vernacular Culture in the Trans-Caribbean*. Lanham, MD: Lexington Books, 2008.

Holt, Thomas. *The Problem of Freedom: Race, Labor, and Politics in Jamaica and Britain, 1832–1938*. Baltimore: Johns Hopkins University Press, 1992.

Hope, Donna P. "From *Browning* to *Cake Soap*: Popular Debates on Skin Bleaching in the Jamaican Dancehall." *Journal of Pan-African Studies* 4, no. 4 (2011): 165–194.

Hope, Donna P. "From the Stage to the Grave: Exploring Celebrity Funerals in Dancehall Culture." *International Journal of Cultural Studies* 13, no. 3 (2010): 254–270.

Hope, Donna P. *Inna di Dancehall: Popular Culture and the Politics of Identity in Jamaica*. Kingston: University of the West Indies Press, 2006.

Hope, Donna P. *Man Vibes: Masculinities in the Jamaican Dancehall*. Kingston: Ian Randle, 2010.

Hope, Donna P. "*Passa Passa*: Interrogating Cultural Hybridities in Jamaican Dancehall." *Small Axe* 10, no. 3 (2006): 119–133.

Horace, Levy. *They Cry Respect: Urban Violence and Poverty in Jamaica*. Mona, Jamaica: Centre for Population, Community and Social Change, Department of Sociology and Social Work, University of the West Indies, 1996.

Houlberg, Marilyn. "Haitian Studio Photography: A Hidden World of Images." *Aperture* 126 (1992): 58–65.

Houston, Joe, et al. *Kehinde Wiley: Columbus*. Los Angeles: Roberts and Tilton, 2006.

Hutson, William. "Interview." In *The WPA Oklahoma Slave Narratives*, ed. T. Lindsay Baker and Julie P. Baker, 543. Norman: University of Oklahoma Press, 1996.

Iton, Richard. *In Search of the Black Fantastic: Politics and Popular Culture in the Post–Civil Rights Era*. New York: Oxford University Press, 2008.

Jackson, John L., Jr. *Real Black: Adventures in Racial Sincerity*. Chicago: University of Chicago Press, 2005.

Jaffe, Rivke. "Talkin' 'bout the Ghetto: Popular Culture and Urban Imaginaries of Immobility." *International Journal of Urban and Regional Research* 36, no. 4 (2012): 674–688.

James, Joy. "Radicalising Feminism." *Race & Class* 40, no. 4 (1999): 15–31.

James, Winston. *Holding Aloft the Banner of Ethiopia: Caribbean Radicalism in Early Twentieth Century America*. New York: Verso, 1999.

Jameson, Fredric. "The Cultural Logic of Late Capitalism." In *Postmodernism, or The Cultural Logic of Late Capitalism*, 1–54. Durham, NC: Duke University Press, 1991.

Jay, Martin. "Scopic Regimes of Modernity." In *Vision and Visuality*, ed. Hal Foster, 2–23. New York: New Press, 1988.

Jay-Z. "Allure." *The Black Album*. Roc-A-Fella Records, 2003.

Johnson, Hume Nicola. "'Performing' Protest in Jamaica: The Mass Media as

Stage." *International Journal of Media and Cultural Politics* 4, no. 2 (2008): 163–182.

Johnson, Walter. *Soul by Soul: Life inside the Antebellum Slave Market*. Cambridge, MA: Harvard University Press, 1999.

Joselit, David. "Notes on Surface: Toward a Genealogy of Flatness." *Art History* 23, no. 1 (2000): 19–34.

Judy, Ronald A. T. "On the Question of Nigga Authenticity." *boundary 2* 21, no. 3 (1994): 211–230.

Keeling, Kara. "I = Another: Digital Identity Politics." In *Strange Affinities: The Gender and Sexual Politics of Comparative Racialization*, ed. Grace Kyung-won Hong and Roderick A. Ferguson, 53–75. Durham, NC: Duke University Press, 2011.

Keeling, Kara. "Passing for Human: *Bamboozled* and Digital Humanism." *Women & Performance: A Journal of Feminist Theory* 15, no. 1 (2005): 237–250.

Kelley, Robin D. G. *Freedom Dreams: The Black Radical Imagination*. Boston: Beacon, 2002.

Kelley, Robin D. G. "Playing for Keeps: Pleasure and Profit on the Postindustrial Playground." In *The House That Race Built: Black Americans, U.S. Terrain*, ed. Wahneema H. Lubiano, 195–288. New York: Pantheon Books, 1997.

Kelley, Robin D. G. *Race Rebels: Culture, Politics, and the Black Working Class*. New York: Free Press, 1994.

Kerr, Merrily. "An Interview with Franklin Sirmans." *New York Arts Magazine* (January 2002): 20–22.

Kim, Christine, ed. *Ironic/Iconic, Artists in Residence*. New York: Studio Museum in Harlem, 2002.

Kim, Christine, ed. *The World Stage: Africa, Lagos-Dakar; Kehinde Wiley*. New York: Studio Museum of Harlem, 2008.

Kracauer, Siegfried. "Photography." Translated by Thomas Y. Levin. *Critical Inquiry* 19, no. 3 (Spring 1993): 421–436.

Kwass, Michael. "Ordering the World of Goods: Consumer Revolution and Classification of Objects in Eighteenth-Century France." *Representations* 82 (Spring 2003): 87–116.

Lacan, Jacques. *The Four Fundamental Concepts of Psychoanalysis*. Translated by Alan Sheridan. New York: Norton, [1978] 1998.

Larkin, Brian. *Signal and Noise: Media, Infrastructure, and Urban Culture in Nigeria*. Durham, NC: Duke University Press, 2008.

Latour, Bruno. *We Have Never Been Modern*. Hemel Hempstead, England: Harvester Wheatsheaf, 1993.

Levine, Lawrence W. *Black Culture and Black Consciousness: Afro-American Folk Thought from Slavery to Freedom*. New York: Oxford University Press, 1977.

Lewis, Sarah. "De(i)fying the Masters." *Art in America* 93, no. 4 (2005): 121–125.

Lil Wayne. "Shine." *Lights Out*. Cash Money Records, 2000.

Lippard, Lucy R. "Frames of Mind." *Afterimage* 24, no. 5 (March–April 1997): 8–11.

Lippard, Lucy R. *Mixed Blessings: New Art in a Multicultural America*. New York: New Press, 2000.

Lipsitz, George. "Diasporic Noise: History, Hip Hop, and the Post-colonial Politics of Sound." In *Dangerous Crossroads: Popular Music, Postmodernism, and the Poetics of Place*, 23–48. London: Verso, 1994.

Lorde, Audre. "Afterimages." In *Chosen Poems: Old and New*, 102–105. New York: Norton, [1968] 1982.

Lovelace, Earl. *The Dragon Can't Dance*. New York: Persea Books, 1998.

Lowenthal, Leo. "The Triumph of Mass Idols." In *Literature, Popular Culture and Society*, 109–140. Englewood Cliffs, NJ: Prentice-Hall, 1961.

MacGaffey, Wyatt. "Complexity, Astonishment and Power: The Visual Vocabulary of Kongo Minkisi." *Journal of Southern African Studies* 14, no. 2 (1988): 188–203.

Majors, Richard, and Janet Mancini Billson. *Cool Pose: The Dilemmas of Black Manhood in America*. New York: Touchstone, 1992.

Manuel, Peter, and Wayne Marshall. "The Riddim Method: Aesthetics, Practice, and Ownership in Jamaican Dancehall." *Popular Music* 25, no. 3 (2006): 447–470.

Marks, Laura U. *The Skin of the Film: Intercultural Cinema, Embodiment, and the Senses*. Durham, NC: Duke University Press, 2000.

Marshall, P. David. *Celebrity and Power: Fame and Contemporary Culture*. Minneapolis: University of Minnesota Press, 1997.

Marshall, Wayne. "Bling-Bling for Rastafari: How Jamaicans Deal with Hip Hop." *Social and Economic Studies* 55, nos. 1 and 2 (2006): 49–74.

Marx, Karl. "The Fetishism of the Commodity and Its Secret." In *Capital: A Critique of Political Economy*, vol. 1, trans. Ben Fowkes, 163–177. London: Penguin, [1867] 1990.

Mbembe, Achille. "Provisional Notes on the Postcolony." *Africa* 62, no. 1 (1992): 3–37.

McAlister, Elizabeth A. *Rara! Vodou, Power, and Performance in Haiti and Its Diaspora*. Berkeley: University of California Press, 2002.

McClintock, Anne. *Imperial Leather: Race, Gender, and Sexuality in the Colonial Contest*. New York: Routledge, 1995.

McDonald, Kamila. "Skin Bleaching and the Dancehall." YouTube video, 2012. Posted by Kamila McDonald, June 19, 2012. https://www.youtube.com/watch?v=Jb5aasZEBX4, accessed June 23, 2014.

McElheny, Victor K. *Insisting on the Impossible: The Life of Edwin Land*. Reading, MA: Perseus Books, 1998.

McFarlane, Shelley-Ann. "Towards an Exploration of Earl 'Biggy' Turner and the New Reggae/Dancehall Aesthetic." In *Fashion Forward*, ed. Alissa de Witt-Paul and Mira Crouch, 1–14. Oxford: Inter-Disciplinary Press, 2011.

Meeks, Brian, and Stuart Hall. *Culture, Politics, Race, and Diaspora: The Thought of Stuart Hall*. Kingston: Ian Randle, 2007.

Mendlesohn, Farah. "Introduction: Reading Science Fiction." In *The Cambridge*

Companion to Science Fiction, ed. Edward James and Farah Mendlesohn, 1–14. Cambridge: Cambridge University Press, 2003.

Mercer, Kobena. "Diaspora Aesthetics and Visual Culture." In *Black Cultural Traffic: Crossroads in Global Performance and Popular Culture*, ed. Harry Justin Elam and Kennell A. Jackson, 242–265. Ann Arbor: University of Michigan Press, 2005.

Mercer, Kobena. "Hew Locke's Postcolonial Baroque." *Small Axe* 15, no. 1 (March 2011): 1–31.

Metz, Christian. "Photography and Fetish." *October* 34 (Autumn 1985): 81–90.

Meyer, Birgit, ed. *Aesthetic Formations: Media, Religion, and the Senses*. New York: Palgrave Macmillan, 2009.

Miller, Daniel, ed. *Materiality*. Durham, NC: Duke University Press, 2005.

Miller, Monica. *Slaves to Fashion: Black Dandyism and the Styling of Black Diasporic Identity*. Durham, NC: Duke University Press, 2009.

Millerson, Gerald. *Lighting for Video*. Oxford: Focal Press, [1975] 1991.

Mills, Claude. "Heat in the City: The Layers of the Dancehall Queen." *Flair Magazine*, April 22, 2002, 8–9.

Mirzoeff, Nicholas. *The Right to Look: A Counterhistory of Visuality*. Durham, NC: Duke University Press, 2011.

Moten, Fred. *In the Break: The Aesthetics of the Black Radical Tradition*. Minneapolis: University of Minnesota Press, 2003.

Moutoussamy-Ashe, Jeanne. *Viewfinders: Black Women Photographers*. New York: Dodd, Mead, 1993.

Murray, Derek Conrad. "Kehinde Wiley: Splendid Bodies." *Nka: Journal of Contemporary African Art* 21 (Fall 2007): 90–101.

Murray-Román, Jeannine. "Histories of Corporeal Meaning-Making in Kingston's Dancehall." In *Anthurium: A Caribbean Studies Journal* 9, no. 1 (2012): 1–5.

Nash Ferguson, Arlene. *I Come to Get Me! An Inside Look at the Junkanoo Festival*. Nassau: Doongalik Studios, 2000.

Neal, Mark Anthony. *What the Music Said: Black Popular Music at the Crossroads*. New York: Routledge, 1999.

Neale, Avon. *Los Ambulantes: The Itinerant Photographers of Guatemala*. Cambridge, MA: MIT Press, 1982.

Neptune, Harvey. *Caliban and the Yankees: Trinidad and the United States Occupation*. Chapel Hill: University of North Carolina Press, 2007.

Neptune, Harvey. "Manly Rivalries and Mopsies: Gender, Nationality, and Sexuality in United States–Occupied Trinidad." *Radical History Review* 87, no. 1 (2003): 78–95.

Oakes, James. *Slavery and Freedom: An Interpretation of the Old South*. New York: Knopf, 1990.

O'Grady, Lorraine, et al. *Lorraine O'Grady, Photomontages*. New York: INTAR Gallery, 1991.

Oguibe, Olu. *The Culture Game*. Minneapolis: University of Minnesota Press, 2004.

Oguibe, Olu. "Photography and the Substance of the Image." In *In/Sight: African Photographers, 1940 to the Present*, ed. Okwui Enwezor, Olu Oguibe, Octavio Zaya, and Solomon R. Guggenheim Museum, 231–250. New York: Guggenheim Museum, 1996.

Okeke, Chika. "Studio Call: Charles H. Nelson Jr. Keeping It Real." *Nka: Journal of Contemporary African Art* 16–17 (Fall–Winter 2002): 104–106.

Olshaker, Mark. *The Instant Image: Edwin Land and the Polaroid Experience*. New York: Stein and Day, 1978.

Owens, Craig. "Posing." In *Beyond Recognition: Representation, Power and Culture*, 201–217. Berkeley: University of California Press, 1992.

Patterson, Orlando. "The Condition of the Low Income Population in the Kingston Metropolitan Area." Kingston: Office of the Prime Minister, 1974.

Patterson, Orlando. "The Emerging West Atlantic System." In *Population in an Interacting World*, ed. William Alonso, 227–260. Cambridge, MA: Harvard University Press, 1987.

Paul, Annie. "'No Grave Cannot Hold My Body Down': Rituals of Death and Burial in Postcolonial Jamaica." *Small Axe* 11, no. 2 (2007): 142–162.

Persley, Nicole Hodges. "Bling, Bling." In *Icons of Hip Hop*, ed. Mickey Hess, 468. Westport, CT: Greenwood Press, 2007.

Peterson, Audrey. "Eddie Elcha's Harlem Stage." *American Legacy Magazine* (Summer 2007): 38–44.

Phelan, Peggy. *Unmarked: The Politics of Performance*. New York: Routledge, 1993.

Phu, T. N. "Shooting the Movement: Black Panther Party Photography and African American Protest Traditions." *Canadian Review of American Studies* 38, no. 1 (2008): 165–189.

Pietz, William. "The Problem of the Fetish, Part 1." *Res* 9 (1985): 5–17.

Pillbrow, Richard. "Light, Magic and the Theatre." *Lighting Journal* 62, no. 2 (1997): 73–82.

Pinn, Anthony. "Sweaty Bodies in a Circle: Thoughts on the Subtle Dimensions of Black Religion as Protest." *Black Theology: An International Journal* 4, no. 1 (2006): 11–26.

Pinney, Christopher. *Camera Indica: The Social Life of Indian Photographs*. Chicago: University of Chicago Press, 1997.

Pinney, Christopher. *The Coming of Photography in India*. London: British Library, 2008.

Pinney, Christopher. "Notes from the Surface of the Image: Photography, Postcolonialism, and Vernacular Modernism." In *Photography's Other Histories*, ed. Christopher Pinney and Nicolas Peterson, 202–220. Durham, NC: Duke University Press, 2002.

Pinney, Christopher, and Nicolas Peterson, eds. "Introduction." In *Photography's Other Histories*, 1–14. Durham, NC: Duke University Press, 2002.

Pinnock, Agostinho M. N. "'A Ghetto Education Is Basic': (Jamaican) Dancehall Masculinities as Counter-Culture." *Journal of Pan African Studies* 1, no. 9 (2007): 47–84.

Poole, Deborah. *Vision, Race and Modernity: A Visual Economy of the Andean Image World*. Princeton, NJ: Princeton University Press, 1997.

Powell, Richard J. *Cutting a Figure: Fashioning Black Portraiture*. Chicago: University of Chicago Press, 2008.

Raengo, Alessandra. *On the Sleeve of the Visual: Race as Face Value*. Hanover, NH: Dartmouth College Press, 2013.

Raiford, Leigh. *Imprisoned in a Luminous Glare: Photography and the African American Freedom Struggle*. Chapel Hill: University of North Carolina Press, 2011.

Raiford, Leigh. "Photography and the Practices of Critical Black Memory." *History and Theory* 48, no. 4 (2009): 112–129.

Rancière, Jacques. *The Emancipated Spectator*. Translated by Gregory Elliott. New York: Verso, 2009.

Regis, Helen. *Caribbean and Southern: Transnational Perspectives on the U.S. South*. Athens: University of Georgia Press, 2006.

Rideout, Victoria, Alexis Lauricella, and Ellen Wartella. *Children, Media, and Race: Media Use among White, Black, Hispanic and Asian American Children*. Evanston, IL: Center on Media and Human Development, Northwestern University, 2011.

Roach, Joseph. *Cities of the Dead: Circum-Atlantic Performance*. New York: Columbia University Press, 1996.

Robinson, Cedric J. *Black Marxism: The Making of the Black Radical Tradition*. Chapel Hill: University of North Carolina Press, [1983] 2000.

Roper, Moses. *A Narrative of His Adventures and Escape from American Slavery*. Philadelphia: Merrihew and Gunn, 1838.

Rose, Tricia. *Black Noise: Rap Music and Black Culture in Contemporary America*. Hanover, NH: University Press of New England, 1994.

Roth, Lorna. "Looking at Shirley, the Ultimate Norm: Colour Balance, Image Technologies, and Cognitive Equity." *Canadian Journal of Communication* 34 (2009): 111–136.

Rowe, Katie. "Interview." In *The WPA Oklahoma Slave Narratives*, ed. T. Lindsay Baker and Julie P. Baker, 543. Norman: University of Oklahoma Press, 1996.

Rucker, Derek D., and Adam D. Galinsky. "Conspicuous Consumption versus Utilitarian Ideals: How Different Levels of Power Shape Consumer Behavior." *Journal of Experimental Social Psychology* 45 (2009): 549–555.

Rucker, Derek D., and Adam D. Galinsky. "Desire to Acquire: Powerlessness and Compensatory Consumption." *Journal of Consumer Research* 35 (August 2008): 257–267.

Rucker, Derek D., Adam Galinsky, and David DuBois. "Power and Consumer Behavior: How Power Shapes Who and What Consumers Value." *Journal of Consumer Psychology* 22, no. 3 (2012): 352–368.

Ryan, James R. *Picturing Empire: Photography and the Visualization of the British Empire*. Chicago: University of Chicago Press, 1998.

Sarig, Roni. *Third Coast: Outkast, Timbaland, and How Hip-Hop Became a Southern Thing*. Cambridge, MA: Da Capo Press, 2007.

Saunders, Patricia. "Is Not Everything Good to Eat, Good to Talk: Sexual Economy and Dancehall Music in the Global Marketplace." *Small Axe* 7, no. 1 (2003): 95–115.

Sayre, Henry M. "The Rhetoric of Pose: Photography and the Portrait as Performance." In *The Object of Performance: The American Avant-Garde since 1970*, 35–65, 275–277. Chicago: University of Chicago Press, 1989.

Schama, Simon. "Perishable Commodities: Dutch Still-Life Painting and the 'Empire of Things.'" In *Consumption and the World of Goods*, ed. John Brewer and Roy Porter, 478–488. London: Routledge, 1993.

Scott, David. *Refashioning Futures: Criticism after Postcoloniality*. Princeton, NJ: Princeton University Press, 1999.

Seale, Bobby. *Seize the Time: The Story of the Black Panther Party and Huey P. Newton*. New York: Random House, 1970.

Sekula, Allan. "The Body and the Archive." *October* 39 (Winter 1986): 3–64.

Shabazz, Jamel, Charlie Ahearn, and Terrence Jennings. *A Time before Crack*. New York: powerHouse Books, 2005.

Sharpe, Jenny. "Cartographies of Globalisation, Technologies of Gendered Subjectivities: The Dub Poetry of Jean 'Binta' Breeze." *Gender & History* 15, no. 3 (2003): 440–459.

Shaw, Andrea. "'Big Fat Fish': The Hypersexualization of the Fat Female Body in Calypso and Dancehall." In *Anthurium: A Caribbean Studies Journal* 3, no. 2 (2005): 1–7.

Silverman, Kaja. *The Threshold of the Visible World*. New York: Routledge, 1996.

Singh, Nikhil Pal. *Black Is a Country: Race and the Unfinished Struggle for Democracy*. Cambridge, MA: Harvard University Press, 2004.

Sirmans, Franklin. "Barkley Hendricks: Ordinary People." In *Barkley L. Hendricks: Birth of the Cool*, ed. Trevor Schoonmaker, 78–87. Durham, NC: Nasher Museum of Art, Duke University, 2008.

Sirmans, Franklin. "In the Cipher: Basquiat and Hip-Hop Culture." In *Basquiat*, ed. Marc Mayer, 91–105. Brooklyn: Brooklyn Museum, 2005.

Sirmans, Franklin. *Mass Appeal: The Art Object and Hip Hop Culture*. Ottawa: Gallery 101, 2002.

Smith, Cauleen, dir. *Drylongso*. Video Data Bank, 2000.

Smith, Shawn Michelle. "The Art of Scientific Propaganda." In *Photography on the Color Line: W. E. B. Du Bois, Race, and Visual Culture*, 43–76. Durham, NC: Duke University Press, 2004.

Snead, James A. "Repetition as a Figure of Black Culture." In *Out There: Marginalization and Contemporary Cultures*, ed. Russell Ferguson, Martha Gever, Trinh T. Minh-ha, and Cornel West, 212–230. New York: New Museum of Contemporary Art, 1990.

Spillers, Hortense J. "Mama's Baby, Papa's Maybe: An American Grammar Book." In *Black, White, and In Color: Essays on American Literature and Culture*, 203–229. Chicago: University of Chicago Press, 2003.

Sprague, Stephen. "Yoruba Photography: How the Yoruba See Themselves." *African Arts* 12, no. 1 (November 1978): 52–59, 107.

Stacey, Jackie. *Star Gazing: Hollywood Cinema and Female Spectatorship*. London: Routledge, 1994.

Stanbury, Lloyd. "Mapping the Creative Industries: The Experience of Jamaica." Paper presented at CARICOM-WIPO Experts Meeting on Creative Industries and Intellectual Property, CARIMON Secretariat, Georgetown, Guyana, February 8–9, 2006.

Stanley Niaah, Sonjah. *Dancehall: From Slave Ship to Ghetto*. Ottawa: University of Ottawa Press, 2010.

Stanley Niaah, Sonjah, ed. "'I'm Bigger Than Broadway': Caribbean Perspectives on Producing Celebrity." Special issue, *Wadabagei: A Journal of the Caribbean and Its Diasporas* 12, no. 2 (2009).

Stanley Niaah, Sonjah. "Mapping Black Atlantic Performance Geographies: Continuities from Slave Ship to Ghetto." In *Black Geographies and the Politics of Place*, ed. Katherine McKittrick and Clyde Woods, 193–217. Cambridge, MA: South End, 2007.

State Property. "Sun Don't Shine." *State Property Album*. Roc-A-Fella and Def Jam Records, 2002.

Sterling, Marvin. *Babylon East: Performing Dancehall, Roots Reggae, and Rastafari in Japan*. Durham, NC: Duke University Press, 2010.

Stolzoff, Norman C. *Wake the Town and Tell the People: Dancehall Culture in Jamaica*. Durham, NC: Duke University Press, 2000.

Strassler, Karen. *Refracted Visions: Popular Photography and National Modernity in Java*. Durham, NC: Duke University Press, 2010.

Taft, Robert. *Photography and the American Scene*. New York: Dover, 1964.

Tagg, John. *The Burden of Representation: Essays on Photographies and Histories*. Minneapolis: University of Minnesota Press, 1993.

Tate, Greg D. "Kehinde Wiley's Cipher Syntax." In *Kehinde Wiley: The World Stage: China*, ed. John Michael Kohler Arts Center, 11–12. Sheboygan, WI: John Michael Kohler Arts Center, 2007.

Taussig, Michael T. *Mimesis and Alterity: A Particular History of the Senses*. New York: Routledge, 1993.

Tejada, Roberto, ed. *Luis Gispert, Loud Image*. Hanover, NH: Hood Museum of Art, Dartmouth College, 2004.

Thaggert, Miriam. *Images of Black Modernism: Verbal and Visual Strategies of the Harlem Renaissance*. Amherst: University of Massachusetts Press, 2010.

Thomas, Deborah A. "Blackness across Borders: Jamaican Diasporas and New Politics of Citizenship." *Identities* 14, nos. 1–2 (January 2007): 111–133.

Thomas, Deborah A. *Modern Blackness: Nationalism, Globalization, and the Politics of Culture in Jamaica*. Kingston: University of the West Indies Press, 2004.

Thompson, Anthony. *An Economic History of the Bahamas*. Nassau: Commonwealth Publications, 1979.

Thompson, Krista A. "'Black Skin, Blue Eyes': Visualizing Blackness in Modern Jamaican Art, 1922–1938." *Small Axe* 8, no. 2 (2004): 1–32.

Thompson, Krista A. *Developing Blackness: Studio Photographs of "Over the Hill"*

Nassau in the Independence Era. Nassau: National Art Gallery of the Bahamas, 2008.

Thompson, Krista A. *An Eye for the Tropics: Tourism, Photography, and Framing the Caribbean Picturesque.* Durham, NC: Duke University Press, 2006.

Thompson, Krista. "On Masking and Performance Art in the Postcolonial Caribbean." In *Caribbean: Art at the Crossroads of the World*, ed. Deborah Cullen, Elvis Fuentes, Yolanda Wood, and Derek Walcott, 284–303. New Haven, CT: Yale University Press, 2012.

Thompson, Krista A. "Performing Visibility: Freaknic and the Spatial Politics of Sexuality, Race, and Class in Atlanta." *Drama Review* 51, no. 4 (Winter 2007): 26–46.

Thompson, Robert Farris. *Flash of the Spirit: African and Afro-American Art and Philosophy.* New York: Vintage, 1983.

Tobin, Beth. "Taxonomy and Agency in Brunias's West Indian Paintings." In *Picturing Imperial Power: Colonial Subjects in Eighteenth-Century British Painting*, 139–173. Durham, NC: Duke University Press, 1999.

Tulloch, Carol. *Black Style.* London: V&A, 2004.

Ulysse, Gina A. *Downtown Ladies: Informal Commercial Importers, a Haitian Anthropologist, and Self-Making in Jamaica.* Chicago: University of Chicago Press, 2007.

Veblen, Thorstein. *The Theory of the Leisure Class.* London: Macmillan, 1899.

Von Eschen, Penny. *Satchmo Blows Up the World: Jazz Ambassadors Play the Cold War.* Cambridge, MA: Harvard University Press, 2004.

Wallace, Derron. "Lighten Up Yu Self! The Politics of Lightness, Success and Color Consciousness in Urban Jamaica." *JENdA: A Journal of Culture and African Women Studies* 14 (2009): 27–50.

Wallace, Michele. "Modernism, Postmodernism, and the Problem of the Visual in Afro-American Culture." In *Out There: Marginalization and Contemporary Cultures*, ed. Russell Ferguson, Martha Gever, Trinh T. Minh-ha, and Cornel West, 39–50. New York: New Museum of Contemporary Art, 1990.

Wallis, Brian. "Black Bodies, White Science: Louis Agassiz's Slave Daguerreotypes." *American Art* 9, no. 2 (1995): 163–181.

Watkins, S. Craig. *Hip Hop Matters: Politics, Pop Culture, and the Struggle for the Soul of a Movement.* Boston: Beacon, 2005.

Watkins, S. Craig. *Representing: Hip Hop Culture and the Production of Black Cinema.* Chicago: University of Chicago Press, 1998.

Watriss, Wendy, and Lois Parkinson Zamora, eds. *Image and Memory: Latin American Photography, 1866–1994.* Austin: University of Texas Press, 1998.

Watson, Henry. *Narrative of Henry Watson, a Fugitive Slave.* Boston: Bela Marsh, 1848.

Watson, Roxanne. "'Daggering' and the Regulation of Questionable Broadcast Media Content in Jamaica." *Communication Law and Policy* 16, no. 3 (2011): 255–315.

Weheliye, Alexander G. *Phonographies: Grooves in Sonic Afro-Modernity.* Durham, NC: Duke University Press, 2005.

Wendl, Tobias. "Observers Are Worried." In *Snap Me One! Studiofotografen in Afrika*, ed. Tobias Wendl and Heike Behrend, 29–35. Munich: Prestel, 1999.

Wendl, Tobias. "Portraits and Scenery in Ghana." In *Anthology of African and Indian Ocean Photography*, 142–155. Paris: Revue Noire, 1999.

West, Cornel. "Nihilism in Black America." In *Race Matters*, 17–31. New York: Vintage, 1994.

West, Cornel. "On Afro-American Popular Music: From Bebop to Rap." In *Prophetic Fragments*, 177–188. Trenton, NJ: African World Press, 1988.

West, Kanye. *All Falls Down*. Roc-A-Fella Records, 2004.

West, Kanye. "Diamonds from Sierra Leone." *Late Registration*. Roc-A-Fella, Island Def Jam, 2005.

West, Kanye. "Drive Slow." Single. Roc-A-Fella Records, Asylum Records, and Atlantic, 2006.

Wideman, John Edgar. *Sent for You Yesterday*. New York: Avon Books, 1983.

Wiegman, Robyn. *American Anatomies: Theorizing Race and Gender*. Durham, NC: Duke University Press, 1995.

Wilkinson, Helen-Ann E. "Limited Core Technology Transfer: The Case of the Moving Image Industry in Jamaica." MFA thesis, York University, Ontario, 1994.

Williams, Eric. *Capitalism and Slavery*. Chapel Hill: University of North Carolina Press, [1944] 1994.

Willis, Deborah. *Posing Beauty: African American Images from the 1890s to the Present*. New York: Norton, 2009.

Wilson, Peter J. *Crab Antics; the Social Anthropology of English-Speaking Negro Societies of the Caribbean*. New Haven, CT: Yale University Press, 1973.

Winston, Brian. "A Whole Technology of Dyeing: A Note on Ideology and the Apparatus of the Chromatic Moving Image." *Daedalus* 114, no. 4 (1985): 105–123.

Wright, Beth-Sarah. "Emancipative Bodies: Woman, Trauma, and a Corporeal Theory of Healing in Jamaican Dancehall Culture." PhD diss., New York University, 2004.

Wright, Beth-Sarah. "Unspeakable: Politics of the Vagina, Memory and Dance in Dancehall Docu-Videos." *Discourses in Dance* 2, no. 2 (2004): 45–60.

Wyman, James B. "From the Background to the Foreground: The Photo Backdrop and Cultural Expression." *Afterimage* (March–April 1997): 2–3.

Yee, Lydia. "Breaking and Entering." In *One Planet under a Groove: Hip Hop and Contemporary Art*, ed. Lydia Yee and Franklin Sirmans, 15–23. Bronx: Bronx Museum of the Arts, 2001.

Yee, Lydia, and Franklin Sirmans, eds. *One Planet under a Groove: Hip Hop and Contemporary Art*. Bronx: Bronx Museum of the Arts, 2001.

Young, Harvey. "Still Standing: Daguerreotypes, Photography, and the Black Body." In *Embodying Black Experience: Stillness, Critical Memory, and the Black Body*, 26–75. Ann Arbor: University of Michigan Press, 2010.

INDEX

Note: page numbers in *italics* refer to illustrations.

backdrops (*continued*)
on, 49, 59–63; in prisons, 104; reality/fantasy on, 49, 59–65, 84, 101, 105–110; science fiction themes on, 52, 105–106, 108; as screens, 53, 60; in studio photography, 79–84; in the theater, 79; time and, 108–111; variety of, 283n17

Bahamas: black nationalism in, 28; changes in education system in, 305n55; class in, 199–203, 306n82; Haitians in, 201–202, 202, 203, 306n84; hip-hop in, 170–171, 172–173, 178–192, 193, 195, 198–199, 302n3; proms in, 9, 43, 169–172, 173–174, 178–195, 198–199; respectability in, 194–195; television in, 172–173; tourism in, 200–201. *See also* Junkanoo

Bahamas Christian Council, 172
Bailey, Admiral, 136–137
Bailey, Amy, 162
Bakare-Yusef, Bibi, 120
Baker, Josephine, 37
Bamako. *See* Mali
Banton, Buju, 154
bare life, 292n17
Barnes, Natasha, 138, 278n83
Baroque, 228–229, 258–260, 263, 312n54
Barthes, Roland, 17, 225, 227, 228, 232, 241, 276n63
Bartley, Marvin, 164
Bartley, Sydney, 155, 300n178
Bashment bus, 1–2, 5, 24
Beads, Body, and Soul (Drewal and Mason), 44
Beebe, Roger, 224
Belly, 34, 146
Benjamin, Walter, 16
Berger, John, 225–227, 230, 232
BET. *See* Black Entertainment Television (BET)

Bethel, Nicolette, 193, 305n55
B.G. (Baby Gangsta), 24–25, 98, 99, 230, 231, 236; *Chopper City in the Ghetto*, 222, 223
Biggers, John, 73
Billson, Janet Mancini: *Cool Pose*, 65
bixel, 36–37, 74, 130–131
Bixel (Newkirk), 36, 36–37
bixelation, 74, 125, 130–131
Black Arts Movement, 257, 316n111
Black Entertainment Television (BET), 34, 145, 172–173, 278n78
black fantastic, 273n17
Black Journal, 89
black light, 245, 257
Black Light (Ringgold), 257
Black Light (Wiley), 19, 44, 45, 218, 219, 219, 245, 246, 247, 248, 257–258
black nationalism, 28–30, 85, 110, 258, 279n86
blackness: in art, 161–162, 233, 301n187, 316n111; commodification of, 29–30, 32–33, 235–236, 254–258, 262–264, 269; hyperblackness, 257, 270; shine and, 37, 219, 224, 232–235, 254, 256; surface and, 36–37, 232–235; visibility and, 232–236, 257–258. *See also* race
Black Panther Party, 85–88
Black Power (Thomas), 28, 29
black power movement, 85–89, 95–96
black public sphere, 3, 271n2
black subjectivity, 236, 270
blinding effect of light, 14–16, 20, 112–113, 128–130, 223
bling: art history and, 230, 237–250, 258–263; on backdrops, 48, 98–104; body and, 32; conspicuous consumption and, 174–178, 222–225; cultural formation through, 32, 198; dancehall and, 144–149, 164; definition of,

community, 2, 3, 10, 11, 23, 25, 48, 113, 114, 132, 164–165, 168, 198–199

Confidential Source, 178

consumerism: in African diaspora, 24–26; citizenship and, 30–32; conspicuous consumption, 24–26, 93–95, 99, 145, 147–151, 171, 198, 277n70; consumer products on backdrops, 8–9, 47–48, 51, 56–59, 57, 58, 61, 64, 67, 96–103, 145, 287n73, 298n141; in dancehall, 119–120, 147–151; digital consumption, 271n1; hip-hop and, 171, 174–178, 221–225; modernity and, 198; representation through, 29–30; status through consumer products, 24, 103, 119, 175, 178, 181, 195, 199–201, 226, 230–232. *See also* bling

contemporary art: dancehall in, 115–117, 155–164; frames for, 248–250; hip-hop in, 29–30, 34–38, 216–220, 221, 236–270; influence of street photography on, 72–79, 245; light in, 5, 251; representation and, 3–5, 29–30, 248–251; skin bleaching in, 115–117, 156–157. *See also names of individual artists*

Cool Pose (Majors and Billson), 65

Cooper, Carolyn, 123

Cooper, Jeff, 187, 187

Copeland, Huey, 250

Counting Money HaHa (The Counting Lesson Revisited) (Patterson), 157–162, 160

Courbet, Gustave: *Stone Breakers*, 106–107

cover art, 222, 223

Crazy Hype, 6

criminality, 17–19, 157

C. R. Walker Senior High School, 180, 181, 183, 201

daggering, 278n78, 301n180

Daguerre, Louis-Jacques-Mandé, 79

dancehall: bling and, 144–149, 164; as a commodity, 153; consumerism in, 119–120, 147–151; in contemporary art, 115–117, 155–164; criticisms of, 27, 117, 153–155, 156, 162; definition of, 118; economics of, 118, 124, 125, 127; fashion in, 120–121, 136, 137, 147–148, 292n20, 292n28, 296n98; history of, 118–121; in Jamaica, 5–7, 8–9, 15, 112–114, 113, 115–134, 136–168; men in, 13, 38, 120–121, 136–138, 137, 145, 157, 292n28; promotion of, 96–97, 122; sexuality and, 119, 122–124, 293n35, 293n37; skin bleaching for, 22–23, 137–138, 139–144; still photography in, 121; street photography in, 145; suppression of, 27, 154–155, 278n78, 300n178, 300nn175–176; on television, 153; in United States, 119; unvisibility and, 117, 163–164; use of screens in, 131–134, 132, 151–153; video footage of, 12, 13, 121–123, 124–126, 151–153, 293n35, 293n37, 293n49; video light in, 5–7, 12, 42, 112–114, 113, 115, 126–134, 127, 128, 129, 136–168, 148; women in, 120–121, 122–124, 137, 292n20, 292n28, 293n35, 293n37

Dancehall Channel, 153

Dancehall Queen, 121

Dandy Lion Preschool, 179, 180, 185

Davis, John, 48, 56–59, 63, 64, 65, 66, 70, 103, 282n6

death, 78, 110–111, 149–150, 226, 285n53

Debord, Guy, 103

DeGussi, Richard, 250

Detroit News, 215

Diamond series (Wiley), 254–256, 255

Gispert, Luis (*continued*)
220; *Untitled (Car Toes)*, 267, 267; *Untitled (Girls with Ball)*, 260, 261, 262, 263, 263, 264; *Untitled (Single Floating Cheerleader, a.k.a. Hoochy Goddess)*, 258–260, 259, 261; *Urban Myths Part I and II*, 220
Gleaner, 135, 139, 153, 162
Gleaner's Best of Jamaica, 144
Goffa (Patterson), 164, 166, 167
Google, 271n1
graffiti, 91, 310n7
Graham, Michael, 6
gravity, 260, 263
Gray, Herman, 257
Green, James, 59, 63, 84, 101, 105
Green, Ralph "Petey," 87
Greenberg, Clement, 228, 280n108
Greenblatt, Stephen, 229
Greenlee, Felicia, 125, 140
green screen, 60–62, 62, 63, 261

Haitians, 201–202, 202, 203, 306n84
Hal, Frans, 227
Hall, Stuart, 9, 272n16, 275n37
Hanchard, Michael, 50, 84, 108
Hanna, Eartha, 173–174
Hart, Janice, 23
Hartman, Saidiya, 32, 273n24
Hawkins, Terell, 100, 100–101, 103, 105
Hayes, Isaac, 175
Heidegger, Martin, 314n94
Henry VIII, 230, 231, 313n59
Herc, DJ Kool, 147
hip-hop: art history and, 224, 230–235, 231, 237–251, 258–263; in the Bahamas, 170–171, 172–173, 178–192, 193, 195, 198–199, 302n3; censorship of, 172–173; conspicuous consumption and, 93–95, 99, 171, 174–178, 221–225; in contemporary art, 34–38, 216–220, 221, 236–270; criticism of, 302n3; depictions on backdrops, 48, 74–78,

91–92, 93, 98–99; entrances in, 174–175, 215–216; history of, 220–221; in Jamaica, 145–147, 298n140; masculinity in, 252–254; modernity and, 198; multiple forms of, 91; proms and, 170–171, 174, 178–192, 193, 195, 198–199, 216; and realness, 107; status and, 181, 195; street photography and, 48, 74–78, 89–95, 98–99; surfacism and, 235–236; on television, 145–146; in Trinidad, 195–197; visibility and, 34, 171, 174–179, 188–192, 210, 213, 214, 215–217, 221–225, 233–235, 257, 258; women in, 184. *See also* bling
Holbein, Hans, the Younger: *The Ambassadors*, 225–226, 226, 229, 232, 233, 243; *Portrait of Henry VIII of England*, 230–232, 231, 233
homophobia, 119, 138, 153, 154
Hope, Donna, 13, 96n98, 138, 141, 144–145, 154, 300n171
Hot Boys, 222
Hoyt, Satch: *From Mau Mau to Bling Bling*, 29, 29
Huie, Albert, 279n86, 301n187; *The Counting Lesson*, 161, 161–162
Hype, Crazy, 151
Hype, Lisa, 139
hyperblackness, 257, 270
HYPE TV, 153
hypervisibility, 14, 34, 39–40, 164–165, 270

Ice-T, 92
Illuminated Presence (Patterson), 4
illusions. *See* visual illusions
India, 172
International Center for Photography, 80
International Monetary Fund, 28, 120, 279n88
Internet, 12, 124–125
Invisible Man (Ellison), 39–40

social mobility, 21, 195

Soirée de Mariage Drissa Balo (Sidibé), 189, *190*

Sonny, 8, *11*, 96–97, *97*, 121, 145, *146*

Soulja Boy, 222

sound of light, 25, 236, 256, 269–270, 277n68

Source, 221

South Africa, 88–89

Sowah, Jack, 6, 12, 42, 112, 113, 121–122, *123*, 124, *125*, 126, 127, 128, 130, 131–133, *134*, 140, 145, 149

Sowah, Prince, 132

spectacle: of celebrity, 21; of consumerism, 103; of photography, 173–174; proms as a, 171, 187–195, 199–203. *See also* visibility

St. Andrew's School, 203

Stanley Niaah, Sonjah, 13, 125, 299n164

Stapp, Blair, *87*

Star, 157

Stars among Stars (Roye), *152*

status: bling and, 181, 230–232; consumer products and, 24, 103, 119, 175, 178, 181, 195, 199–201, 226, 230–232; hip-hop and, 181, 195; proms and, 171, 199–201; social mobility and, 21; street photography and, 42, 50–51, 69, 70; video light and, 148, 150–151. *See also* value

St. Augustine's College, *170*, *186*, 203, *204*, 305n62

St. Juste, Chappie, 165, 301n193

Stone Breakers (Courbet), 106–107

Stone Love dancehall, 133

Strachan, Ian G., 302n3

street photography: in Atlanta, 47, *48*, *49*, 54–59, *57*, *58*, *64*, 65, 66, 70; in dancehalls, 145; death and, 78, 110–111, 285n53; demography of clients for, 53–54; digital photography use in, 53, 72; economics of, 49, 52–53; full-body view in,

63; green screen use in, 60–62, *62*, *63*; hip-hop and, 48, 74–78, 89–95, 98–99; identity crisis of, 106; influence on contemporary art, 245; in Jamaica, 8, 10–11, *11*, 48, 52, 96–97, *97*, 145; materiality and, 16–17, 72; memory and, 54, 78, 92, 110–111; in New Orleans, 8, 40, *41*, 47–48, *49*, *50*, *52*, *53*, *54*, *55*, *61*, *62*, *62*, *64*, *67*, *68*, 98–99, *99*, *102*, *109*; in New York, 74, *75*, 89; Polaroid use in, 16, 42, *52*, *53*, 71–72, 108–109; posing for, 9, 42, 49, 65–70, 91, 92, 97, 104, 105, 107, 290n132; presentation of photographs, 53, 71–72, 283n11; props in, 93–95; reality/artificiality in, 51, 63–65; reproduction of photographs, 71–72; state control of, 278n78; status and, 42, 50–51, 69, 70; time and, 52, 54, 84, 108–111; visibility and, 65–71, 78, 84, 93, 97–98, 107; in Washington, DC, 8, 89, 289n103. *See also* backdrops; club photography; Nelson, Charles H.

St. Sebastian II (Wiley), 248–250, *249*, 254

surfaces: blackness and, 35–38, 232–235; light and, 238–245, 252–254, 268; shine on, 177, 223–230, 303n23, 311n31; skin as photographic, 114, 140–144; surfacism, 37–38, 190–192, 212, 225–230, 232, 233–236, 238, 241–245

Sweet Auburn Festival, 47, 54, 65

Talbot, William Henry Fox, 79, 274n36

Tate, Greg, 108, 254

Taussig, Michael, 104

television: in the Bahamas, 172–173, 307n95; censorship of, 172–173; dancehall on, 153, 155; hip-hop on, 145–146; in Jamaica, 115, 135,

293n37; in hip-hop, 185; at proms, 181–185. *See also* gender

World Stage: Jamaica, The (Wiley), 4, 163

Wright, Beth-Sarah, 124

Wyman, James, 79

Y'all Niggas Ain't Ready (Nelson), *43*

Yee, Lydia, 216

Yellowman, 118–119

Young, Lewis, *81*

Zealy, Joseph T., 275n39